The Palace Museum's Essential Collections

BRONZEWARE
from
THE SHANG TO JIN DYNASTIES

The Commercial Press

Bronzeware from the Shang to Jin Dynasties

Chief Editor	Du Naisong 杜迺松
Deputy Chief Editor	Li Mijia 李米佳
Editorial Board	He Lin 何林 , Jia Hongdi 賈紅荻 , Jiao Donghua 焦東華
Photographers	Hu Chui 胡錘 , Liu Zhigang 劉志崗 , Zhao Shan 趙山 , Feng Hui 馮輝
Translator	Chan Sin-wai 陳善偉
Assistant Translator	Florence Li 李穎儀
Editorial Consultant	Hang Kan 杭侃
Project Editors	Xu Xinyu 徐昕宇 , Fu Mei 傅薇
Cover Design	Zhang Yi 張毅
Published by	The Commercial Press (Hong Kong) Ltd. 8/F., Eastern Central Plaza, 3 Yiu Hing Rd, Shau Kei Wan, Hong Kong http://www.commercialpress.com.hk
Printed by	C & C Offset Printing Co., Ltd. C & C Building, 36 Ting Lai Road, Tai Po, N.T., Hong Kong
Edition	First Edition in December 2015

ISBN 978 962 07 5658 0

Printed in Hong Kong

Introducing the Palace Museum to the World

SHAN JIXIANG

Built in 1925, the Palace Museum is a comprehensive collection of treasures from the Ming and Qing Dynasties and the world's largest treasury of ancient Chinese art. To illustrate ancient Chinese art for people home and abroad, the Palace Museum and The Commercial Press (Hong Kong) Ltd. jointly published *The Complete Collection of Treasures of the Palace Museum*. The series contains 60 books, covering the rarest treasures of the Museum's collection. Having taken 14 years to complete, the series has been under the limelight among Sinologists. It has also been cherished by museum and art experts.

After publishing *The Complete Collection of Treasures of the Palace Museum*, it is understood that westerners, when learning about Chinese traditional art and culture, are particularly fond of calligraphy, paintings, ceramics, bronze wares, jade wares, furniture, and handicrafts. That is why The Commercial Press (Hong Kong) Ltd. has discussed with the Palace Museum to further co-operate and publish a new series, *The Palace Museum's Essential Collections*, in English, hoping to overcome language barriers and help more readers to know about traditional Chinese culture. Both parties regard the publishing of the series as an indispensable mission for Chinese history with significance in the following aspects:

First, with more than 3,000 pictures, the series has become the largest picture books ever in the publishing industry in China. The explanations show the very best knowledge from four generations of scholars spanning 90 years since the construction of the Museum.

Second, the English version helps overcome language and cultural barriers between the east and the west, facilitating the general public's knowledge of Chinese culture. By doing so, traditional Chinese art will be given a fresher image, becoming more approachable among international art circles.

Third, the series is going to further people's knowledge about the Palace Museum. According to the latest statistics, the Palace Museum holds more than 1.8 million pieces of artifacts (among which 228,771 pieces have been donated by the general public and purchased or transferred by the government since 1949). The series selects nearly 3,000 pieces of the rare treasures, together with more than 12,000 pieces from *The Complete Collection of Treasures of the Palace Museum*. It is believed that the series will give readers a more comprehensive view of the Palace Museum.

Just as *The Palace Museum's Essential Collections* is going to be published, I cannot help but think of Professor Qi Gong from Beijing Normal University; famous scholars and researchers of the Palace Museum Mr. Xu Bangda, Mr. Zhu Jiajin, and Mr. Liu Jiu'an; and well-known intellectuals Mr. Wu Kong (Deputy Director of Central Research Institute of Culture and History), and Mr. Xu Qixian (Director of Research Office of the Palace Museum). Their knowledge and relentless efforts are much appreciated for showing the treasures of the Palace Museum to the world.

Looking at History through Art

YANG XIN

The Palace Museum is a comprehensive collection of the treasures of the Ming and Qing Dynasties. It is also the largest museum of traditional art and culture in China. Located in the urban centre of Beijing, this treasury of ancient Chinese culture covers 720,000 square metres and holds nearly 2 million pieces of artifacts.

In the fourth year of the reign of Yongle (1406 A.D.), Emperor Chengzu of Ming, named Zhu Di, ordered to upgrade the city of Beiping to Beijing. His move led to the relocation of the capital of the country. In the following year, a grand, new palace started to be built at the site of the old palace in Dadu of the Yuan Dynasty. In the 18th year of Yongle (1420 A.D.), the palace was complete and named as the Forbidden City. Since then the capital of the Ming Dynasty moved from Nanjing to Beijing. In 1644 A.D., the Qing Dynasty superceded the Ming empire and continued using Beijing as the capital and the Forbidden City as the palace.

In accordance with the traditional ritual system, the Forbidden City is divided into the front part and the rear part. The front consists of three main halls, namely Hall of Supreme Harmony, Hall of Central Harmony, and Hall of Preserving Harmony, with two auxiliary halls, Hall of Literary Flourishing and Hall of Martial Valour. The rear part comprises three main halls, namely Hall of Heavenly Purity, Hall of Union, Hall of Earthly Tranquillity, and a cluster of six halls divided into the Eastern and Western Palaces, collectively called the Inner Court. From Emperor Chengzu of Ming to Emperor Puyi, the last emperor of Qing, 24 emperors together with their queens and concubines, lived in the palace. The Xinhai Revolution in 1911 overthrew the Qing Dynasty and more than 2,000 years of feudal governance came to an end. However, members of the court such as Emperor Puyi were allowed to stay in the rear part of the Forbidden City. In 1914, Beiyang government of the Republic of China transferred some of the objects from the Imperial Palace in Shenyang and the Summer Palace in Chengde to form the Institute for Exhibiting Antiquities, located in the front part of the Forbidden City. In 1924, Puyi was expelled from the Inner Court. In 1925, the rear part of the Forbidden City was transformed into the Palace Museum.

Emperors across dynasties called themselves "sons of heaven," thinking that "all under the heaven are the emperor's land; all within the border of the seashore are the emperor's servants"("Decade of Northern Hills, Minor Elegance," Book of Poetry). From an emperor's point of view, he owns all people and land within the empire. Therefore, delicate creations of historic and artistic value and bizarre treasures were offered to the palace from all over the country. The palace also gathered the best artists and craftsmen to create novel art pieces exclusively for the court. Although changing of rulers and years of wars caused damage to the country and unimaginable loss of the court collection, art objects to the palace were soon gathered again, thanks to the vastness and long history of the country, and the innovativeness of the people. During the reign of Emperor Qianlong of the Qing Dynasty (1736–1796), the scale of court collection reached its peak. In the final years of the Qing Dynasty, however, the invasion of Anglo-French Alliance and the Eight-Nation Alliance into Beijing led to the loss and damage of many art objects. When Puyi abdicated

from his throne, he took away plenty of the objects from the palace under the name of giving them out as presents or entitling them to others. His servants followed suit. Up till 1923, the keepers of treasures of Palace of Established Happinesss in the Inner Court who actually stole the objects, set fire on them and caused serious damage to the Qing Court collection. Numerous art objects were lost within a little more than 60 years. In spite of all these losses, there was still a handsome amount of collection in the Qing Court. During the preparation of construction of the Palace Museum, the "Qing Rehabilitation Committee" checked that there were around 1.17 million items and the Committee published the results in the Palace Items Auditing Report, comprising 28 volumes in 6 editions.

During the Sino-Japanese War, there were 13,427 boxes and 64 packages of treasures, including calligraphy and paintings, picture books, and files, were transferred to Shanghai and Nanjing in five batches in fear of damages and loot. Some of them were scattered to other provinces such as Sichuan and Guizhou. The art objects were returned to Nanjing after the Sino-Japanese War. Owing to the changing political situation, 2,972 pieces of treasures temporarily stored in Nanjing were transferred to Taiwan from 1948 to 1949. In the 1950s, most of the antiques were returned to Beijing, leaving only 2,211 boxes of them still in the storage room in Nanjing built by the Palace of Museum.

Since the establishment of the People's Republic of China, the organization of the Palace Museum has been changed. In line with the requirement of the top management, part of the Qing Court books were transferred to the National Library of China in Beijing. As to files and essays in the Palace Museum, they were gathered and preserved in another unit called "The First Historical Archives of China."

In the 1950s and 1960s, the Palace Museum made a new inventory list for objects kept in the museum in Beijing. Under the new categorization system, objects which were previously labelled as "vessels", such as calligraphy and paintings, were grouped under the name of "Gu treasures." Among them, 711,388 pieces which belonged to old Qing collection and were labelled as "Old", of which more than 1,200 pieces were discovered from artifacts labelled as "objects" which were not registered before. As China's largest national museum, the Palace Museum has taken the responsibility of protecting and collecting scattered treasures in the society. Since 1949, the Museum has been enriching its collection through such methods as purchase, transfer, and acceptance of donation. New objects were given the label "New." At the end of 1994, there were 222,920 pieces of new items. After 2000, the Museum re-organized its collection. This time ancient books were also included in the category of calligraphy. In August 2014, there were a total of 1,823,981 pieces of objects in the museum collection. Among them, 890,729 pieces were "old," 228,771 pieces were "new," 563,990 were "books," and 140,491 pieces were ordinary objects and specimens.

The collection of nearly two million pieces of objects were important historical resources of traditional Chinese art, spanning 5,000 years of history from the primeval period to the dynasties of Shang, Zhou, Qin, Han, Wei, and Jin, Northern and Southern Dynasties, dynasties of Sui, Tang, Northern Song, Southern Song, Yuan, Ming, Qing, and the contemporary period. The best art wares of each of the periods were included in the collection without disconnection. The collection covers a comprehensive set categories, including bronze wares, jade wares, ceramics, inscribed tablets and sculptures, calligraphy and famous paintings, seals, lacquer wares, enamel wares, embroidery, carvings on bamboo, wood, ivory and horn, golden and silvery vessels, tools of the study, clocks and watches, pearl and jadeite jewellery, and furniture among others. Each of these categories has developed into its own system. It can be said that the collection itself is a huge treasury of oriental art and culture. It illustrates the development path of Chinese culture, strengthens the spirit of the Chinese people as a whole, and forms an indispensable part of human civilization.

The Palace Museum's Essential Collections Series features around 3,000 pieces of the most anticipated artifacts with nearly 4,000 pictures covering eight categories, namely ceramics, jade wares, bronze wares, furniture, embroidery, calligraphy, and rare treasures. The Commercial Press (Hong Kong) Ltd. has invited the most qualified translators and

academics to translate the Series, striving for the ultimate goal of achieving faithfulness, expressiveness, and elegance in the translation.

We hope that our efforts can help the development of the culture industry in China, the spread of the sparkling culture of the Chinese people, and the facilitation of the cultural interchange between China and the world.

Again, we are grateful to The Commercial Press (Hong Kong) Ltd. for the sincerity and faithfulness in their cooperation. We appreciate everyone who have given us support and encouragement within the culture industry. Thanks also go to all Chinese culture lovers home and abroad.

Yang Xin former Deputy Director of the Palace Museum, Research Fellow of the Palace Museum, Connoisseur of ancient calligraphy and paintings.

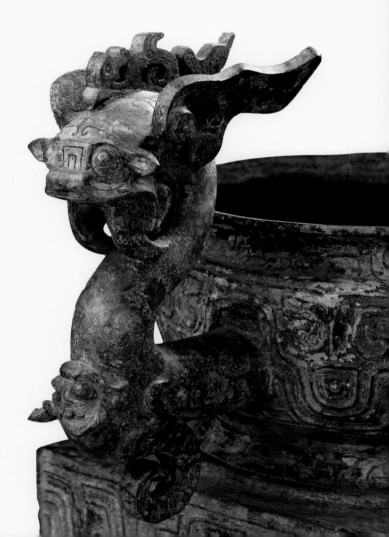

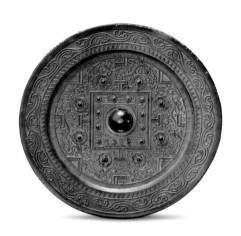

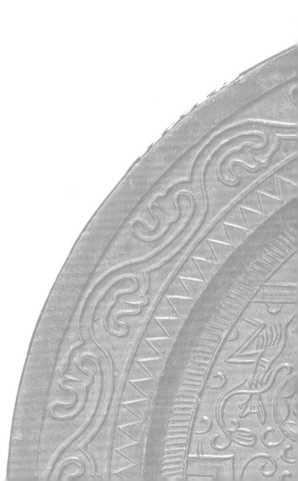

Contents

List of Bronzeware

VESSELS FOR FOOD

1. *Ding* (Cooking Vessel) Inscribed with the Character "Huo"
 Overall height 21.4 cm
 Diameter of mouth 18 cm

2. Rectangular *Ding* (Cooking Vessel) Made by an Official Fou as a Sacrificial Utensil
 Overall height 29.6 cm
 Diameter of mouth 22.5 × 17 cm

3. Rectangular *Ding* (Cooking Vessel) Made by Tian Gao for Mother Xin
 Overall height 15.6 cm
 Diameter of mouth 10.2 × 15 cm

4. Large *Yan* (Cooking Vessel) with Animal Mask Design
 Overall height 80.9 cm
 Diameter of mouth 44.9 cm

5. *Gui* (Food Container) with Inscription "Er"
 Overall height 14.2 cm
 Diameter of mouth 19.7 cm

6. *Gui* (Food Container) with Three Ears and Nipple Design
 Overall height 19.1 cm
 Diameter of mouth 30.5 cm

7. *Dou* (Food Container) with Inscription "Ning"
 Overall height 10.5 cm
 Diameter of mouth 12.1 cm

8. *Ding* (Cooking Vessel) with a Disc and Animal Mask Design
 Height 20.2 cm
 Diameter of mouth 16.4 cm

9. *Ding* (Cooking Vessel) with Inscription "Shui"
 Height 23 cm
 Diameter of mouth 20 cm

10. Shi Lü *Ding* (Cooking Vessel)
 Height 15.8 cm
 Diameter of mouth 16.2 cm

11. Song *Ding* (Cooking Vessel)
 Height 38.4 cm
 Diameter of mouth 30.3 cm

12. *Ding* (Cooking Vessel) Made by Da
 Height 39.7 cm
 Diameter of mouth 38.7 cm

13. *Ding* (Cooking Vessel) Made by Zi Duan, Master Wen of the State of Guo
 Height 30 cm
 Diameter of mouth 30.9 cm

14. *Ding* (Cooking Vessel) Made by Ke to Pray for Happiness and Longevity
 Height 35.4 cm
 Diameter of mouth 33 cm

15. *Li* (Cooking Vessel) Made by Shi Qin to Worship His Parents
 Height 50.8 cm
 Diameter of mouth 47 cm

16. Rectangular *Li* (Cooking Vessel) with Design of a Slave at a Door Whose Feet Had Been Cut Off as a Punishment
 Height 13.5 cm
 Diameter of mouth 11.2 × 9 cm

17. *Gui* (Food Container) with Coiling *Kui*-dragon Design
 Height 15.8 cm
 Diameter of mouth 18.5 cm

18. *Gui* (Food Container) Made by Qin Lin to Worship Father Yi
 Height 16.7 cm
 Diameter of mouth 21.1 cm

19. *Gui* (Food Container) Made by Rong
 Height 14.8 cm
 Diameter of mouth 20.6 cm

20. *Gui* (Food Container) with Inscription "Bo Zuo"
 Height 14.9 cm
 Diameter of mouth 20.9 cm

21. *Gui* (Food Container) Made by Shi You
 Height 22.5 cm
 Diameter of mouth 20.9 cm

22. *Gui* (Food Container) Made by Zhui
Overall height 39.4 cm
Diameter of mouth 27 cm

23. *Gui* (Food Container) Made by Ge Bo
Height 23.5 cm
Diameter of mouth 21.3 cm

24. *Gui* (Food Container) Made by Cui
Height 21.1 cm
Diameter of mouth 18 cm

25. *Gui* (Food Container) Made by Tai Shi Zu
Height 19.8 cm
Diameter of mouth 21.2 cm

26. Song *Gui* (Food Container)
Height 22 cm
Diameter of mouth 24 cm

27. *Gui* (Food Container) Made by Yang
Height 18.7 cm
Diameter of mouth 21.6 cm

28. Dou Bi *Gui* (Food Container)
Height 15.1 cm
Diameter of mouth 23.5 cm

29. Large *Fu* (Food Container) with *Kui*-dragon Design
Height 37 cm
Diameter of mouth 55.8 cm

30. *Xu* (Food Container) Made by Guo Cong
Overall height 14 cm
Width 38.5 cm
Diameter of mouth 24.9 × 19.1 cm

31. *Xu* (Food Container) Made by Du Bo for Offering Sacrifices to His Grandfather, Father, and Close Friends
Overall height 36.8 cm
Diameter of mouth 27.1 × 17.5 cm

32. *Yu* (Food or Water Container) Made by Bo
Overall height 39.9 cm
Diameter of mouth 53.5 cm

33. Big *Ding* (Cooking Vessel) with Coiling Serpent Design
Overall height 75 cm
Diameter of mouth 77 cm

34. *Ding* (Cooking Vessel) with Coiling Serpent Design
Overall height 45 cm
Width 55.5 cm

35. Rectangular *Yan* (Cooking Vessel) with Design of Four Snakes
Overall height 44.7 cm
Width 33.7 cm
Diameter of mouth 28.7 × 23.2 cm

36. *Gui* (Food Container) with Dragon-shaped Ears
Overall height 33.9 cm
Width 43 cm
Diameter of mouth 23.1 cm

37. *Pu* (Food Container) Made by the Grand Minister of Education of the State of Lu
Overall height 28.3 cm
Diameter of mouth 25.5 cm

38. *Dou* (Food Container) with Design of a Hunting Scene in Copper Inlay
Overall height 21.4 cm
Diameter of mouth 18.5 cm

39. Qiao *Ding* (Cooking Vessel) Made by Yin Ken, King of Chu
Overall height 59.7 cm
Diameter of mouth 46.6 cm

40. *Ding* (Cooking Vessel) with Posy Design
Overall height 18.2 cm
Width 25.8 cm
Diameter of mouth 17.9 cm

41. *Fu* (Food Container) Made by Yin Ken, King of Chu
Overall height 11.7 cm
Diameter of mouth 31.8 × 21.7 cm

42. *Dou* (Food Container) with Interlaced Hydras Design of Turquoise Inlay
Overall height 39 cm

Diameter of mouth 20 cm

VESSELS FOR WINE

43. *Jue* (Wine Vessel) with Animal Mask Design
Overall height 16.1 cm
Width 14.8 cm

44. *Jiao* (Wine Vessel) with Inscription "Ning"
Overall height 21.4 cm
Diameter of mouth 16.5 x 8.4 cm

45. Rectangular *Jia* (Wine Vessel) with Inscription "Ce"
Overall height 28.5 cm
Diameter of mouth 13.3 × 11 cm

46. *Jia* (Wine Vessel) with Animal Mask Design
Overall height 34 cm
Diameter of mouth 23 cm

47. *Gu* (Wine Vessel) with Inscription "Shou"
Overall height 26.4 cm
Diameter of mouth 14.8 cm

48. *Zhi* (Wine Vessel) with Inscription "Shan Fu"
Overall height 17.5 cm
Diameter of mouth 8.6 cm

49. *Zun* (Wine Vessel) with Three Ram Heads on Its Shoulders
Overall height 52 cm
Diameter of mouth 41 cm

50. Rectangular *Zun* (Wine Vessel) Made by Xuya Clan to Worship Ancestors
Overall height 45.7 cm
Diameter of mouth 33.6 × 33.4 cm

51. *Zun* (Wine Vessel) with Inscription "You"
Overall height 13.2 cm
Diameter of mouth 20.7 cm

52. Rectangular *You* (Wine Vessel) with a Cross Hole
Overall height 34.5 cm
Diameter of mouth 6.6 cm

53. *Lei* (Wine Vessel) Made by Jue to Worship Zu Jia
Overall height 41.8 cm
Diameter of mouth 17.9 cm

54. *You* (Wine Vessel) Made by Yu to Worship Zu Ding
Overall height 23.7 cm
Diameter of mouth 11.6 × 8.4 cm

55. Owl-shaped *You* (Wine Vessel) with Inscription "Fu Bei"
Overall height 17.1 cm
Diameter of mouth 11 x 8.1 cm

56. Si *Gong* (Wine Vessel) with Animal Mask Design
Overall height 15 cm
Width 20 cm

57. *You* (Wine Vessel) Made for Sacrifice by Yi Qi in the Fourth Year of Dixin's Reign
Overall height 32 cm
Width 19.7 cm
Diameter of mouth 8.8 cm

58. *You* (Wine Vessel) with Ox Design
Overall height 29.5 cm
Diameter of mouth 14.3 × 11 cm

59. *Hu* (Wine Vessel) with Inscription "Shi"
Overall height 35 cm
Diameter of mouth 18.9 x 14.4 cm

60. *He* (Wine Vessel) with Bowstring Pattern
Overall height 21.2 cm
Diameter of mouth 4.5 cm

61. A Pair of *Jue* (Wine Vessel) with Bird Design
Overall height 22 cm
Diameter of mouth 17.4 × 7.5 cm

62. *Zhi* (Wine Vessel) with Phoenix Design
Overall height 14.5 cm
Diameter of mouth 8.3 cm

63. *He* (Wine Vessel) Made by Lai Fu
Overall height 21.5 cm
Diameter of mouth 13.5 cm

64. Rectangular *Hu* (Wine Vessel) with Lotus and Crane Design
Overall height 122 cm
Width 54 cm
Diameter of mouth 30.5 × 24.7 cm

65. *Fou* (Wine Vessel) Made by Craftsmen
Overall height 46.9 cm
Diameter of mouth 18.4 cm

66. *Hu* (Wine Vessel) with Scenes of Feasting, Fishing, Hunting, and Battle Inlaid with Red Copper
Overall height 31.6 cm
Diameter of mouth 10.9 cm

67. *Hu* (Wine Vessel) with Two Bird-shaped Ears Inlaid with Gold, Silver, and Turquoise
Overall height 36.9 cm
Diameter of mouth 17.4 cm

68. *Hu* (Wine Vessel) in the Shape of Gourd
Overall height 35.5 cm
Diameter of mouth 9 cm

69. *He* (Wine Vessel) with a Loop Handle and Interlaced Hydra Design
Overall height 24.2 cm
Width 24.2 cm

VESSELS FOR WATER

70. *Pan* (Water Vessel) with Inscription "Ya Yi"
Height 12.8 cm
Diameter of mouth 35.3 cm

71. *Pan* (Water Vessel) Made by Huan
Overall height 12.7 cm
Diameter of mouth 41 cm

72. *Ling* (Water or Wine Container) Made by Zheng Yibo
Overall height 45.5 cm
Diameter of mouth 14.7 cm

73. *Pan* (Water Vessel) Made by Qi Yingji's Nephew
Overall height 15.5 cm
Diameter of mouth 50 cm

74. *Yi* (Water Vessel) in the Shape of a Beast
Overall height 20.3 cm
Width 42.7 cm

75. *Yi* (Water Vessel) made by Cai Zi
Overall height 11.9 cm
Diameter of mouth 27.3 cm

76. Rectangular *Pan* (Water Vessel) with Design of Interlaced Hydra, Tortoise, and Fish
Overall height 22.5 cm
Diameter of mouth 73.2 × 45.2 cm

MUSICAL INSTRUMENTS

77. Big *Nao* (Percussion Instrument in the Shape of a Big Bell) with Animal Mask Design
Overall height 66 cm
Spacing of Xian 48.5 cm

78. *Zhong* (Bell, Musical Instrument) Made by Zu
Overall height 39.5 cm
Spacing of Xian 18.8 cm

79. *Zhong* (Bell, Musical Instrument) Made by Shu Lü of the State of Guo
Overall height 65.4 cm
Spacing of Xian 36 cm

80. Ke *Zhong* (Bell, Musical Instrument)
Overall height 65.4 cm
Spacing of Xian 36 cm

81. One of *Bian Zhong* (Chime Bells, Musical Instrument) with Tiger Design
Overall height 27.1 cm
Spacing of Xian 16 cm

82. Zhe Jian *Zhong* (Bell, Musical Instrument)
Overall height 38.2 cm
Spacing of Xian 20.6 cm

83. *Zhong* (Bell, Musical Instrument) Made by Ying Ci, Prince of Zheng
Overall height 42.5 cm
Spacing of Xian 21.5 cm

84. *Goudiao* (Musical Instrument) Made by Qi Ci
Overall height 51.4 cm
Spacing of Xian 19.9 cm

85. Zhe Ci *Zhong* (Bell, Musical Instrument)
Overall height 18.3 cm
Spacing of Xian 10.5 cm

86. *Bian Zhong* (Chime Bells) with Interlaced Hydra Design
 1. Overall height 21.1 cm
 Spacing of Xian 14.6 cm
 2. Overall height 19.8 cm
 Spacing of Xian 13.8 cm
 3. Overall height 18.2 cm
 Spacing of Xian 12.7 cm
 4. Overall height 17 cm
 Spacing of Xian 11.6 cm
 5. Overall height 15.8 cm
 Spacing of Xian 10.9 cm
 6. Overall height 14.3 cm
 Spacing of Xian 9.9 cm
 7. Overall height 13.2 cm
 Spacing of Xian 8.8 cm
 8. Overall height 11.8 cm
 Spacing of Xian 8.2 cm
 9. Overall height 11.5 cm
 Spacing of Xian 7.8 cm

WEAPONS

87. Big *Yue* (Axe) with Animal Mask Design
Height 34.3 cm
Width 36.5 cm

88. *Ge* (Dagger Axe) with Thread Design Inlaid with Red Copper
Length 21.1 cm
Width 6.9 cm

89. *Mao* (Spear) with Jade Blade
Length 18.3 cm
Width 4.8 cm

90. *Ge* (Dagger Axe) Made for the Use of Han Wang Shi Ye
Length 14.9 cm
Width 6.7 cm

91. *Jian* (Sword) with Inscription "Shao Ju"
Length 54 cm
Width 5 cm

92. *Jian* (Sword) of Gou Jian, King of Yue
Length 64 cm
Width 4.7 cm

93. *Ge* (Dagger Axe) of Yin Zhang, King of Chu
Length 22.3 cm
Width 7.2 cm

94. *Ji* (Halberd) with a Wheel
Length 37 cm
Width 12.2 cm

95. *Dui* (Spear Ornament) Made by Da Liang Zao for Shang Yang's Use
Length 5.7 cm
Width 2.4 cm

96. *Yue* (Finial of Dagger Axe) Inlaid with Gold and Silver
Length 17.1 cm
Width 6.7 cm

97. **Hawk Tally**
Length 4.7 cm
Width 3.6 cm

98. **Tiger-shaped *Jie* (Warrant, Serving as a Pass)**
Length 10.7 cm
Width 15.9 cm

BRONZEWARE FOR DAILY USE

99. **Bronze Chariot Ornament with Double-rabbit Design**
Height 8.8 cm
Width 15.6 cm

100. **Bronze Horse Mask with Animal-mask Design**
Height 17.8 cm
Width 34.5 cm

101. **Bronze Chengzhou Bell**
Height 8.5 cm
Spacing of Xian 6.5 cm

102. **Bronze Chariot Linchpin in the Shape of a Human Head**
Height 12 cm
Width 5.6 cm

103. **Bronze Chariot Bell with Inscription "Ze Bao"**
Height 17 cm
Width 9 cm

104. **Bronze Stove with Coiling Serpent Design**
Overall height 34.5 cm
Diameter 50.5 cm

105. **Bronze Shovel with Small Openings**
Height 9.5 cm

Width 33.5 cm

106. **Bronze Chariot *Wei* (Axle Endpiece) with Interlaced Hydra Design**
Height 9.3 cm
Width 9.2 cm

107. **Bronze Candleholder with Silver-inlaid Lozenge Design**
Height 32.1 cm
Width 21.9 cm

108. **Bronze Mirror with Four Patterns in the Shape of the Chinese Character "山" (Mountain)**
Diameter 11.4 cm

109. **Bronze Mirror with Five Patterns in the Shape of the Chinese Character "山" (Mountain)**
Diameter 11.4 cm

110. **Bronze Mirror with *Kui*-dragon Design**
Diameter 19.3 cm

111. **Bronze Mirror with Feather Design**
Diameter 7.7 cm

112. **Bronze Mirror with Lozenge Design**
Diameter 13 cm

113. **Bronze Mirror with Petal Design**
Diameter 9.2 cm

114. **Bronze Belt Hook Inlaid with Gold and Turquoise**
Length 14 cm
Width 1.4 cm

115. **Bronze *Huzi* (Urinal) with Dragon-and-Phoenix Design in Gold and Silver Inlay**
Height 13.6 cm
Width 22.6 cm

116. **Turtledove-shaped Bronze Head of Walking Stick Inlaid with Silver**
Height 7.7 cm
Width 13.4 cm

117. **Bronze *Dui* (Food Container) with the Character "Gui"**
Height 18.8 cm
Width 23.4 cm

118. **Bronze Weighing Apparatus**
Height 3.5 cm
Width 4.7 cm

119. **Yang Chu *Ding* (Cooking Vessel)**
Height 19.4 cm
Width 14.7 cm

120. **Chang Yang Gong *Ding* (Cooking Vessel) for Sacrificial Use**
Height 29.3 cm

Width 19 cm

121. **Gilded Bronze *Ding* (Cooking Vessel) Made in the Fourth Year of Yuanshi Period**
Height 17.2 cm
Width 20.6 cm

122. **Animal-shaped Bronze Cooking Stove**
Height 10.9 cm
Width 21.9 cm

123. **Bronze Flat Flask with Two Ears Decorated with Deer Design**
Height 10.5 cm
Width 9.6 cm

124. **Long-necked Bronze Vase with Cloud Design in Silver Inlay**
Height 29.3 cm
Width 19 cm

125. **Bronze Flat Flask in the Shape of a Garlic Bulb**
Height 30.7 cm
Width 32.2 cm

126. **Bronze Jar with Inscription "Wan Jin"**
Height 37.5 cm
Diameter of belly 22.8 cm

127. **Loop-handled Bronze Jar with a Bird-shaped Cover**
Height 34.4 cm
Diameter of belly 26.3 cm

128. **Bronze Jar with Inscription "Le Wei Yang"**
Height 34.9 cm
Diameter of belly 30 cm

129. **Bronze Jar in the Shape of a Waist Drum**
Height 19.4 cm
Width 30.3 cm

130. **Gilded Bronze Jar**
Height 44.9 cm
Width 37.2 cm

131. **Bronze *Fang* (Rectangular Jar) with Inscription "Zhong Shi Si Jin"**
Height 35.9 cm
Width 24.7 cm

132. **Bronze Ladle with Inscription "Ban Sheng"**
Length 15 cm
Diameter of ladle 11.5 cm

133. **Bronze *Zun* (Wine Vessel) Inlaid with Gold and Silver**
Height 9.5 cm
Diameter 12.4 cm

134. **Gilded Bronze *Zun* (Wine Vessel) with a Handle**
Height 8.7 cm
Width 11.8 cm

135. **Bronze *Zun* (Wine Vessel) with Inscription "Guang Wu"**
Height 16.2 cm

Diameter 25 cm

136. **Bronze Chengyu *Hu* (Dry Measure) Made in the 21st Year of Jianwu Period**
Overall height 41 cm
Dry measure 35.3 cm
Diameter of plate 57.5 cm

137. **Bronze Washer Made in the Fourth Year of Yuanhe Period**
Height 21.5 cm
Diameter 45.5 cm

138. **Bronze Washer with Inscription "Fu Gui Chang, Yi Hou Wang"**
Height 7.2 cm
Diameter 37.9 cm

139. **Bronze Washer with Inscription "Shu Jun"**
Height 8.5 cm
Width 32.4 cm

140. **A Bronze Chime Bell with Cloud Design**
Overall height 49.8 cm
Spacing of Xian 25.6 cm

141. **Bronze Drum with Design of Human Figures, Birds, and Animals**
Height 19.1 cm
Diameter of face 32.4 cm

142. **Bronze Candleholder with Inscription "Guan"**
Height 30.1 cm
Width 21.6 cm

143. **Bronze Candleholder in the Shape of an Ox**
Height 9.5 cm
Length 19.5 cm

144. **Bronze Candleholder in the Shape of a Ram**
Height 10.4 cm
Length 15.6 cm

145. **Bronze Candleholder Made in the Third Year of Jianzhao Period**
Height 6 cm
Width 25.5 cm

146. **Bronze Candleholder with a Base in the Shape of a Wild Goose's Leg, Made in the First Year of Suihe Period**
Height 16.1 cm
Width 12.7 cm

147. **Bronze Candleholder with Inscription "Shao Fu"**
Height 7.3 cm
Width 20.5 cm

148. **A Combined Set of Three Bronze Candleholders**
Height 12.4 cm
Width 17 cm

Bronzeware in China

DU NAISONG

China is one of the world's civilizations, and the beginnings of its classical culture took place long ago. Of the various factors relating to the emergence of its "civilization," the coming into being and the development of bronze casting industry played an important part. "The Bronze Age" saw the highest production of bronzeware, and represented the highest level of technical development at that time.

The term "bronze" refers to copper-tin, copper-lead, and copper-tin-lead alloys. Bronzes are characterized by their exquisite form, sumptuous decorations, elegant inscriptions, skilful casting, and glowing brilliance, reflecting a profound cultural connotation. They have important historical, artistic, and scientific value for understanding the origins of Chinese civilization, the histories of the Shang and Zhou dynasties, the history of science and technology, the evolution of the Chinese characters, and Chinese culture and art.

The Palace Museum in Beijing has over 10,000 items of bronzeware in its collection, 1,600 of which have inscriptions, making it the largest repository of bronze objects in China. A large part of these come from the Qing Court collections, and some from recent acquisitions, private donations, and archaeological finds. The collection basically provides a comprehensive coverage from the Shang and Zhou dynasties to the Han, Wei, and Six Dynasties, to the Sui and Tang Dynasties, and to the Song Dynasty. In terms of category, these collected items cover food containers, wine vessels, water vessels, musical instruments, weapons, horse and chariot devices, bronze mirrors, and measuring instruments. In terms of their nature, there are bronze ritual and musical instruments and bronze vessels for daily use. Roughly speaking, bronze ritual and musical instruments were more popular in the Shang and Zhou dynasties while bronze vessels for daily use were popular after the Qin and Han dynasties.

The bronzeware and bronze inscriptions in the Palace Museum are rich in content. This volume has selected the most representative 203 objects (or sets) in its collection, including 98 ritual utensils and musical instruments and 105 vessels for daily use, for the enjoyment of the reader. This article combines important bronzeware collected in the Palace Museum and recent archaeological finds to explain the evolution of bronzeware as well as its historical and artistic value.

BRONZES IN THE SHANG AND ZHOU DYNASTIES – CHIEFLY FOR RITUALS AND MUSIC

The Xia Dynasty – Bronzeware's Beginnings

The origin of bronzeware in China has been an issue of concern in recent years. It is recorded in the *Shiben* (*The Origin of the World*) that "the Chiyou Tribe made weapons" and in the *Yuejueshu* (*The Lost History of Yue*) that "when Yu lived in the cave, he used copper to make

his spear." Information from these stories in ancient histories tells us about the means of production and lifestyle at that time, which is valuable for tracing the origin of bronzeware in China.

Archaeological finds in recent years indicate that the earliest bronze objects in China are the bronze knives that were unearthed from the Majiayao culture at Linjia, Dongxiang in Gansu Province, and the Machang culture at Liancheng, Yongdeng in Gansu Province. This shows that bronze objects appeared 5,000 years ago at the latest, and this is the beginning of bronzeware.

Many objects show that the Xia Dynasty (circa 2070 BC – 1600 BC) was the beginning of the Bronze Age in China. Little has been written on Xia culture. In the 1950s, archaeologists discovered the Erlitou culture at Erlitou, Yanshi in Henan Province, which, according to C14 testing, belongs to the period of 2090 BC to 1680 BC, which corresponds to the Xia Dynasty.

Most bronze objects discovered at Erlitou are small tools, weapons, and decorative pieces. It is worth noting that a number of bronze wine vessels, such as *jue*, *jia*, and *he*, food containers, such as *ding*, and musical instruments, such as *ling*, also appeared at that time. Most were bronzeware, with a small number made of copper. Making objects with a hollow interior needed an interior mould and an exterior mould, which is harder than making objects with a solid interior. Judging from the marks left on a bronze wine vessel *jue* in moulding, it needed at least four exterior moulds, which show that casting had moved from the single-mould to the multiple-mould at that time.

In short, Erlitou bronze culture was an important stage that laid the foundation for the later development of a brilliant bronze culture.

The Shang Dynasty – A Period of Bronzeware Development

The Shang Dynasty that succeeded the Xia Dynasty made further developments in the economy and culture. The development of bronzeware in the Shang Dynasty can be divided into two periods: the early period is from the establishment of the kingdom by King Tang to the removal of its capital to Yin by King Pangeng (circa 1600 BC – 1300 BC) and the late period, from the removal of the capital to Yin by King Pangeng to the loss of the country by King Xin (Zhou) (circa 1300 BC – 1046 BC).

Bronze objects unearthed at the Erligang Site in Zhengzhou, Henan Province are representative of the bronzeware of the early Shang Dynasty. During this period, the shape of bronzeware was standardized and the walls of the utensils became even and thin. The major types of bronzeware included, among others, food containers such as *ding*, *li*, *yan*, and *gui*; wine vessels such as *jue*, *jia*, *gu*, *lei*, *zun*, *he*, and *you*; water vessels, such as *pan*; and weapons and tools, such as *ge*, *zu*, *ji*, and *jue*.

This period witnessed a new quest for and innovation in bronzeware. Cooking vessels *ding*, *li*, and *yan* had deep bellies. The three legs of *ding* had an ear to match a leg, and an ear between the two legs. *Gui* food containers, which were rarely seen, normally had a deep belly. Wine vessels *jue* and *jia* had flat bottoms. The spout and tail of a *jue* wine vessel were relatively short. Some *jia* wine vessels had pouched legs, on their mouths were symmetrical columns in the shape of a mushroom, with a single handle on one side. The body of the wine vessel *gu* was thick and short. The wine vessel *he* had a long body, three pouched legs and a dome lid. The water vessel *pan* had no ears. The blade of a dagger axe *ge* was thin and the *yue* axes were rectangular in shape. Decorations were simple and plain. Most had single-layer patterns, with two *kui*-dragons coiling upward to form an animal mask, and the upper and lower parts had circles to serve as the frame. There were also patterns of clouds and thunder, whorls, and bowstrings. Web patterns were rarely seen at that time. Rectangular cooking vessels *ding* had nipples on their left, right and lower sides, which were characteristic features of that time. Inscriptions were rarely seen on the vessels. Of the inherited and unearthed pieces, only a few had characters indicating the clan, such as the "*Ding* (Cooking Vessel) Inscribed with the Character 'Huo'" (Figure 1) had the character *huo*. These can be regarded as the earliest Chinese characters on bronzeware.

Bronze objects representative of the late Shang Dynasty are those unearthed in the ruins of Anyang

Yin Ruins (present-day Xiaotun Village, Anyang City, Henan Province), then the capital city of the dynasty. It built on the foundation of the previous period and had greater improvement and development. Copper smelting and foundries were further professionalized during this period and reached its peak.

Bronzeware of the late Shang Dynasty is generally characterized by its exquisite casting, rich variety, large quantity, elegant modelling, and elaborate design. This period also saw the emergence of large pieces and the growth of inscriptions. The "Rectangular *Ding* (Cooking Vessel) Made by an Official Fou as a Sacrificial Utensil" (Figure 2), for example, had an inscription of as long as 22 characters, which provides important information for studying the economic history of the Shang Dynasty.

New types of bronzeware of this period included, among others, the food containers *yu* and *dou*, and the dagger *bi*. Nobles in the Shang Dynasty were fond of drinking, and wine vessels of this period included the *hu* (jar), *zhi* (goblet), *jiao* (tripod), *sigong* (drinking vessel), *fangyi* (rectangular vessel), and bird-beast *zun* (cup). Musical instruments of the period included the bell *nao*. Weapons and tools included bow-shaped vessels, knives with animal heads, *zhou* (helmet), *chan* (shovel), *fu* (axe), and *ju* (saw). Accessories for horses and chariots included *wei* (axle end piece) and others.

As for the shape of bronzeware, most three-legged vessels had columnar legs. The cooking vessel *ding* could be round-shaped, tri-lobed, round-shaped with flat legs, or square with four legs. The cooking vessel *li* had two upright handles on the mouth rim. The cooking vessel *yan* was mostly made up of the cauldron *li* and the steamer *zeng*, as illustrated in the "Large *Yan* (Cooking Vessel) with Animal Mask Design" (Figure 4). The food container *gui* either had no ears or two ears. The "*Gui* (Food Container) with Three Ears and Nipple Design" (Figure 6) had three ears on the belly, which is quite special and unique. The wine vessel *jue* had a protruding base, with two very high columns. The cooking vessel *jia* had a long and round belly or a tri-lobed body. The "Rectangular *Jia* (Wine Vessel) with Inscription 'Ce'" (Figure 45), for example, had a rectangular body and a dignified and elegant shape, and is a rare treasure. The wine vessel *gu* had a thin, long, and flared body, with a

protruding waist. The wine vessel *hu* (jar) had a long neck, a bulging belly, and a pair of pierced ears on the neck. The wine vessel *you* was round or rectangular in shape. The water vessel *pan* usually had a shallow belly and a high ring foot. The musical instrument *nao* was usually composed of three or five pieces. The "Big *Nao* (Percussion Instrument in the Shape of a Big Bell) with Animal Mask Design" (Figure 77) was a huge *nao*, which is rarely seen. The dagger-axe *ge* was divided into several types: vertical interior, curved interior, or tubular interior. At that time, dagger-axes with an arched handle and holes appeared (Figure 88), and the body of the dagger-axe was decorated with inlaid copper. The body of *mao* (a spear) was broad and large. The "*Mao* (Spear) with Jade Blade" (Figure 89) had a jade head with a bronze handle and an exquisite design. The axe *yue* usually had a rectangular body. The "Big *Yue* (Axe) with Animal Mask Design" (Figure 87), for example, had a plum-flower pattern, showing elegance and dignity.

Decorations on bronze objects were rich and colourful. There were motif patterns and supporting patterns. Some added small patterns to motif patterns to form a three-layer pattern. Patterns were predominantly animal masks and *kui*-dragons. Large wine vessels, as shown in the "*Zun* (Wine Vessel) with Three Ram Heads on Its Shoulders" (Figure 49), had decorations on their belly in the form of animal masks, which had protruding eyes and a feeling of cold elegance and weirdness. The *kui*-dragon had one horn, one foot, an opened mouth, and a curled-up tail. Patterns of real animals included those of elephants, oxen, birds, silkworms, cicadas, fish, and tortoises. Geometric patterns include those of clouds and thunder, bowstrings, ring bands, nipples, and whorls, which usually serve as supplementary patterns.

The modelling approach at that time often used a combination of two-dimensional sculpturing and three-dimensional sculpturing. Separate casting advanced, which provided a new technology for casting elaborate and elegant vessels. The three-dimensional sculptured animal heads in the "Rectangular *Zun* (Wine Vessel) Made by Xuya Clan to Worship Ancestors" (Figure 50) and in "*Zun* (Wine Vessel) with Three Ram Heads on Its Shoulders" (Figure 49), for example, were first cast separately,

and then put onto an exterior of the vessel and cast together with the body of the vessel.

Bronze inscriptions began to develop in the late Shang Dynasty. They were generally short and concise, of one or two characters or a dozen characters, and the longer ones could have 40 to 50 characters. The lines were neat and orderly and the calligraphy was dignified and forceful. Some characters had the characteristics of the "Bozhe" style, which was pointed at the top and end of the character, but bold in the middle. The "*You* (Wine Vessel) Made for Sacrifice by Yi Qi in the Fourth Year of Dixin's Reign" (Figure 57), for example, had an inscription of 42 characters, and is one of the longest inscriptions of bronzeware passed down from the Shang Dynasty. Some inscriptions clearly indicated the clan of the bronze owner, or the clan emblem, such as "Ya" or "Ning." Some inscriptions reflect the gifts given by superiors to their subordinates, such as the recording of the *xili* (i.e. the granting of the meat for sacrifice) in the "*You* (Wine Vessel) Made by Yu to Worship Zu Ding" (Figure 54). The inscription records that the vessel owner paid tribute of wine and food to the King of the Shang Dynasty in the "*Gui* (Food Container) with Inscription 'Er'" (Figure 5); and the inscription records that the emperor granted a minor official named Fou a piece of land to grow rice in the "Rectangular *Ding* (Cooking Vessel) Made by an Official Fou as a Sacrificial Utensil" (Figure 2). These inscriptions are of great value for the study of family histories, the sacrificial system, social life, and history of the relations with other nationalities during the Shang Dynasty.

The Western Zhou Dynasty – Bronzeware under a Comprehensive System of Rites and Music

People of the Zhou Dynasty were from the Ji (family name) clan and they were initially active in Shaanxi and Gansu Provinces. In 1046 BC, they annihilated the Shang Dynasty and established the Western Zhou Dynasty. The Western Zhou Dynasty established a more comprehensive political system and system for rites and music, and bronze ritual vessels and musical instruments became important tools for consolidating its political power.

During this time, there were many long inscriptions on bronzeware. These inscriptions are even more reliable than materials in literature and can be used for verifying or supplementing information found in other texts. From Western bronzes and their inscriptions, the Western Zhou Dynasty can generally be divided into two periods: from Emperor Wuwang to Emperor Muwang can be named the early Western Zhou period (circa 1046 BC – 922 BC), and the time from Emperor Gongwang to Emperor Youwang can be named the late Western Zhou period (circa 922 BC – 771 BC).

The Early Western Zhou Period

The characteristics of bronzeware in the early Western Zhou period are not very different from those of the late Western Zhou period. The shape was heavy, thick, and majestic, but there were variations in types and quantity. First, the types of bronze objects. The major food containers were *ding*, *gui*, and *yan*, while *li* and *dou* were fewer in number. Wine vessels included *jue*, *jiao*, *jia*, *gu*, *zhi*, *zun*, *zun* with bird and beast sculptures, *you*, *hu*, rectangular *yi*, *sigong*, and ladle.

The types of wine vessels of this period were numerous, but the actual number was small, and these vessels were mainly used in sacrifices. This was related to the lesson the Zhou Dynasty learned from the fall of the Shang Dynasty when King Zhou had "lakes of wines and forests of meat." This point can be verified by comparing the content of the "Document of Prohibition against Alcoholic Drinks" in *The Book of History* and the inscription on the "Da Yu Ding Made During the Reign of Emperor Kangwang of the Western Zhou Dynasty" (now in the collection of the National Museum of China). Water containers include trays. For musical instruments, *zhong* (bells) replaced *shangnao*. Hanging bells improved the quality of sound and the accuracy of tone. Weapons included *ji* (Chinese halberd), which was a combination of a dagger-axe and a spear. Bronze swords came into existence. There was also the emergence of combined wine vessel bases such as *jin*, chariot and horse accessories such as *xia* and musical instruments such as *luanling*. There were also ritual bronzeware combinations, such as the matching of *jue* with *zhi*, and *ding* with *gui*. This period was also the beginning

of the "array *ding* system." According to this system, the shape, structure, and patterns of every *ding* to be arranged had to be the same, but the size was progressively reduced so that they were arranged from large to small. Many inherited and unearthed *ding* arranged in this order proved the structure of this system.

In terms of shape and structure, the columnar legs of three-legged vessels, such as *ding* and *yan*, coexisted with hoof-shaped legs. Some large round-shaped *ding* were full of artistic qualities. Some had relatively shallow bellies, such as the "Shi Lü *Ding* (Cooking Vessel)" (Figure 10) in the reign-period of Emperor Chengwang in the Zhou Dynasty. Some round-shaped *ding* had a tray under the body to place charcoal for heating, and this was a new invention. What deserves our special attention is that the *ding, gui, zun, you,* and rectangular *yi* during the periods of Emperor Kangwang and Emperor Zhaowang were characterized by their droopy bellies. Most *li* had belly ears. *Gui* were mostly seen in the late Western Zhou period, but the "*Gui* (Food Container) with Coiling *Kui*-dragon Design" (Figure 17) in this volume is of the early Western Zhou period, and also the earliest extant bronze *gui* container. Also appearing in this period were *gui* containers with a square base under the ring foot, and *gui* containers with four ears. There were also *jue* with bird patterns, *ding* with ears on the belly and a flat lid, *li* with a longneck, *he* with four legs, *zun* with a single handle, *hu* with a long body and pierced ears, *pan* with two ears, and the weapon *ge*. These are different from similar vessels in the Shang Dynasty.

At that time, the main motifs were still animal masks and *kui*-dragons, and certain creativity and changes were seen. Patterns of coiling *kui*-dragons, the body of a bird with an animal head, double-body dragons with one head and two bodies began to appear. Patterns of phoenixes frequently appeared in important places of the vessel, which were eye-catching and beautiful. The "*Zhi* (Wine Vessel) with Phoenix Design" (Figure 62), which has three bands of protruding phoenixes on the body of the vessel, creates a strong three-dimensionality. Geometric patterns also had certain development, showing simple and plain vertical lines. There were spectacular and beautiful ridges protruding from the surface of the vessel.

The bronze inscriptions at that time became longer, running to more than a 100 characters, and the calligraphy followed the "Bozhe" style of the late Shang Dynasty. Some of these inscriptions concerned sacrifices and wars, while others discussed appointments, imperial instructions, and the granting of gifts. Inscriptions on appointments and instructions appeared in the Western Zhou Dynasty. The "*Gui* (Food Container) Made by Qin Lin to Worship Father Yi" (Figure 18), for example, indicated clearly in its inscription that the container was made for offering sacrifices to Father Yi. The inscription on the "*Li* (Cooking Vessel) Made by Shi Qin to Worship His Parents" (Figure 15) records that Shi Qin made this sacrificial vessel for his deceased parents. "Shi Lü *Ding* (Cooking Vessel)" (Figure 10) had an inscription of 79 characters, reflecting that soldiers under the management of Shi Lü refused to follow the Zhou emperor to conquer the *fangguo*. Bo Mao Fu, the superior of Shi Lü, fined Shi Lü 300 *lüe*, and warned that he would be punished continuously if they refused to join the expedition, and the names of the disobeying soldiers would be announced. The "*Gui* (Food Container) Made by Rong" (Figure 19) has an inscription recording the Zhou emperor granting Rong "100 shells" (Zhou currency)," which was a huge sum, and this can be collated with the line "bestow me with 100 shells" in "Xiaoya" in the *Book of Poetry*.

The Late Western Zhou Period

In the late Western Zhou period, bronzeware were mostly light, thin, simple, and crude. Simple designs were adopted and inscriptions were often long. Inscriptions beyond a 100 characters usually came out from this period, which are of very high historical and literary value.

Bronze wine vessels *jue, jiao, jia, gu, zhi,* and rectangular *yi* basically disappeared, but *hu, lei, he, zun,* and *zun* with bird and animal designs remained. Food containers *gui* and *xu*, and the water containers *yi* were new additions of this period. Water vessels *pan* and *yi* were used together, and *yi* was often found placed in a *pan* in archaeological sites. The development

of *zun* with bird and animal designs continued and rabbit-shaped *zun* was newly discovered. Bells further developed and they came in sets of four bells, six bells, and eight bells. The "array *ding* system" was popular in this period.

There were changes to the shapes of bronzeware. Many *ding* and *yan* had hoof-shaped legs, the "*Ding* (Cooking Vessel) Made by Da" (Figure 12) and the "*Ding* (Cooking Vessel) Made by Ke to Pray for Happiness and Longevity" (Figure 14) being typical examples. Some *ding* had a spout on one side of the mouth rim, and some *pan* also had a spout on their mouth. *Gui* had three short legs under the ring foot and had a lid. *Li* had upturned edges and legs. A special kind of *li* with a stove appeared. Usually a sculptured human figurine without feet was cast outside the stove door, as illustrated in the "Rectangular *Li* (Cooking Vessel) with Design of a Slave at a Door Whose Feet Had Been Cut Off as a Punishment" (Figure 16). *Gui* had a wide flared mouth, from which it narrowed downwards to the belly. The upper and lower lids and vessel had each four rectangular legs, and the vessel could be placed upside down. *Pan* often had ears on the belly, and there were square *pan* in this period. *Hu* had ears with rings. The *yuan* of *ge* had a triangular front.

New patterns and designs characteristic of the era began to emerge, such as ring bands, ragged curves, scales, and double rings. Some bronzeware had only a few bands of bowstrings or no decorations. The emergence of rough and careless designs was related to the fact that more emphasis was given to inscriptions in this period. At that time, animal-mask designs were often put on the legs of the vessels, and designs with phoenixes and birds were still popular. There was further development in three-dimensional decorations, as shown in the "One of *Bian Zhong* (Chime Bells, Musical Instrument) with Tiger Design" (Figure 81), where a sculptural tiger with a curled-up tail and bared teeth was cast in a lively way.

In this period, the arrangement of inscriptions was even and neat, the characters were refined and precise, and the calligraphy was smooth, elegant, and beautiful. The width of a vertical stroke was the same all the way through. This kind of style is known as "jade pillar style." The contents of the inscriptions are wide-ranging, reflecting the prominent function of bronzeware in the "ritual and musical system." These inscriptions are extremely valuable in studying ancient history, collating ancient books, and researching on the form, pronunciation, and meaning of ancient characters. They also become increasingly important in the study of the art of calligraphy. For the vessels with inscriptions of the later period as listed in this volume, there are four important aspects in terms of meaning and value.

First, sacrificial rites were important activities of the noble families and states in the Western Zhou. It is recorded on many vessels that they are sacrificial utensils made for the dead. The inscriptions of the "*Gui* (Food Container) Made by Zhui" (Figure 22), for example, record that its owner Zhui made this *gui* to worship ancestors after receiving a reward from the Zhou emperor. The purposes of the sacrificial rites were to inherit and maintain kinship and clan relations, so as to secure rule in a slave-system country.

Second, appointments and rewards. Appointments usually refer to an emperor's selection of his officials. The inscriptions actually serve as letters of appointment. The location of this activity was often an ancestral temple of the ruling house, palace, or Imperial Room. The appointment was often followed by the granting of rewards. The inscription on the "Song *Ding* (Cooking Vessel)" (Figure 11) records that the Emperor of Zhou appointed Song to manage Chengzhou, and gave him 20 families of slaves for building a new palace. Song was granted clothes, jade articles, flags, and items for chariots and horses. In accordance with the rites, Song returned to the Imperial Room after the appointment and offered beautiful jade tablets and gems to the Emperor. Furthermore, the inscription on the "Ke *Zhong* (Bell, Musical Instrument)" (Figure 80) reflects that Ke received a reward of single-shafted chariot after being appointed by the Zhou emperor. These inscriptions can be used alongside written texts for research on the systems of appointment, rituals, and naming.

Third, wars and expeditions. States and noble families went to war and on expeditions to plunder wealth and obtain slaves. The inscription on "Shi Lü *Ding* (Cooking Vessel)" (Figure 10) records that the Zhou emperor ordered the royal and noble families

and dukes to dispatch troops to conquer the *fangguo*.

Fourth, reflections on changes in the land system. The land of Western Zhou was owned by the Zhou emperor alone. He might grant land and the slaves cultivating the land to his officials and dukes for their use and their subsequent generations. However, they had only the right to use the land, but not for ownership, and they needed to pay tribute regularly to the emperor. It should be noted that some inscriptions in the middle and latter period started to reflect the practice of bartering products for lands between the nobles. The inscription on the "*Gui* (Food Container) Made by Ge Bo" (Figure 23) records that Ge Bo used four horses in exchange for 30 pieces of land from Pengsheng, and the two parties entered into a contract for this. From the information recorded in inscriptions and various texts, the political and economic development path of the Western Zhou can be seen.

In addition to the above, the inscriptions in the latter period of the Western Zhou include many other matters, such as trading of slaves, defining boundaries, making oaths of alliance, and penalties and laws. This article will not discuss the details.

The Eastern Zhou Dynasty (The Spring and Autumn Period and the Warring States Period) – Changes and Blooming of Bronzeware

The Western Zhou Dynasty fell after it was conquered by Quan Rong, and in 770 BC Emperor Pingwang of Zhou moved the capital eastward to Luoyang, which became known as the "Eastern Zhou." The Eastern Zhou is mainly divided into two periods, the Spring and Autumn period and the Warring States period. The political, economic, and cultural changes also had an impact on bronzeware and the contents of the bronze inscriptions.

Changes and Innovations of Bronzeware in the Spring and Autumn Period

In this period, the Zhou royal family used fewer bronze vessels, and the various large and small feudal states generally cast their own vessels. This was obviously different from the Shang and Western Zhou Dynasties. The use of iron production tools in agriculture and handicraft industry helped promote the development and breakthrough innovations in bronzeware casting. The further adoption of the separate casting technique and other new pursuits were prominent achievements in this period. Take the "Rectangular *Hu* (Wine Vessel) with Lotus and Crane Design" (Figure 64) as an example. Its body was huge. The crouching tigers on the base, the dragons with two ears on the body of the vessel, and the crane at the centre of lotus petals on the lid were all made by the separate casting method. This vessel was complex in structure, reflecting the new spirit of change. It should be particularly noted that the traditional method for casting bronzeware in ancient China was clay moulding, but stone could also be used. In recent archaeological discoveries, bronzeware made by wax casting was found. The invention and application of the stamping technique for impressing moulded patterns (the stamping method) was another achievement in the workmanship for casting. This new technique involved pressing a pottery or wooden mould with engraved patterns onto a master mould to produce a continuous group of patterns. A mould could be used repeatedly on different pottery moulds; therefore, this method could save time, speed up production, and greatly enhance production efficiency. The coiling serpent design on the "Big *Ding* (Cooking Vessel) with Coiling Serpent Design" (Figure 33) and the patterns of lines in "T" shape connected to each other on the "Rectangular *Yan* (Cooking Vessel) with Design of Four Snakes" (Figure 35) were all produced by stamping.

The inlays of gold, silver and copper were unique in the craft of inlay on bronzeware. The "*Dou* (Food Container) with Design of a Hunting Scene in Copper Inlay" (Figure 38) was a top-quality work incorporating the inlay craft, by which copper inlay was used to engrave the image of a hunter and the postures of flying birds and running beasts. Gold inlay was also common on important bronze weapons. The "*Jian* (Sword) with Inscription 'Shao Ju'" (Figure 91) is a good example. On the sword, the hand-guard and head of the handle were inlaid with turquoises and gold. Both sides of the sword had a gold-inlaid inscription in tadpole script. The decorations, designs, and inscription on the sword are exquisite

and meticulous. It is worthy of being considered as national treasure.

Many types of utensils in this period embraced the characteristics of the times. *Ding, li, yan, gui,* ball-shaped *dui,* and lid-bearing *dou* were food containers; *fou* was a kind of wine vessel; a washing *fou* was a water vessel; a *jian* could contain water or ice; and *chunyu, zheng,* and *goudiao* were musical instruments. There were also many weapons, such as *ge, mao, ji,* and *jian.*

In terms of shape and structure, *ding* usually had a lid with three buttons in the shape of an animal, and a splay foot in the shape of a hoof. *Yan* was mostly in square shape and divided into two parts: *zeng* and *li. Gui* usually had a splay flared mouth, a belly that narrowed downwards, and a heightened foot. *Dou* had a deep belly and often had a lid. A *yi* without legs that look like a ladle emerged in this period. *Yongzhong, niuzhong,* and *bozhong* were developed at the same time and were made in large quantities. *Ge* had more holes, and *mao* became long and thin to enhance their power of destruction. *Ji* that was separated into different parts was further developed.

With respect to the designs and patterns on bronzeware, the newly emerged and common adornment was mainly the coiling serpent design, which looked like a network composed of many small interlaced snakes. After this, an interlaced hydra design also emerged. *Chi* was a legendary hornless dragon, with its mouth open, its tail curled-up, and its body coiled. At the latter part of this period, a kind of line carving portrait technique with very fine carved lines started to bloom in contrast to the mysterious and stereotypical patterns characteristic of the Shang and Zhou Dynasties.

Bronze inscriptions were mainly cast inscriptions. Long inscriptions are fewer in number, and various feudal states generally made utensils by themselves, reflecting the characteristics of national inscriptions. Typical utensils were the "*Pu* (Food Container) Made by the Grand Minister of Education of the State of Lu" (Figure 37), the "*Ling* (Water or Wine Container) Made by Zheng Yibo" (Figure 72), the "*Pan* (Water Vessel) Made by Qi Yingji's Nephew" (Figure 73), the "*Jian* (Sword) of Gou Jian, King of Yue" (Figure 92), and the "Zhe Jian *Zhong* (Bell, Musical Instrument)" (Figure 82). The contents of the inscriptions are mostly related to sacrificial activities and marriages, but sometimes they record matters about the owners of the utensils or other people. The making of bronze playthings also increased.

At that time, as there were many feudal states which differed in writing, the inscriptions were many and varied. Some are narrow or wide. Others, such as the inscription of the "*Pu* (Food Container) Made by the Grand Minister of Education of the State of Lu," deliberately imitate the Bozhe style of the Shang and Zhou dynasties. The characters therefore were made more varied and decorative. On the bronze weapons of the States of Yue, Wu, and Chu, which were located around the Jiang and Huai Rivers, bird-and-insect scripts which have twists and turns are often used as adornments. The inscription on the "*Jian* (Sword) of Gou Jian, King of Yue" (Figure 92) in this volume is regarded as a typical bird-and-insect script. Besides the bird-and-insect script, there is also the tadpole script as shown on the inscription of "*Jian* (Sword) with Inscription 'Shao Ju'" (Figure 91), which is extraordinarily beautiful. All these examples represent ancient people's innovation and their pursuit of the art of calligraphy.

The Warring States Period

During the Warring States period, the use of iron tools in the bronze casting industry provided new vigour to the production of bronzeware. The traditional ritual vessels and musical instruments declined whereas daily utensils increased. Bronze containers are mainly *ding, dou, hu, dui, fou,* and *pan*; but *gui* became uncommon. Light-weight and practical bronzeware are mainly *dui* (food container) which has two ears with rings and short legs, ball-shaped *dui,* and round-belly *he* (wine vessel). *Bian zhong* (bell) flourishes and *zun* (wine vessel) with bird and animal designs further developed. As infantry and cavalry were the main means of waging war, *ge, mao* and split-system *ji* became popular. Personal adornments sprang up, in particular bronze mirrors and belt hooks. The latter, also known as *shibi,* were originally used with "*hu* dress," which was introduced into the Central Plains of China in the Spring and Autumn period and the Warring States period.

With respect to the shape and structure of

bronzeware, *ding* generally has short legs, with three buttons on the lid in the shape of sacrificial animals, rings, and birds. The *ding* from the State of Chu in southern China had tall, thin, and flaring legs. *Gui* had longer legs but its mouth did not flare anymore. *Li*, the lower body of *yan*, only had three short legs. Spherical *dun* was still in existence. *Dou* usually had long handles, and the *dou* from the State of Yan in northern China was most typical. There was a variety of *hu*, such as round, rectangular, and flat *hu*, as well as circular ones with a spout. *Hu* in the shapes of a calabash, fish, and an eagle's head had been found. *He* had round bellies with loop handles. Dagger axes with three to four pierced holes were commonly seen. *Zun* (Butts) and *dui* (ferrules) beneath the dagger-axe and spear shafts were also common, such as the "*Dui* (Spear Ornament) Made by Da Liang Zao for Shang Yang's Use" (Figure 95), which clearly states that the ferrule was made for Shang Yang's use. Furthermore, weapons such as *pi* (a long, blade-like spear) and *shu* (a rod-like weapon without a blade) that had been recorded in various texts were found during archaeological research. Most *fu* (military seals), which were used for transmitting orders and military strategies, were mostly in the shape of a tiger, while some were in the shape of eagles.

The most common patterns seen on the bronzeware are interlaced hydras and coiling dragons, while many had shell, spiral square, cord and cloud-in-triangle patterns. Carved line patterns also have considerable development. Large flat portraits were usually engraved on *hu*, *dou*, and *jian*. This carved pattern was related to the appearance of steel, which created conditions for carving craftsmanship. The famous piece entitled "*Hu* (Wine Vessel) with Scenes of Feasting, Fishing, Hunting, and Battle Inlaid with Red Copper" (Figure 66) has a cloud-in-triangle design as its boundary and the drawing is divided into three layers. The first layer is a picture of picking mulberry leaves and hunting, the second layer is a picture of feasting and shooting, and the third layer is a picture of fighting at sea and on land. It is of important value for studying the production, daily life, warfare, rites and customs, and architecture of the time. With the continuous development of the techniques of inlaying gold, silver, and turquoise, many artifacts are exquisite, beautiful, and elegant.

The bronze inscriptions in this period were short, simple, and often by carving. They frequently recorded volume measures such as *dou* and *sheng* or weight measures such as *jin* (catty) and *liang* (tael), which reflected the business and economic development in this period. The inscriptions on swords, dagger axes, and spears usually indicated that they were cast at state-controlled weapon manufactories or certain places.

In short, the Eastern Zhou period was a time of huge social changes. The growth in productivity promoted the development of bronze casting craftsmanship. Bronzeware at this time is noted for its fine casting and skilful workmanship, thus creating a new generation of style.

BRONZEWARE FOR DAILY USE AS A SUMMARY OF THE SOCIAL LIFE IN ANCIENT TIMES

In the Spring and Autumn period and the Warring States period, with the decline of the ritual and musical systems, bronze ritual vessels and musical instruments were gradually replaced by bronzeware for daily use. From the Qin and Han Dynasties onwards, such changes had become irreversible. The development of bronzeware for daily use was more significant and obvious.

Elegant and Beautiful Bronzeware for Daily Use in the Pre-Qin Period

The major bronzeware for daily use in the pre-Qin period were production tools such as spades and hoes, and chariot and horse accessories such as *wei* (a brass part for a cart), *xia* (linchpin of wheel), headgears, and chariot bells. Clothing accessories such as bronze mirrors and belt hooks, as well as other daily utensils such as ladles, knives, lamps, and charcoal stoves were also produced. The mass production of mirrors and

belt hooks shows that they gradually became goods sold at the market.

Due to the excavation of a number of chariot and horse pits and the unearthing of a large number of chariot and horse accessories in archaeological discoveries in recent years, much of the mystery shrouding them has been solved. Important chariot and horse accessories included *wei*, *xia*, *xian*, *biao*, *danglu*, headgears, and *luanling*. Most of them were exquisite and elegant. Most *wei* in chariots in the Shang Dynasty were decorated with *kui*-dragons and banana leaves, and some *xia* with human heads. In the past, it was believed that the horse's headgear was known as "*fangxiang*," it is now clear that it was a decorative accessory for the horse's forehead in the Western Zhou period, as shown in the "Bronze Horse Mask with Animal-mask Design" (Figure 100). Many decorations for chariots and horses were animal shaped, such as the "Bronze Chariot Ornament with Double-rabbit Design" (Figure 99); some were in the shape of birds. These decorations are more artistic.

The craftsmanship of some daily utensils was exquisite, such as the "Bronze Candleholder with Silver-inlaid Lozenge Design" (Figure 107), the "Pigeon-shaped Bronze Head of Walking Stick Inlaid with Silver" (Figure 116), and the "Bronze *Huzi* (Urinal) with Dragon-and-Phoenix Design in Gold and Silver Inlay" (Figure 115). They were decorated with beautiful patterns and of excellent craftsmanship. Bronze charcoal stoves, also called *xuan*, had been developed since the Spring and Autumn period. Such stoves were mostly round with a chain beam on top and three legs at the bottom. Its accessory was a bronze dustpan, also known as a shovel, which was a tool for lifting and moving charcoal. The "Bronze Stove with Coiling Serpent Design" (Figure 104) and the "Bronze Shovel with Small Openings" (Figure 105) are typical examples.

Bronze mirrors have an early origin. The earliest bronze mirrors that have been found so far are those of the Qijia culture unearthed from Guinan in Qinghai Province, which are around 4,000 years old. A certain amount of unearthed bronze mirrors from the Shang, Zhou, and the Spring and Autumn periods have also been unearthed. By the time of the Warring States period, bronze mirrors grew like mushrooms.

In terms of area, bronze mirrors unearthed from the Hunan Province were of the largest quantity and highest quality. Mirrors unearthed from the northern areas around the Yellow River are relatively small in number. On the whole, mirrors of the Warring States period were thin and they usually had a small button in the shape of a bowstring. The decorations of these mirrors were many and varied, with motifs such as dragons, four mountains, coiled dragons, lozenges, four leaves, animals, feathers, dragons and phoenixes, linked arcs, geometric patterns, and hunting scenes. The "Bronze Mirror with Four Patterns in the Shape of the Chinese Character '山' (Mountain)" (Figure 108), the "Bronze Mirror with Five Patterns in the Shape of the Chinese Character '山' (Mountain)" (Figure 109), the "Bronze Mirror with *Kui*-dragon Design" (Figure 110), and the "Bronze Mirror with Lozenge Design" (Figure 112), collected in this book are all treasures of the Warring States period. During this period, there were various types of belt hooks, such as bar-shaped hooks and bamboo joint-shaped hooks, and some even inlaid with gold, silver, and turquoise (Figure 114), which were quite rare.

Taken as a whole, bronzeware for daily use in the Warring States period was on the principle of keeping them fine, beautiful, light, and practical. This principle was followed in the Qin and Han periods, and gradually developed into a complete system of the growth of bronze for daily use.

The Achievement of Bronzeware for Daily Use in the Qin and Han Periods

After Qin unified the country in 221 BC, its measures for unification were reflected on bronzeware for daily use. The edict of unified weights and measures, for example, was directly engraved on the official measuring and weighing vessels. The edict could also be carved on a copper plate, known as the "edict plate," which was then inlaid into the weighing vessels. The "Bronze Weighing Apparatus" (Figure 118) in the Palace Museum was engraved with the 40-character edict on the unification of weights and measures in the 26th year of the reign of the First Emperor of the Qin Dynasty.

Bronze containers of the Qin Dynasty have also been discovered. A set of Qin vessels, for example,

was found at the Western Palace in Luoyang, Henan Province in 1950, and it is now in the collection of the Palace Museum in Beijing. The vessels include one *ding* (caldron), one *dui* (spherical container) and two round pots. The lid of the "Bronze *Dui* (Food Container) with the Character 'Gui'" (Figure 117) has the character *gui* 軌 in the lesser seal script, which, according to textual research, was a character used in ancient times which carry the same meaning as *gui* 簋 (cooking vessel). This set of vessels was typical utensils that marked the transition from the Warring States period to the early Han Dynasty. Furthermore, precious bronzeware for daily use, such as bronze chariot and horses accessories, weapons, mirrors, and musical instruments were also unearthed from the Mausoleum of the First Emperor of the Qin Dynasty.

Judging from records in documents and inscriptions, even though there were private casting workshops and business transactions, bronze smelting and casting in the Han Dynasty were mainly controlled by the government. The central government set up the Imperial Workshop and Directorate for Imperial Manufactories. During the period of the Han Emperor Wudi, the Commandant of the Imperial Gardens was established to manage the bronze smelting industry. The Three Offices of the Imperial Forest under the Commandant of the Imperial Gardens were charged with the specific responsibilities of manufacturing bronzeware for daily use in the imperial palaces.

Bronzeware for daily use in this period mainly include food containers such as *ding, gui, fu, zeng, mou, jiaodou,* and *ranlu*; wine vessels such as *zhong* (a round pot), *fang* (a rectangular pot), *zun , zhi, erbei,* and *shao*; water containers such as *xi, xuan,* and *pan*; musical instruments such as *zhong, gu, duiyu,* and *goudiao*; and clothing accessories and daily items such as mirrors, belt hooks, lamps, stoves, irons, and censers. These items cover all aspects of daily life.

In terms of smelting techniques, most bronzes of this period were crude with plain surfaces, but the metalwork, such as gold and silver inlaying, gilding, the inlaying of turquoise and precious stones, coupling by separate casting and the rivet fastening technique, and thin-line carving were the important aspects in the development of bronze craftsmanship.

In the following, we will focus on discussing some important types of bronzeware.

Most bronze *ding* of the Han Dynasty were elliptical in shape, with ears on the belly and short hoof-shaped legs. The "Chang Yang Gong *Ding* (Cooking Vessel) for Sacrificial Use" (Figure 120) collected in this book is a typical piece. On the lid and under the mouth rim there is an inscription in seal script: "Chang Yang Gong Ding holds one *dou*." Some *ding* recorded volume measures such as *dou* and *sheng* and weight measures such as *jin* (catty) and *liang* (tael), as well as the year of casting. Some *ding* were gilded throughout, others had the characters *chengyu*, which meant "for the consumption of the emperor," and this provides important information for studying the imperial vessels of the royal family.

There are various types of bronze pots, such as *zhong, fang, jia* (a flat pot), a flat pot with a garlic-shaped mouth, a pot with a bird's head, and a pot in the shape of an olive. The most special is the "Bronze Jar in the Shape of a Waist Drum" (Figure 129), which is particularly valuable. At that time, pots with hoop handles were commonplace. Many pots have auspicious inscriptions written in both the seal and clerical scripts.

Most of the *zun* for containing or warming wine had a round and deep belly, and three short hoof-shaped or animal-shaped legs. Some had handles. Collected in this book is the "Bronze Chengyu *Hu* (Dry Measure) Made in the 21st Year of Jianwu Period" (Figure 136). Though it is called *hu* (dry measure), it is actually a *zun* and not used as a measuring instrument. The body was gilded, and the craftsmanship is exquisite. The inscription records its name, size, characteristics, and the names of the maker and supervisor. It provides valuable information for studying the bronze smelting industry and official titles of casters in the Eastern Han Dynasty. The main wine-drinking vessels were cups with handles, which have an elliptical body with half-moon ears on both sides, while some of them have a single ear.

Water containers included *xi* and *xuan*, both for washing. The former had a round belly and a relatively large body, while the latter had a round belly with a relatively small but higher body. There were many *xi*, which were normally decorated with

scales. Most contained the date of casting. Some had words of blessing, while others were cast with the place where the containers were made, such as "Bronze Washer with Inscription 'Shu Jun'" (Figure 139) and the "Bronze Washer Made in the Fourth Year of Yuanhe Period" (Figure 137).

Bronze lamps and bronze censers were comparatively large in number and of many varieties; all were exquisite. Bronze lamps were named *ding*, and most were in the shape of a *dou*. Some had a base stand in the shape of the legs of a wild goose, as in "Bronze Candleholder with a Base in the Shape of a Wild Goose's Leg, Made in the First Year of Suihe Period" (Figure 146). Some had the name of "A Combined Set of Three Bronze Candleholders" (Figure 148). Some lamps were in the shapes of human figures, animals, or flames, as in the "Bronze Candleholder in the Shape of an Ox" (Figure 143) and the "Bronze Candleholder in the Shape of a Ram" (Figure 144). Censers were for burning incense. As their lids were in the shape of a mountain ridge with openwork carved holes, symbolizing Boshan, a fairy mountain in the ocean, this censer was also called a "Boshan Censer." The "Gilded Bronze Boshan Censer" (Figure 151) in this book is refined and beautiful, and is a rarity among censers.

At this time, bronze mirrors and belt hooks were in common use. The patterns on bronze mirrors in the early Western Han period followed mostly those of the Warring States period, but many mirrors had a line of three or four characters with auspicious messages, such as "Thinking of each other always; be wealthy and happy" and "Happiness and wealth forever." Some had elegant inscriptions in the bird script, as in the "Bronze Mirror with Inscription in Bird-and-Insect Script" (Figure 157). Before and after the reign of Emperor Wudi of the Han Dynasty, the buttons of bronze mirrors changed from a bow into a semicircular shape. The button base was in the shape of a persimmon. The edge was broad and flat, and the body became heavier. At the end of the late Western Han Dynasty, the "Gilded Bronze Mirror with Geometric Pattern" (Figure 158) appeared. As its patterns were similar to the structure of a chessboard of Liubo chess in ancient times, it was also called a "Bo-chess Pattern Mirror." Some

mirrors had inscriptions of the four gods, birds and animals, the 12 periods of a day, and the deities, which should relate to the theory of Yin and Yang and the Five Elements. Bronze mirrors in the Eastern Han Dynasty were extremely huge with a slightly protruding surface. Mirrors with portraits in relief and mirrors with mythological creatures began to be seen, such as the "Bronze Mirror with Design of Human Figures, Birds, and Animals" (Figure 159). The picture on the mirror is divided into several sections, including sections in relief on music, talking, and fighting. The contents are gorgeous, and the workmanship is exquisite. Bronze mirrors in the late Eastern Han Dynasty were inscribed with auspicious phrases, such as "Eternal Blessing for Posterity" and "Elevation to High Position." The belt hooks became larger, and most had inlaid gold and silver, turquoise inlay and gilded decorations. The "Bronze Belt Hook Inlaid with Crystal" (Figure 162) collected in this book is a belt hook inlaid with three pieces of crystal, which is rather rare.

Apart from the bronze objects mentioned above, bronze axes and irons were also common bronzeware for daily use in this period.

The bronze culture of remote areas is full of the stylistic features of local minority peoples, which reflect the multi-ethnic character of China's ancient bronze culture. Bronze artifacts of the northern tribes, such as Xiongnu and Donghu, frequently have openwork bronze panels, which fully reflect the characteristics of grassland culture and the high artistic expression of the tribes. The motifs include human figures, horses, oxen, rams, boars, and deer. Some even have animals chasing each other, or biting and fighting, as shown in the "Bronze Panel with Design of a Tiger Biting a Horse in Openwork" (Figure 164) and the "Bronze Ornament in the Shape of Two Snakes Biting a Frog" (Figure 167). Bronze drums were well developed in the southwest, and the sun, egret, boat racing, and feathered man patterns on the drum are characteristic. The "Bronze Drum with Design of Human Figures, Birds, and Animals" (Figure 141), for example, has at its centre the sun radiating light, which is an obvious characteristic of the minority people living in the southeastern parts of China.

The Blooming Period of Bronze Mirror Development from the Wei and Jin Period to the Sui and Tang Dynasties

The types of bronze artifacts during the time from the Wei and Jin period to the Sui and Tang Dynasties were mainly similar to those of the Eastern and Western Han Dynasties, but there was a drop in quantity and quality. It is worth noting that the development of bronze mirrors was outstanding and reached their zenith in the Tang Dynasty.

Major bronze artifacts in the Wei and Jin period and the Northern and Southern Dynasties included *fu, jiaodou, jiuzun, yandi, wan, pan, xi, xuan, tuoyu*, and *tongzhen*. The "Bronze *Fu* (Cooking Vessel) Made in the Third Year of Taikang Period" (Figure 171) collected in this book was cast by the official unit the Right Directorate for Imperial Manufactories of the Western Jin Dynasty and its shape is representative of its time. Most of the *jiaodou* in this period were round, thin, and tall. They had a handle either in the shape of a dragon head or a bird's head. Some had a spout on one side of their mouth. Irons were popular in this period. Bronze water droppers were in the shape of an animal or a tortoise. There were bronze paperweights in the shape of coiling dragons.

There was also further development in bronze mirror craftsmanship. The mirror surface was obviously more protruding, and the leaves in the shape of a stem that decorated the button base were lengthened, with some even extending to the edge of the mirror. The decorations of the mirrors followed the patterns of mythological animals and portraits in the Eastern Han Dynasty. During the Western Jin Dynasty, mirrors with four leaves and four phoenixes and mirrors with four leaves and eight phoenixes were in vogue.

In the Sui and Tang Dynasties, the bronze smelting industry was managed by the Foundry Office, which was under the Directorate for Imperial Manufactories. The main types of bronze artifacts include *jiaodou, wan, shao, zhu, guan, hu, ping, bei, pan, xi*, and *yi*. Musical instruments include *zhong, ling, bo*, and *luo*. Bronze mirrors, however, were the most numerous.

The body of a *jiaodou* was thick and heavy. The mouth rim had a spout in the shape of a triangle. The bronze bowl, also called *tongbo*, was in a semi-global shape with a lid and a tray, some with bowstrings decorated on the neck. Long-necked jars with a spout on one side of the shoulder were important artifacts of this period. Bronze trays were round with a high leg and some of them had edges in the shape of sunflower petals. Bronze cups are typical of the time. They had a long and round belly with a round base stand. The "Gilded Bronze Cup with Design of Horsemanship and Archery" (Figure 184) was gilded throughout with a design of flowers and showing horsemanship and archery, and is a masterpiece of Tang Dynasty bronze. Small pieces of bronzeware for daily use were commonplace, such as *shao* (ladle), *zhu* (chopsticks), *he* (box), *jiandao* (scissors), *suo* (lock), *nie* (tweezers), *daishi* (belt ornament), *madeng* (stirrup), and *yandi* (water dropper).

Bronze mirrors in the Sui and Tang Dynasties have an important position in the development of bronze mirrors. A large proportion of the mirrors were thick and glossy, such as the "*heiqigu*" (black paint ancient) mirrors, the "*lüqigu*" (greenpaint ancient) mirrors, and the "*shuiyinqin*" (mercury percolated) mirrors. At this stage, the ratio of tin and lead in a mirror was raised to 30 percent, and with the advances in the techniques of mirror polishing, the bronze mirrors are still bright enough today to reflect one's image. The shapes of bronze mirrors were varied. Besides mirrors in round or rectangular shapes, there were mirrors in the shape of a water chestnut flower, a sunflower, a rectangle with round corners, and the character *ya* (亞), as well as mirrors with handles. From the Sui to the early Tang Dynasties, mirrors with patterns of the 12 seal characters for the 12 Earthly Branches and four gods, eight trigrams, four animals, and dragons were popular. Many bronze mirrors were cast with an inscription written in regular script on the edge of their outer section and inscribed with beautiful lines from poems, as shown in the "Bronze Mirror with Inscription 'Zhao Ri Ling Hua'" (Figure 179) and the "Bronze Mirror with Inscription 'Yu Xia Pan Kan'" (Figure 180). All these exhibit the superb craftsmanship and functions of mirrors.

Bronze mirrors in the High Tang period were of a high quality and large in number. Besides mirrors in the shapes of water chestnut flowers and sunflower

petals, rectangular mirrors gradually increased in number. There was a rich variety of patterns, major ones being flowers and butterflies, *luan* and phoenixes, birds and animals, intertwining flowers, *baoxiang* flowers, cloud dragons, grapes, an immortal in the Moon Palace (Figure 188), stories about people, and playing polo (Figure 189). The techniques of inlaying gold, silver, and shells were developed in this period. The development of bronze mirrors started to slow down in the late Tang period. Bronze mirrors became lighter and thinner, with simple patterns. Mirrors in the shape of the character *ya* (亞) and rectangular mirrors with round corners began to emerge. Mirrors in the shape of the character *wan* (卍) and with the characters *qianqiuwansui* (longevity) were new additions. Mirrors with Eight Trigram patterns and inscriptions of the Heavenly Stems and Earthly Branches, and the 12 symbolic animals continued to be made in the Five Dynasties and the Song Dynasty.

Judging from the above development of bronzeware, it can be said that this has embodied the cultural integration and cross-fertilization of different ethnic groups in China. The prosperous development of Tang mirrors reflects an important feature of Tang Dynasty civilization.

The Admiration and Imitation of the Old in Song Bronzeware

By the time of the Northern and Southern Song Dynasties, the Chinese bronze smelting industry drew to an end. The materials for bronzeware were drastically different from that of the past. Yellow copper, a copper-zinc alloy, was frequently used. Governed by the thoughts of admiring the ancient and esteeming the ancient ideas, the most prominent types and stylistic features of bronze artifacts from the time of the Northern and Southern Song Dynasties were the imitation and reproduction of bronzeware from the time of the Shang and Zhou Dynasties. The technique of extracting copper from a solution of copper sulfate hydroxide was an important invention of this period.

The major bronzeware artifacts of the Northern and Southern Song Dynasties include *guo* (wok), *shao* (ladle), *zhu* (chopsticks), *hu* (pot), *zun*, *zhihu*, *jingping* (water pot), *deng* (lamp), *lu* (stove), *quan*, *bijia* (brush holder), and *tongjing* (bronze mirror). With the growth of Buddhism, a large number of pagodas were produced.

The highest achievement of this stage is the making of imitations. The *ding*, *gui*, *dou*, *zun*, *hu*, *gu*, *you*, *zun* with bird and animal patterns and *zhong* from the Shang and Zhou Dynasties to the Han, Wei, and Six Dynasties had been reproduced by imitation. Some of the imitations could pass for the genuine article. Made during the reign period of Emperor Huizong in the Northern Song Dynasty, the "Bronze *Zun* (Wine Vessel) Made in the Third Year of Xuanhe Period" (Figure 195) and "A Set of Six Bronze Bells with Inscription 'Da Sheng'" (Figure 196) are representative works of imitation bronzeware from the Song Dynasty.

Mirrors in the Song Dynasty were on the decline. They were light, thin, and coarse, and the patterns were far from exquisite. A characteristic of Song mirrors was the inscription of private workshop marks. Mirrors of the states of Liao and Jin (Jurchen), opponents of the Northern and Southern Song Dynasties, deserve special attention for their ethnic characteristics. Most Liao mirrors were characterized by decorations of lotus flowers, joined lines, tortoise backs, bead rings, and children playing with flowers. Jin mirrors had mostly patterns of lotus flowers, chrysanthemum, and stories about people. Inscriptions on the Liao and Jin mirrors usually had year designations, place names, names of official units, and signature of the examiner.

Bronzeware in ancient China and their inscriptions are rich in content. The discovery and study of bronzeware have continued from ancient times to the present. Considerable progress has been made in the study of these objects, which have been sleeping for several thousand years with their inscriptions and green patina of age. All these lay an important foundation for us to study further and delve deeper into bronzeware in China.

THE RITUAL AND MUSICAL BRONZEWARE

VESSELS FOR FOOD

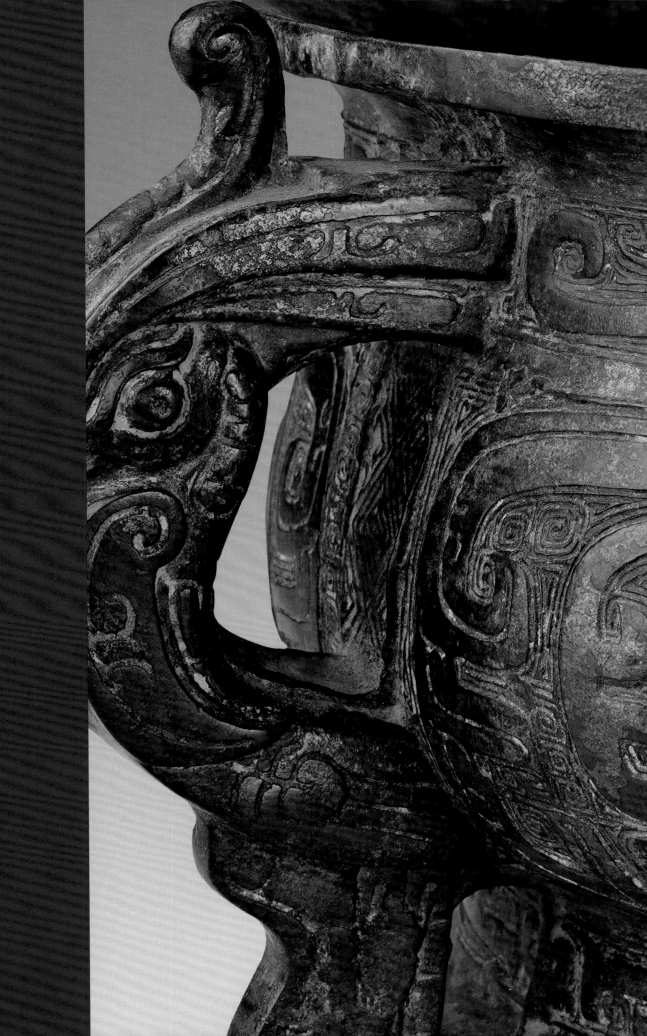

1

Ding (Cooking Vessel)
Inscribed with the Character "Huo"
Shang Dynasty

Overall height 21.4 cm
Diameter of mouth 18 cm
Qing court collection

This vessel has two upright handles, a mouth with an everted rim, a round belly, and three columnar legs. The neck is decorated with a band of *kui*-dragons, the belly, with animal masks, and the legs, with banana leaves. Inscribed on the interior wall is the character *huo*, emblem of the owner's clan.

This vessel is thick, heavy, and dignified in appearance, and covered with different patterns. The animal masks inspire awe in their ferocity. The background patterns are neat and delicate. The entire vessel is maintained in good conditions and its natural incrustations add a tinge of mystery to the piece.

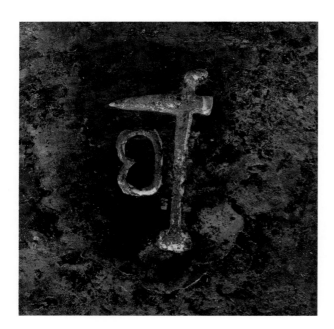

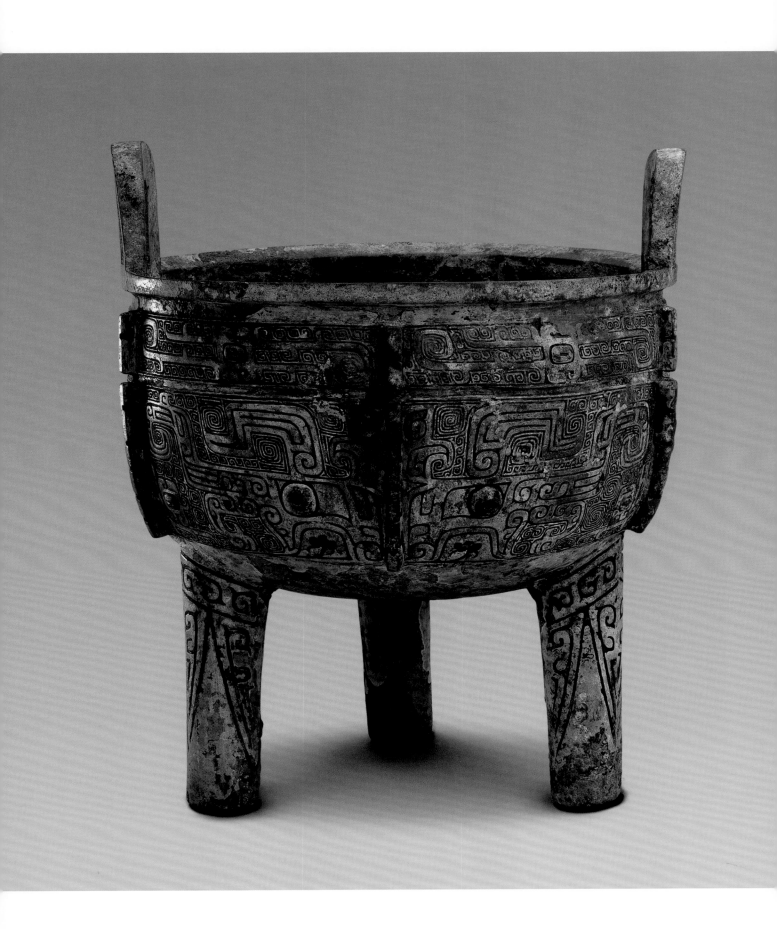

2

Rectangular *Ding* (Cooking Vessel)
Made by an Official Fou as a Sacrificial Utensil

Shang Dynasty

Overall height 29.6 cm
Diameter of mouth 22.5 × 17 cm
Qing court collection

This vessel has two upright handles, a square lip, a long rectangular belly, and four columnar legs. The four walls of the vessel and its neck have cloud and thunder patterns as the background, which is decorated with *kui*-dragons. The belly is decorated with large animal masks, and on the lower parts of the two sides of the animal mask are each decorated with an inverted *kui*-dragon. The interior wall has an inscription of 22 characters in four lines stating that the emperor grants his subordinate, a minor official named Fou, a piece of land in Ru to grow rice for a period of five years.

This vessel is majestic, thick, and heavy in appearance and has harmonious and well-arranged decorations. Its inscription records the emperor granting a minor official permission to grow rice. This detail provides important information for the study of the economic history of the Shang Dynasty.

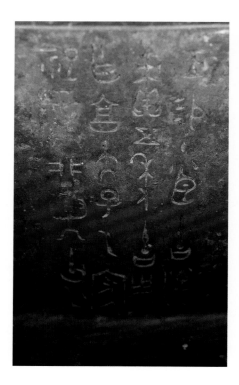
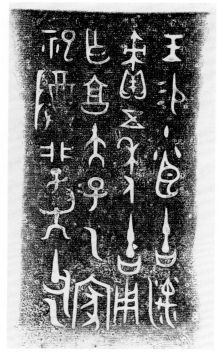

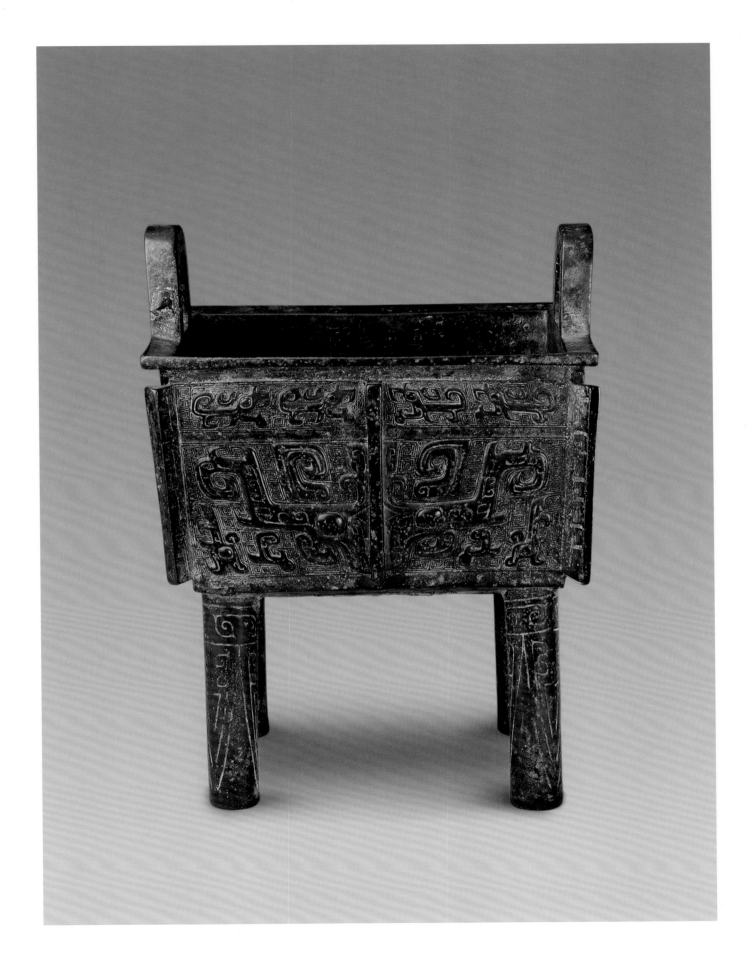

3
Rectangular *Ding* (Cooking Vessel)
Made by Tian Gao for Mother Xin
Shang Dynasty

Overall height 15.6 cm
Diameter of mouth 10.2 × 15 cm

 This vessel has two upright handles, a square lip, and four columnar legs. It has a flat lid, with a button in the middle. The upper part of its belly has an animal mask design, and the three sides on the left, right, and lower parts are decorated with nipples. The legs have patterns of descending leaves. Its lid is decorated with animal masks. The interior wall and the lid have the same inscriptions of six characters in two lines, which show that this is a sacrificial vessel that Tian Gao made for his mother Xin.

 The shape of this vessel is classic and plain, with exquisite patterns. It has a flat lid, which is rare for square vessels.

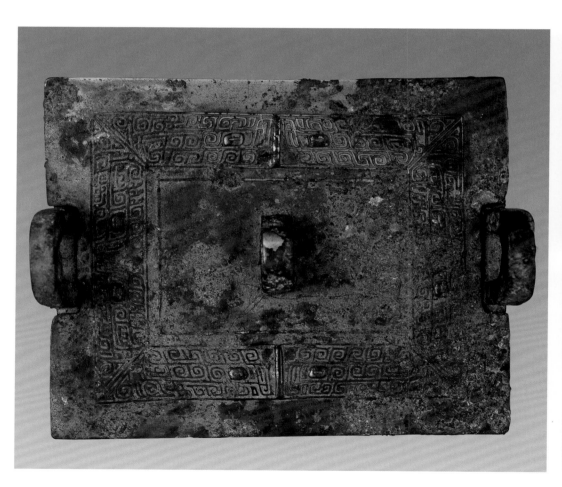

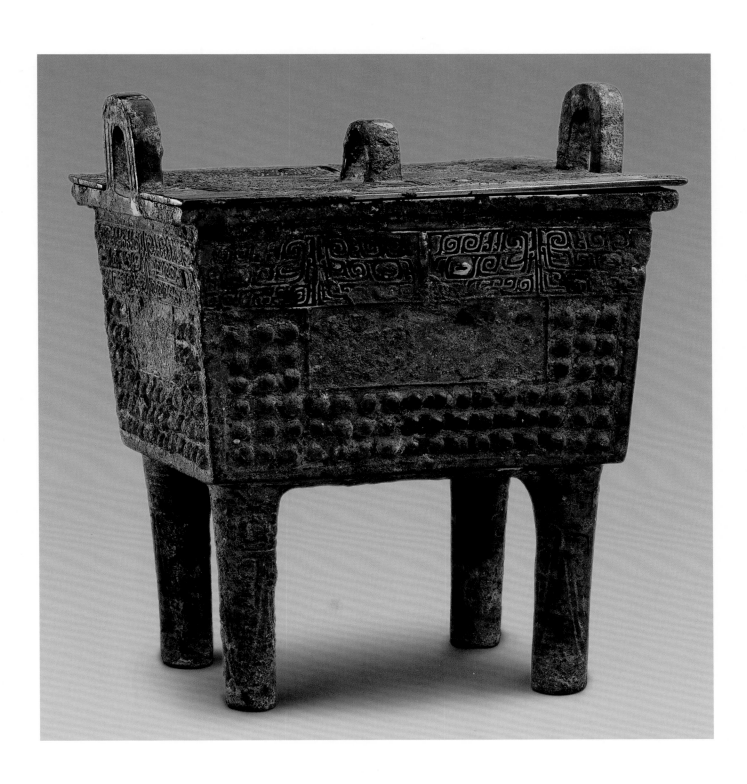

4

Large *Yan* (Cooking Vessel)
with Animal Mask Design

Shang Dynasty

Overall height 80.9 cm
Diameter of mouth 44.9 cm
Qing court collection

This vessel has two upright handles, a wide flared mouth, a square lip, and a deep belly. There are small holes in the middle part of the vessel. It has three legs in the shape of a cauldron, and solid hoof-shaped legs. The neck is decorated with *kui*-dragons forming three groups of animal masks, with each group being separated by protruding flanges. The belly is decorated with *kui*-dragons in the shape of a distorted triangle. The patterns on the neck and belly have thunder as the background. The upper part of the three cauldron-shaped legs is decorated with animal masks, with the protruding flanges as the nose. Its lower part is decorated with three bands of bowstrings.

This *yan* cooking vessel, a steamer, consists of two parts: *zeng* (steamer) and *li* (cauldron). It was an important ritual utensil. This vessel's huge size, its exquisite and elaborate patterns as well as its green incrustations gained throughout the ages, mean it is a rarity.

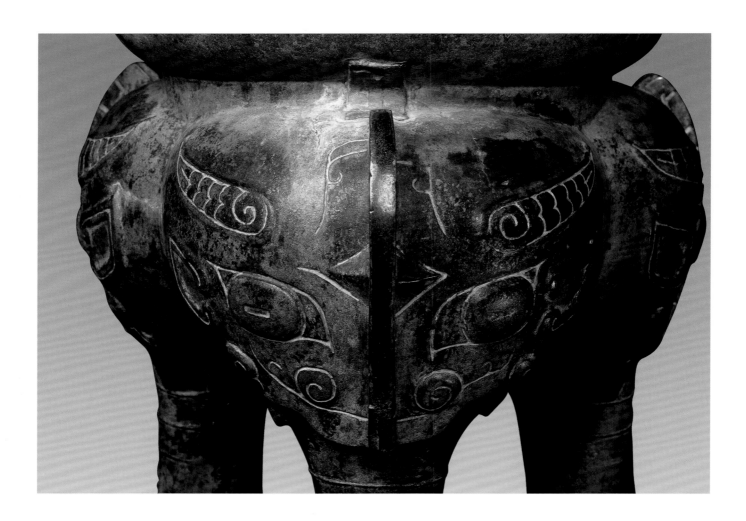

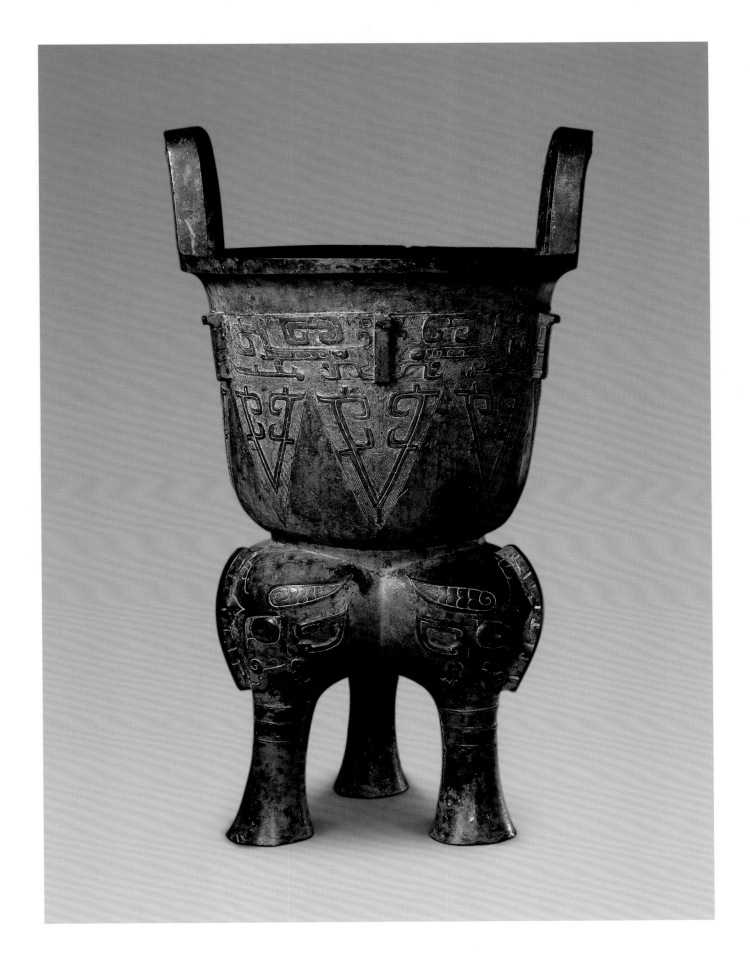

5

Gui (Food Container) with Inscription "Er"

Shang Dynasty

Overall height 14.2 cm
Diameter of mouth 19.7 cm

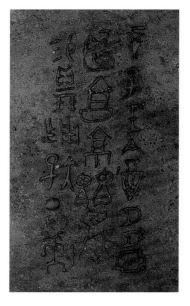

This vessel has a mouth with an everted rim, a vertical wall, a deep belly, two handles, and a ring foot. The neck is decorated with a band of animal masks, separated by two protruding heads of sacrificial animals. The ring foot is adorned with animal masks. The upper parts of the handles are decorated with animal heads, and there are jade pendants on the lower parts. Inside the vessel, there is an inscription of 20 characters in three lines, which records the feasts and granting of rewards by the nobility.

The style of this food container is simple and plain, and the inscription is of historical value.

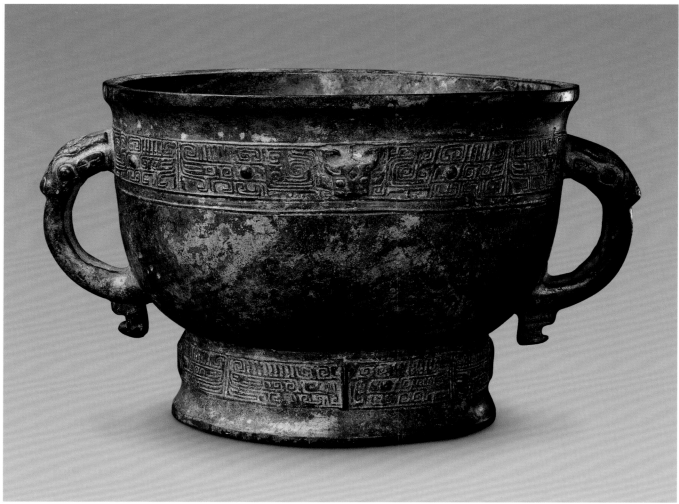

6

Gui (Food Container)
with Three Ears and Nipple Design
Shang Dynasty

Overall height 19.1 cm
Diameter of mouth 30.5 cm
Qing court collection

This vessel has a mouth with an everted rim, a bulging belly, handles with three animals, and a tall ring foot. The neck is decorated with eyes, the belly, with nipples and thunder, and the foot, with animal masks.

Most *gui* vessels in the Shang Dynasty have no ears, or two ears, or four ears. This vessel has three ears, which is a rare design. It also has beautiful and elaborate patterns, making it a rare piece inherited from the past.

This vessel was originally stored at the Summer Palace, but was returned to the Forbidden City in 1951.

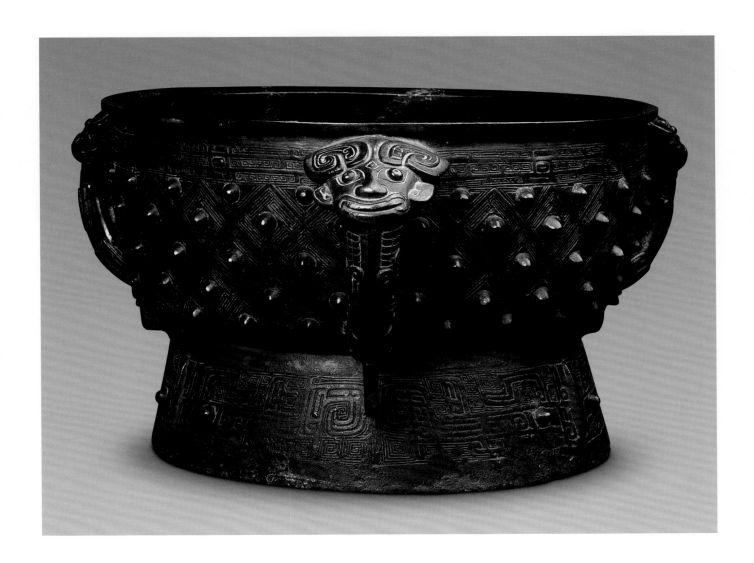

7

Dou (Food Container) with Inscription "Ning"

Shang Dynasty

Overall height 10.5 cm
Diameter of mouth 12.1 cm

This container has a vertical mouth, a shallow belly, and a tall ring foot. The belly is decorated with whorls, the ring foot, with two bands of bowstrings. The interior base has an inscription of one character.

Dou, a food container and a very important ritual vessel, has to be grouped in even numbers. Bronze *dou* containers from the Shang Dynasty are rare, and this vessel is a valuable resource for the study of bronze sacrificial vessels of the period.

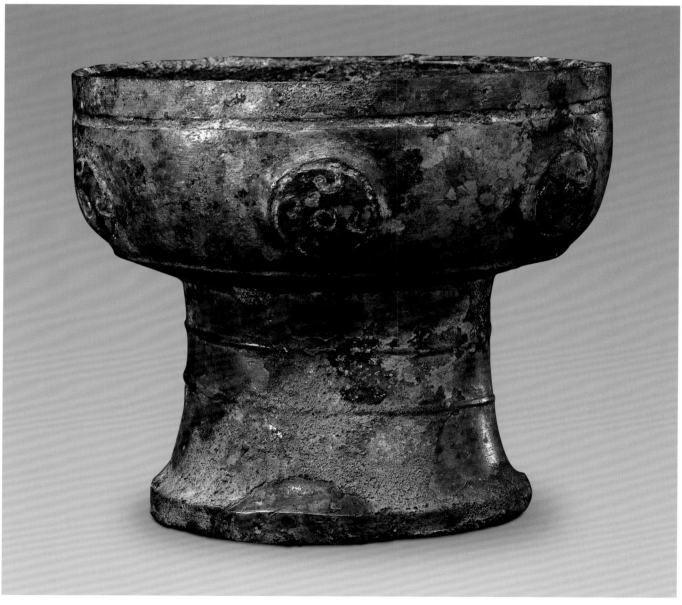

8

Ding (Cooking Vessel)
with a Disc and Animal Mask Design

Early Western Zhou Dynasty

Height 20.2 cm
Diameter of mouth 16.4 cm

The body of this vessel is round. It has upright handles, a shallow belly, and a round base. The lower part has three flat legs in the shape of three *kui*-dragons. In the middle part of the three legs is a round disc for holding charcoal for warming. The belly has an animal motif, with the eyes of the animals at its centre, which makes it extremely harmonious.

The flat-leg design of this vessel is unique. The upright *kui*-dragons form the three legs, and their curled-up tails enhance the charm of the entire piece. In the Shang Dynasty, vessels had flat legs in the shape of *kui*-dragons and birds. Flat-leg vessels with a disc first appeared in the early Zhou Dynasty.

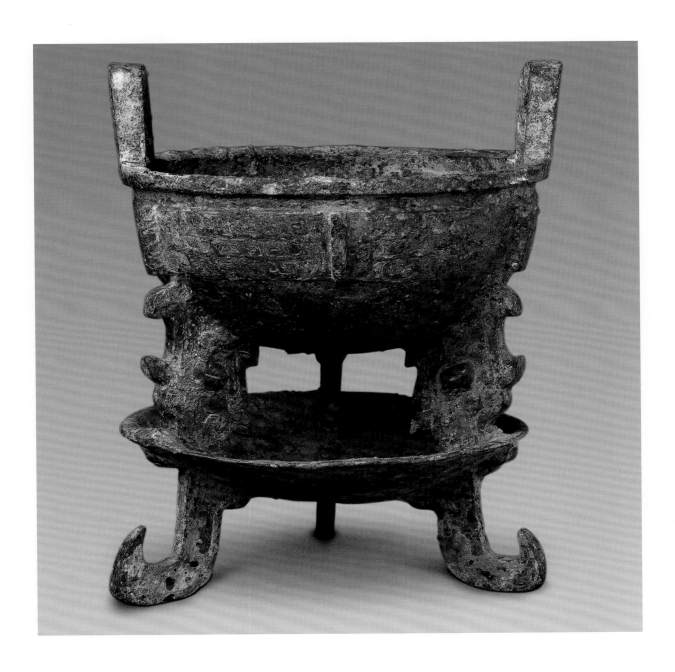

9

Ding (Cooking Vessel)
with Inscription "Shui"

Early Western Zhou Dynasty

Height 23 cm
Diameter of mouth 20 cm

This vessel has a round belly, two upright handles, a round bottom, and three columnar legs. On the belly are four flanges shaped like hooks, with their four sides protruding. The front and back sides of the upper part of the belly are decorated with a typical *kui*-dragon with one horn, one leg, an open mouth, and a curled-up tail. The middle part of the vessel has vertical lines, and the lower part, descending leaves in the shape of a triangle. The upper parts of the legs are decorated with animal masks, and the lower parts, with two bands of bowstrings. Inscribed on the interior base is the character *shui* (water), which was either a family emblem or a personal name.

The overall appearance of this vessel is elegant. The flanges on the belly and legs increase its grandeur and magnificence. The three legs show the transition from columnar legs to hoof-shaped legs, and the position of the handles is somewhere between upright handles and side ears. All these show that this vessel is from the early Western Zhou Dynasty.

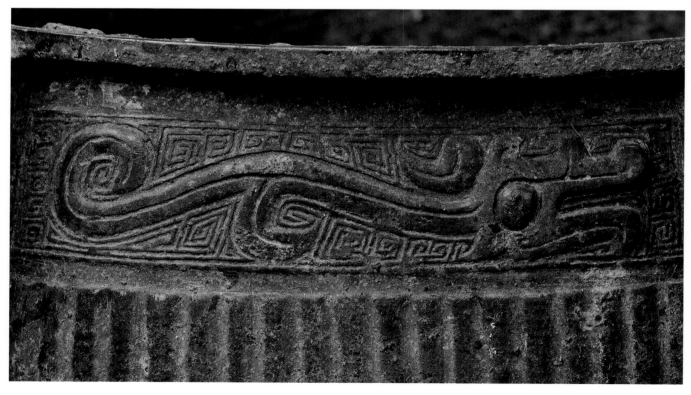

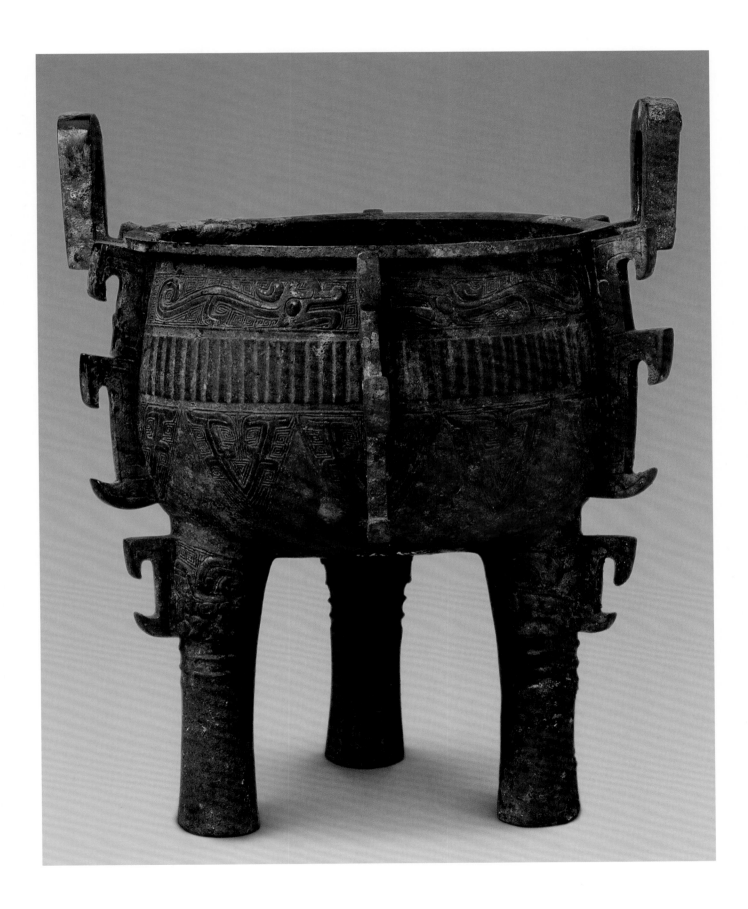

10

Shi Lü *Ding*
(Cooking Vessel)
Early Western Zhou Dynasty

Height 15.8 cm
Diameter of mouth 16.2 cm

This vessel has a round and shallow belly, upright handles, and three columnar legs. Below the mouth rim is a band of birds with long bodies, split tails, and drooped beaks against a background of clouds and thunder. Cast on the interior wall is an inscription of 79 characters in eight lines, recording the punishment of soldiers who refused to follow the Zhou emperor when he went to conquer the *fangguo*. The soldiers had to pay a penalty of 300 *lüe* (coins) and were also given a warning by their superior Bo Maofu.

This vessel was made during the reign of Emperor Chengwang of the Zhou Dynasty (1042 BC–1021 BC). Its inscription reflects soldiers' anti-war sentiments during the early Western Zhou Dynasty. It is extremely rare to find inscriptions describing punishments. The form and design of this vessel are highly refined and the long inscription makes this a typical bronze vessel.

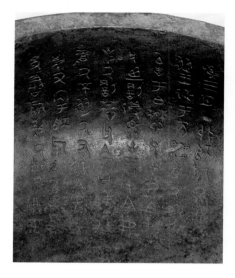

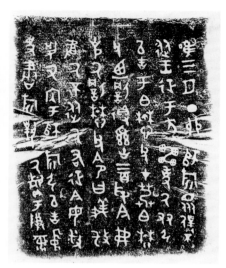

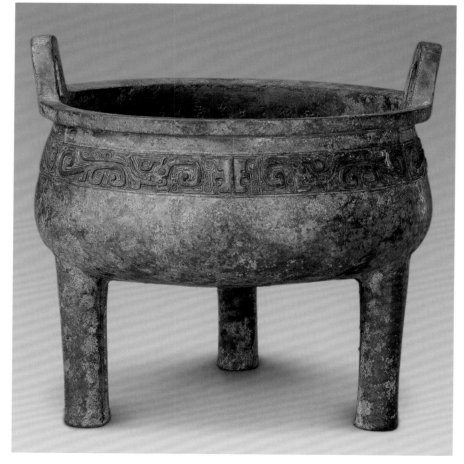

11

Song *Ding*
(Cooking Vessel)

Western Zhou Dynasty

Height 38.4 cm
Diameter of mouth 30.3 cm
Qing court collection

This vessel has a round belly, upright handles, a flat outward mouth rim, a round bottom, and hoof-shaped legs. The upper part of the belly has two bands of bowstrings. The interior of the vessel carries an inscription of 151 characters in 14 lines, which records the Emperor of Zhou ordering Song to manage matters relating to the newly-built palaces, and granting him ceremonial clothes, jade pendants, and flags.

This inscription has important historical value for the study of rituals and naming system in the Western Zhou Dynasty.

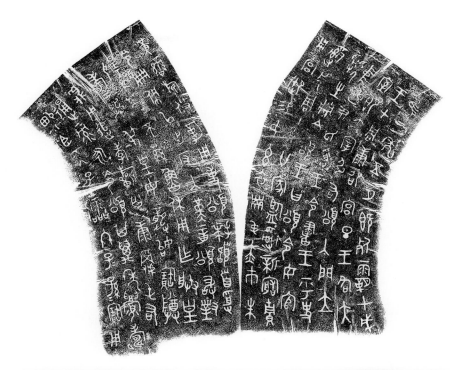

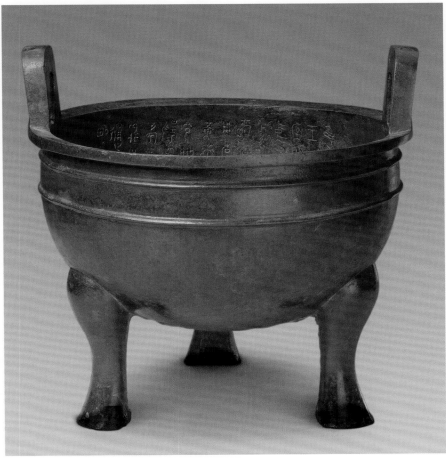

12

Ding (Cooking Vessel)
Made by Da
Late Western Zhou Dynasty

Height 39.7 cm
Diameter of mouth 38.7 cm

This vessel has a round belly, upright handles, a flat outward mouth rim, a round bottom, and hoof-shaped legs. On the upper part of the belly are two bands of bowstrings. The interior has an inscription of 80 characters, which records the Emperor of Zhou ordering Da and fellow officials to stay inside the imperial palaces and guard them; Da was given 30 horses, and Da made this vessel to praise the emperor's favouring him and to offer sacrifices to Ji Bo.

The vessel, with a bold and vigorous appearance and a simple and plain design, is one of the most common forms of bronzeware in the late Western Zhou period. Its inscription has a great value in research on the guard system and grants given in the Western Zhou period.

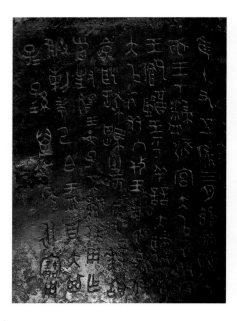 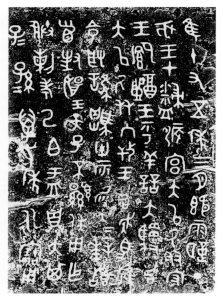

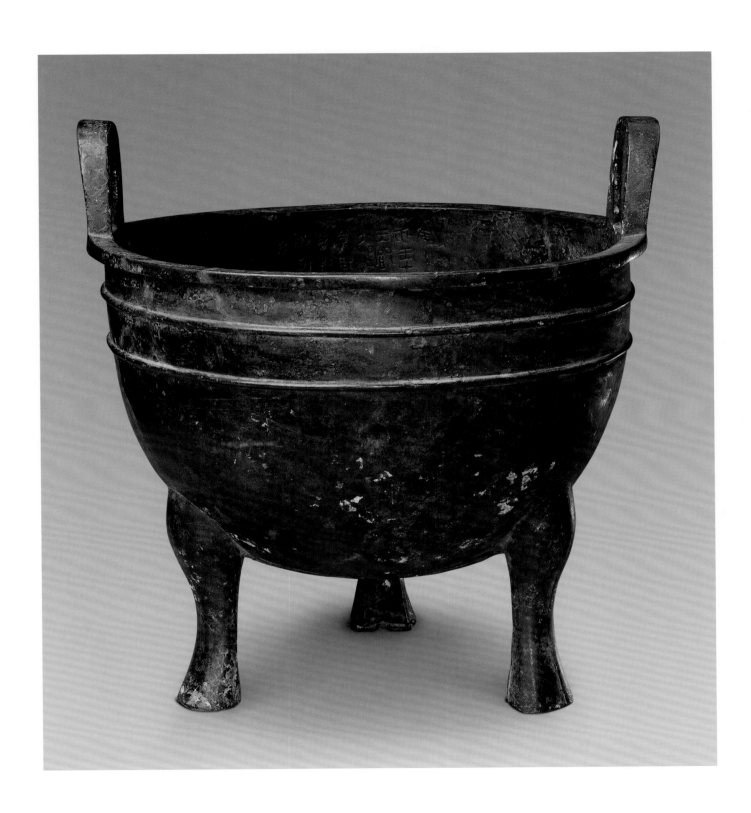

13

Ding (Cooking Vessel)
Made by Zi Duan,
Master Wen of the State of Guo
Late Western Zhou Dynasty

Height 30 cm
Diameter of mouth 30.9 cm
Qing court collection

This vessel has a round belly, upright handles, a flat outward mouth rim, a round bottom, and hoof-shaped legs. Decorated on the upper part of the belly is a band of distorted animal belts, and the lower part is decorated with ring band patterns, separated by bowstrings. The interior wall has an inscription of 21 characters in four lines, which records that this vessel was made by Zi Duan, Master Wengong of the State of Guo, for Shu Fei.

Guo, a feudal state of the early Zhou period, was divided into the Eastern Guo and the Western Guo. The State of Eastern Guo, now located in the northeastern part of present-day Xingyang City in Henan, was subjugated by the State of Zheng in 767 BC. The State of Western Guo, now located in the eastern part of present-day Baoji City in Shaanxi, had moved its capital eastward to the present-day southeastern part of the Shaan County in Henan Province during the late Western Zhou period, and was annihilated by the State of Jin in 655 BC. Master Wengong of Guo was the head of the State of Guo during the late Western Zhou period. This vessel provides important information for the study of bronzes and the history of the State of Guo in the late Western Zhou Dynasty.

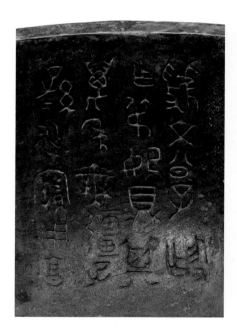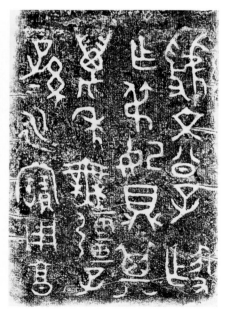

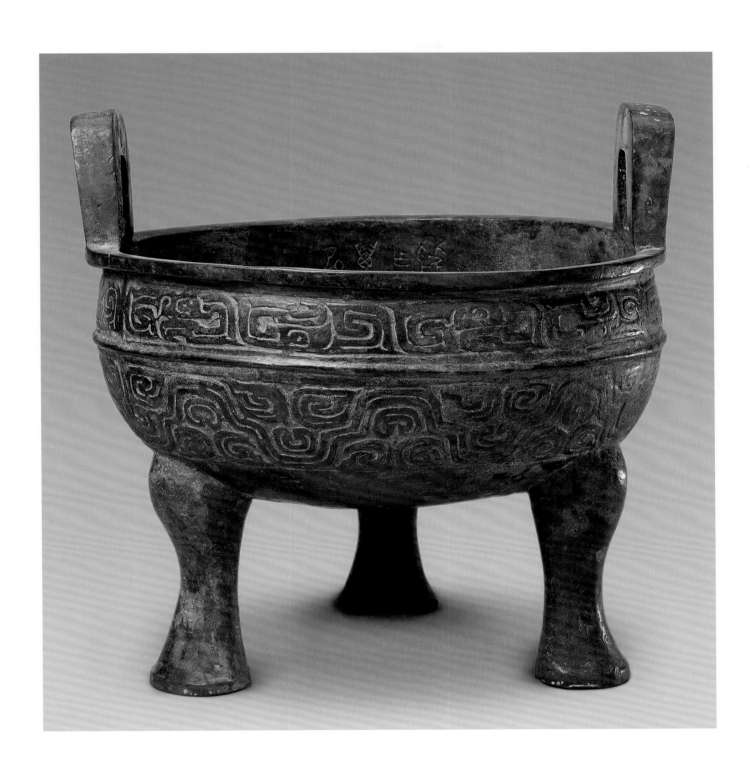

14

Ding (Cooking Vessel)
Made by Ke to Pray for
Happiness and
Longevity

Western Zhou Dynasty

Height 35.4 cm
Diameter of mouth 33 cm

This vessel has a slightly contracted mouth, a square lip with a broad rim, a bulging belly with a thick and solid wall, and hoof-shaped legs. Decorated below the mouth rim are three groups of distorted animal masks, separated by six ridges. The belly has a broad ring band design. On both sides of the handles is a symmetrical dragon motif. The upper part of the three legs has protruding animal heads. The interior base of the belly has three cavities facing the leg. Each side of these cavities has a cleave left behind in the moulding. The interior wall has an inscription of 72 characters, which records the Zhou Emperor ordered Ke, the Food Official, to command the eight troops of the Zhou Dynasty and Ke made this tripod for commemorate this royal favour.

This vessel is thick and heavy. It has a bold, vigorous, dignified, and serious appearance. Its design is sanguine and smooth, and the calligraphy in the long inscription is mature. There are eight existent vessels made by Ke, including one large and seven small vessels, which were unearthed from Famen Temple in Ren Village, Fufeng County, Shaanxi Province in 1890. These vessels can now be found in the Palace Museum, Tianjin Art Museum, Shanghai Museum, Nanjing University, Japan Calligraphy Museum, Yurinkan Museum, and Kurokawa Institute of Ancient Cultures. This example is a miniature Ke vessel.

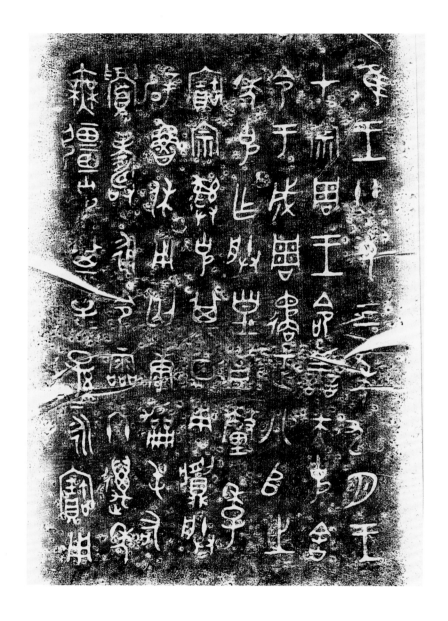

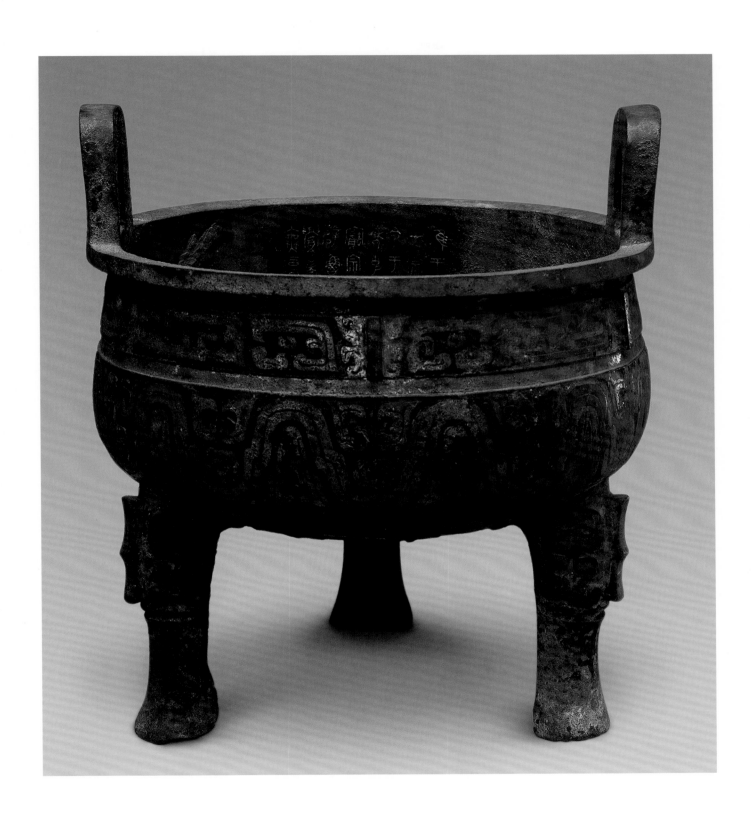

15
Li (Cooking Vessel)
Made by Shi Qin to Worship His Parents
Western Zhou Dynasty

Height 50.8 cm
Diameter of mouth 47 cm

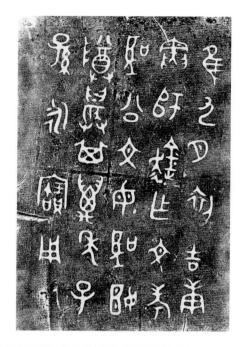

This vessel has a round mouth, a flat rim, and a flat lip. The handles on the belly are taller than its mouth rim, and it has three pouched legs. The neck and belly are decorated with *kui*-dragons, with cloud and thunder patterns as their background. The exterior of the legs has ridges. The interior of the belly has an inscription of 28 characters in five lines, recording Shi Qin making a sacrificial utensil for his deceased parents.

The shape of this vessel is magnificent and spectacular, and its design is superbly beautiful. Strongly decorative, it can be said to be "the king of cooking vessels." The writing style of its inscription is strictly structured with vigorous dots and lines. It is a superb example of bronze inscription calligraphy.

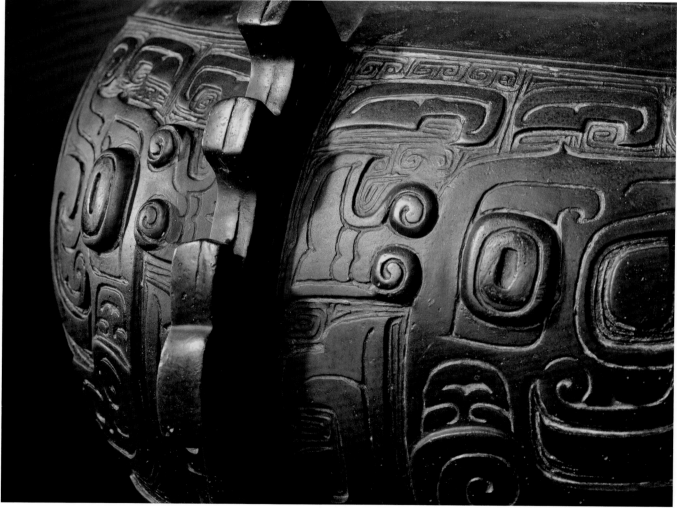

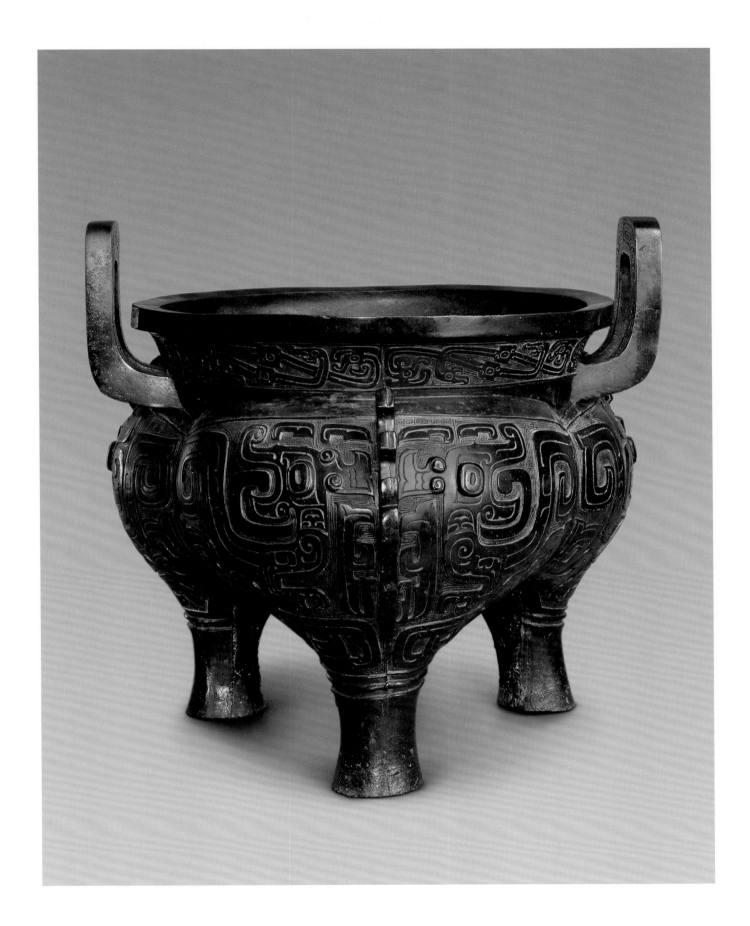

16

Rectangular *Li* (Cooking Vessel)
with Design of a Slave at a Door Whose Feet Had
Been Cut Off as a Punishment

Western Zhou Dynasty

Height 13.5 cm
Diameter of mouth 11.2 × 9 cm

This vessel is divided into two parts. The upper part for containing food is rectangular in shape. It has a flat mouth, a square lip, and its four corners form the shape of a circle. The lower part, which is slightly smaller than the upper part, is for cooking and warming food. On one side there are two doors which can be opened or closed, and inscribed on the exterior of the doors is a picture of a slave who was punished by having his feet cut off. There are holes in the remaining three sides, allowing smoke to be emitted. The upper part and the neck are decorated with the *qiequ* pattern, the four sides of the belly are adorned with ring bands, and the lower part has a cloud design.

Cutting off the feet was a cruel punishment practised in ancient times. The shape of this vessel is unique and comparatively rare. The image of a slave suffering such punishment, which is cast on the door of the vessel, is a true reflection of the life of a slave in the Western Zhou period, and provides important information for the study of slavery.

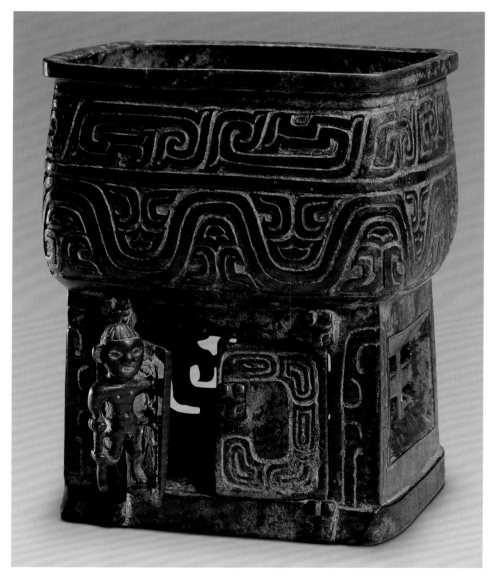

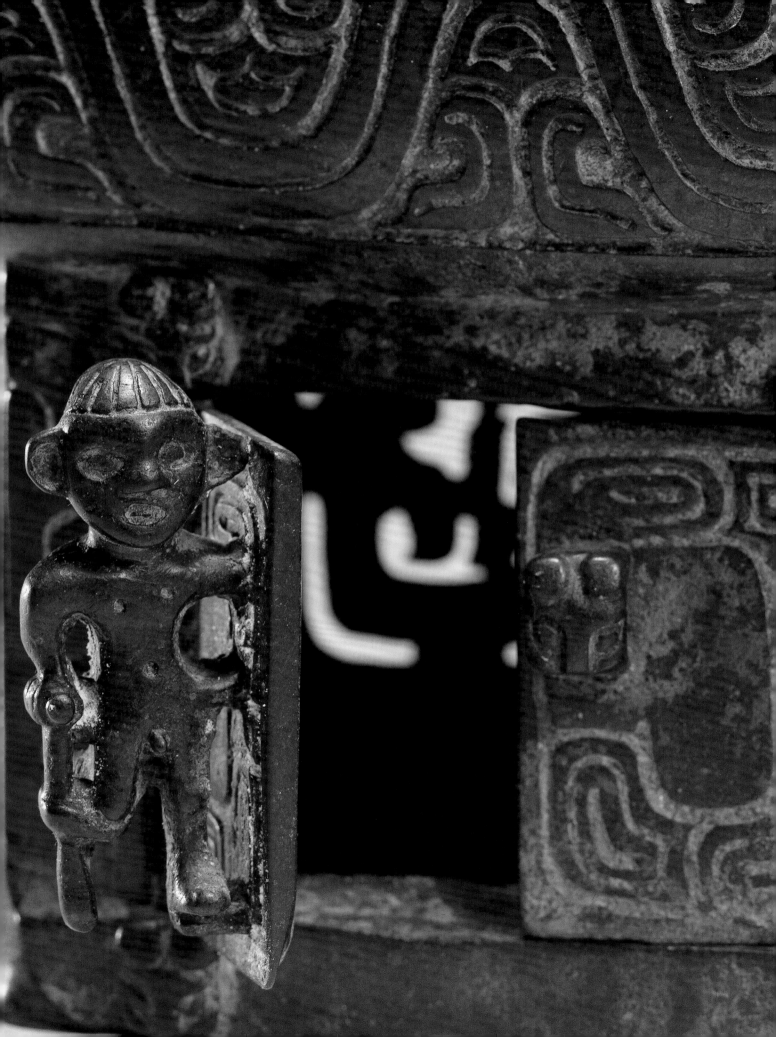

17

Gui (Food Container) with Coiling *Kui*-dragon Design

Early Western Zhou Dynasty

Height 15.8 cm
Diameter of mouth 18.5 cm
Qing court collection

This vessel has a wide flared mouth, a round belly, handles in the form of animal heads, and a ring foot. The belly is decorated with *kui*-dragons in relief, with the dragons facing each other with projecting round eyes, wide-opened mouths, curled tongues, and with their bodies and tails coiled up. Below the handles are lobes decorated with the tails and claws of birds. The ring foot is decorated with a *kui*-dragon with a bent body, a curled-up tail, a single horn, and a downward-facing mouth. Its entire body has small clouds as its background.

The form of this vessel is dignified and its decorations are rich and beautiful. The coiled *kui*-dragon design is common bronzeware of the early Western Zhou period and is relatively rare. This vessel is the earliest bronze food container.

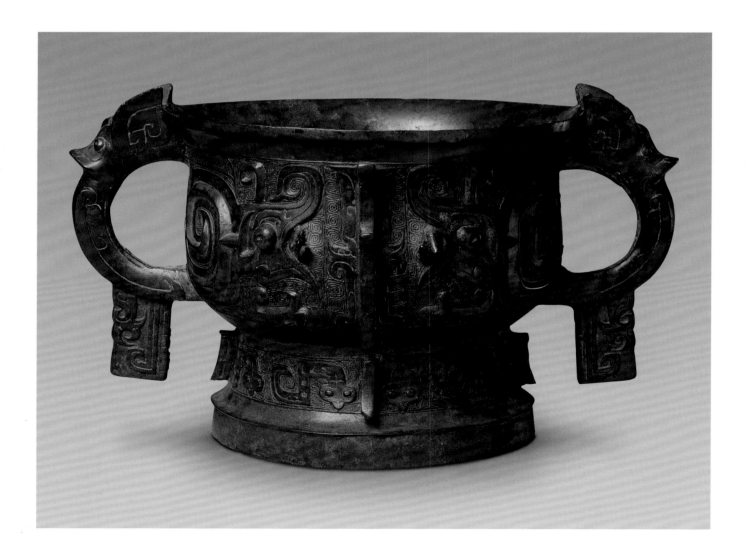

18

Gui (Food Container)
Made by Qin Lin to Worship Father Yi

Early Western Zhou Dynasty

Height 16.7 cm
Diameter of mouth 21.1 cm
Qing court collection

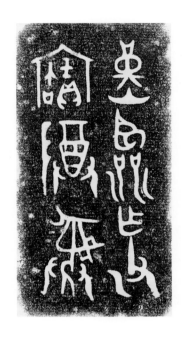

This vessel has a wide flared mouth, a round belly, two handles, and a ring foot. The decoration of the entire body is sumptuous and beautiful. The belly has half-covered animal masks, and the neck and the ring foot have a band of decorations made up of dragons and clouds, separated by animal heads. The handles are a combination of the images of dragons and birds. The upper part is a dragon head with two upright horns and protruded fangs. The lower part is a bird with a curved beak, and its body and wings are in a slightly arched shape. Engraved on the rectangular loops are birds' feet and tails. The interior base has an eight-character inscription, recording that this object was made by Qin Lin to serve as a sacrificial vessel for his father Yi.

The patterns and shape of this vessel are exquisite. The castings on its two handles are elaborate and vivid, which is a rarity in bronzeware of the Shang and Zhou Dynasties.

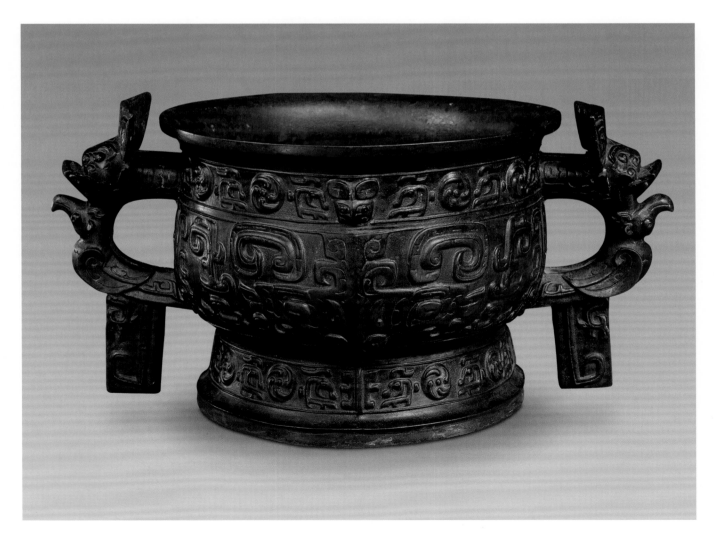

19

Gui (Food Container)
Made by Rong
Early Western Zhou Dynasty

Height 14.8 cm
Diameter of mouth 20.6 cm
Qing court collection

This vessel has a round mouth, a flat rim, a flat lip, a shallow belly, four animal handles, and a tall ring foot. The upper and lower parts of the belly have each a band of protruding bowstrings decorated with whorl patterns interlaced with an upside-down *kui*-dragon. The animal horn of each handle is taller than the rim of the mouth and it has small lobes engraved with animal feet. The ring foot is decorated with four groups of animal masks. The interior base has an inscription of 30 characters in five lines, recording Emperor of Zhou granting 100 coins to Rong, who returned the emperor's favour with the making of this vessel.

Judging by the shape, design, and contents of the inscription of this vessel, it belongs to the early period of the reign of Emperor Kangwang in the Western Zhou Dynasty. The form of this vessel is magnificent, its shape, dignified and sedate, and its design, simple and elegant. This four-handle vessel is rarely seen in similar utensils, and can be seen as a typical vessel of the period. The inscription mentions that Rong the vessel-owner received from the Zhou emperor 100 coins, which was a huge sum rarely noted in bronze inscriptions, and this has some historical value for the study of the social economy of the early Zhou Dynasty.

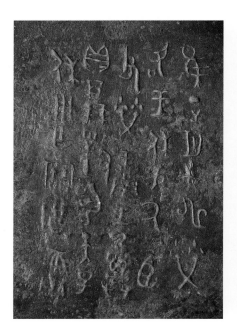 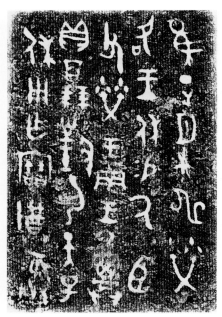

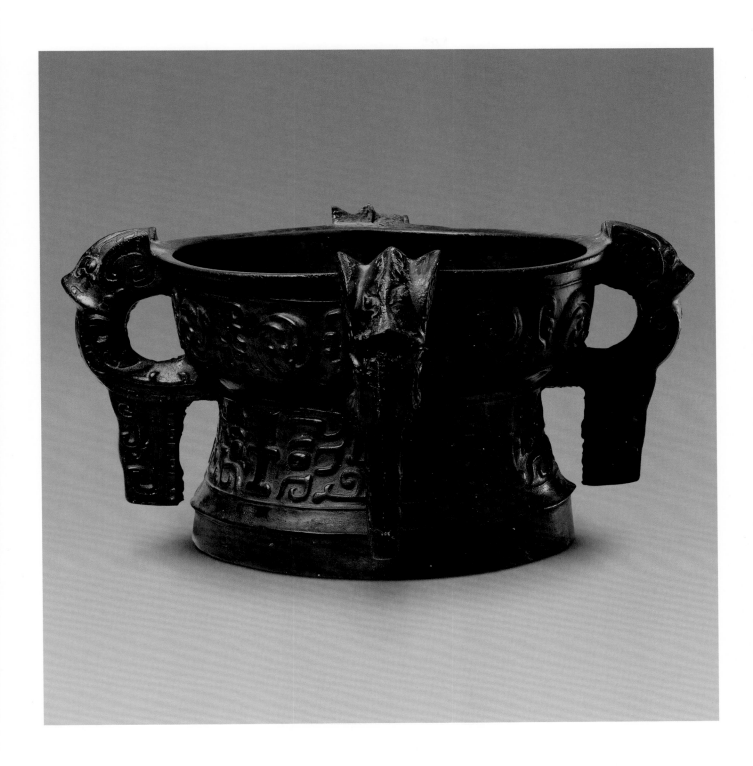

20

Gui (Food Container)
with Inscription "Bo Zuo"
Western Zhou Dynasty

Height 14.9 cm
Diameter of mouth 20.9 cm
Qing court collection

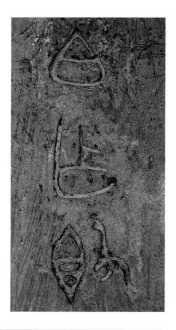

This vessel has a wide flared mouth, a square lip, two handles, a bulging belly, and a ring foot. The decorations on the handles are lively, with the upper part engraved with the head of a phoenix, which has an erect coronet, round opened eyes that stand out, and the lobes are engraved with the phoenix's feet and tail. The neck is decorated with a long-tail phoenix, separated in the middle by the head of a sacrificial animal. The belly has patterns of two phoenixes facing each other with their beaks curved, their coronets drooping, and their tails trailing behind, which is truly spectacular. The foot is decorated with eyes and oblique-angled clouds and thunder. The interior base has an inscription carrying the words: "This vessel was made by Bo."

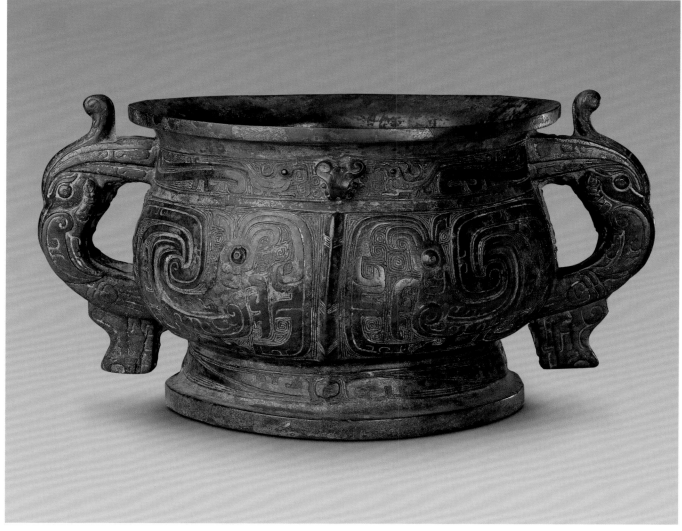

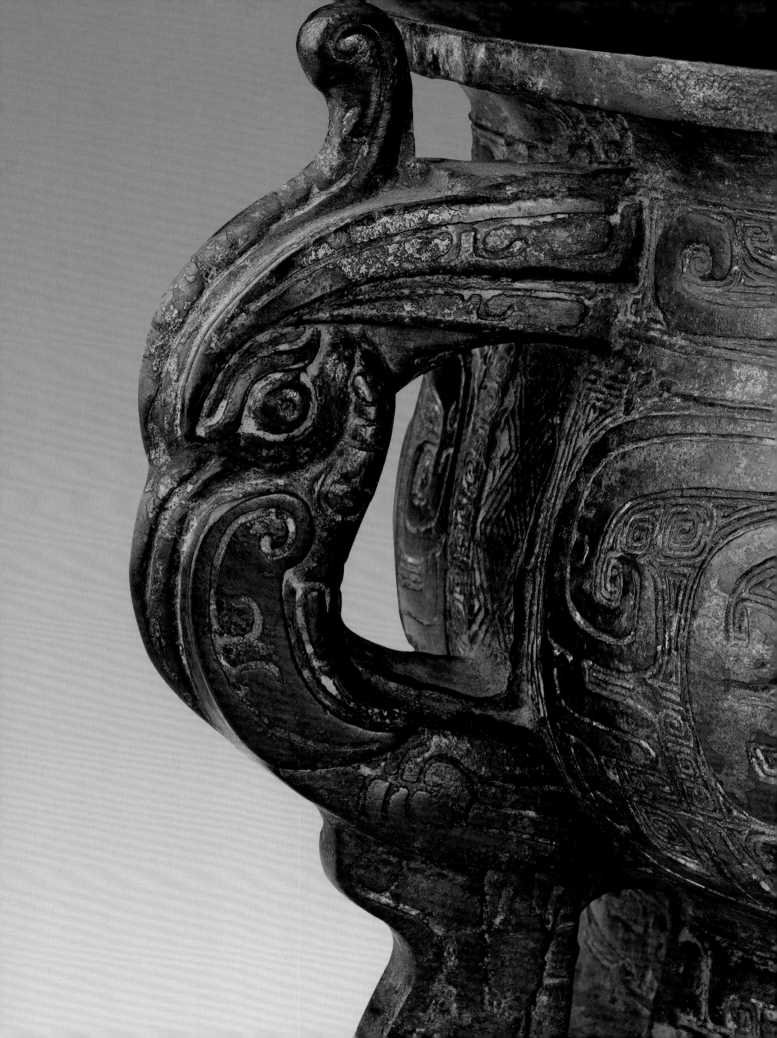

21

Gui (Food Container)
Made by Shi You

Late Western Zhou Dynasty

Height 22.5 cm
Diameter of mouth 20.9 cm

This vessel has a small mouth, a bulging belly, two handles, a lid, and there are three legs with animal masks under its ring foot. The animal horns on the handles are in the shape of a spiral shell, and the animal noses are upturned. Double rings decorate under the mouth, the rim of the lid, and the ring foot, while tiles decorate the belly and the top of the lid. Engraved on the lid and body are two similar inscriptions of 107 characters and 106 characters respectively. They record Emperor of Zhou conferring a noble title on Shi You at the Great Temple of Wu so that the latter could inherit official titles and fiefs; the emperor also granted him clothes, pendants, and chariots. Emperor of Zhou instructed Shi You to never forget to execute his duties. Shi You was grateful for the honours given by Emperor of Zhou and cast this sacrificial vessel for his ancestors.

The form of this vessel was popular in the late Western Zhou period. The inscriptions are important materials for the study of the heredity titles and official emoluments in the Western Zhou Dynasty.

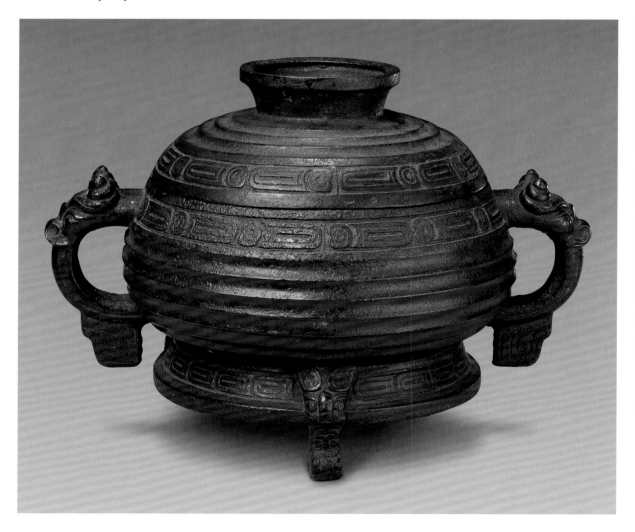

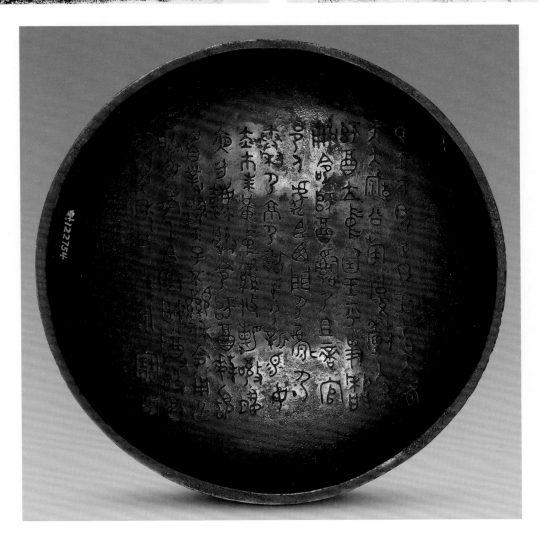

22
Gui (Food Container)
Made by Zhui
Western Zhou Dynasty

Overall height 39.4 cm
Diameter of mouth 27 cm
Qing court collection

This vessel has a round body, a contracted neck, a drooping belly, and a lid, with a square base at the bottom. The handles are cast into the shape of a dragon turning back its head. The ears of the dragon are high and upright, with its curled tail as a lobe. Decorated on the lip and four sides of the square base are *kui*-dragons and a phoenix, with the phoenix turning back its back and drooping its coronet. The upper and lower parts are separated by bands with *qiequ* patterns, and the entire body has cloud and thunder patterns as the background. On the top of the lip is also a phoenix bird design. There is an inscription of 60 characters in seven lines on the vessel and the lip. The contents are Zhui saying that he worked diligently on matters under his administration day and night, and for this, he received many grants from the Zhou emperor; he praised the favours he obtained from the emperor and cast this sacrificial vessel for his ancestors.

The shape of the vessel is magnificent and beautiful, and the form of the dragon ears is lively. The inscriptions on the vessel help in researching the sacrifices and honorifics of the Western Zhou Dynasty.

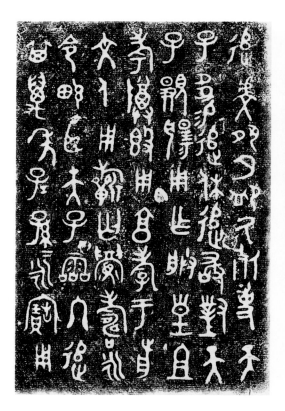
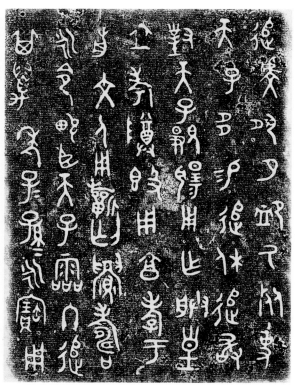

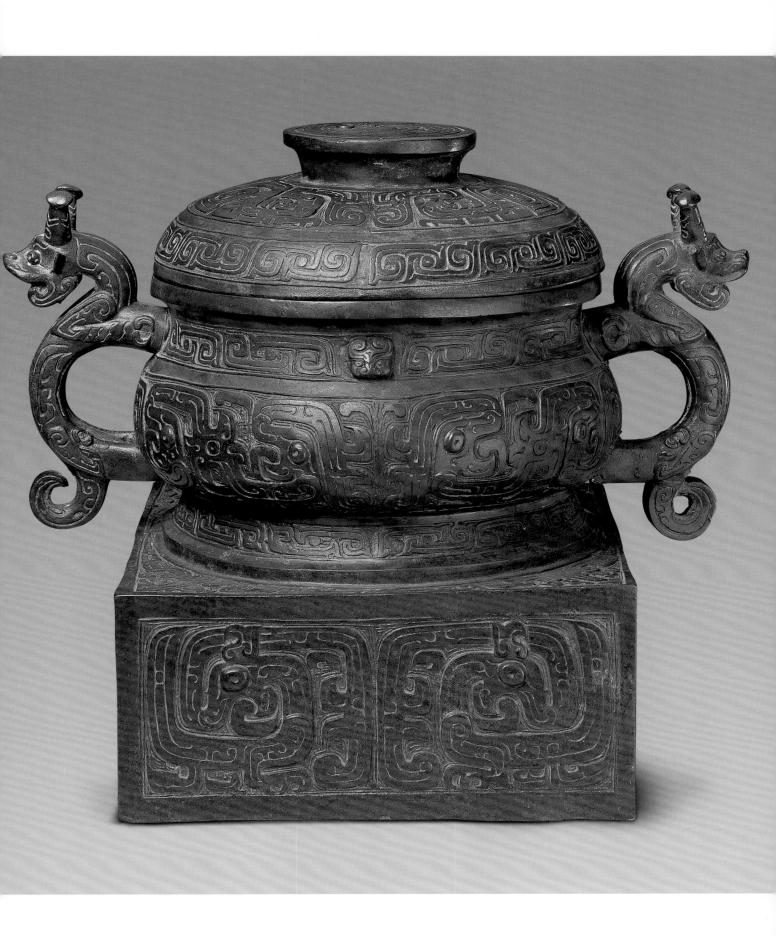

23
Gui (Food Container) Made by Ge Bo
Western Zhou Dynasty

Height 23.5 cm
Diameter of mouth 21.3 cm

This vessel has a round belly, a ring foot, and a square base. It has two animal head handles, with their lower part resembling the curled trunks of an elephant. Cast on the front and back sides of the neck are half-protruding animal heads with *kui*-dragon and whorl patterns on two sides. The belly and the central part of the square base are adorned with vertical stripes. The ring foot has designs of four-petalled flowers and whorls. The four corners of the surfaces of the square base are decorated with animal masks and the two sides and upper parts of the four vertical planes are decorated with ragged curves and whorls. The interior base has an inscription of 82 characters in eight lines. With some characters lost, it records that Ge Bo used four good horses given in exchange for 30 pieces of land from Pengsheng, with each holding the contracts and determining the boundaries.

This vessel belongs to the period of Emperor Gongwang of the Zhou Dynasty (922 BC – 900 BC). The land exchange recorded in the inscription are several hundred years longer than the demolition of the well-field system in the 15th year of the reign of King Xuan of Lu (594 BC) recorded in historical documents, which formally and officially recognized the legality of privately-owned land. This has important values for the study of the changes in land systems in the middle and latter parts of the Western Zhou Dynasty.

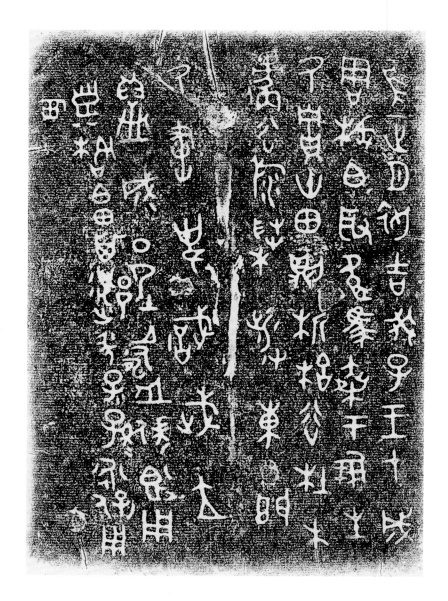

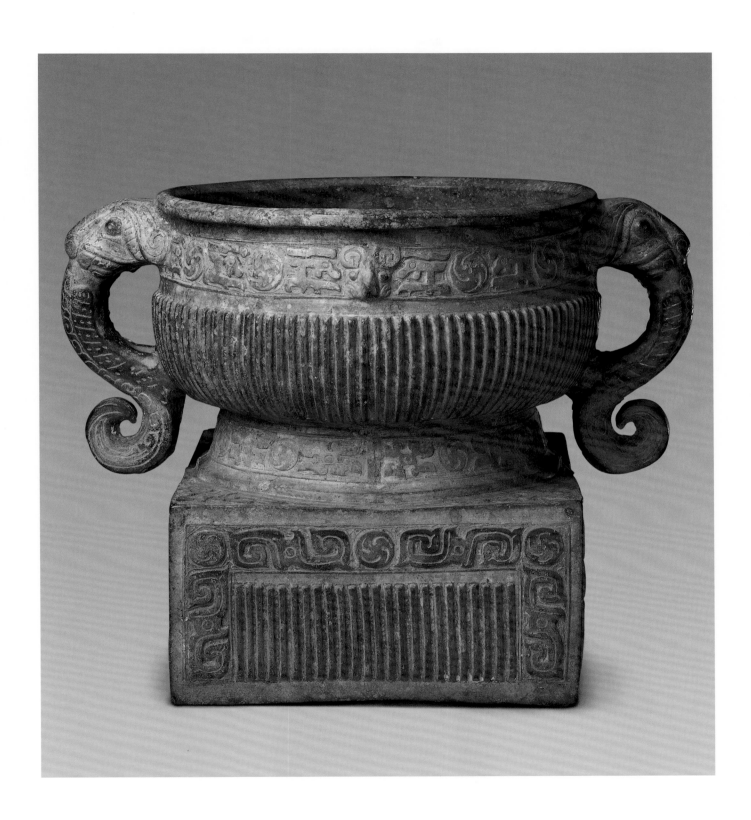

24

Gui (Food Container) Made by Cui

Western Zhou Dynasty

Height 21.1 cm
Diameter of mouth 18 cm

This vessel has a wide flared mouth, a square lip, a contracted neck, a bulging belly, two side ears, and there are three flat legs under its ring foot. The rim of the lid and the lower part of the mouth are ornamented with small thunder patterns and with ragged curves as the background. The belly and lid top are decorated with vertical stripes. There is a band of bowstrings on its ring foot. The lid and body have an identical inscription of 16 characters in three lines, recording that Cui made this vessel for his aunt Kui to pray for her longevity.

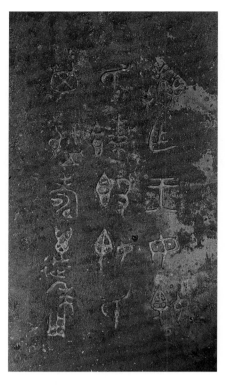
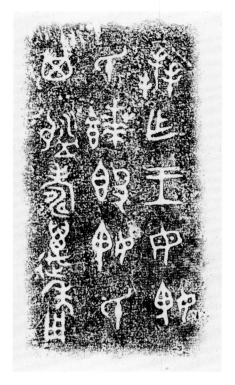
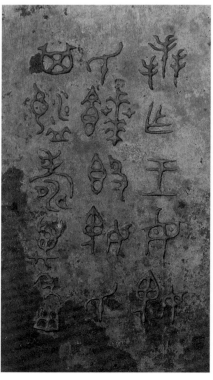
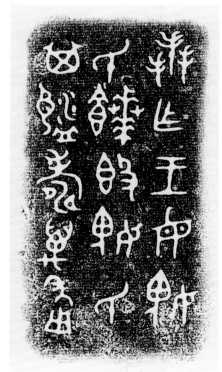

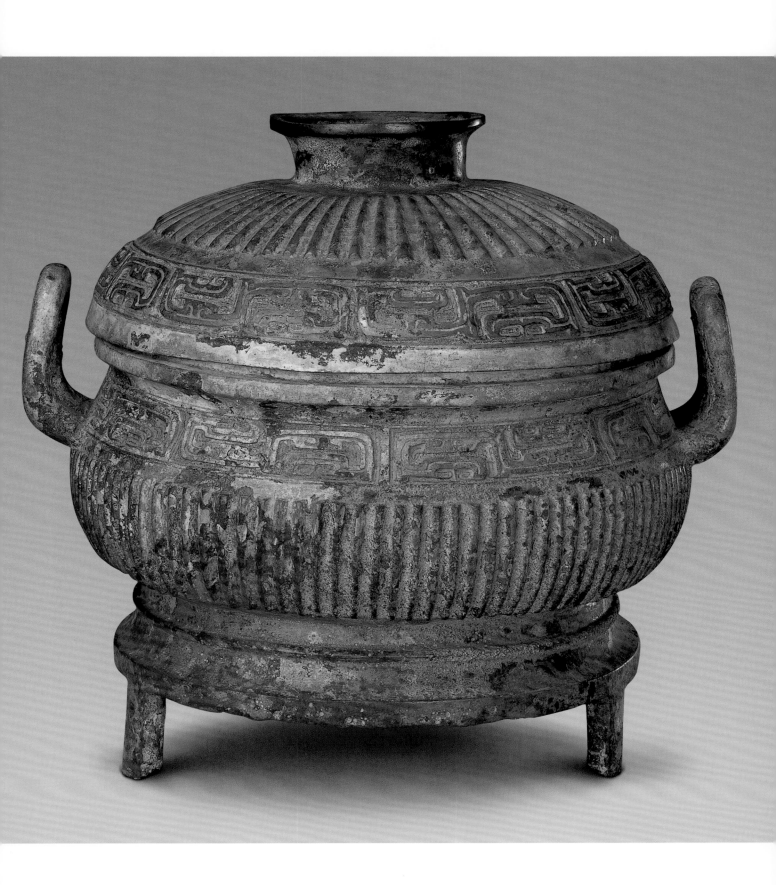

25

Gui (Food Container)
Made by Tai Shi Zu

Western Zhou Dynasty

Height 19.8 cm
Diameter of mouth 21.2 cm

This container has a wide flared mouth, a contracted neck, a bulging belly, and a short ring foot. The lid and belly are decorated with vertical stripes, and the neck and ring foot, with a band of protruded bowstrings. Both sides of the body are decorated with two medallion carved animal heads as handles, and this is a unique feature of its design. Inscribed on the interior base and the interior of the lid is an identical inscription of 70 characters in seven lines, which records the Zhou emperor summoned Tai Shi Zu at the Grand Room of the Shiliang Palace to bestow a tiger skin on him, and Zu as a result made this vessel. Zu's usher was Shichen, and the one who bestowed Zu the tiger skin was Zai Hu, then Palace Minister, an important official.

Judging from the shape and inscriptions of this container, it should be a vessel of the middle and late Western Zhou Dynasty and has great historical value.

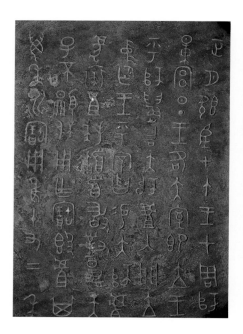 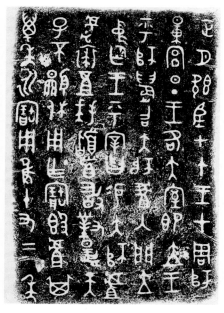 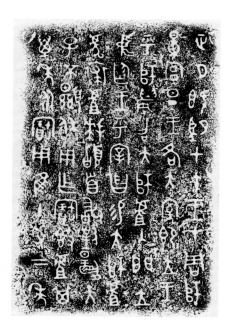

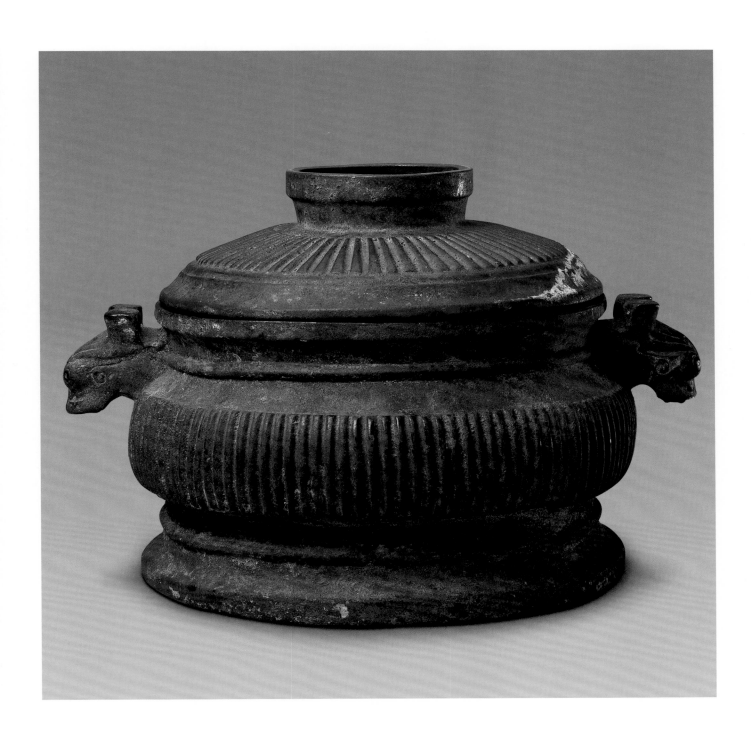

26
Song *Gui* (Food Container)
Western Zhou Dynasty

Height 22 cm
Diameter of mouth 24 cm

This vessel has a small mouth, a bulging belly, animal-head handles with pendants, and there are three flat legs with animal-masks under its ring foot. Decorated under its mouth are ragged curves. The belly is cast with tiles, and there is a scale design on the ring foot. The interior of the vessel has an inscription of 150 characters, which tells of Emperor of Zhou conferring a title on Song to allow him to be in charge of the administration of matters relating to the new palace, and that the emperor gave him many gifts; Song also held a ceremony to return the emperor's favour.

The shape of this vessel is exquisite. Its long inscription has great value in the study of the conferment system of the period.

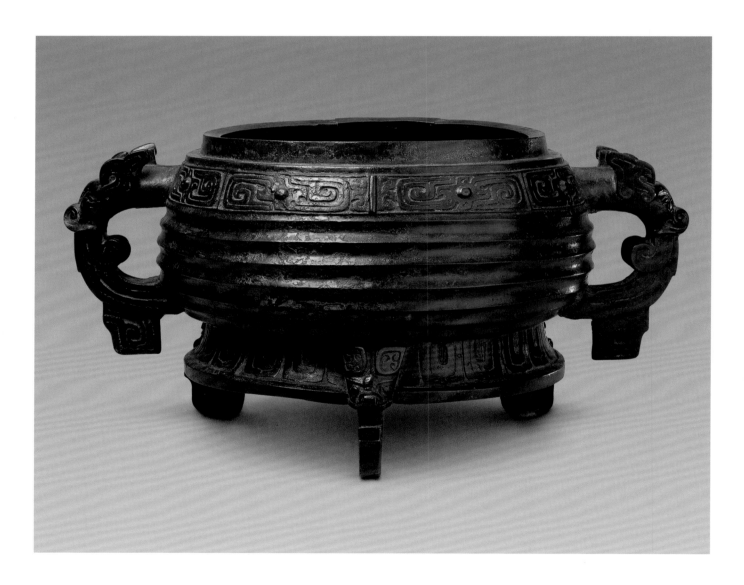

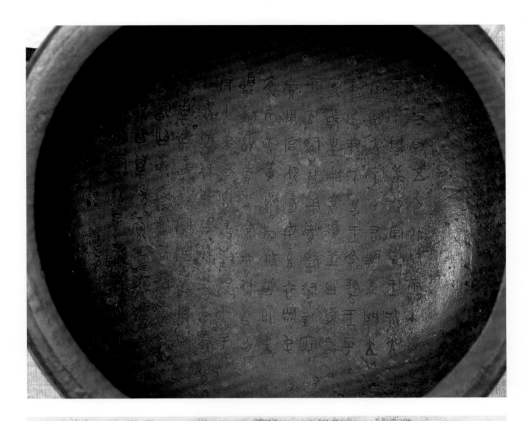

27

Gui (Food Container)
Made by Yang

Western Zhou Dynasty

Height 18.7 cm
Diameter of mouth 21.6 cm

This vessel has a small mouth, a bulging belly, handles with animal heads holding rings, and there are three short legs with animal masks with curled-up tails under its ring foot. The lid is lost. The neck and ring foot are decorated with distorted animals with clouds and thunder patterns as the background. Cast on the belly are tiles. The interior has an inscription of 106 characters in ten lines, which records that the Zhou emperor conferred the title of Minister of Works to Yang at Kang Palace for him to manage land and counties, and he also granted him clothes and flags.

The inscription of this vessel has great historical value for the study of the conferment and official systems of the Western Zhou Dynasty.

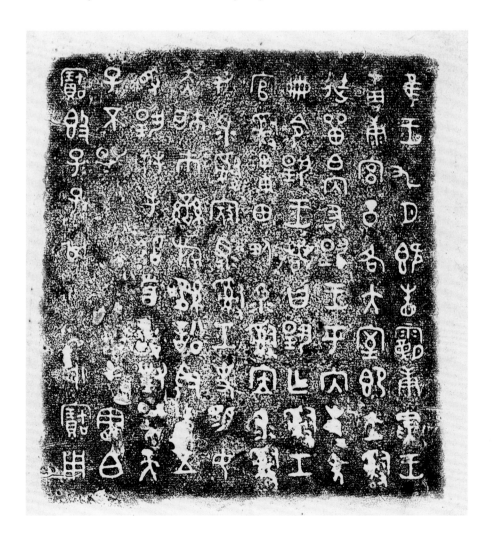

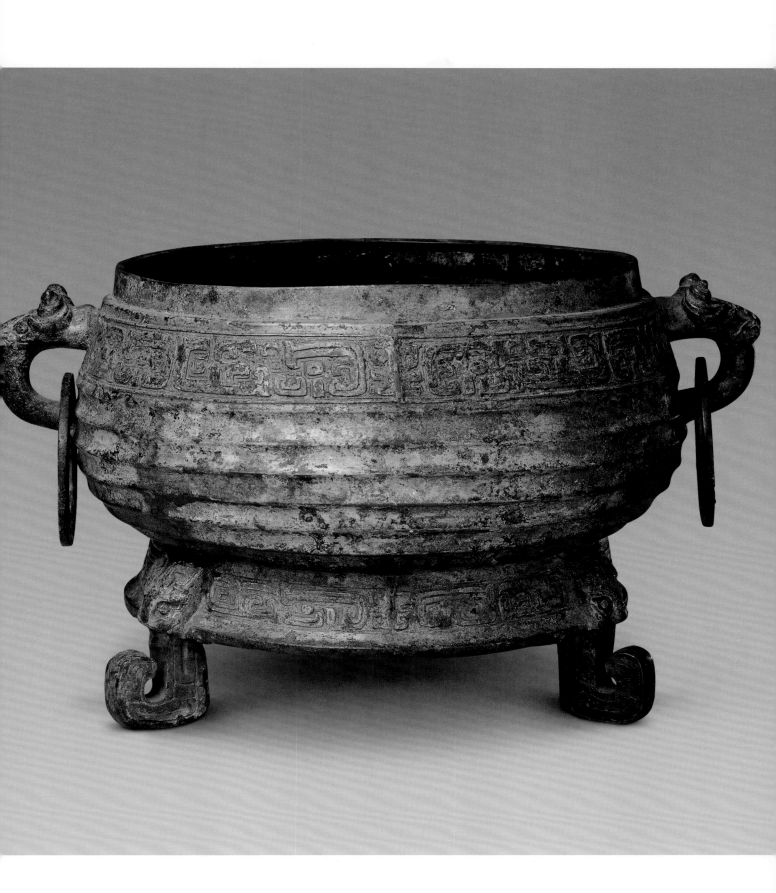

28

Dou Bi *Gui* (Food Container)

Western Zhou Dynasty

Height 15.1 cm
Diameter of mouth 23.5 cm

This vessel has a short body, a small mouth, a bulging belly, a ring foot, and handles with animal heads holding rings. The lid is lost. The entire body is cast with tiles. The interior has an inscription of 92 characters in nine lines, which records the Zhou emperor granting Dou Bi official clothes and flags, and letting him take up the official titles of the Head of the Ministry of War and Head of Bows and Spears.

The shape of this vessel is typical of the style that emerged in the early and middle periods of the Western Zhou Dynasty.

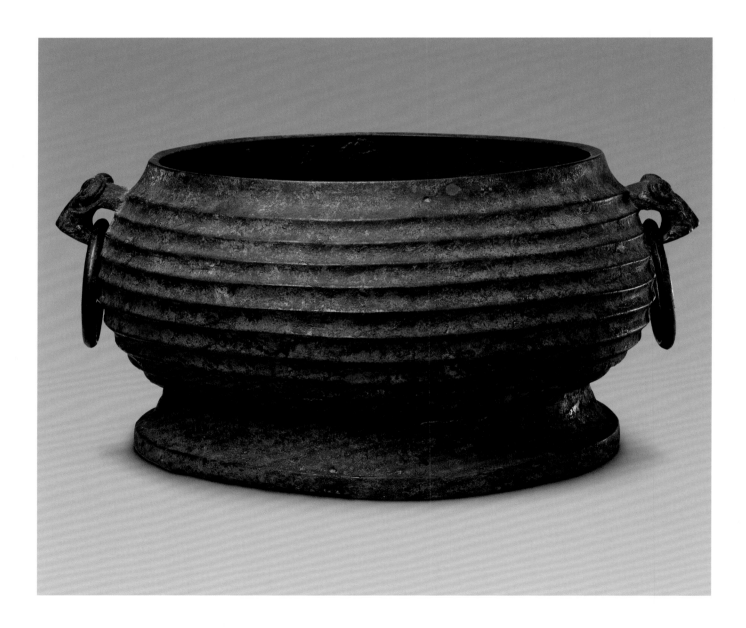

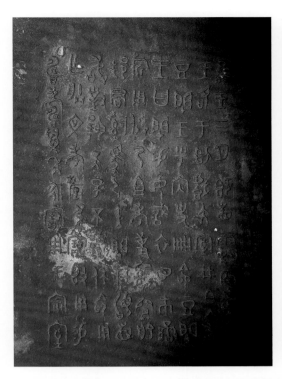

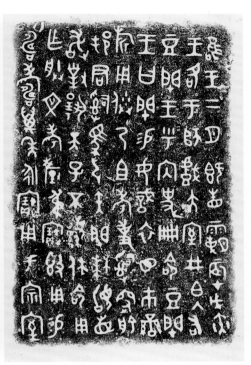

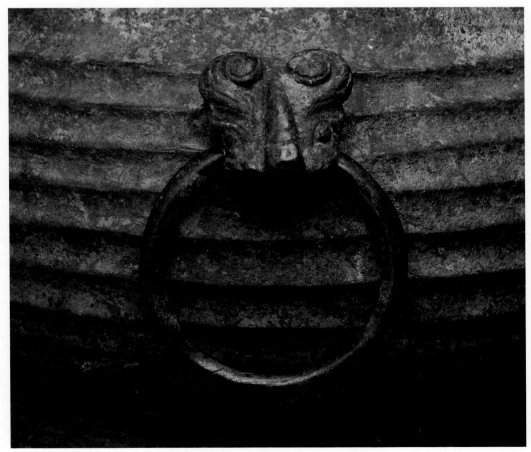

29

Large *Fu* (Food Container) with *Kui*-dragon Design

Early Western Zhou Dynasty

Height 37 cm
Diameter of mouth 55.8 cm

This container has a wide flared mouth with a lid that fits the rim. From the mouth rim down, the belly narrows such that the body turns into the shape of a diagonally vertical funnel. Its legs are rectangular in shape. The size and shape of the lid and body are the same. There is a rectangular handle on the top of the lid. The entire body is ornamented with flower patterns, and the neck, belly, lid, legs, and handle have *kui*-dragon patterns. Each group has two *kui*-dragons facing each other and has a cloud and thunder pattern as the background. The *kui*-dragon has a long body, projecting eyes, an opened mouth, one horn, one leg and a curled-up tail. There are two bands of *kui*-dragons between the body and lid, decorated with simple vertical lines with a shape resembling radiation lines.

Fu is a large food container. In the past, it was believed that the time of the first appearance of bronze food containers was no earlier than the reign period of Emperor Gongwang of the Western Zhou Dynasty. The form and decorations of this container have bronze features that existed before the time of Emperor Gongwang. During the middle and late Western Zhou Dynasty, the included angle of a food container was a right angle instead of a round corner, while having four round-shaped corners was a characteristic of the bronzeware in the early Western Zhou Dynasty. What is more, the *kui*-dragon and straight-line design of this container are similar to that of the *ding* container of the same period. This container is the earliest bronze food container that has been seen so far.

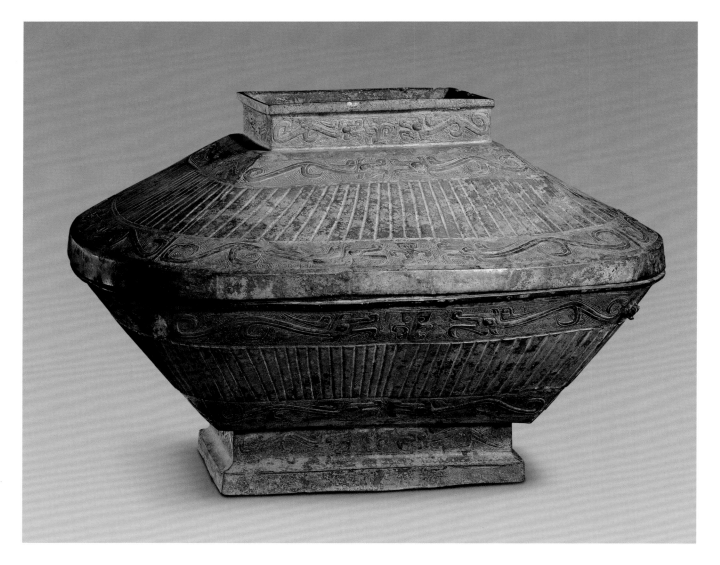

30

Xu (Food Container)
Made by Guo Cong
Late Western Zhou Dynasty

Overall height 14 cm
Width 38.5 cm
Diameter of mouth 24.9 × 19.1 cm

Xu is an ellipsoid with a contracted mouth and a bulging belly. It has two animal head handles and a splay ring foot with four short feet with animal heads under it. The neck is decorated with a band of double rings and its belly, with tiles. Inscribed on the interior base are 138 characters in 12 lines, which is about the event that took place on a certain day in the seventh month of the 25th year of the reign period of Emperor Liwang of the Zhou Dynasty when the emperor ordered the historiographer to record the land transfer of Zhang and two other persons. This container was made to record this event and also to commemorate his deceased grandfather Ding Gong and his deceased father Hui Gong. The symbol at the end of this inscription is the insignia of the clan.

The modelling and design of this container does not have the rich and elegant style of bronzeware of the early Western Zhou Dynasty, but keeps the tradition of having long inscriptions to record achievements. The double ring and tile patterns were a new design that arose in the late Western Zhou Dynasty, which represents the new style of simplicity popular at the time. As the contents of its inscription are about the usage, allocation, and transfer of land, it provides important information for the study of the land system, contract stipulations, official titles, as well as property rights relating to individuals and clans.

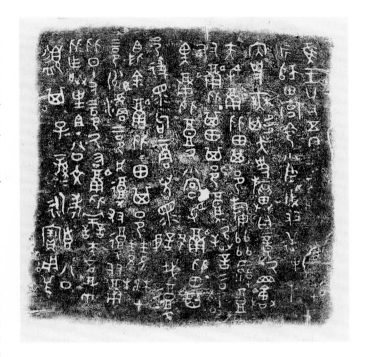

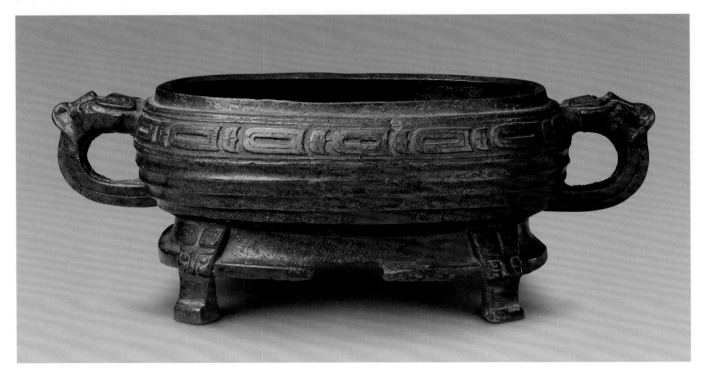

31

Xu (Food Container)
Made by Du Bo for Offering Sacrifices to His Grandfather, Father, and Close Friends

Late Western Zhou Dynasty

Overall height 36.8 cm
Diameter of mouth 27.1 × 17.5 cm
Qing court collection

This container is conical in shape. It has a bulging belly, handles with animal heads, and a splay ring foot. It has a lid with rectangular buttons that are placed upward to form this four-legged vessel. The rim of the lid and the shoulders are decorated with *qiequ* patterns, and the lid and belly are decorated with tiles. The lid and body have an identical inscription of 30 characters in four lines, recording Du Bo making this container to offer sacrifices to his ancestors and close friends.

The design of this container is elegant and the patterns are simple and exquisite. The inscription is neatly arranged and written in a meticulous, neat, and smooth style. The maker of this container Du Bo was mentioned in ancient documents and it can be ascertained that this container was made during the reign of Emperor Xuanwang of the Zhou Dynasty (827 BC – 782 BC). In addition, the inscription mentioned that the container was made for friends, which is extremely rare.

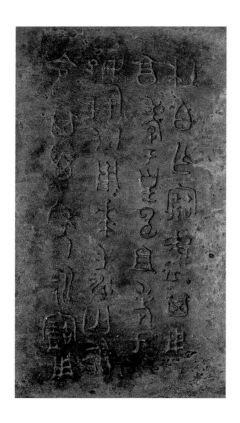
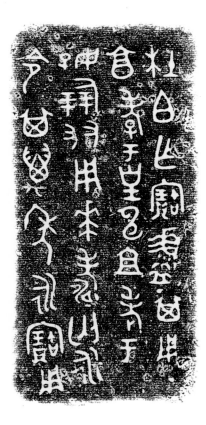
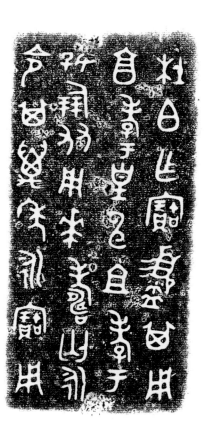

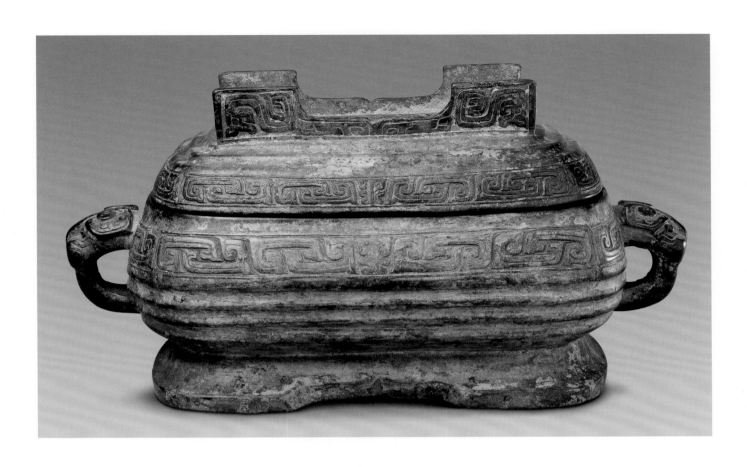

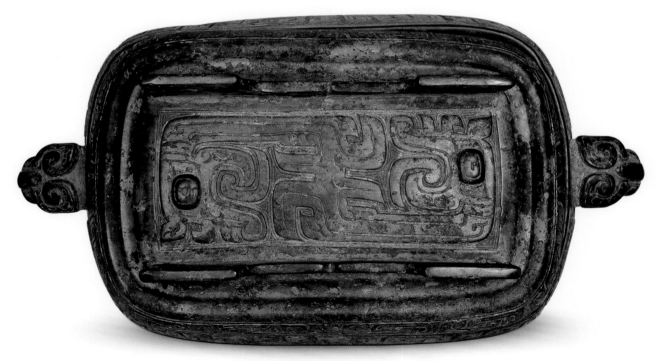

32

Yu (Food or Water Container)
Made by Bo

Late Western Zhou Dynasty

Overall height 39.9 cm
Diameter of mouth 53.5 cm
Qing court collection

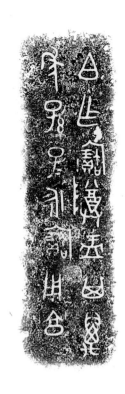

The container has a round body, a wide flared mouth, a deep belly with a pair of side ears, and a ring foot. The central line facing the two side ears has elephant heads with curled-up trunks. The neck is decorated with two birds facing each other, the belly, with leaves, and the foot, with birds turning back their heads. The interior has an inscription of 15 characters in two lines, recording that Bo made this container.

Yu, a large food container that can also be used to contain water, was popular in the Western Zhou Dynasty. This container has a magnificent shape and the patterns are stately, exquisite, and beautiful. The shape is typical of bronze utensils in the late Western Zhou Dynasty.

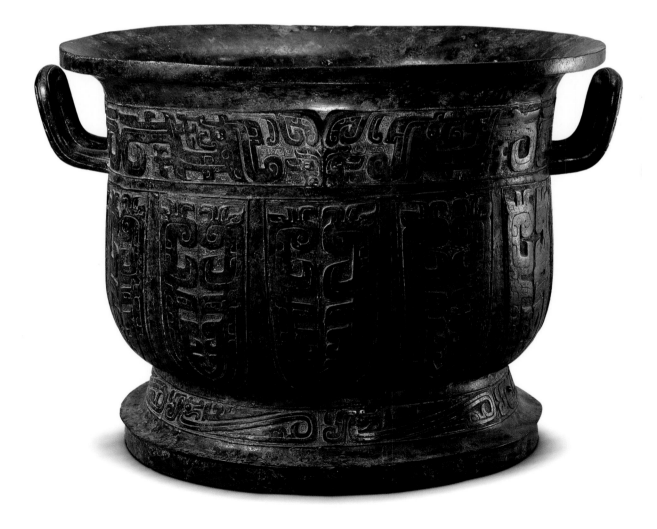

33

Big *Ding* (Cooking Vessel) with Coiling Serpent Design

Spring and Autumn Period

Overall height 75 cm
Diameter of mouth 77 cm

The body of this vessel is round. It has a wide flared mouth, a contracted neck, and side ears. The front and back sides of the belly are each decorated with animal heads holding rings in their mouths. It has a round base and three hoof-shaped legs. The neck is decorated with coiling serpents, double rings, and triangles. The belly is ornamented with two bands of cord, a band of *kui*-dragons, coiling serpents, and descending leaves, and the legs, with animal masks. The interior has an inscription of five lines with damaged characters.

The modelling of this vessel is magnificent. It is dignified with a beautiful flower design. In the Spring and Autumn period, patterns that emerged in the late Western Zhou Dynasty, such as the simple and bold double ring design, were gradually replaced by more elaborate, neat and exquisite one such as the coiling serpent design. This vessel has both double ring and coiling serpent designs, and this is a reflection of the process of transition. This vessel was unearthed in Xinzheng City in Henan Province in 1923.

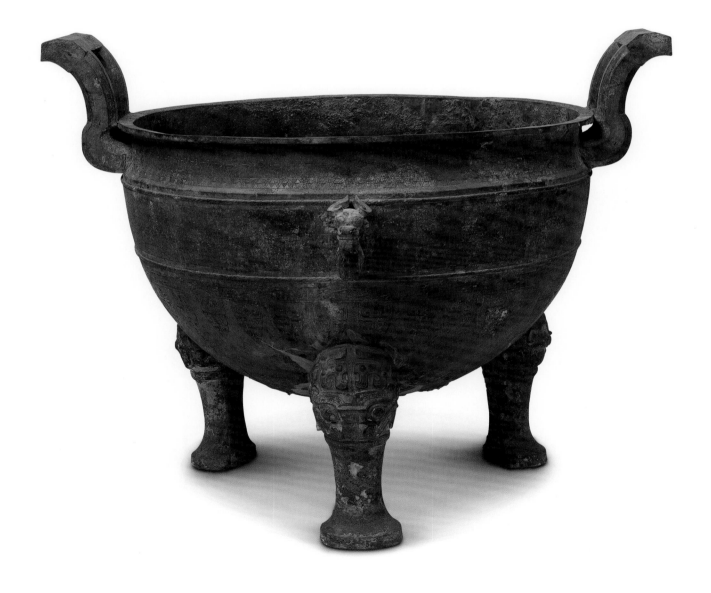

34

Ding (Cooking Vessel)
with Coiling Serpent Design

Spring and Autumn Period

Overall height 45 cm
Width 55.5 cm

This round-shaped vessel has two side ears which are slightly curved, a huge belly, a round base, and three hoof-shaped feet. It has a round lid adorned with three small ring-shaped buttons. The top of the lid is decorated with coiling serpents. Both faces of the ears are ornamented with coiling serpents, and its sides, with meander patterns. The belly is adorned with two bands of coiling serpents, separated by a cord in the middle. The feet are decorated with animal masks.

The body of this vessel is large, cast with elaborate patterns. The main motif is the coiling serpents, which embodies the characteristics of utensils in the Spring and Autumn period. Vessels as a type of ritual utensil still occupied an important position at this time. The main features of vessels during the period usually have side ears and lids with three animal-shaped or round buttons on top.

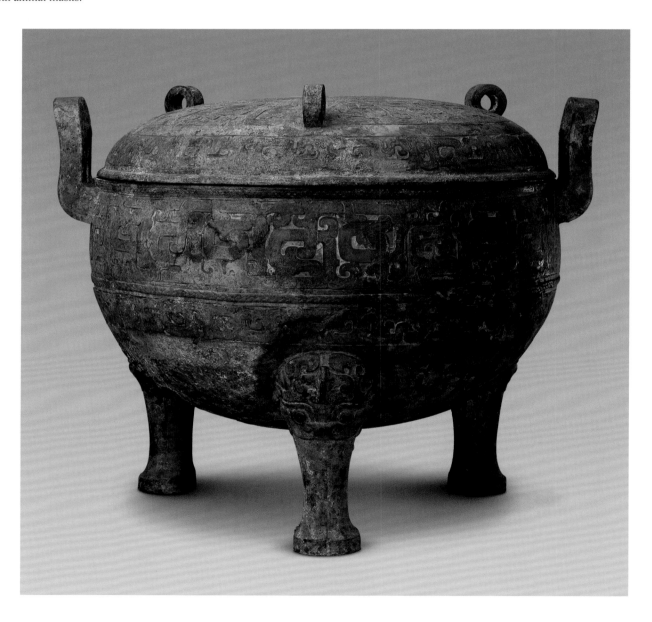

35

Rectangular *Yan* (Cooking Vessel) with Design of Four Snakes

Spring and Autumn Period

Overall height 44.7 cm Width 33.7 cm
Diameter of mouth 28.7 × 23.2 cm

This cooking vessel consists of the two separate parts of a *zeng* (steamer) and a *li* (cauldron). The steamer, its upper part, is in the shape of a long rectangular funnel with a wide flared mouth and two upright handles. There are small holes on its flat bottom and there are mortise holes as its secondary outlets. The cauldron, its lower part, has a vertical mouth, upright handles, and inside the mouth there is a concaved stand for the insertion of mortise holes. The four corners of the shoulders are each decorated with a coiling snake with its head raised. This vessel has a bulging belly, like four balls connected to each other, and it has four hoof-shaped legs in the shape of an animal. The handles of the steamer are decorated with distorted double rings and the belly, with patterns of lines in the "T" shape connected to each other in three layers. The belly is adorned with snakes and the coiling snakes on its four corners are decorated with scale patterns. The decoration of the four snakes on the cauldron is a rarity.

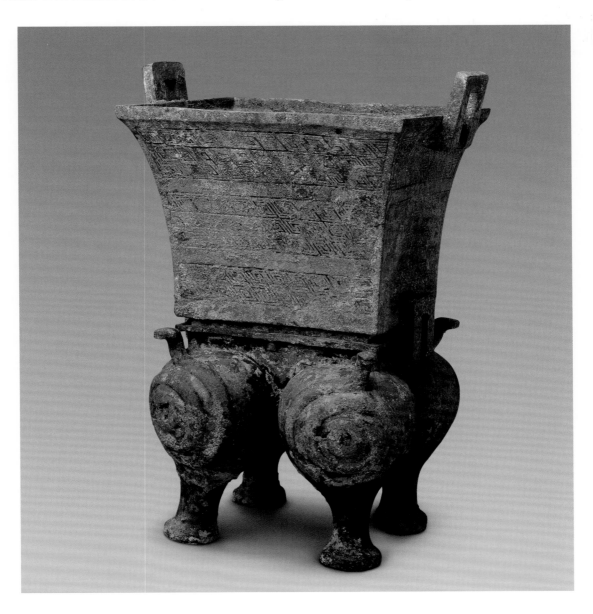

36

Gui (Food Container)
with Dragon-shaped Ears
Spring and Autumn Period

Overall height 33.9 cm
Width 43 cm
Diameter of mouth 23.1 cm

This container has a wide flared mouth, a contracted neck, a round belly with a pair of dragon-shaped ears on its sides, and a ring foot connected to a rectangular base. It has a lid, and a single handle openwork carved in the shape of a lotus petal. At the middle of the lid top is a decoration of coiling serpents. The edge of the lid, the belly, and the rectangular base are adorned with cloud bands. The neck and foot have double rings.

This container is magnificent and majestic in its design, especially the lively decoration of the dragon-shaped ears. The decoration of lotus petals on the lid is a common feature of the Spring and Autumn period. This container is a masterpiece in the art of bronze in that period.

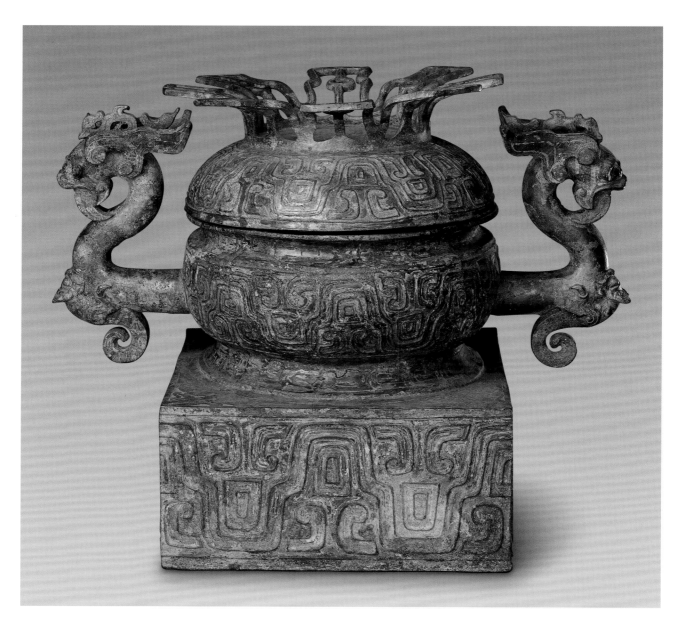

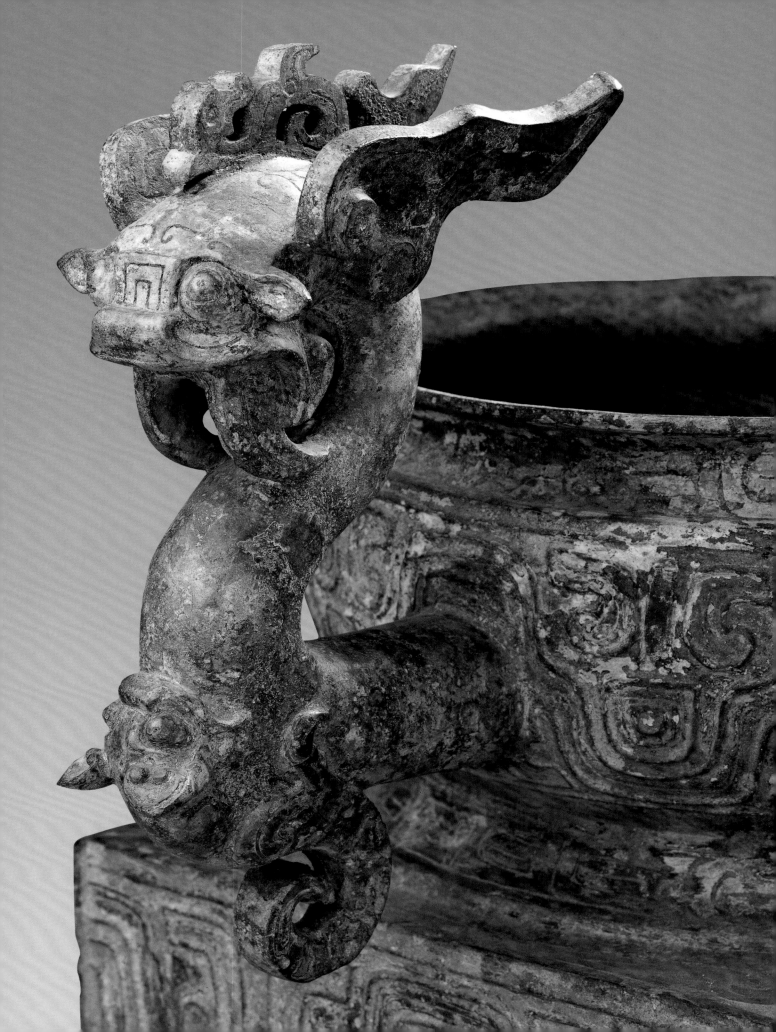

37

Pu (Food Container) Made by the Grand Minister of Education of the State of Lu

Spring and Autumn Period

Overall height 28.3 cm
Diameter of mouth 25.5 cm

This container is in the shape of a *dou*. It has a shallow tray with a lid. The top of the lid is decorated with lotus petals. The lid, belly, and foot are adorned with coiling serpents, and the foot has carved holes. There is an identical inscription of 25 characters in four lines on the body and lid, which records the maker of this vessel praying for longevity.

The container was named "*pu*," which should be an alias of the *dou*. Based on the design, decoration, and contents of the inscription, this container is a utensil of the State of Lu in the Spring and Autumn period. It is said that this container was unearthed from Linqian Village, Qufu City in Shandong Province in 1932.

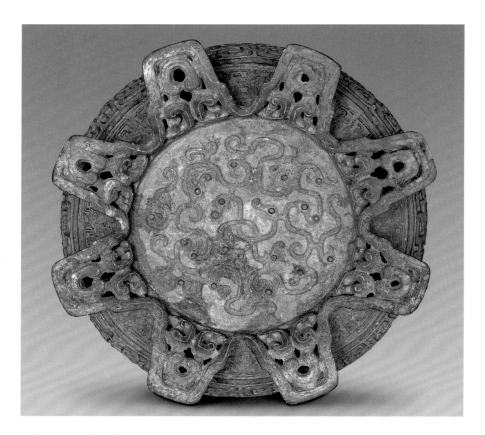

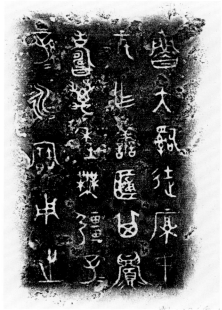 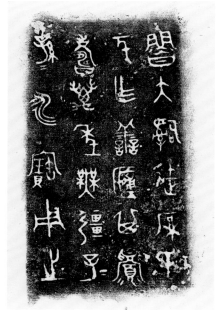

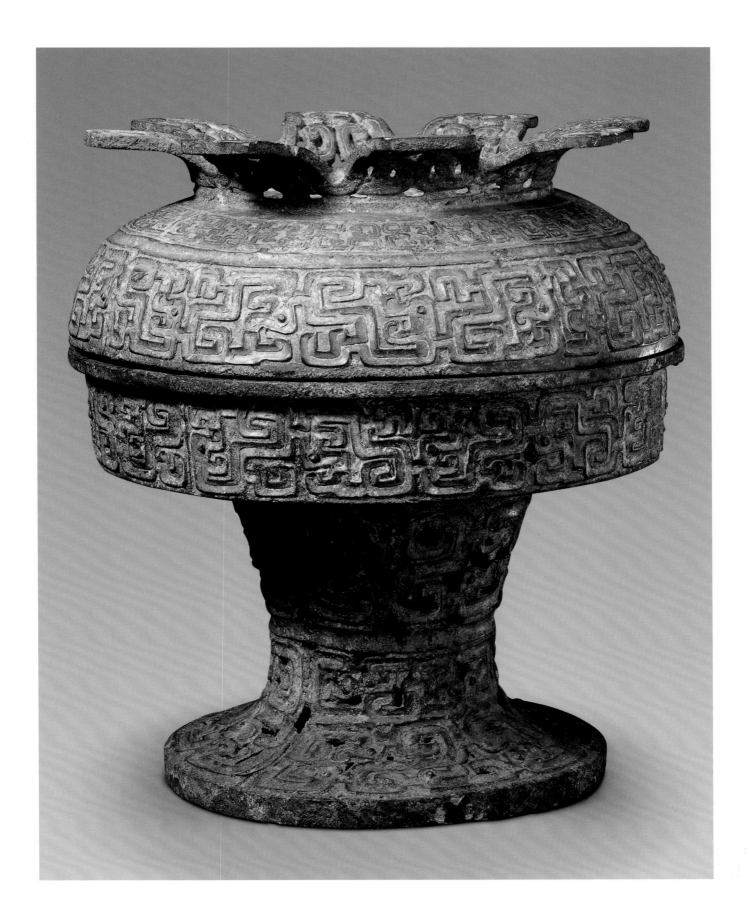

38

Dou (Food Container)
with Design of a Hunting Scene in Copper Inlay

Spring and Autumn Period

Overall height 21.4 cm
Diameter of mouth 18.5 cm
Qing court collection

This container is hemispheric in shape. It has a deep belly, a narrow mouth, ring-shaped handles, and a long-stem ring foot. The belly is decorated with red copper inlays of a hunting scene with a rich and lively depiction of the people and animals. The foot is decorated with birds and animals.

The skill of inlaying red copper is to cast on the body of the utensil a pattern groove, inlay the forged red copper into the groove, and then grind it to complete the process. This skill, which began in the Shang Dynasty, was popular in the Spring and Autumn period. The use of inlay skills enriched the methods of decorating bronzeware and reflected advances in bronze craftsmanship.

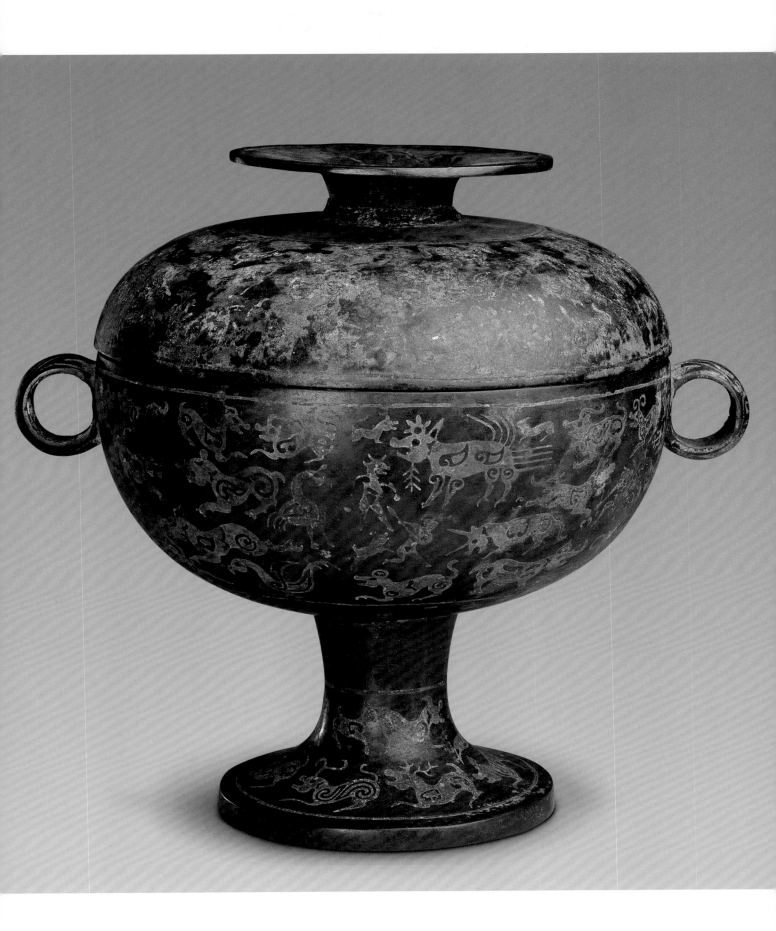

39

Qiao *Ding*
(Cooking Vessel)
Made by Yin Ken, King of Chu
Warring States Period

Overall height 59.7 cm
Diameter of mouth 46.6 cm

This vessel has a round body, a vertical mouth, a square lip, two upright handles, a deep belly, and three hoof-shaped legs with the upper part decorated with animal masks in relief. It has a lid, and the centre of the lid top has a pair of animal heads holding rings in their mouths (the rings are lost). The sides of the rings have three buttons decorated with vertical lines. The entire body is adorned with cloud and thunder patterns, the surface of the lid, with two bands of protruded bowstrings, and the belly, with a band of protruding bowstrings. The mouth rim has an inscription of 12 characters, recording that the maker of this vessel was Yin Ken. The top of the lid is engraved with four characters, and the interior, three characters.

Yin Ken was Xiong Yuan, King Kaolie of the State of Chu in the Warring States period. He ruled the state from 262 BC to 238 BC. This vessel is huge in size and skilfully cast. Its patterns and inscription have the characteristics of the Warring States period. Its inscription has great value in research on the heritage and sacrificial systems of the State of Chu. This vessel was unearthed in 1933 in Lisangudui, Zhujiaji Village in Shou County, Anhui Province.

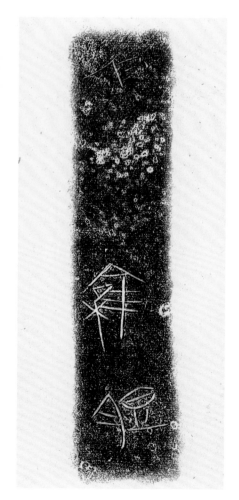

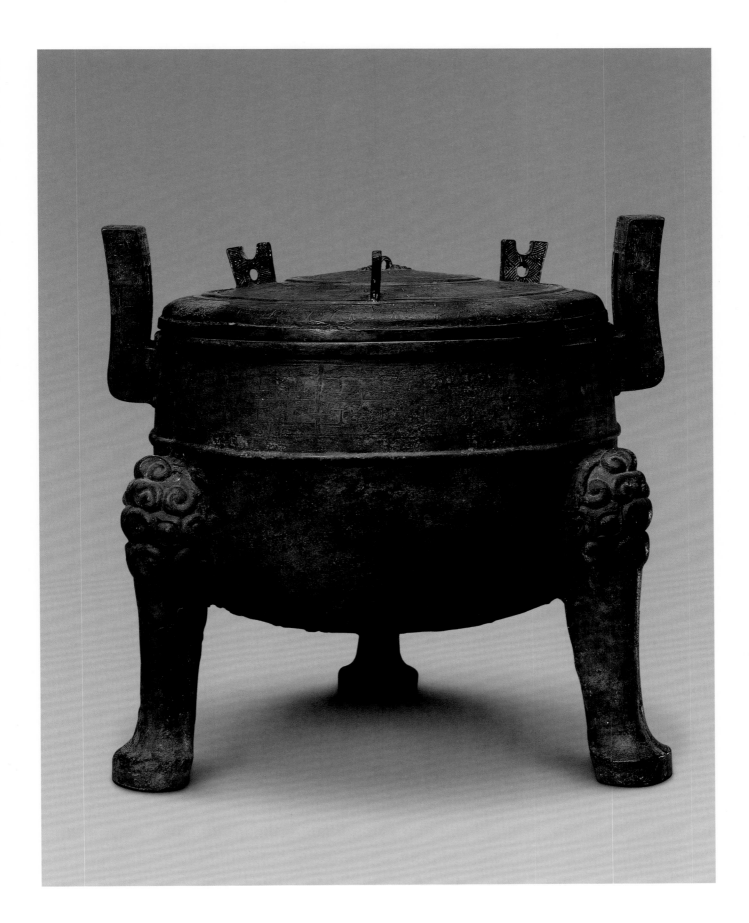

40

Ding (Cooking Vessel)
with Posy Design

Warring States Period

Overall height 18.2 cm
Width 25.8 cm
Diameter of mouth 17.9 cm
Qing court collection

This vessel has a round body, two upright hands, and three hoof-shaped legs. It has a lid, on which are three buttons with sacrificial animals. The middle of the lid top is decorated with whorls and surrounded by seven posies. The edge of the lid has a band of whorls, separated by a band of thunder patterns, and the whorls have cord patterns as the boundary. The belly is decorated with two bands of clouds, separated by two bands of posy whorls, and the front sides of the handles are decorated with clouds.

The motif of this vessel is the posies that became popular in the Warring States period. This pattern is lively and beautiful with a breath of freshness.

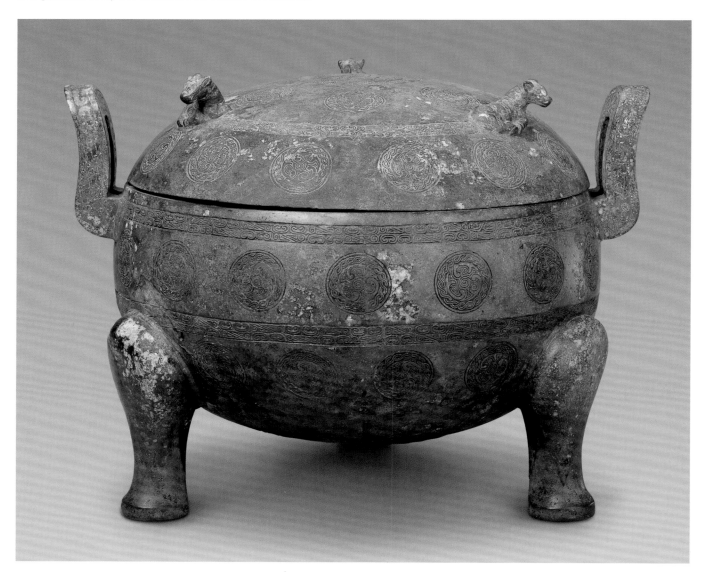

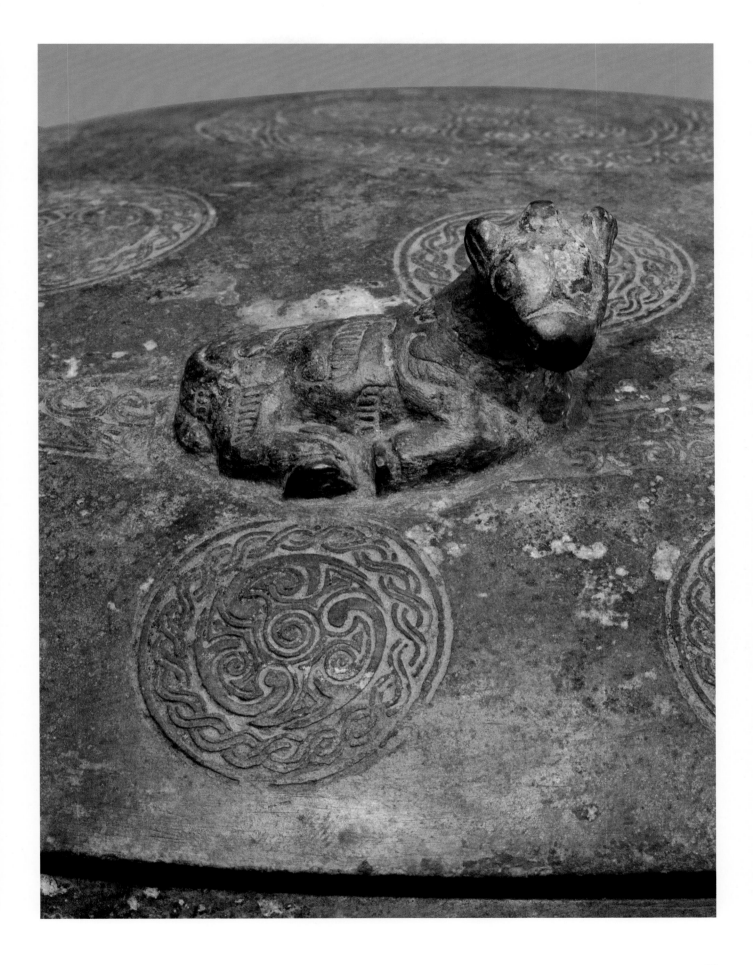

41

Fu (Food Container)
Made by Yin Ken, King of Chu
Warring States Period

Overall height 11.7 cm
Diameter of mouth 31.8 × 21.7 cm

This container is rectangular in shape. It has a vertical mouth with an inward rim, a flat base, and four feet in the shape of a rectangle. The belly is decorated with clouds and geometric design. One side of the mouth rim has an of inscription of 12 characters, and the exterior base has two characters.

The Palace Museum has in its collection three food containers made by Yin Ken, King of the State of Chu. The inscriptions on the mouth rims are the same, while those on the exterior bases are different. Inscriptions provide important information for the study of the sacrificial system and Chinese characters of Chu. This container was unearthed from in Lisangudui, Zhujiaji Village in Shou County, Anhui Province.

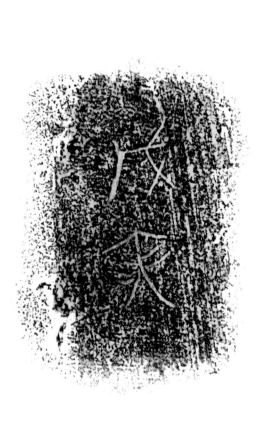

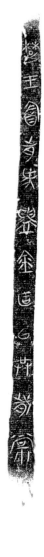

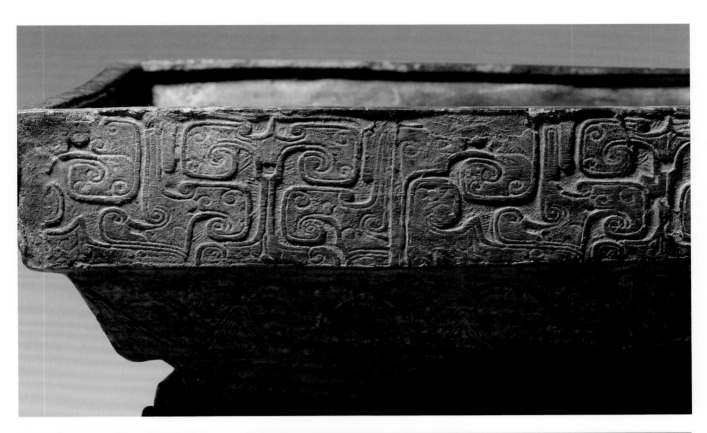

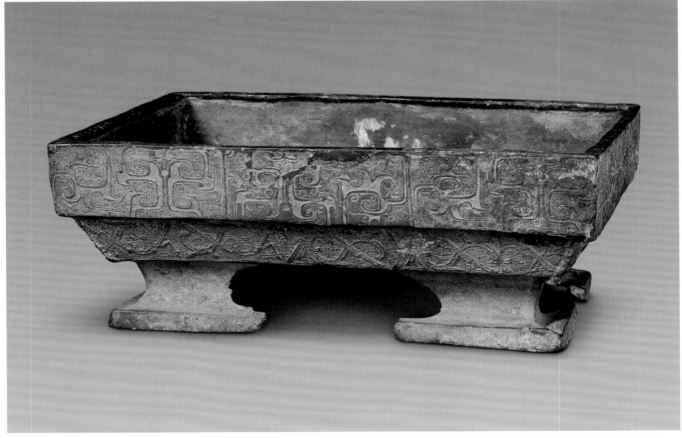

42

Dou (Food Container)
with Interlaced Hydras Design of Turquoise Inlay
Warring States Period

Overall height 39 cm
Diameter of mouth 20 cm

This food container has a round body, two ring handles, a shallow belly, a round lid with a round handle on it, and a bell-shaped foot with a contracted waist and a high stem. The decoration of the entire container is inlaid with turquoise. The belly and lid edge are decorated with coiling serpents and banana leaves, the handle has a band of coiling serpents, a band of saw teeth, two bands of lozenges, separated by a band of cords. The handles are decorated with saw teeth, the foot, with clouds and thunder, and coiling serpents.

This container was made in the State of Yan in the Warring States period. Its shape is tall and slim, its form is elegant, its decoration is elaborate and refined, and its craftsmanship is superb. This container provides excellent information for studying the bronze workmanship of the State of Yan. Yan was one of the vassal states in the early Western Zhou Dynasty and its people surnamed Ji. Its territory covered the northern part of the present-day Hebei Province and the western part of present-day Liaoning Province and Beijing.

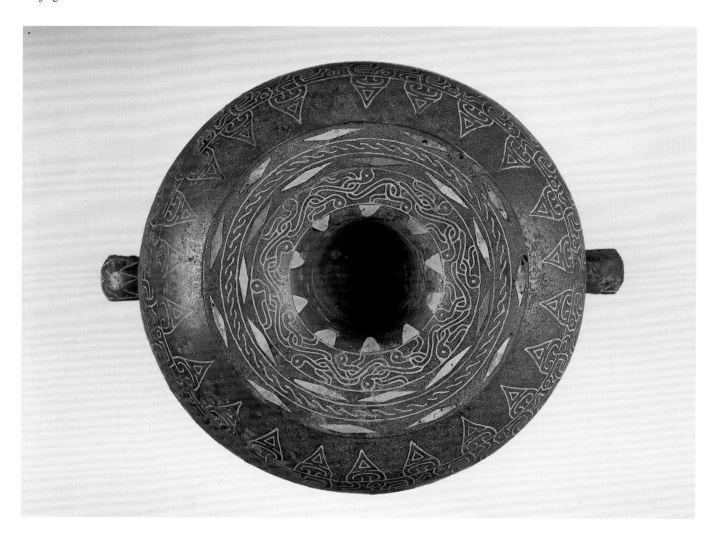

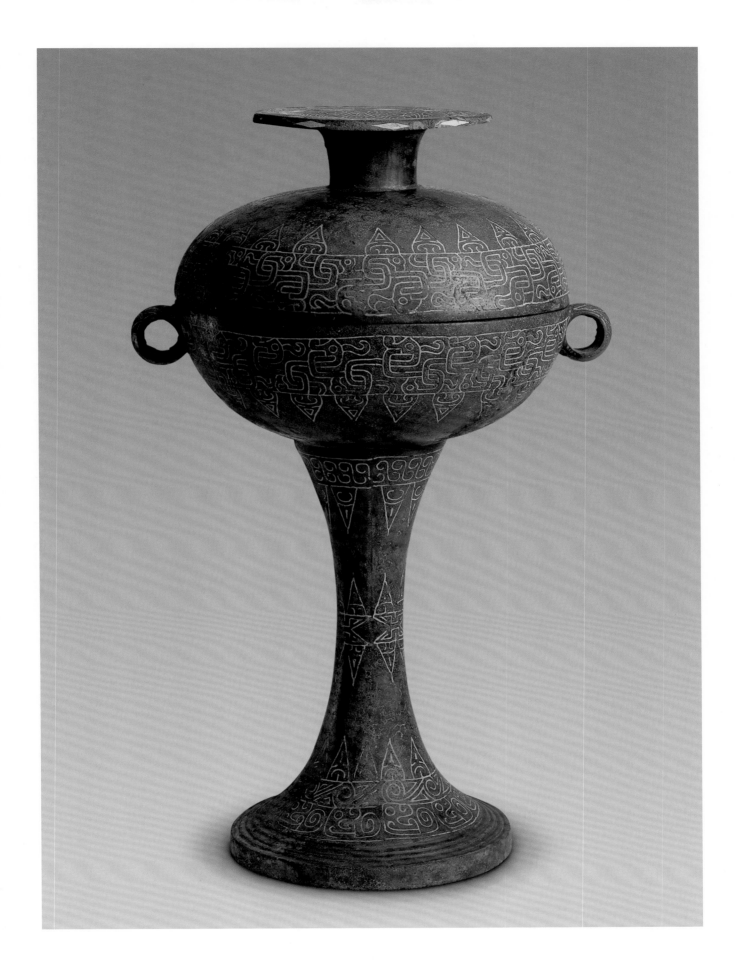

THE RITUAL AND MUSICAL BRONZEWARE

VESSELS FOR WINE

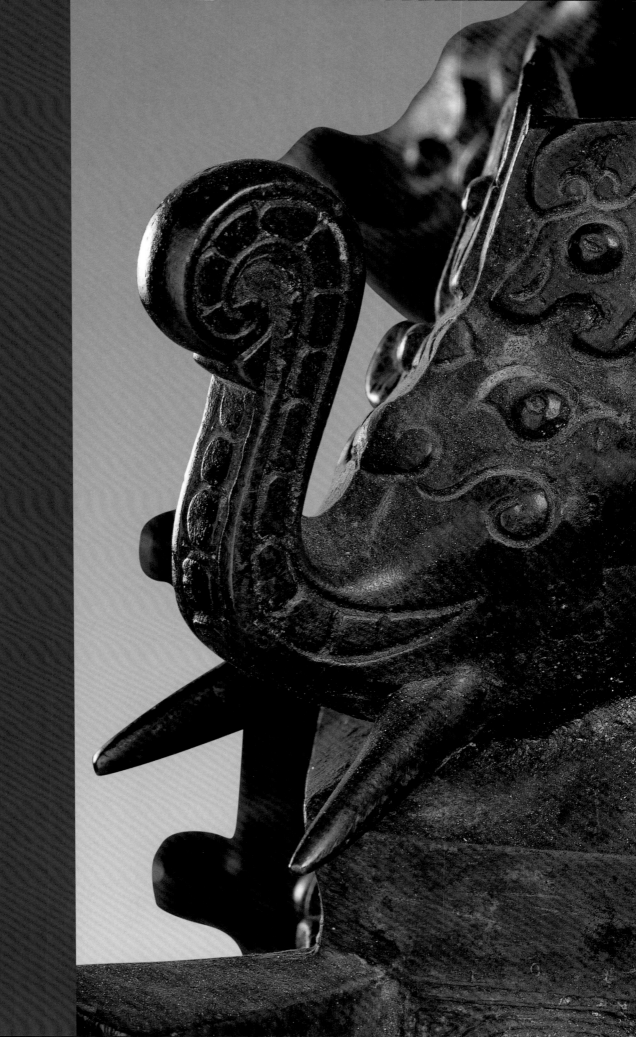

43

Jue (Wine Vessel)
with Animal Mask Design

Early Shang Dynasty

Overall height 16.1 cm
Width 14.8 cm

This wine vessel has a round belly, three conical legs, a spout in the front, and a tail at the back. It has a wide flared mouth with two small columns on its two sides. It has a flat base. The front and back of the belly are each decorated with an animal mask.

Jue, a wine vessel, has a thin wall, a narrow spout, a flat base, and short columns. It has all the typical features of wine vessels in the early Shang Dynasty.

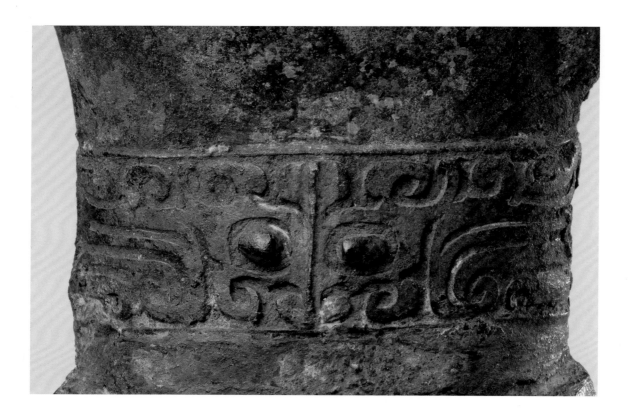

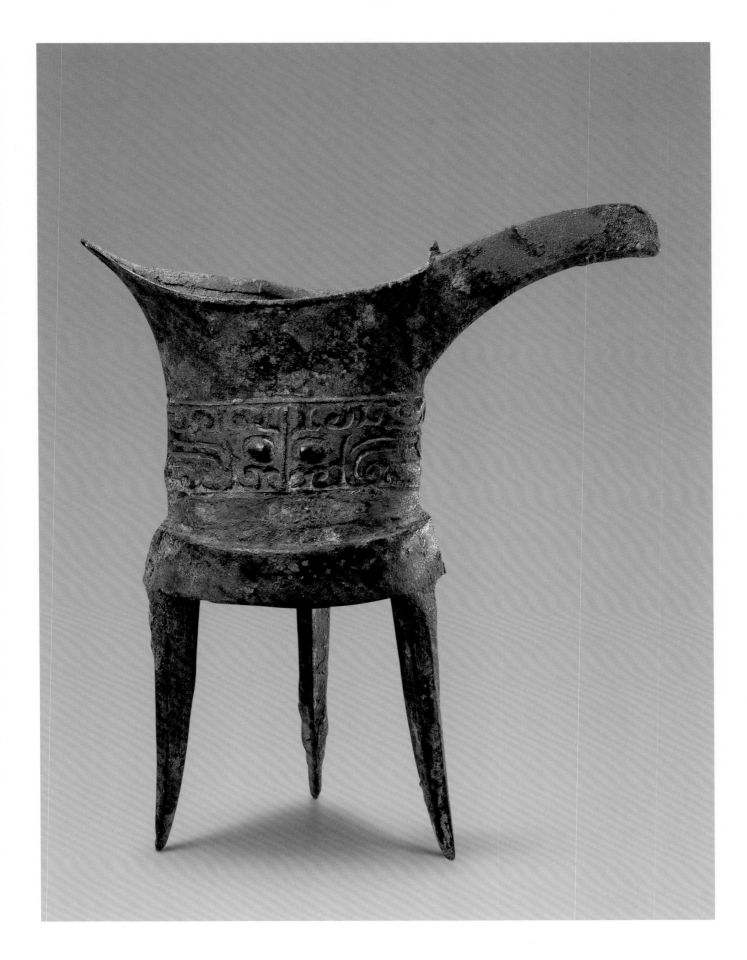

44

Jiao (Wine Vessel) with Inscription "Ning"

Shang Dynasty

Overall height 21.4 cm
Diameter of mouth 16.5 × 8.4 cm
Qing court collection

This wine vessel has a long and round belly, a round base, and a single handle. It has a pointed spout and a pointed tail. It has pointed splay legs in the shape of a triangle. The belly is decorated with animal masks, the spout, tail, and exterior wall are decorated with banana leaves. The interior of the handle is inscribed with the character *ning*.

This *jiao* vessel, a wine receptable, is much smaller in number than that of other wine vessels such as *jue* and *jia*. The earliest bronze *jiao* was found during the period of Erlitou culture. This *jiao* has elegant modelling and exquisite decorations, making it a beautiful work of art and a rare treasure.

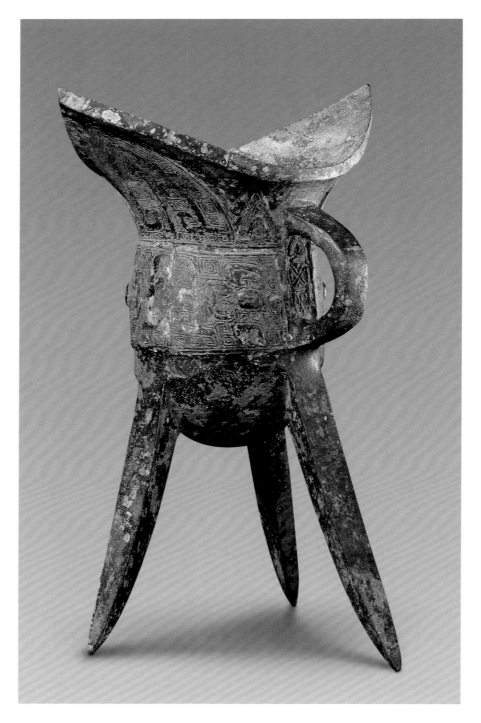

45

Rectangular *Jia* (Wine Vessel) with Inscription "Ce"

Shang Dynasty

Overall height 28.5 cm
Diameter of mouth 13.3 × 11 cm

This cooking vessel has a square body, round corners, four triangular splay legs, a handle with animal masks, two square prism pillars, and a flat lid with a button, which is formed by two birds connecting to each other, on its top. The lid and belly are decorated with animal masks, the neck and feet, with banana leaves, the columns, banana leaves and thunder. The interior base has an inscription of the character *ce*.

Jia is a wine vessel. But rectangular *jia* is quite rare. The entire body of this vessel has elaborate, skilful, and beautiful decorations, representative of bronze wine vessels in the Shang Dynasty.

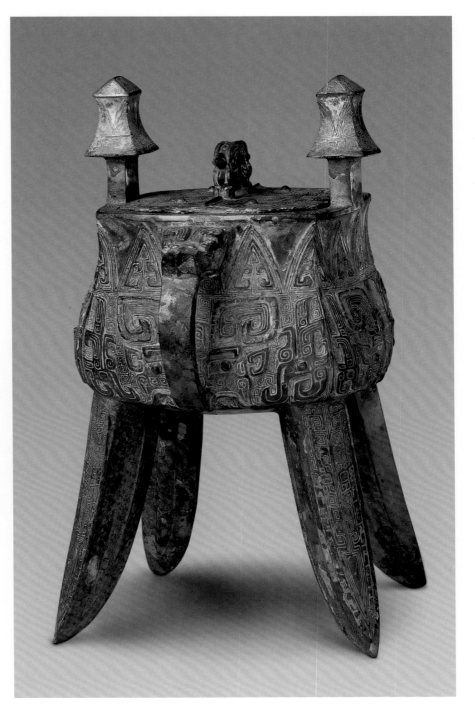

46
Jia (Wine Vessel)
with Animal Mask Design
Early Shang Dynasty

Overall height 34 cm
Diameter of mouth 23 cm

This vessel has a wide flared mouth, a contracted waist, three hollowed legs, two columns, and a handle. The belly and feet are decorated with animal masks, and the pillar tops, whorls.

This vessel, with its classic and simple style and exquisite decorations, is a fine example from the early Shang Dynasty.

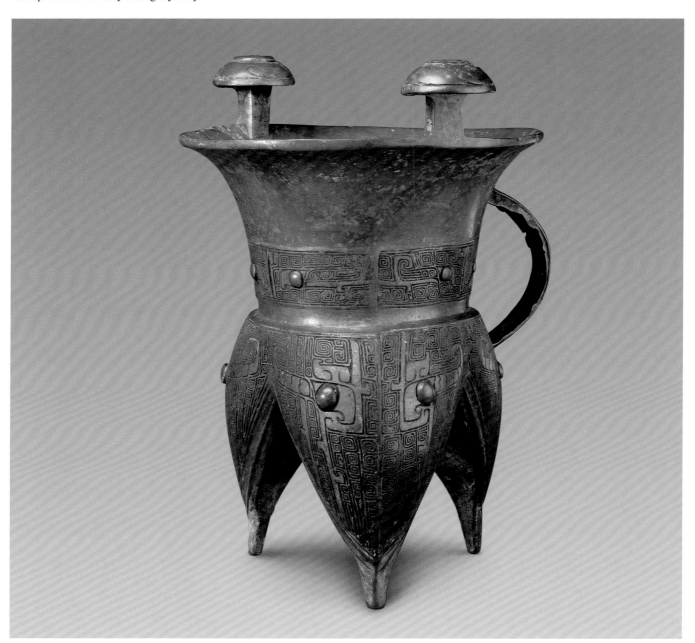

47

Gu (Wine Vessel) with Inscription "Shou"

Late Shang Dynasty

Overall height 26.4 cm
Diameter of mouth 14.8 cm

This vessel has a flared mouth, a contracted waist with flanges, and a ring foot. The neck is decorated with banana leaves, the belly, with animal masks, and the splay foot, with openwork carved animal masks. The interior wall of the foot is inscribed with the character *shou*.

Gu, a wine vessel, and *jue* make up the most basic composition, which was first seen in the early Shang Dynasty. This vessel is elegantly shaped and its foot is decorated with openwork carved animal masks, which is quite rare, making it an excellent example of bronzeware from the late Shang Dynasty.

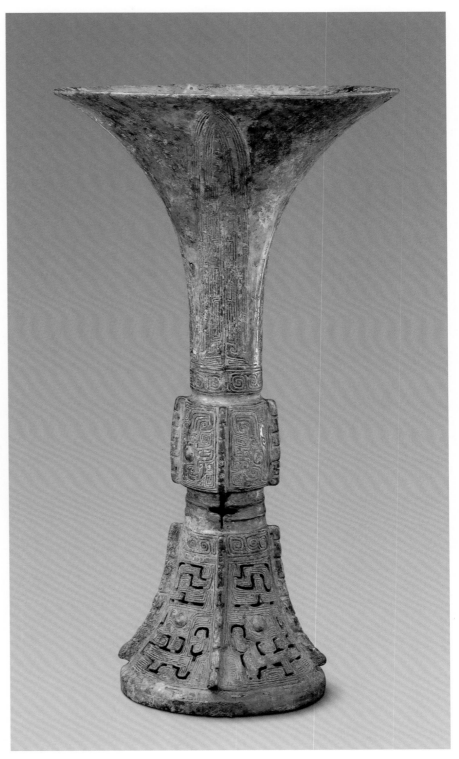

48

Zhi (Wine Vessel) with Inscription "Shan Fu"

Late Shang Dynasty

Overall height 17.5 cm
Diameter of mouth 8.6 cm
Qing court collection

This vessel has a wide flared mouth, a contracted neck, a bulging belly, and a ring foot. It has a round lid with a columnar handle on its top. The rim of the lid is decorated with thunder patterns and the neck and foot, with *kui*-dragons. The interior is inscribed with the two characters *shan fu*.

Zhi is a wine vessel. During feasting, the seniors hold the *zhi* vessel and the subordinates, the *jiao* vessel. Bronze *zhi* was popular from the late Shang to the early Western Zhou dynasties.

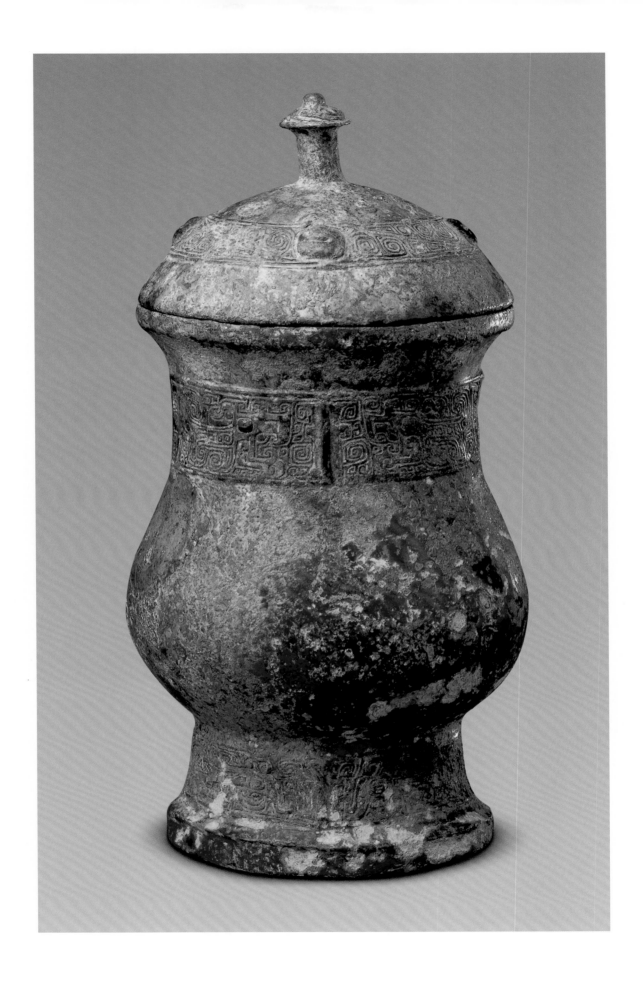

49

Zun (Wine Vessel)
with Three Ram Heads on Its Shoulders

Shang Dynasty

Overall height 52 cm
Diameter of mouth 41 cm

This vessel has a *pan*-shaped mouth, a contracted neck, a shrugged shoulder, a belly that narrows downward, and a high ring foot. The shoulder is cast with three ram heads with exquisite workmanship and a vigorous and magnificent style. The belly is decorated with extremely distorted *taotie* patterns, creating a quaint and ferocious feeling.

This wine vessel *zun* was popular from the Shang to the Western Zhou dynasties. This vessel is elegant, dignified, and made with exquisite workmanship, and is a treasure among bronzeware of the Shang Dynasty. The decorations of this vessel are relatively sparse and its foot has cross-shaped openwork carved holes, which is a characteristic of the bronzeware of the late Shang Dynasty. The body and ram heads were cast separately. The body was cast first, and holes were reserved on the shoulder for the ram heads, and then the pottery-moulds of the ram heads and the body of the vessel were cast together. This shows that the method of separate casting had already appeared by the time of the Shang Dynasty.

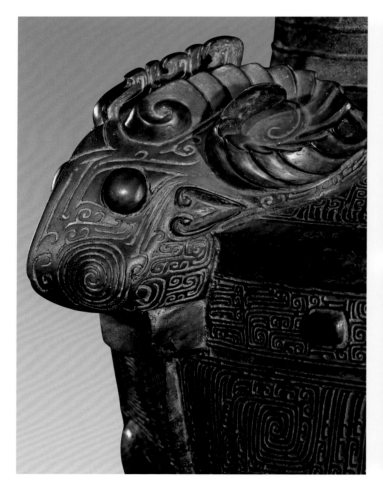

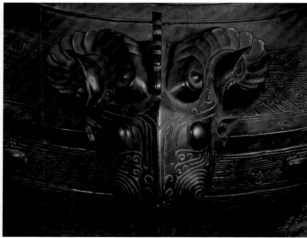

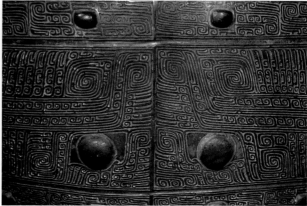

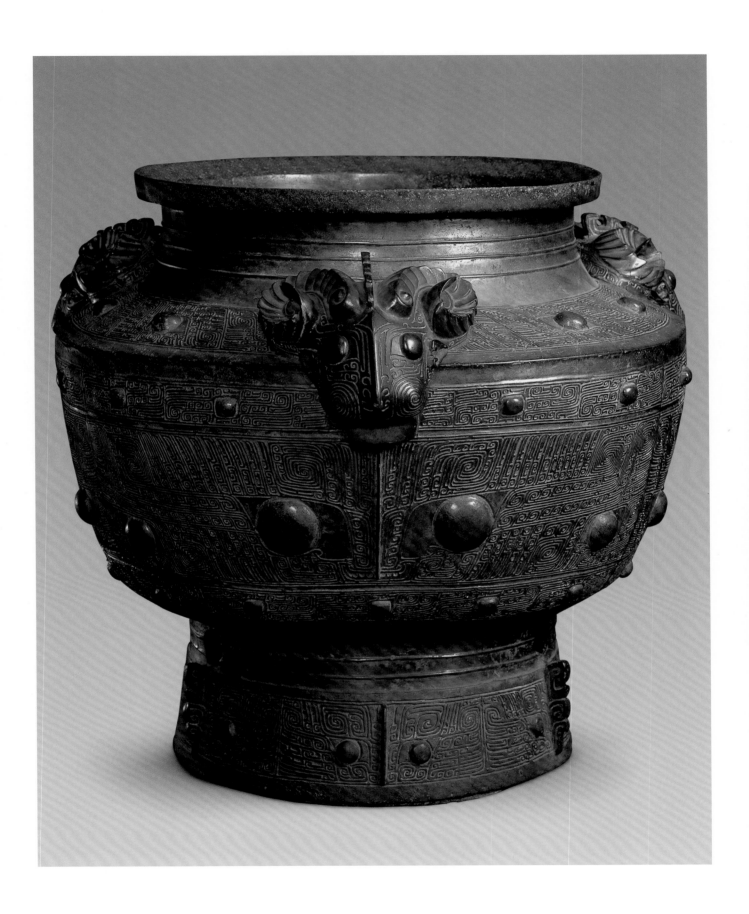

50

Rectangular *Zun* (Wine Vessel)
Made by Xuya Clan
to Worship Ancestors

Late Shang Dynasty

Overall height 45.7 cm
Diameter of mouth 33.6 × 33.4 cm
Qing court collection

This vessel is rectangular in shape. It has a wide and flared mouth, a foot, a bulging belly with flanges. The four corners of the shoulder are decorated with four carved elephants' heads with their trunks raised and teeth bared. The spaces existing between the four elephant heads are decorated with animal heads, whose horns are in the shape of a petal. The neck is adorned with *kui*-dragons and the belly and foot, with *kui*-dragons and animal masks. The interior wall close to the mouth has an inscription of nine characters in two lines, recording that this vessel was made by the Xuya clan as a sacrificial utensil for their ancestors and royal princes.

The shape of this vessel is majestic, its workmanship is exquisite, and its decorations are grand and beautiful. The combination of the realistic elephants' heads and the exaggerated animal heads add mystery to this sacrificial vessel. This vessel was first in the collection of the Summer Palace. It was transferred to the Palace Museum by the State Bureau of Cultural Relics in 1951.

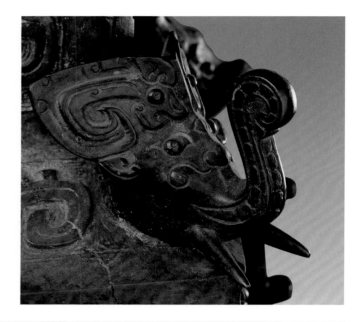

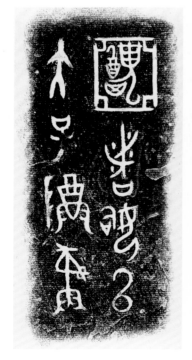

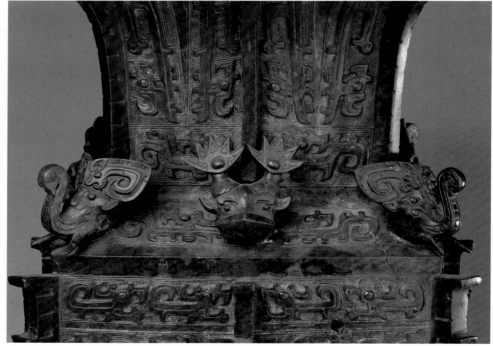

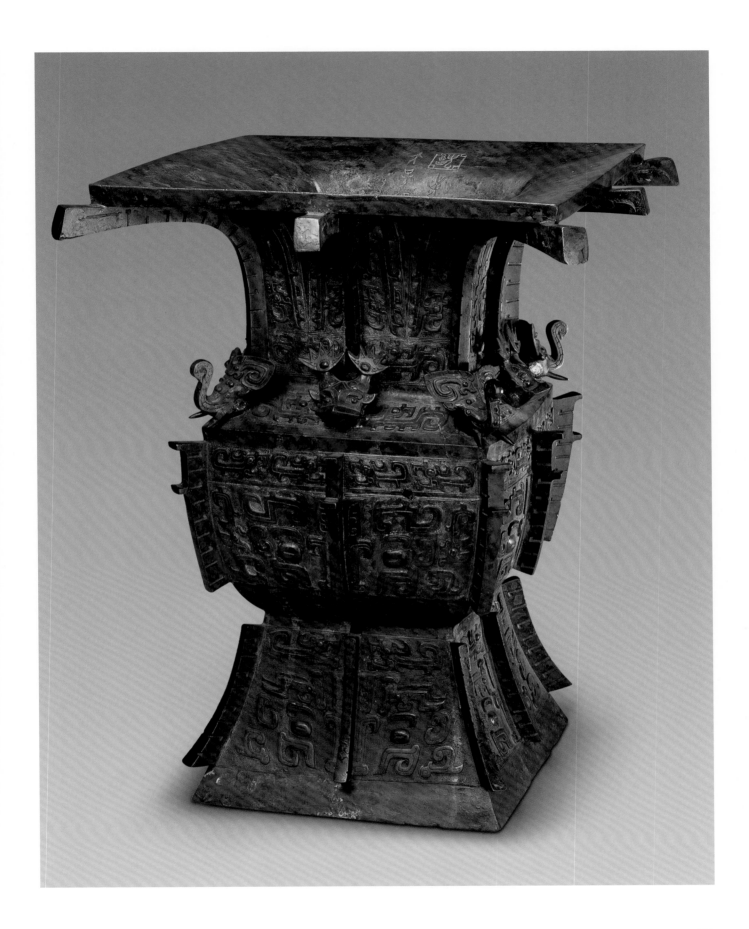

51

Zun (Wine Vessel)
with Inscription "You"

Late Shang Dynasty

Overall height 13.2 cm
Diameter of mouth 20.7 cm

This vessel has a wide flared mouth, a round belly, and a ring foot. The neck is decorated with two bands of rings and chevrons, and its rim is decorated with pointed leaves. The belly has nine elephants in relief, with rectangular spirals as its background. The foot is decorated with four bands in tile pattern and three cross-shaped holes. The interior base is inscribed with the character *you*.

This *zun* vessel is also called a Nine Elephants *zun*. The shape of this vessel is low and short, with an appearance that is rarely seen. The decorations are elaborate and refined, especially the nine-elephant design, which is at once realistic and exaggerated, highlighting the skilful technique.

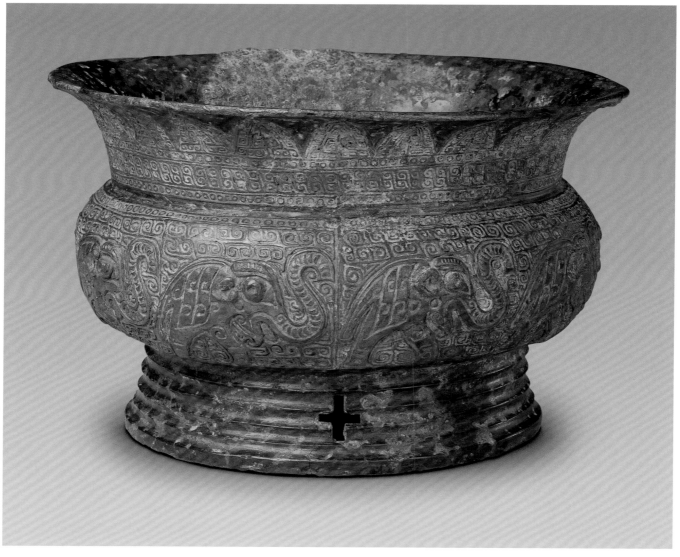

52

Rectangular *You* (Wine Vessel) with a Cross Hole

Shang Dynasty

Overall height 34.5 cm
Diameter of mouth 6.6 cm

This vessel has a flared mouth and a round lid with a standing bird button on its top and animal masks on all sides. The left side of the lid has a cicada with a raised tail curled around a hole where a chain would have linked to the loop handle. The chain is now lost. This vessel has a long neck, a loop handle whose two sides have two birds with tails curling upward to link up with the handle. It has a rectangular belly with a hole in the shape of a cross at the centre. The corners of the shoulders are decorated with four animal masks. The upper and lower parts of the hole are decorated with animal masks, and the left and right sides, eyes. It has a ring foot decorated with eye patterns.

You is a wine container. Its shape is ingenious and its decorations are articulate. This container is heavily rusted, yet the detailed patterns are still clearly distinguishable. This is representative of bronze art in the Shang Dynasty.

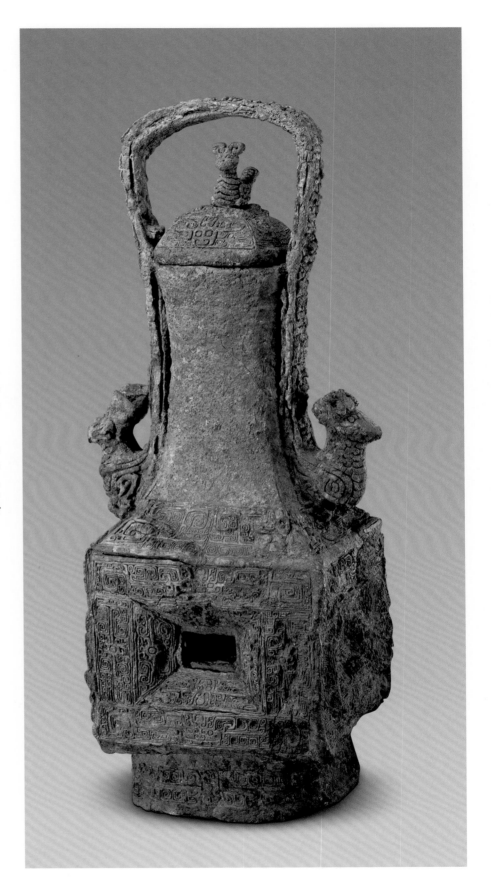

53
Lei (Wine Vessel)
Made by Jue to Worship Zu Jia

Shang Dynasty

Overall height 41.8 cm
Diameter of mouth 17.9 cm

This vessel has a tray-shaped mouth, a short neck, broad shoulders, a round foot, a belly that narrows downward, and a ring foot. The shoulders have two ears with animals holding rings. The lower part of the belly has a nose in the shape of an animal head, the neck, two bands of bowstrings, and the shoulder, rectangular spirals. Inside the mouth, there is an inscription of 17 characters.

The appearance of this vessel is simple and elegant. As it is rare to have an inscription that is self-titled *lei*, it has certain value for studying the shape of vessels of the Shang Dynasty.

 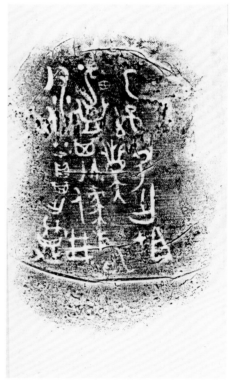

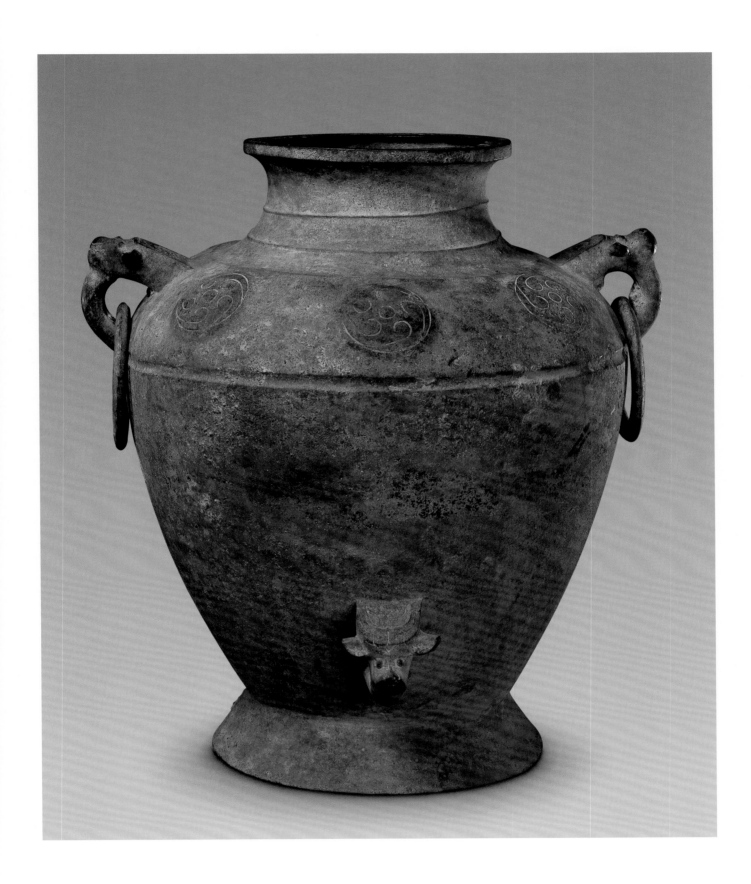

54
You (Wine Vessel)
Made by Yu to Worship Zu Ding
Shang Dynasty

Overall height 23.7 cm
Diameter of mouth 11.6 × 8.4 cm

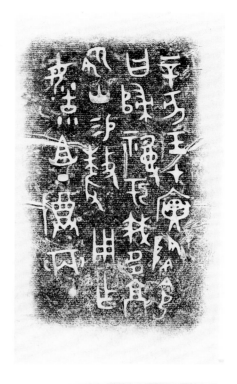

This container has a vertical mouth, a long neck, a flat round belly that droops, and a high ring foot. It has a lid with a ruined button on top. The neck has ring ears. It has a loop handle. The neck has a band of *kui*-dragons with their heads turning back. The interior of the vessel and under the lid have identical 25-character inscriptions in four lines. The inscriptions record an emperor of the Shang Dynasty offering wine and meat to his ancestors at his temporary imperial residence and receiving blessings from the gods. He therefore made this *you* container to commemorate this event.

The inscription of this *you* container is comparatively long, which is rare for bronzeware of the Shang Dynasty, and this provides important information for studying the sacrificial and honorific systems of the time.

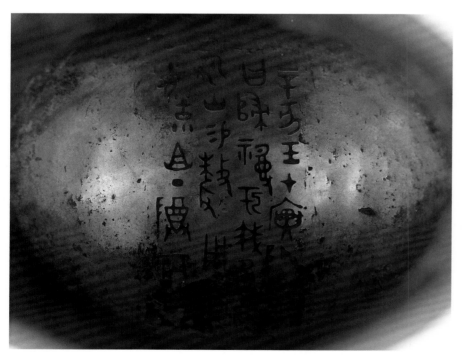

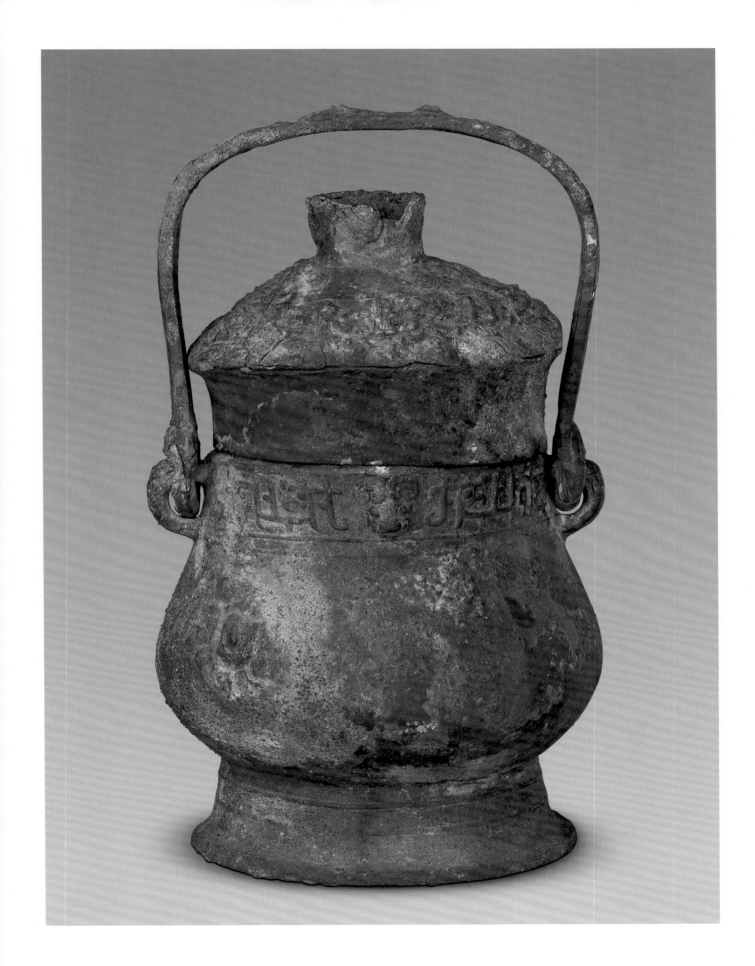

55

Owl-shaped *You* (Wine Vessel) with Inscription "Fu Bei"

Shang Dynasty

Overall height 17.1 cm
Diameter of mouth 11 × 8.1 cm
Qing court collection

This vessel is in the shape of an owl. It has a wide flared mouth, a contracted neck, a huge belly, and four animal-shaped feet. It has a round lid decorated with owl-heads and the button on its top is mushroom-shaped and decorated with rectangular spirals. The neck has two protruding heads of sacrificial animals. The belly has patterns of birds' wings. The lid and body are both identically inscribed with the two characters *fu bei*, in which *fu* means a quiver and *bei* means a clan emblem.

Most of the wine vessels in the Shang Dynasty are animal-shaped, such as owls, pigs, or of tigers embracing a person, which reflects the special aesthetic taste of people in the Shang Dynasty. This vessel is thick, heavy, and ingenious in appearance, and stands out among other bronze vessels of that time.

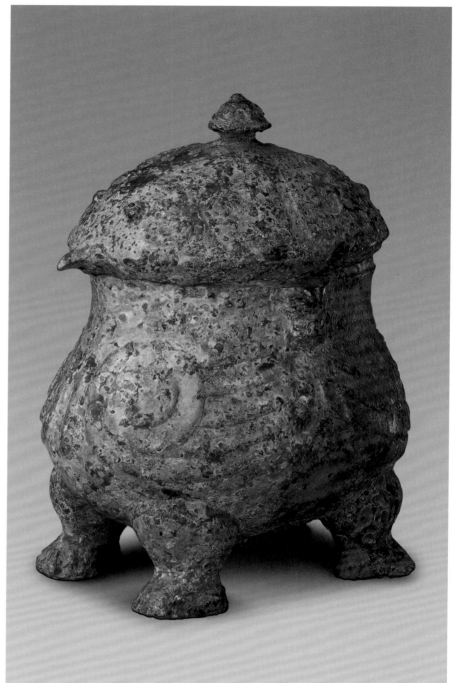

56

Si *Gong* (Wine Vessel) with Animal Mask Design

Shang Dynasty

Overall height 15 cm
Width 20 cm

This vessel has a wide, flared mouth in the shape of a cone, an upturned spout, a bulging belly, a high ring foot, and a handle with an animal head. The spout has birds with long tails. The mouth is decorated with *kui*-dragons, the belly, with animal masks, and the ring foot, with *kui*-dragons.

Gong is a wine container popular from the late Yin Ruins period to the early Western Zhou Dynasty. This vessel is thick and heavy in appearance and is exquisitely decorated. It has the typical features of a wine container of the Shang Dynasty.

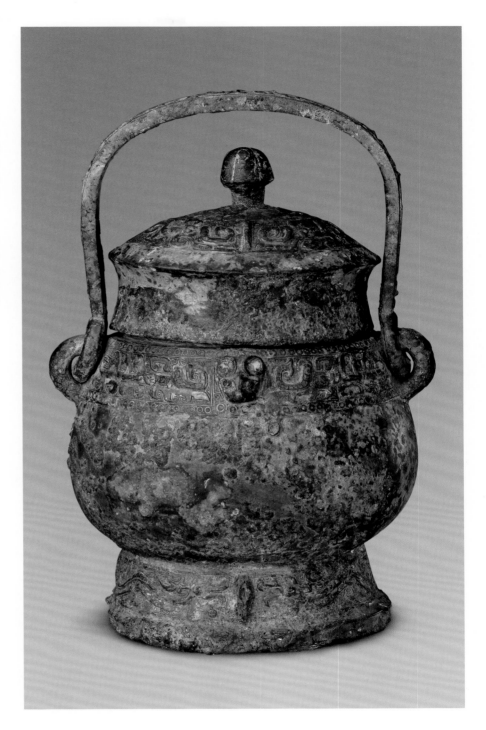

57

You (Wine Vessel)
Made for Sacrifice
by Yi Qi
in the Fourth Year of
Dixin's Reign

Late Shang Dynasty

Overall height 32 cm Width 19.7 cm
Diameter of mouth 8.8 cm

This vessel has a vertical mouth, a long neck, a conical belly, and a ring foot. The neck has a loop handle cast with rhinoceros heads. It has a lid and a columnar button on its top. The neck is decorated with a band of animal masks. The foot has two bands of round rings, separated by rhombuses. The interiors of the lid and body have an identical inscriptions. The exterior has an inscription of 42 characters in eight lines, which is about the king of the Shang Dynasty offering sacrifices to his ancestor King Yi, having a feast for his officials, and giving them shells as gifts.

This vessel was cast in the fourth year of Dixin's reign and is typical of bronzeware of the late Shang Dynasty. The inscription, which has 42 characters, is the longest extant bronze inscription from this period. It provides important information on sacrifices and social life at that time.

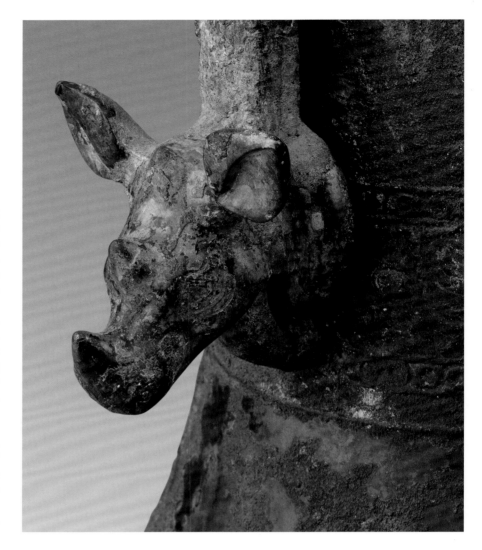

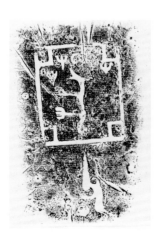

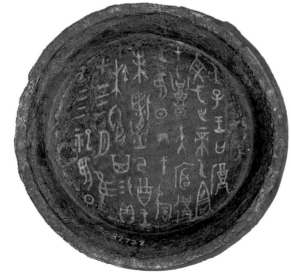

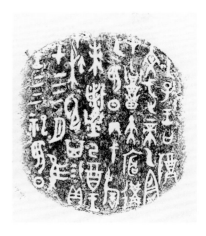

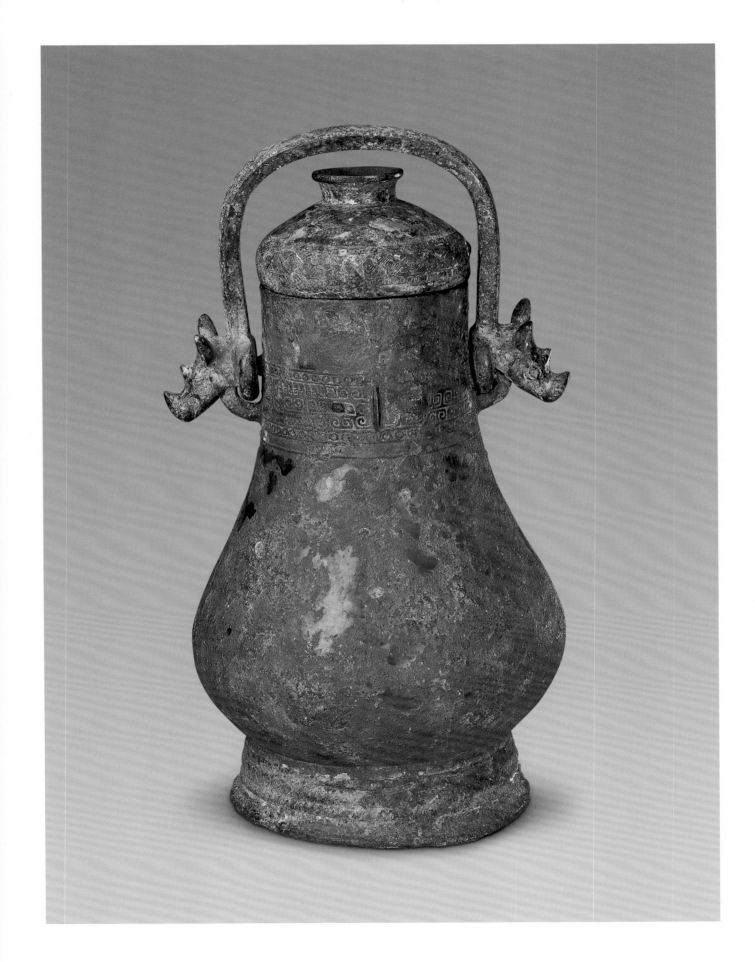

58

You (Wine Vessel)
with Ox Design

Shang Dynasty

Overall height 29.5 cm
Diameter of mouth 14.3 × 11 cm

This vessel has a vertical mouth, a bulging belly, a high ring foot, a loop handle with animal heads, a lid, and a dragon-shaped button. The body of the lid and the neck of the vessel are decorated with oxen while the rim of the lid is decorated with double-body dragons. The belly has four protruding pyramids, separated by four-eye patterns. The foot and handle have double-body dragon patterns.

The shape and decorations of this vessel is unique, which is seldom seen in bronzeware of the period.

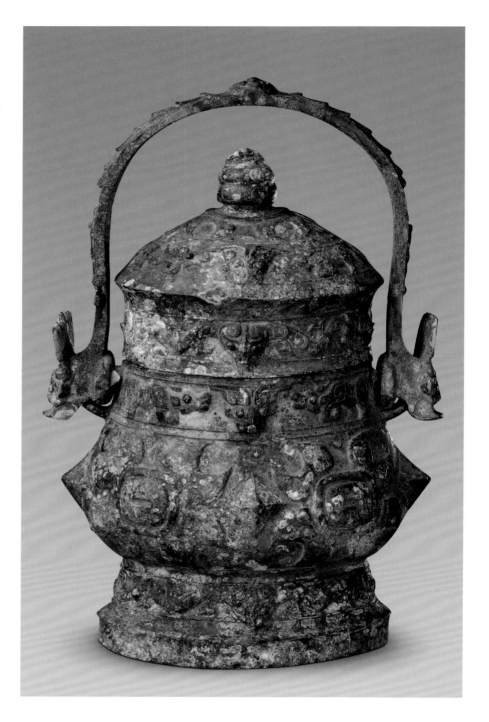

59

Hu (Wine Vessel) with Inscription "Shi"

Late Shang Dynasty

Overall height 35 cm
Diameter of mouth 18.9 × 14.4 cm
Qing court collection

This piece has a wide, flared mouth, a long neck, pierced ears, a bulging and drooping belly, and a ring foot. The mouth rim, neck, and belly have a *taotie* design. Between the *taotie* designs of the neck and belly is a band of clouds and thunder and *kui*-dragons in various shapes. The pierced handles are decorated with animal masks. The interior base is inscribed with the character *shi*, which is probably a clan emblem.

Hu is a wine container that was popular in the Shang Dynasty. The shape of this container remained unchanged until the Han Dynasty. This piece has the shape typical of the late Shang Dynasty.

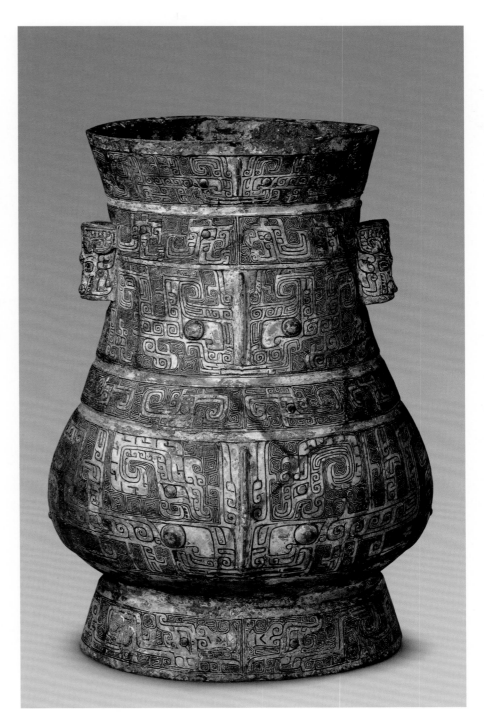

60

He (Wine Vessel)
with Bowstring Pattern

Early Shang Dynasty

Overall height 21.2 cm
Diameter of mouth 4.5 cm
Qing court collection

This vessel has a deep belly, a round drum top, and a tube-shaped spout. It is tri-lobbed and has four pouched legs, and a handle. The upper part of the belly is decorated with three bands of bowstrings.

The vessel is a wine-mixer for adjusting the density of wine. Its shape shows that it comes from the early Shang period.

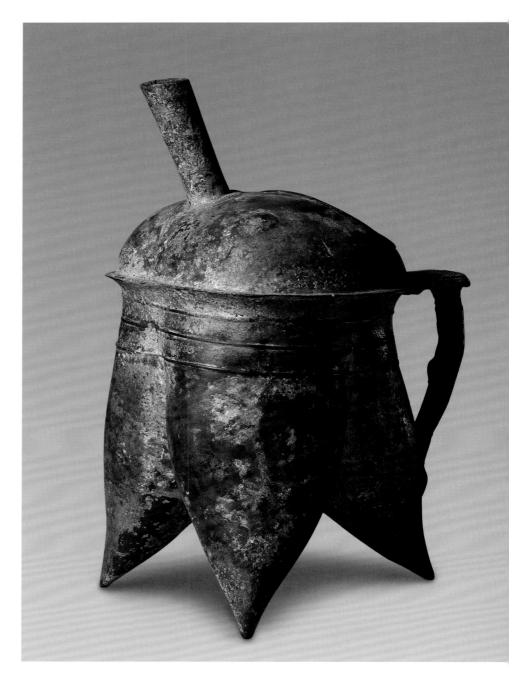

61

A Pair of *Jue* (Wine Vessel) with Bird Design

Early Western Zhou Dynasty

Overall height 22 cm
Diameter of mouth 17.4 × 7.5 cm
Qing court collection

This pair of wine vessels have the same size and shape. They have a deep belly, a round bottom, two cap-topped columns on two sides of the mouth rim, a long spout, a pointed tail, a handle shaped in animal head, and three splay pointed feet. The belly and the lower part of the spout are decorated with birds, with thunder patterns as the background.

During the early Western Zhou period, the number of *jue* dwindled enormously, and pairs of *jue* are extremely rare. These two pieces are skilfully cast and beautifully decorated. The symmetrical birds with long tails and high coronets on the left and right sides are typical of the style in the early Western Zhou period.

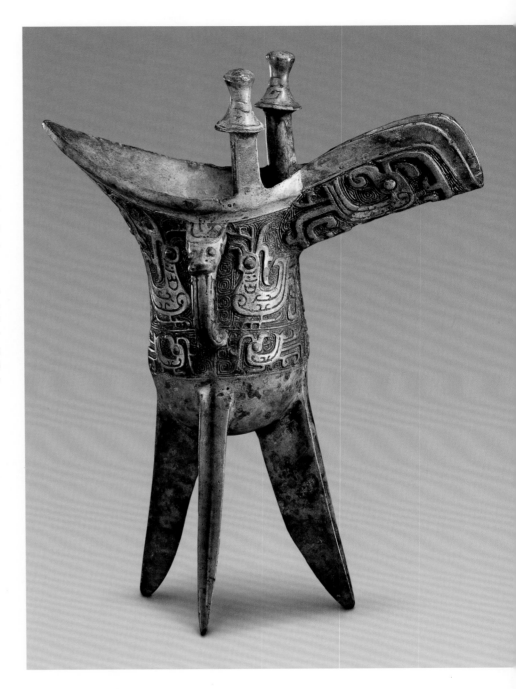

62

Zhi (Wine Vessel)
with Phoenix Design

Early Western Zhou Dynasty

Overall height 14.5 cm
Diameter of mouth 8.3 cm
Qing court collection

This wine vessel has a wide, flared mouth. Its deep belly is in the shape of a tube with its lower part bulging. It has a ring foot. The body of this vessel is decorated with three bands of phoenixes which are separated by protruding bowstrings.

Zhi was popular in the late Shang and early Western Zhou dynasties, but was rarely seen after the middle Western Zhou Dynasty. The phoenix design was a popular style in the early Western Zhou period. The three bands of phoenixes clearly stand out, giving a strong three-dimensional perspective, which is rarely seen.

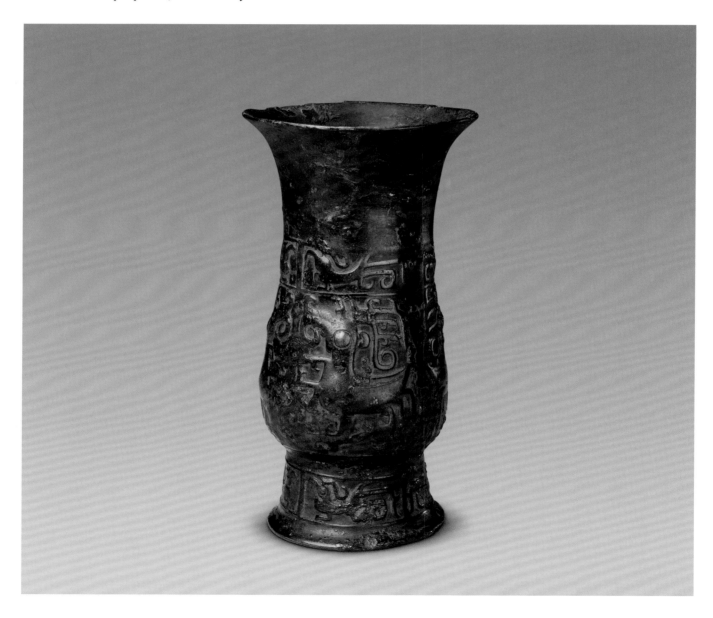

63

He (Wine Vessel)
Made by Lai Fu

Early Western Zhou Dynasty

Overall height 21.5 cm
Diameter of mouth 13.5 cm

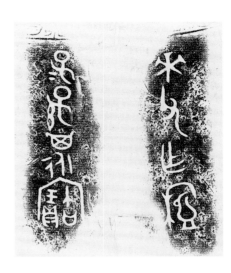

This vessel has a tri-lobed low body. It has a contracted neck, a wide and flared mouth, a square lid, a small long spout, and a handle with an animal head. It has a round lid, which are cast together with the handle. The rim of the lid and the neck are decorated with animal masks and bowstrings, and on its legs are two bands of bowstrings. The lid and vessel have an identical inscription of 11 characters in two lines. The body inscription is next to the handle.

Bronze wine vessels began to appear in the early Shang Dynasty, and became popular in the late Shang and Western Zhou periods.

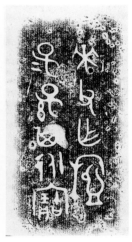

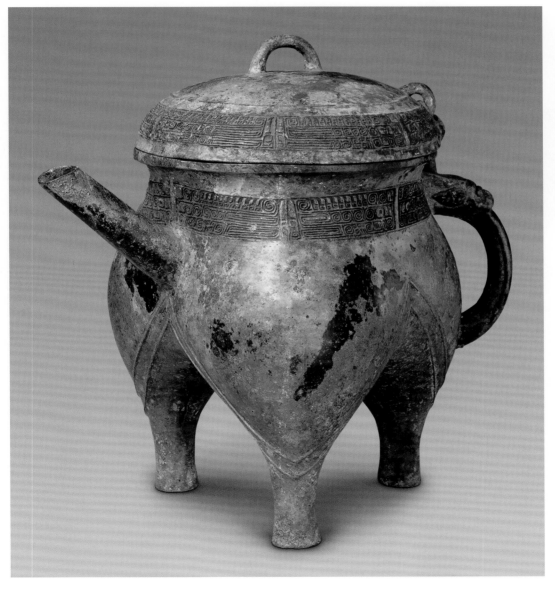

64

Rectangular *Hu* (Wine Vessel) with Lotus and Crane Design

Spring and Autumn Period

Overall height 122 cm
Width 54 cm
Diameter of mouth 30.5 × 24.7 cm

This body of this wine vessel is rectangular with round corners. It has an open mouth, a long neck with side ears in the shape of a dragon and with carved holes, a drooping belly with a monster cast at each of its four corners. Under the ring foot there are two crouching tigers which serve as feet for the vessel. It has a lid, around its rim are two layers of cast hollow lotus petals. Cast at the centre of the lid is a white crane spreading its wings and stretching its neck, about to let out cry. The body of the vessel has the intertwining *kui*-dragons and birds.

The vessel has a huge body, and it can be said to be the king of vessels. The design of dragon, crane, and tiger on the body is extremely lively, having a beautiful rhythm. The shape and decoration of this vessel are typical of the wine vessels of the Spring and Autumn period, and its rich artistic manifestation displays the creative spirit of revitalization that occurred in the Spring and Autumn period. It was unearthed in 1923 in Xinzheng City in Henan Province.

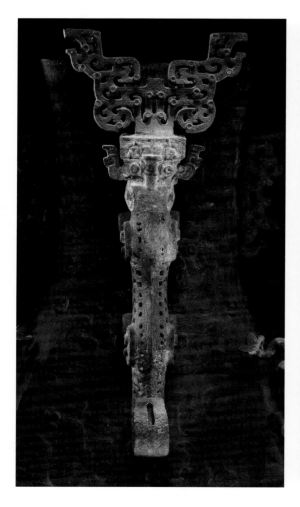
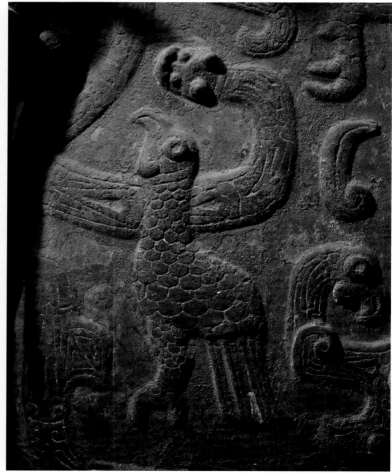

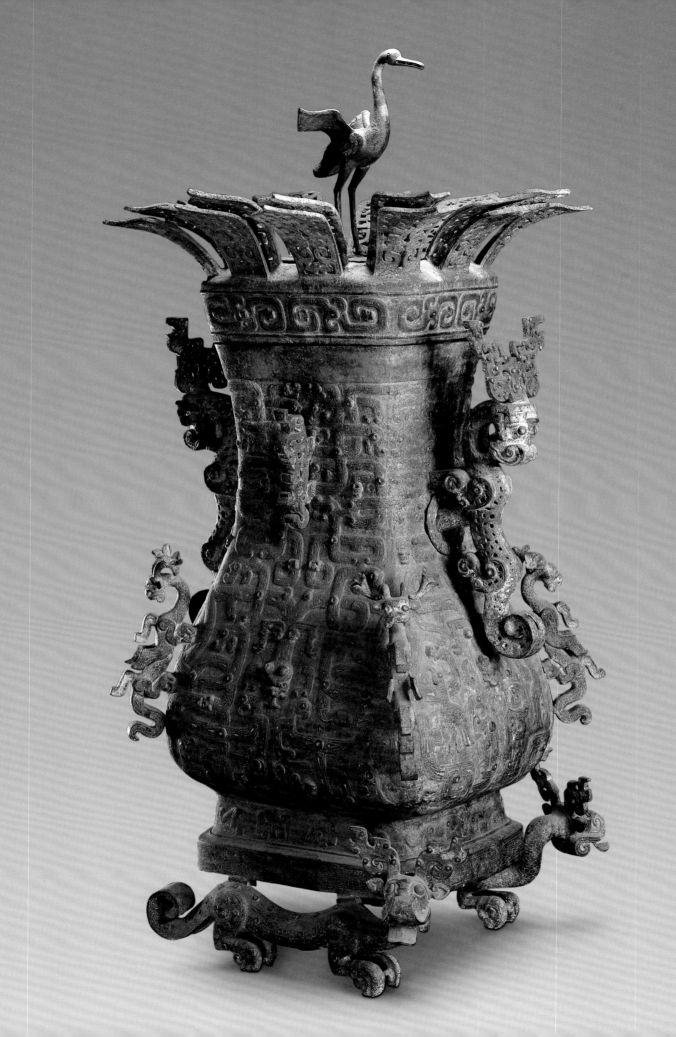

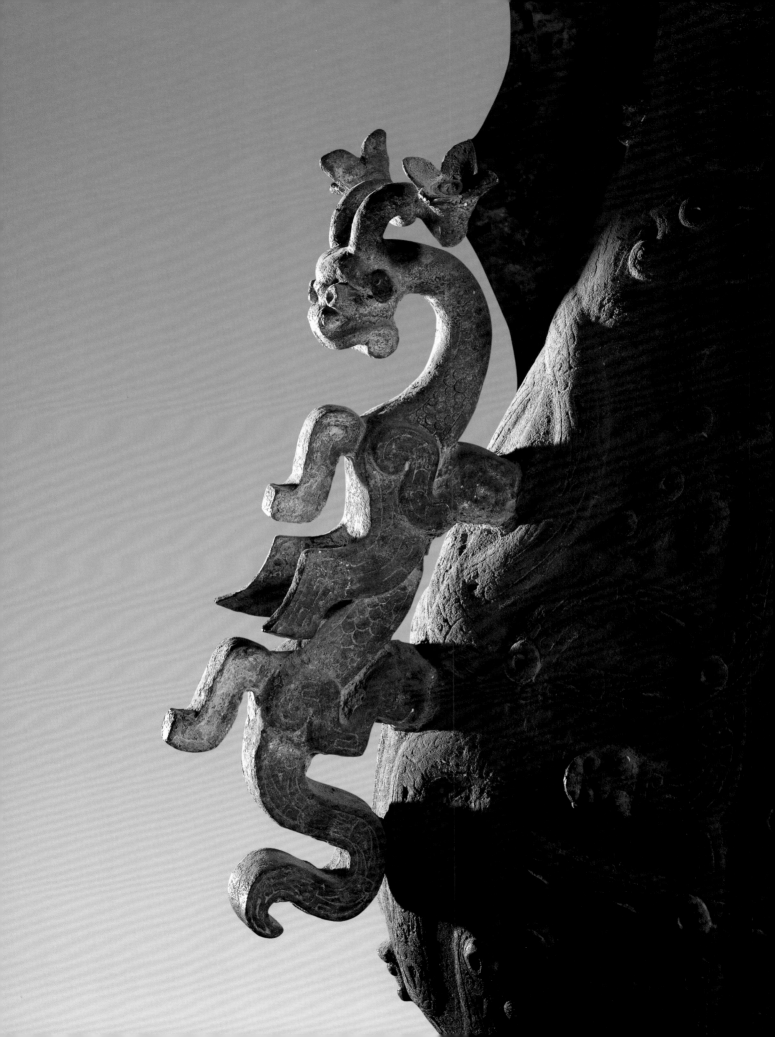

65

Fou (Wine Vessel)
Made by Craftsmen

Warring States Period

Overall height 46.9 cm
Diameter of mouth 18.4 cm

The body of this wine vessel is round. It has a vertical mouth, and under its rim is a band of protruding flanges. It has a small neck and broad shoulders. These have four ring ears, the bulging belly narrows downward, and the vessel has a ring foot. Inscribed on its neck are nine characters in one line, recording craftsmen casting vessels for the empress.

Ke is a wine container. The shape of this vessel is plain with simple lines. It was made during the time of King You of the State of Chu. It was unearthed at Lisangudui, Zhujiaji Village in Shou County, Anhui Province.

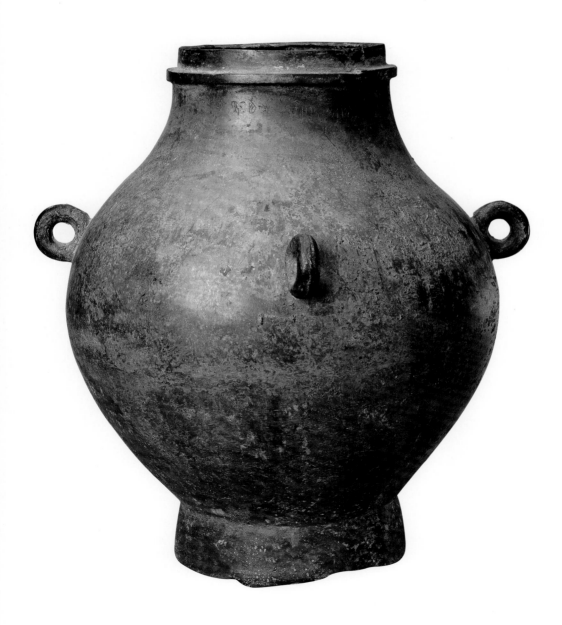 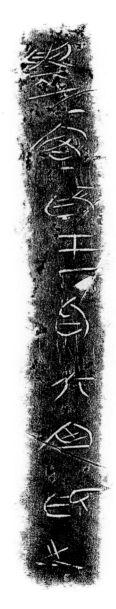

66

Hu (Wine Vessel) with Scenes of Feasting, Fishing, Hunting, and Battle Inlaid with Red Copper

Warring States Period

Overall height 31.6 cm
Diameter of mouth 10.9 cm
Qing court collection

The vessel has a wide flared mouth, a contracted neck, sloping shoulders, a bulging belly, and a ring foot. On the shoulder is a pair of ears with animals holding rings. The body of the vessel is decorated with a drawing inlaid with red copper. The drawing has a cloud-in-triangle design as its boundary and is divided into three layers. The first layer is a picture of picking mulberry leaves and hunting; the second layer is a picture of revelling and shooting, and the third layer is a picture of fighting at sea and on land, which reflect the social activities of the nobility such as hunting and feasting during the Warring States period.

The decorative patterns of this vessel are rich, and they are important for the study of the production, life, war, social customs, and architecture of that time. The inlays of the drawing are exquisite, well structured, harmoniously balanced, and richly depicted, with life-like characters. It can be seen that the level of attainment in the art of drawing of that time was very high. It heralds the art of brick and stone portraits of the Han Dynasty and this specimen occupies an important position in the history of art.

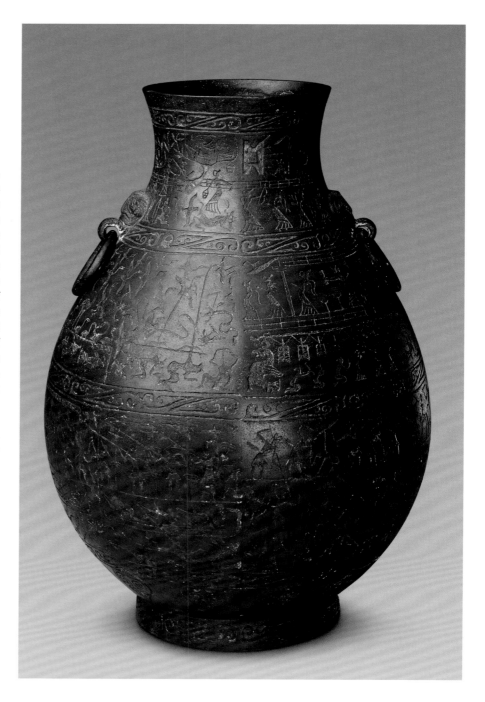

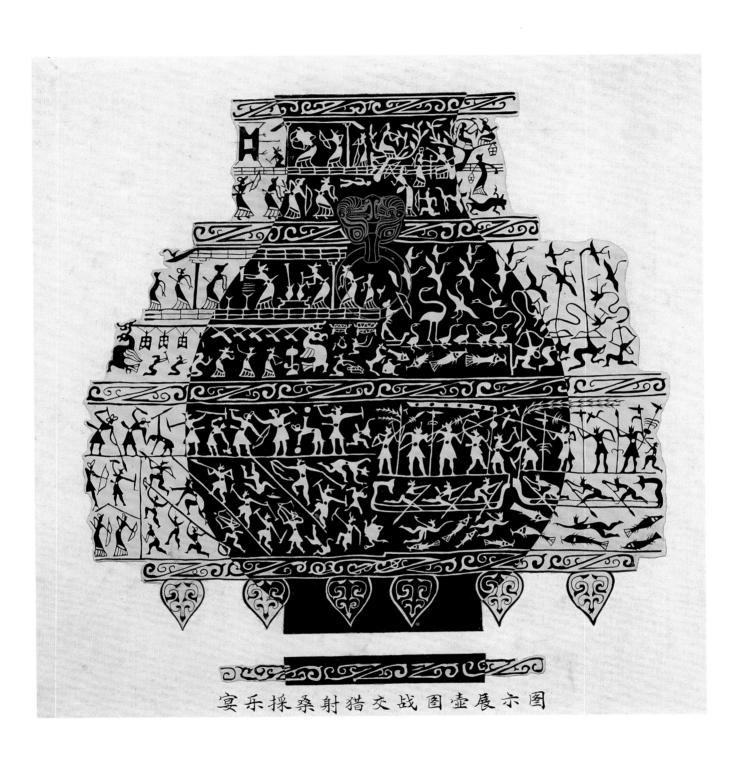

宴乐操桑射猎交战图壶展示图

67

Hu (Wine Vessel) with Two Bird-shaped Ears Inlaid with Gold, Silver, and Turquoise

Warring States Period

Overall height 36.9 cm
Diameter of mouth 17.4 cm
Qing court collection

The body of this vessel is round. It has a tray-shaped mouth. The mouth rim has openwork carved *kui*-dragons. It has a contracted neck, a protruding belly, and a short ring foot. On each of the two sides of its shoulders is a bird-shaped ear, with the bird lying prostrate and with a ring on its back. The neck of the vessel is inlaid with gold and silver and turquoise that forms a geometric design. Its belly is segmented into four sections by four bands of protruding flanges, and inside the belly are inlaid red copper clouds.

The art of inlaying gold and silver is to inlay gold or silver threads or pieces on the surface of bronze to form patterns or characters, and then press them flat and polish them till they shine. Various skills such as inlaying gold and silver, inlaying red copper and turquoise, have been used in the making of this vessel. To apply these methods on one vessel is rarely seen, and this shows the high level of development of bronze craftsmanship in the Warring States period.

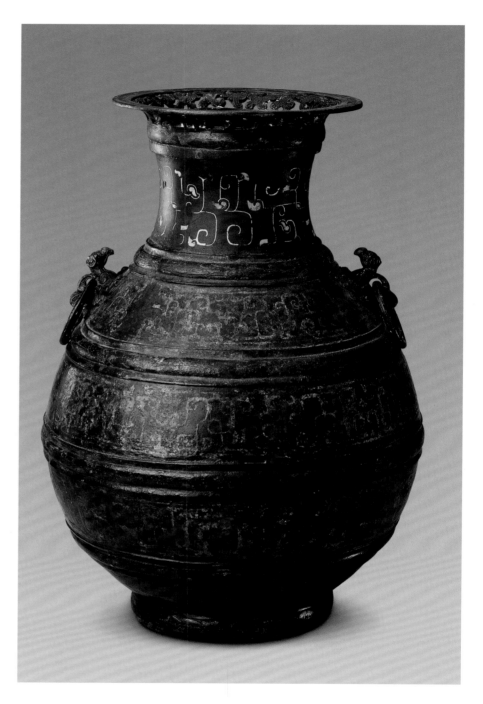

68

Hu (Wine Vessel) in the Shape of a Gourd

Warring States Period

Overall height 35.5 cm
Diameter of mouth 9 cm

The entire body of this vessel is like a gourd. It has a vertical mouth. Its neck is curved and tilted towards the handle. It has a round belly, which has a loose ring handle, and a ring foot. It has a round lid which has a ring button in the middle and a short tube-shaped spout on its side, which allows the pouring of wine without having to lift the lid.

It is generally believed that a wine vessel in the shape of a gourd is made by imitating the "Gourd-shaped Star" of ancient times. Contained in this vessel is *xuan* wine for offering sacrifices to the heaven. Gourd-shaped vessels are rarely seen in bronzeware. A piece of a gourd-shaped vessel was unearthed in Suide County in Shaanxi Province. This piece was unearthed in Hui County in Henan Province.

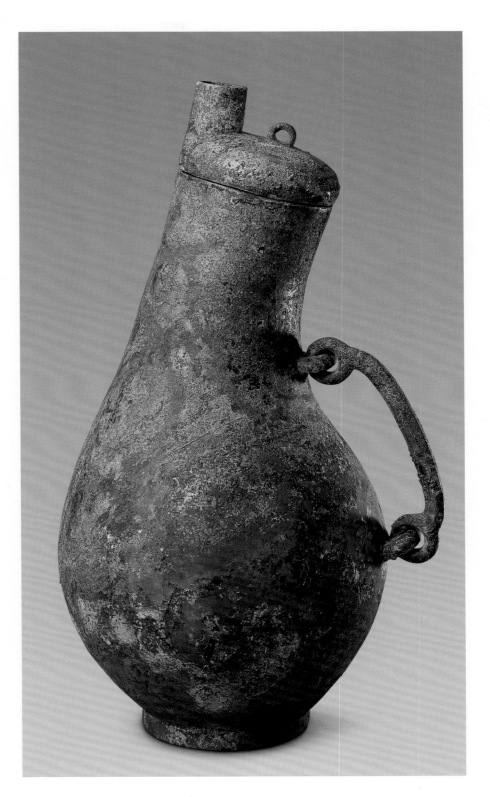

69

He (Wine Vessel)
with a Loop Handle and Interlaced Hydra Design
Warring States Period

Overall height 24.2 cm
Width 24.2 cm
Qing court collection

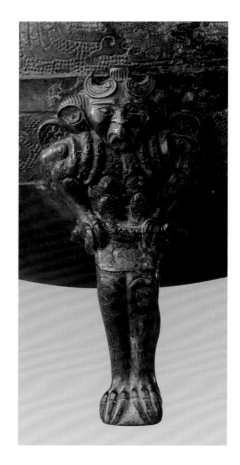

This vessel has a round body, a vertical mouth, and a lid which has a monkey squatting on the lip button, with the chained rings on its neck linked to the loop handle. The whole loop handle is in the shape of an openwork carved hydra. The head of the hydra stretches forward to the spout, its front and rear feet rest respectively on the shoulders of the vessel, and its tail droops. The spout is in the shape of a bird's head, with its beak slightly opened, and on top of its head is a crouching tiger. The three legs of the vessel are in the shape of strange animals with a human face, a bird's beak, four claws, and have a tail. There are horns on the two sides of their heads and wings behind their backs. The two front claws are for catching snakes and the two rear claws stand together and form the legs of the vessel. The entire body of the vessel is decorated with flowers, the mouth rim, coiling dragons, the belly, three-layer patterns, the upper and lower parts of the body, patterns of hooked and linked clouds, and the middle part of the body, coiling dragons, segmented by two bands of broad belts.

The decoration of this vessel is elaborate, and much skill was taken in presenting the details, with every small single part made in the most accurate and vivid manner. This is an exceptional piece of art.

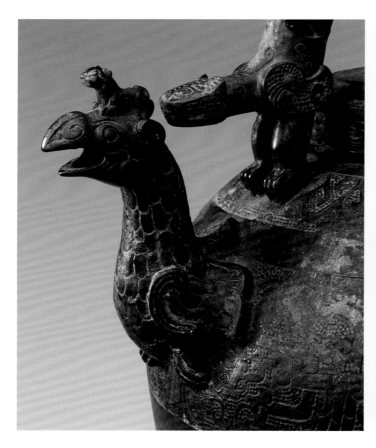

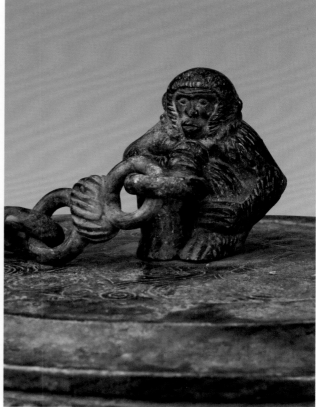

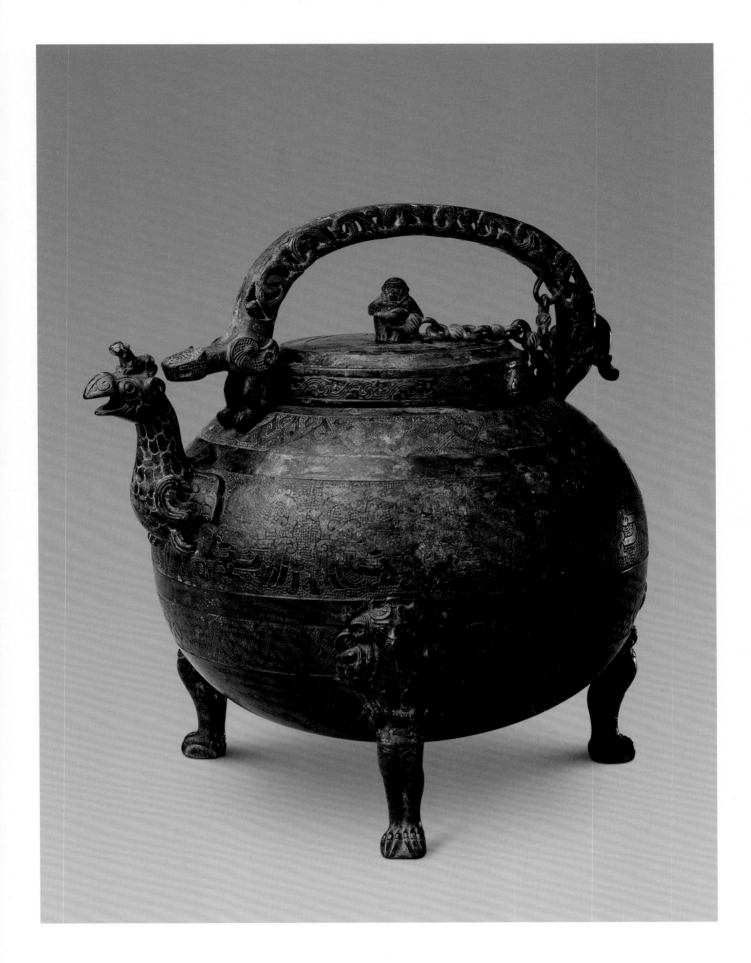

THE RITUAL AND MUSICAL BRONZEWARE

BRONZEWARE

VESSELS FOR
WATER

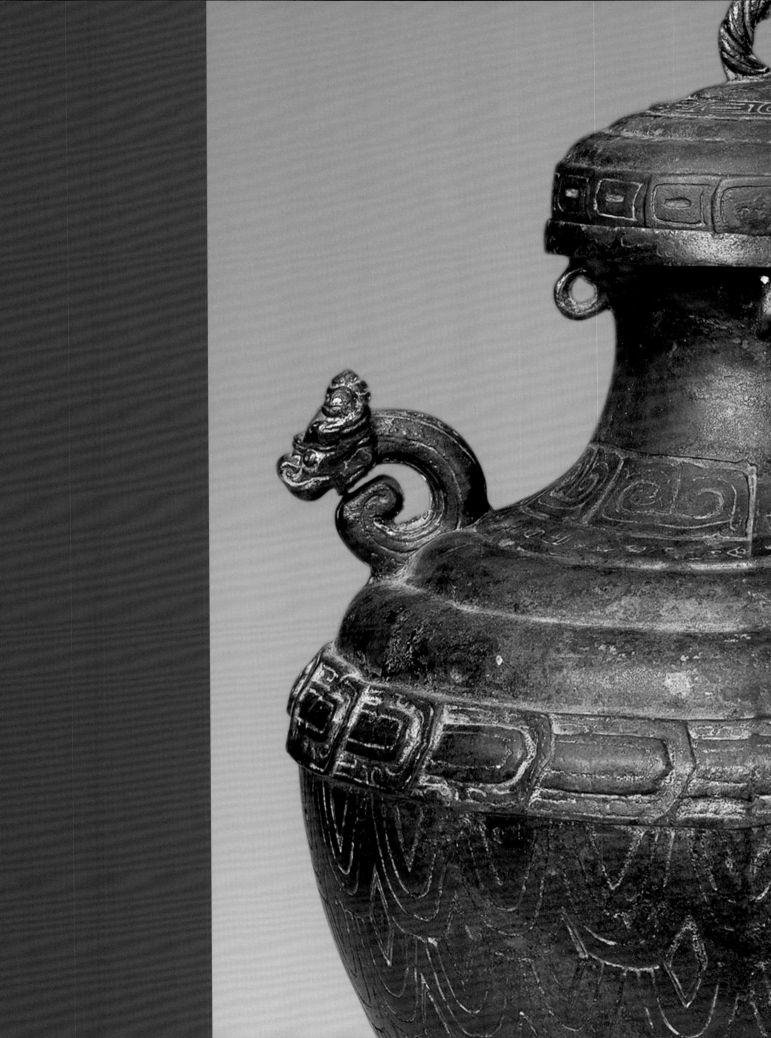

70

Pan (Water Vessel) with Inscription "Ya Yi"

Shang Dynasty

Height 12.8 cm
Diameter of mouth 35.3 cm

This vessel has a round mouth, a shallow belly, a round base, and a ring foot. Below the mouth are chequered thunder patterns. The foot is decorated with animal masks with flanges as the nose, and clouds and thunder patterns as the background. There are three equidistant punched holes on the ring foot. The interior base has coiling dragons, with the body of the dragon coiling around the rim. The body of the dragon is decorated with scales and shells, with projecting eyes. Inscribed on the head of the dragon are two characters, which are the name of the clan of the vessel owner.

Pan is a water container. It can also be used for containing ice. This vessel was used when conducting the ritual of washing hands at feasts given by the emperor. *Pan* is usually used in combination with *yi*, another type of water container.

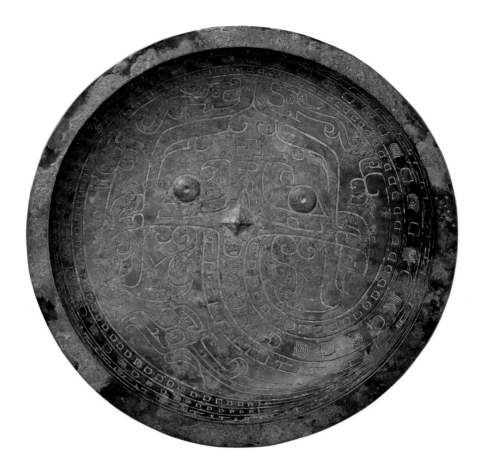

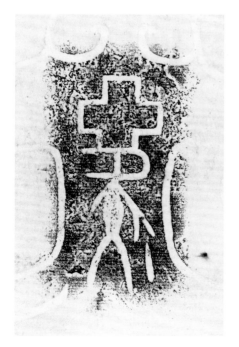

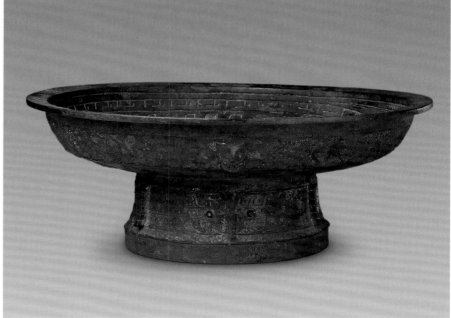

130

71

Pan (Water Vessel) Made by Huan

Late Western Zhou Dynasty

Overall height 12.7 cm
Diameter of mouth 41 cm

This vessel has a round mouth, a shallow belly, and side ears which are higher than the mouth of the vessel. It has a splay ring foot. The belly is decorated with a band of double rings, and the foot, ring bands. The interior base is cast with an inscription of 103 characters in ten lines, which is about Emperor of Zhou granting clothes, belts, jade pendants, flags, saddlery, and copper spears at the Zhou Kang Mu Palace. The maker cast this vessel to commemorate this event and to offer sacrifices to his parents Zheng Bo and Zheng Ji.

This vessel belonged to the Emperor Liwang of the Western Zhou Dynasty (877 BC – 841 BC). The shape and design of this vessel is skilful and beautiful. Its long inscription, in particular, has great significance for the study of ceremonial rituals and the conferment of nobility titles by emperors of the Zhou Dynasty.

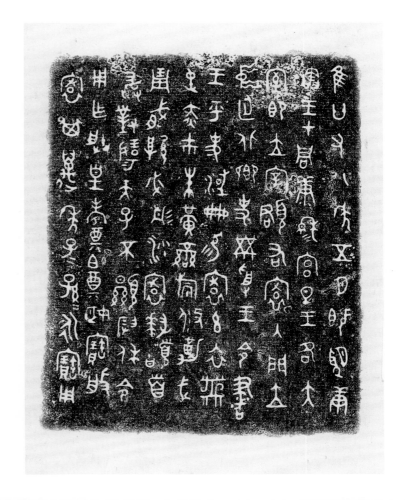

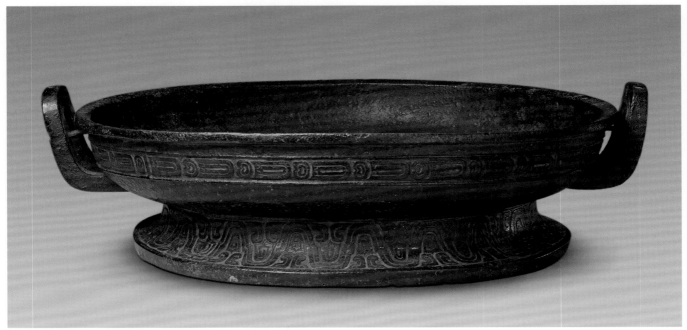

131

72
Ling (Water or Wine Container)
Made by Zheng Yibo
Early Spring and Autumn Period

Overall height 45.5 cm
Diameter of mouth 14.7 cm
Qing court collection

This container has a wide flared mouth, a contracted neck, broad shoulders, a narrowed belly, and shoulders with animal-shaped side ears. It has a lid with a cord ring button on its top. The lid top and all the sides are decorated with a band of double rings. Below the mouth are whorls. The neck has ragged curves, the belly, scales, whose upper and lower parts have each a band of double rings. The exterior wall of the mouth of the lid and the neck of the vessel are inscribed with an identical inscription, recording that Zheng Yibo cast this vessel for Jijiang while at the same time using it to commemorate his expedition.

Ling is a designation used by the maker in the bronze inscriptions. It is a vessel for containing wine or water. It appeared in the late Western Zhou Dynasty, and was used until the Spring and Autumn period. The shape of this vessel is unique, and its design, exquisite.

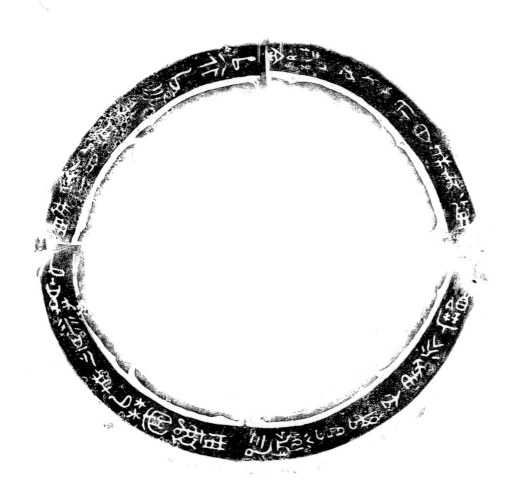

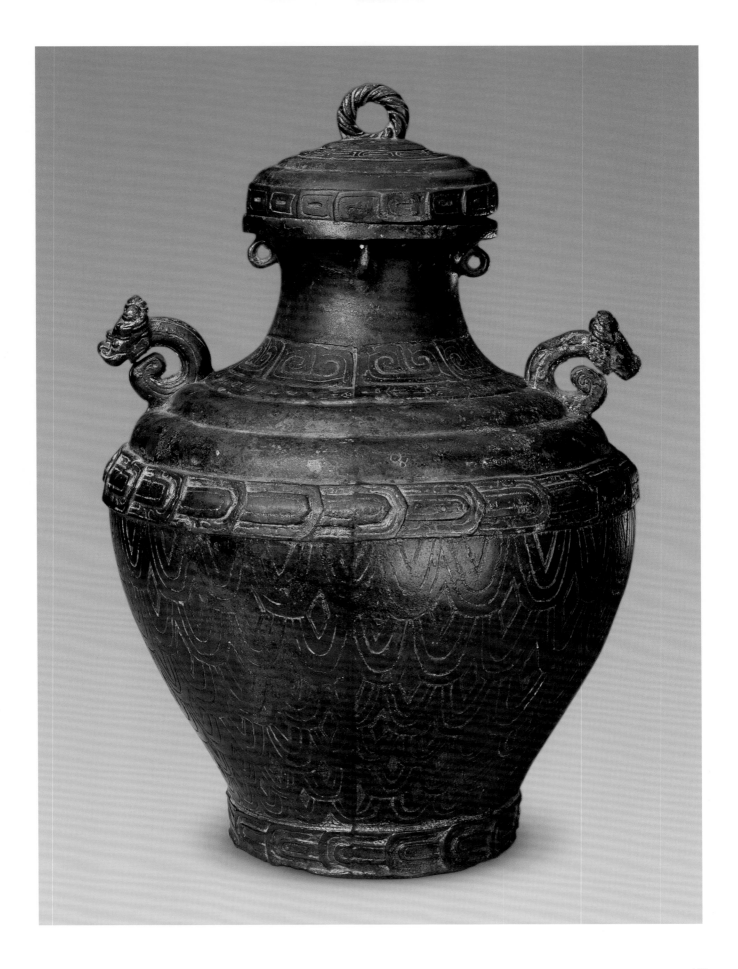

73

Pan (Water Vessel) Made by Qi Yingji's Nephew

Spring and Autumn Period

Overall height 15.5 cm
Diameter of mouth 50 cm
Qing court collection

This vessel has a round mouth, with its rim turning outward. It has a shallow belly, a flat base, and a splay ring foot. On its side ears are two prostrating animals. The belly and foot are decorated with coiling dragons. The interior base has an inscription of 23 characters in four lines, recording that this vessel was made for a nephew of Yingji in the State of Qi.

As the maker of this vessel can be clearly identified, it adds important information to the study of bronzeware in the State of Qi during the Spring and Autumn period.

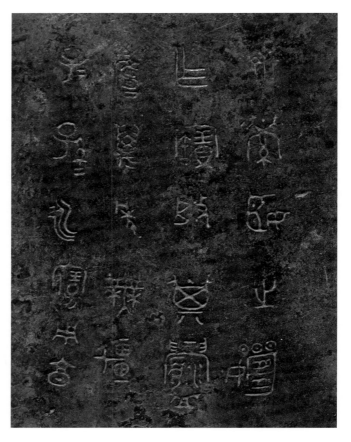

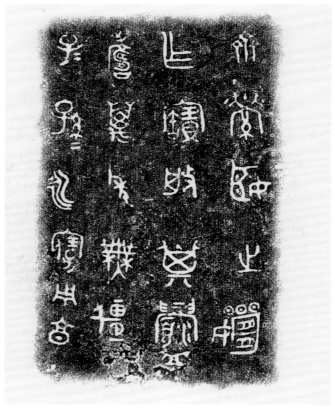

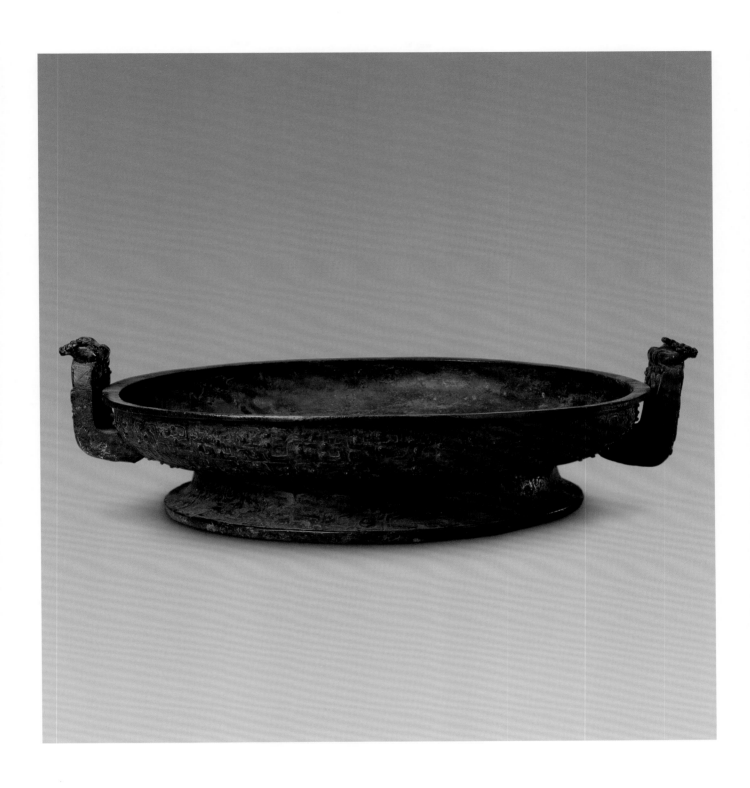

74

Yi (Water Vessel)
in the Shape of a Beast

Spring and Autumn Period

Overall height 20.3 cm
Width 42.7 cm
Qing court collection

The entire body of this water vessel is in the shape of a beast. The mouth of the beast serves as a spout, and on each side of the mouth there is a curved pointed tooth. The tail is its handle, which is in the shape of the coiled body of a dragon, and the mouth of the dragon is holding the rim of the vessel. Lying prone on the head of the dragon is a beast with a bent body and a curled-up tail. This beast and the head of the dragon both look downward into the interior of the vessel. On the two sides of the body of the dragon are tigers in relief, with their heads raised. The tail of the dragon has a beast with its head raised, its body bent, and its tail curled-up. Under the belly of this vessel are four flat legs in the shape of a bird.

Yi is a water container for washing hands. The shape of this vessel is special, its conception ingenuous, and the workmanship consummate. This vessel is a rare treasure.

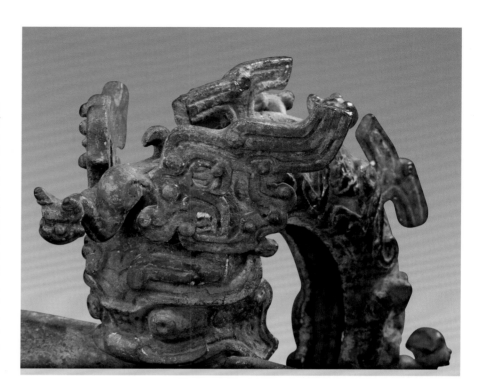

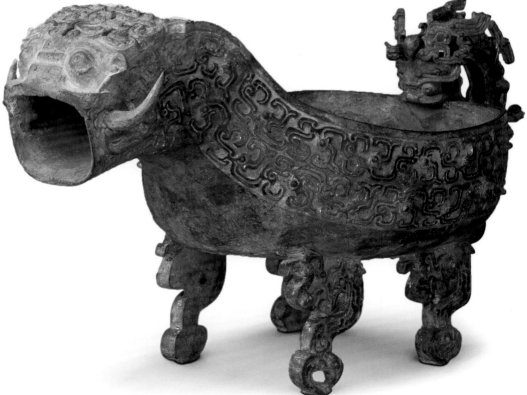

75

Yi (Water Vessel) Made by Cai Zi

Spring and Autumn Period

Overall height 11.9 cm
Diameter of mouth 27.3 cm

This vessel is conical in shape. Its raised-head spout is higher than the mouth of the vessel. On another side is a small ring handle. It has a flat base without any feet. Under the mouth rim is a band of coiling dragons and cords. The interior base has an inscription of seven characters in two lines, recording that this vessel was made by Cai Zi.

Cai, surnamed Ji, was a feudal state established in the early years of the Western Zhou Dynasty. It was in the area of present-day Shangcai and Xincai in Henan Province, and was annihilated by the State of Chu in 447 BC. This vessel has definite value for the study of the history and style of bronzeware in the State of Cai during the Spring and Autumn period.

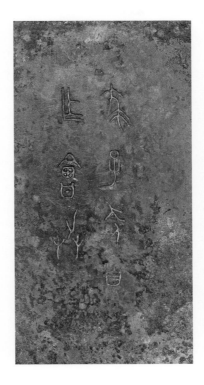
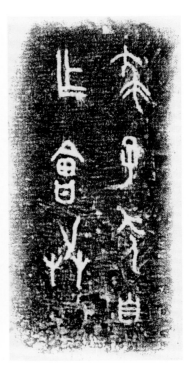

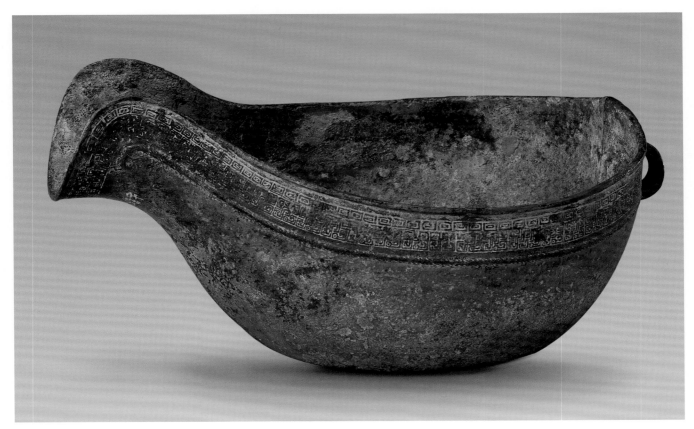

76

Rectangular *Pan* (Water Vessel)
with Design of Interlaced Hydra, Tortoise, and Fish

Warring States Period

Overall height 22.5 cm
Diameter of mouth 73.2 × 45.2 cm
Qing court collection

This vessel is rectangular in shape. It has a vertical mouth, an upturned rim, a shallow belly, and a flat base, under which there are four legs in the shape of a tiger lying prostrate. On the two sides of the exterior wall of this vessel are a pair of animal heads each holding a ring. The interior and exterior of this vessel are covered with beautiful decorations. The interior base has wave patterns made up of coiling dragons, on which are seven rows of animals in relief, such as tortoise, fish, and frogs, which are arranged alternatively, looking as though they are swimming slowly in the water. On a corner of the ring base are 12 frogs in relief, as though they just emerged from the water. Decorated on the interior wall and its mouth rim are coiling dragons. The designs on the front and rear sides of the exterior wall of the belly are the same. They are both decorated in the middle with two bears lying curled up, with the front foot of the bear on the right grabbing a hydra, teasing it. On its two sides are winged sharp-toothed monsters, with the one on the left swallowing a hydra, and the other one on the right swallowing a lizard. The design of the left and right sides are the same, with two squatting unicorns in relief, one of which is nursing a ram.

This body of vessel is comparatively large. The casting is exquisite, its pattern, fine and detailed, and the images of the various animals are lively, which is a manifestation of its superb artistic expression. The unique contents of the decorative patterns are important materials for the study of mythology of ancient times.

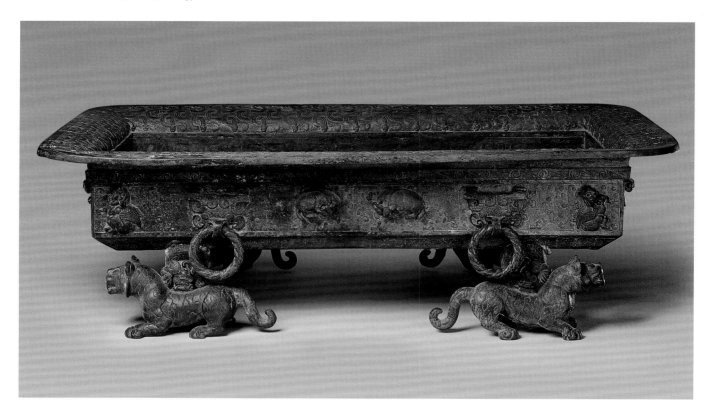

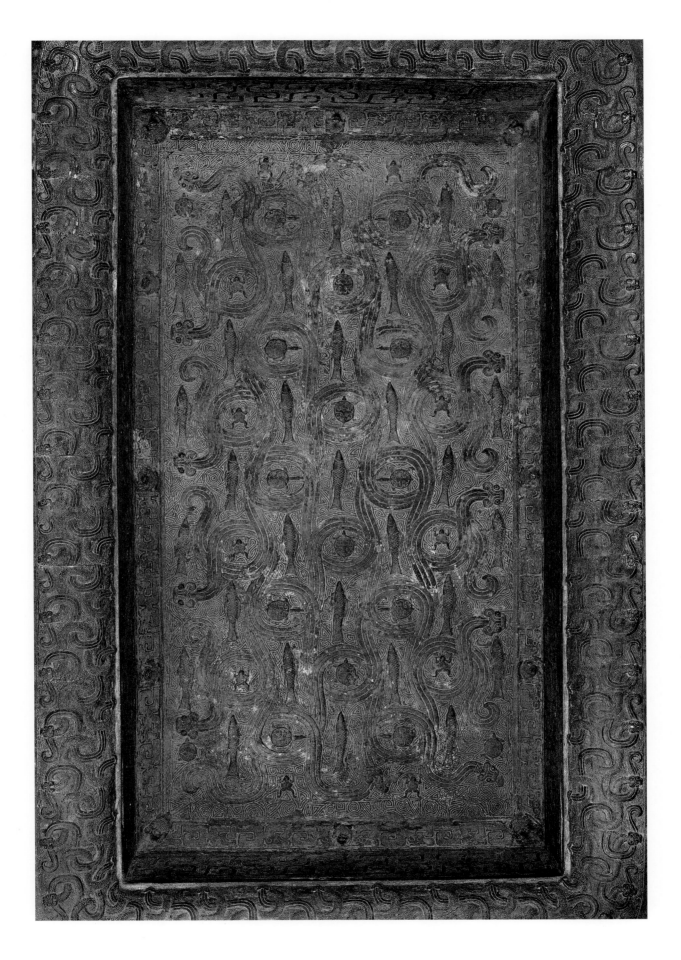

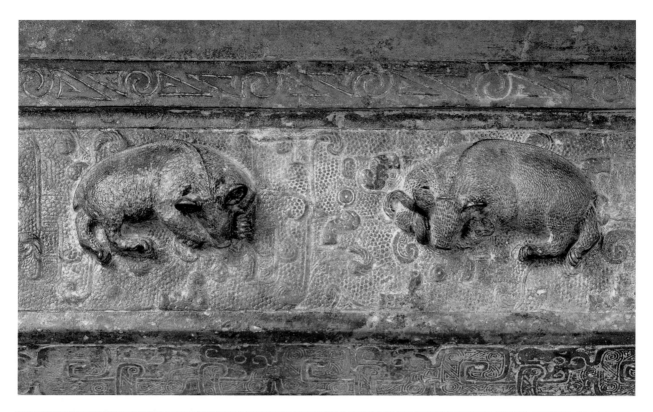

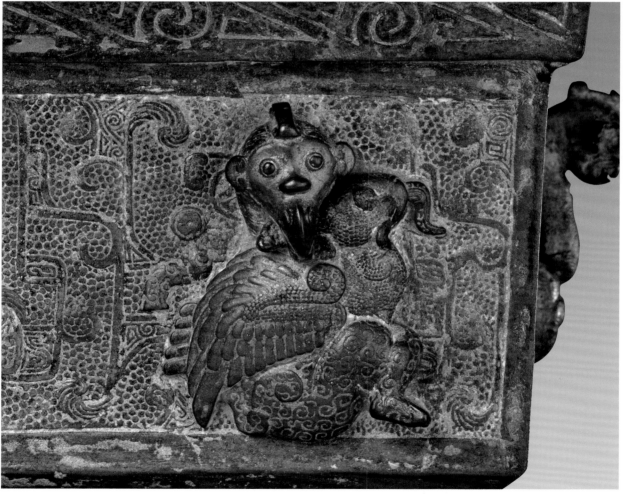

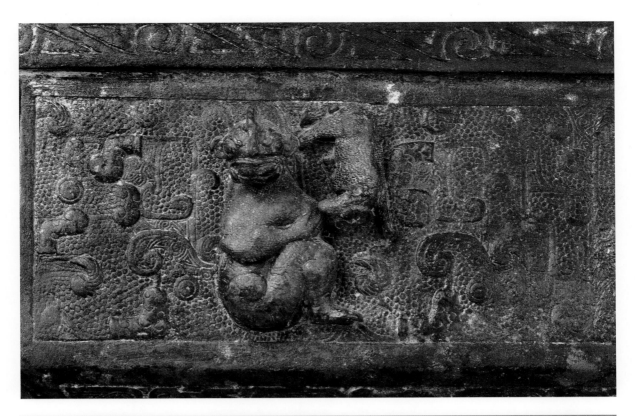

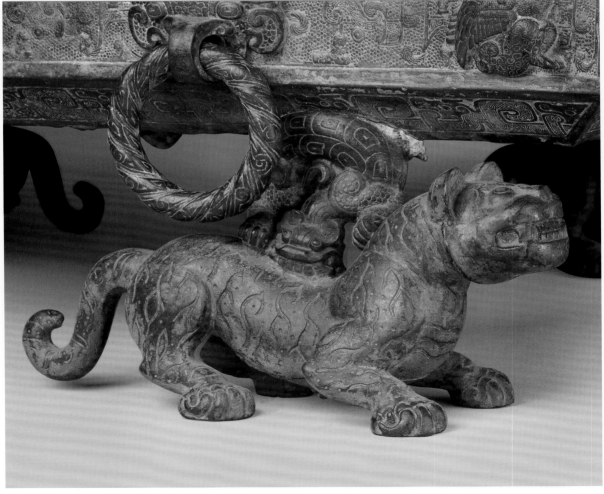

THE RITUAL AND MUSICAL BRONZEWARE

MUSICAL INSTRUMENTS

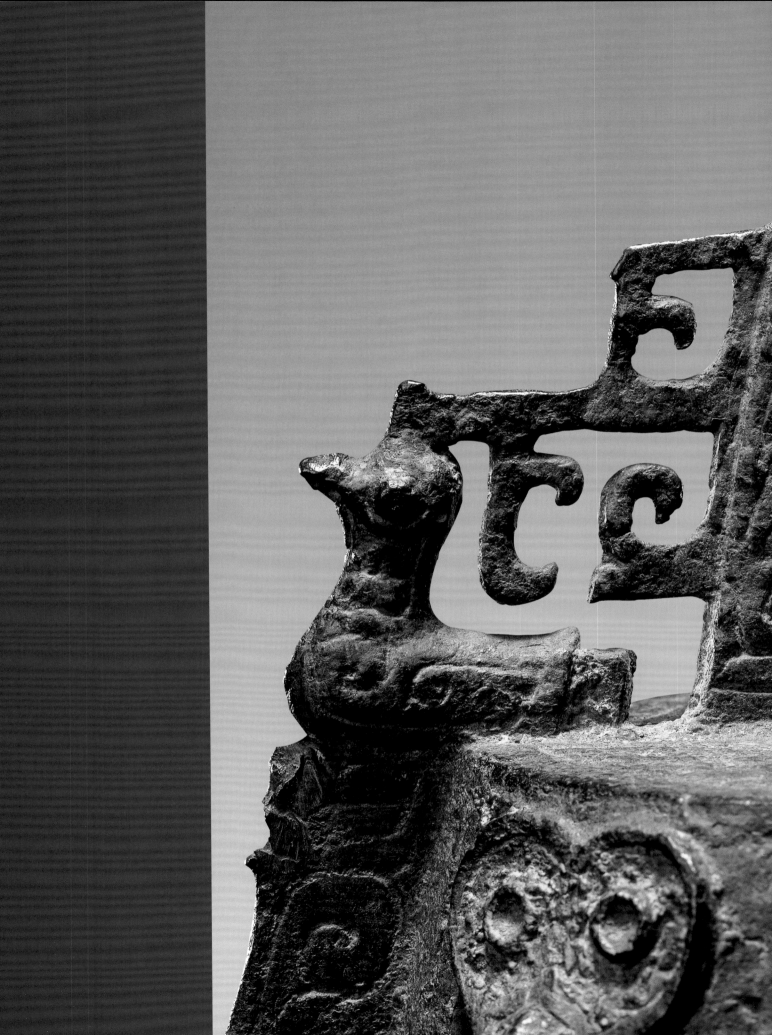

77

Big *Nao* (Percussion Instrument in the Shape of a Big Bell) with Animal Mask Design

Shang Dynasty

Overall height 66 cm
Spacing of Xian 48.5 cm

This *nao* has a hollow handle, which can be inserted into a seat. *Sui* is decorated with variant animal mask patterns, and the two sides have cloud and thunder patterns. The two sides of the bell are decorated with protruding thick-striped animal mask patterns, with small thunder patterns as background design.

Nao is a percussion instrument. The handle is called *yong*. Below the mouth where the bell is struck is called *sui*. The middle part of the bell corpus is called *zheng*, and the top is called *wu*. This instrument was popular in the late Shang and early Zhou period. Big *nao*-s were mostly unearthed in areas south of the Yangtze River, in particular Hunan Province where most excavations were found.

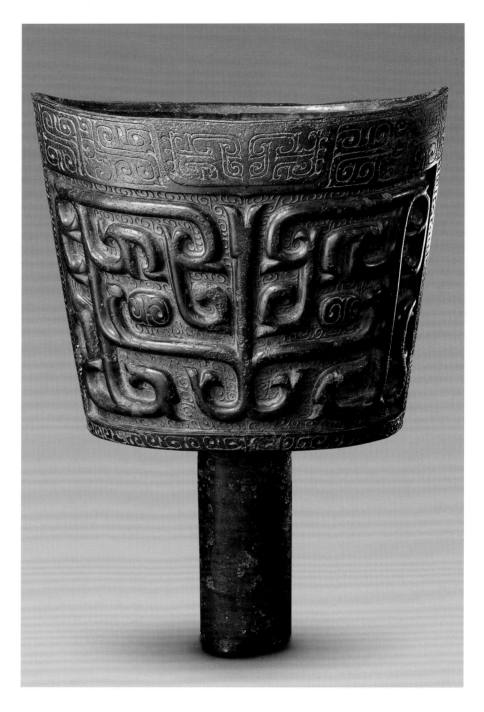

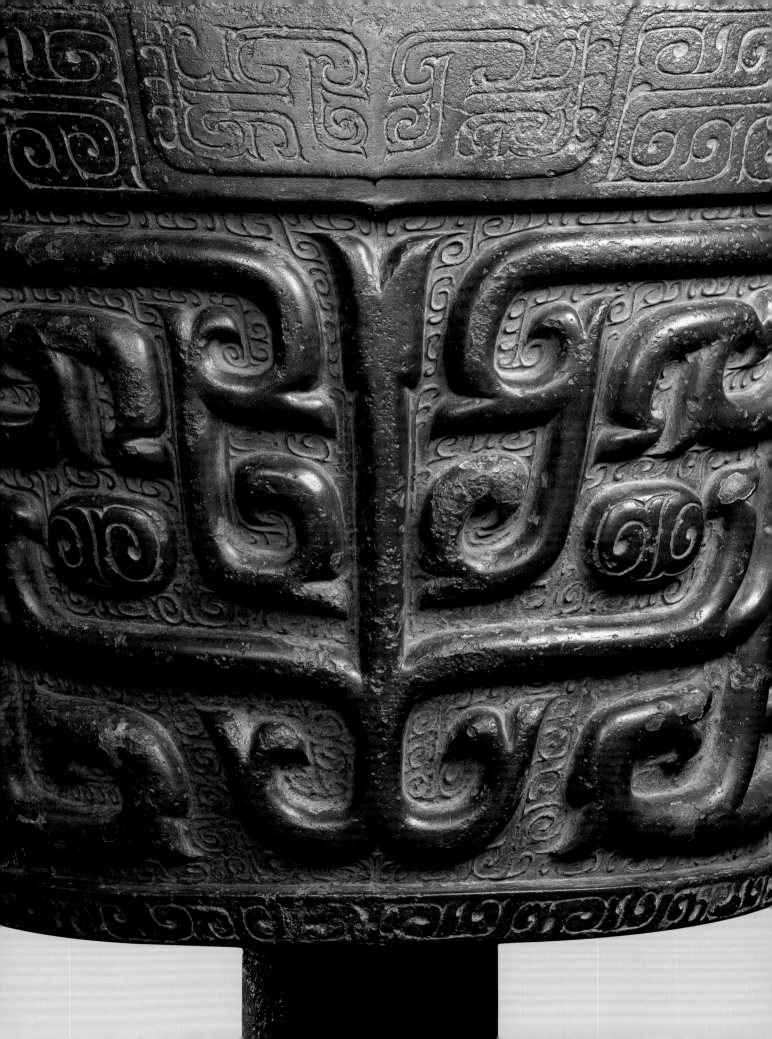

78

Zhong (Bell, Musical Instrument)
Made by Zu

Western Zhou Dynasty

Overall height 39.5 cm
Spacing of Xian 18.8 cm

This bell has a rather high handle, on which is a reinforcement hook *gan*, and the bell mouth has a "cutaway" profile. The corpus is decorated with cloud-in-triangle patterns. The two sides of the *zheng* are called *zhuan*, ornamented with cloud-in-triangle patterns, and the *sui* is decorated with cirrus designs. Caste on the *zheng* and the left drum *gu* is an inscription of 35 characters in nine lines, which mainly records that this valuable bell was made by Zu to commemorate the deceased Ji Bo and the banquet organized for members of the clan.

The inscription on this bell is a valuable reference for studying the social life and sacrificial activities of a clan in the Western Zhou period.

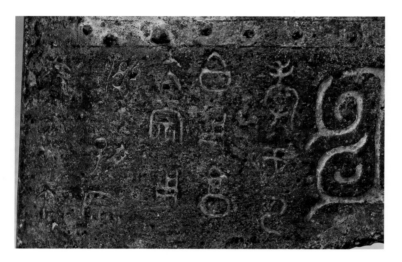

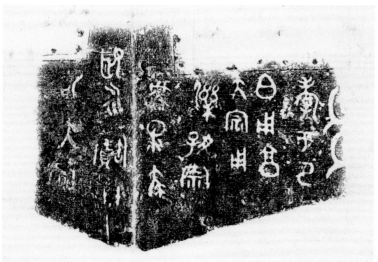

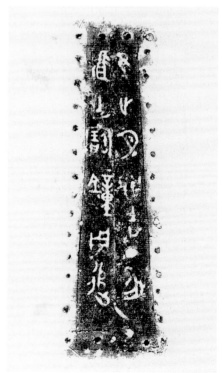

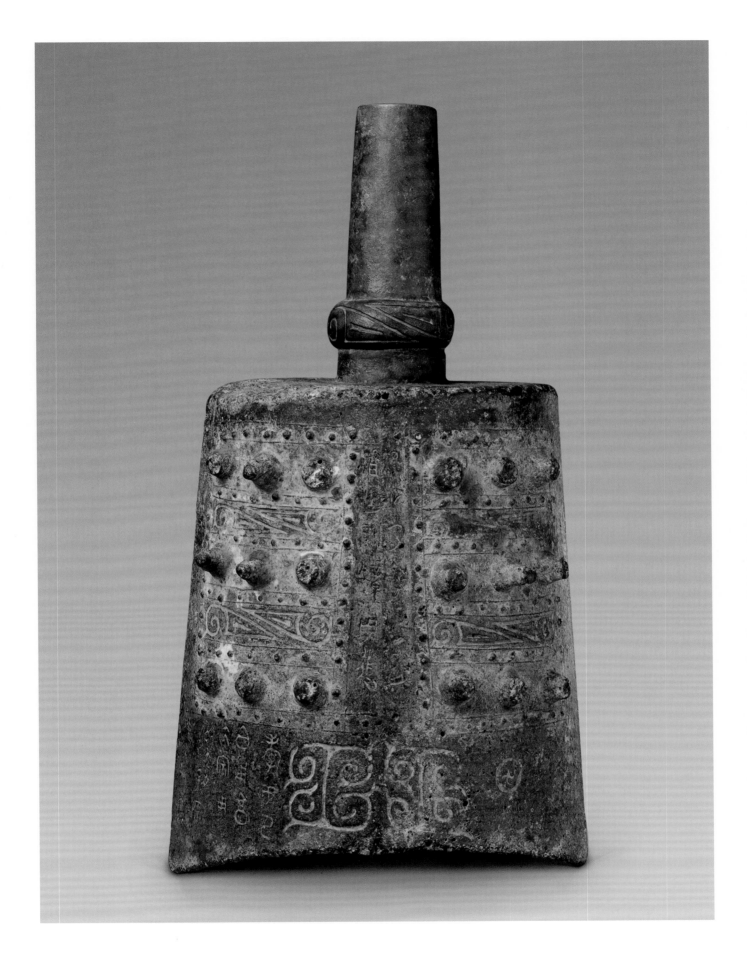

79

Zhong (Bell, Musical Instrument)
Made by Shu Lü of the State of Guo
Late Western Zhou Dynasty

Overall height 65.4 cm
Spacing of Xian 36 cm

This bell has a tall handle which has a half-ring button on one side. The bell has 36 long studs and the mouth has a "cutaway" profile. The handle is decorated with patterns of circular stripes, double rings, and ragged curves. The corpus top has designs of *kui*-dragons, the *zhuan*-s are ornamented with ragged curves, and the *sui* has a pair of elephant trunks in an opposite direction. On the *zheng* and left drum is an inscription of 91 characters, to be read onward starting from the *zheng*. The inscription records that Shu Lü of the State of Guo praised the loyalty of the people of the elder generation to the emperor of Zhou, and that he had to carry on his ancestors' great virtue to serve and be loyal to the emperor. Shu Lü had been awarded by the emperor many times and therefore this big bell was made.

This *zhong* is an instrument made at the time of Emperor Liwang of the Zhou Dynasty. The appearance and designs are meticulous, and the inscription has high historical value.

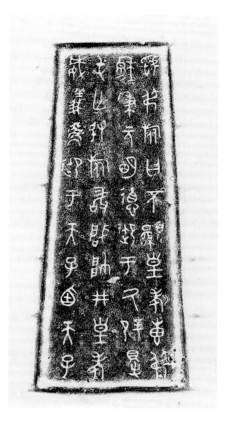

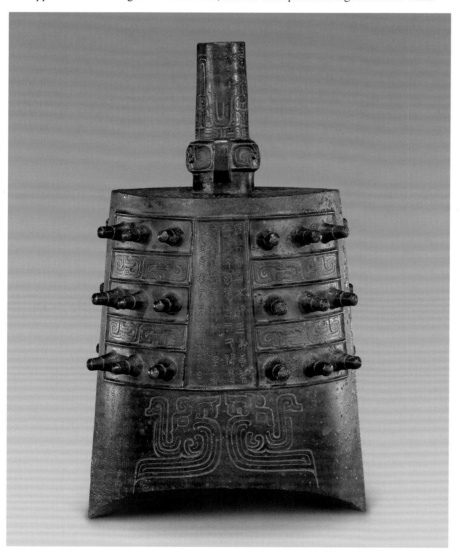

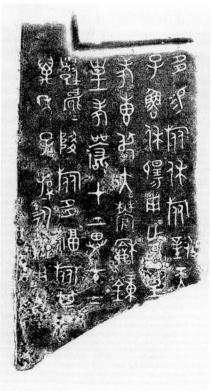

80

Ke *Zhong* (Bell, Musical Instrument)

Western Zhou Dynasty

Overall height 65.4 cm
Spacing of Xian 36 cm

This bell is an ellipsoid with a tall handle which has a ring button on one side. The bell has 36 long studs and the mouth has a "cutaway" profile. The *zhuan* has ragged curves, and the *sui* has a pair of *kui*-dragons in the opposite direction. On the *zheng* and left drum is an inscription of 39 characters reflecting that Ke was rewarded a single-shafted chariot after he was conferred a title by the emperor.

This Ke *Zhong* is the largest one among the five that exist. Since it was unearthed at the end of the Qing Dynasty, this *zhong* had been collected by well-known epigraphic collectors such as Ding Shuzhen and Nakamura, as well as Neiraku Art Museum in Nara. In March 2010, it was bought by the Palace Museum in Beijing from overseas, so that the bell can be handed down for posterity. The bell's designs are meticulous and stately. The contents and form of the inscription have important historical and artistic value. This bell is significant for studying the history and geography of Western Zhou.

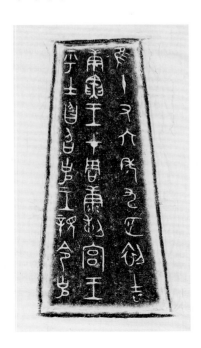

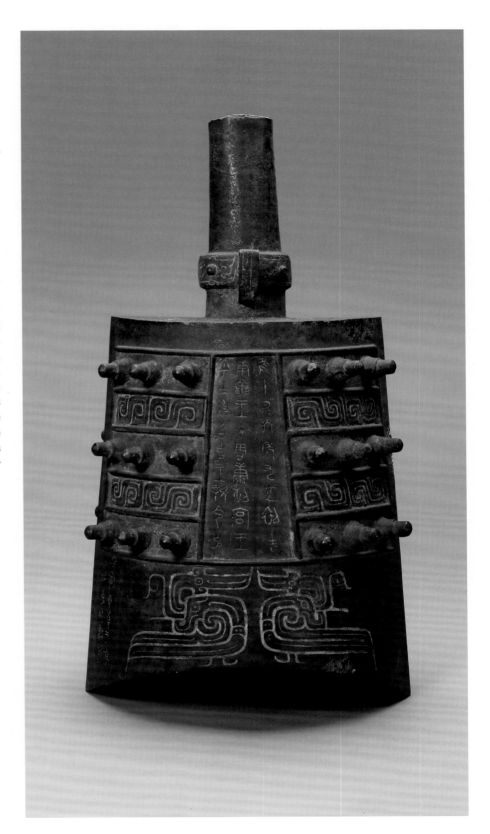

81
One of *Bian Zhong*
(Chime Bells, Musical Instrument) with Tiger Design
Western Zhou Dynasty

Overall height 27.1 cm
Spacing of Xian 16 cm

This bell is a flat cylinder with a flat lug. Each side of the lug has a bird. The long crests of the birds are connected to the lug with gorgeous fretwork. Each of the front and back of the bell has a sculpture of a tiger. The two sides of the bell have halberds and the mouth is flat. The front and back of the bell corpus have designs of animal masks and owl's heads. The centre of the *sui* is decorated with an animal mask and a *kui*-dragon is on each of its two sides. An animal mask is also formed by the corresponding *kui*-dragons engraved respectively at the front and back of the bell.

This *zhong,* which is in the shape of a flat cylinder and a flat mouth, is also called a *bo*. The bells are usually hung in a group according to size when in performance, and therefore are known as chime bells (*bian zhong*). This *zhong* is one piece of the *bian zhong*.

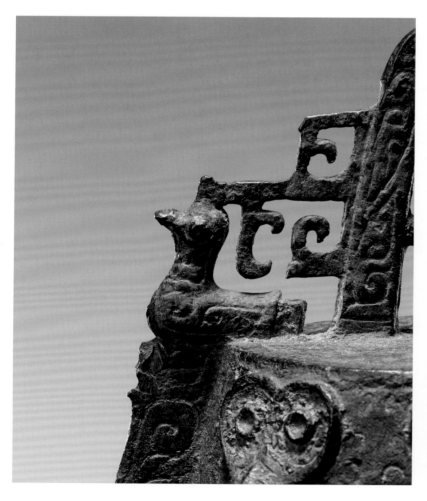

150

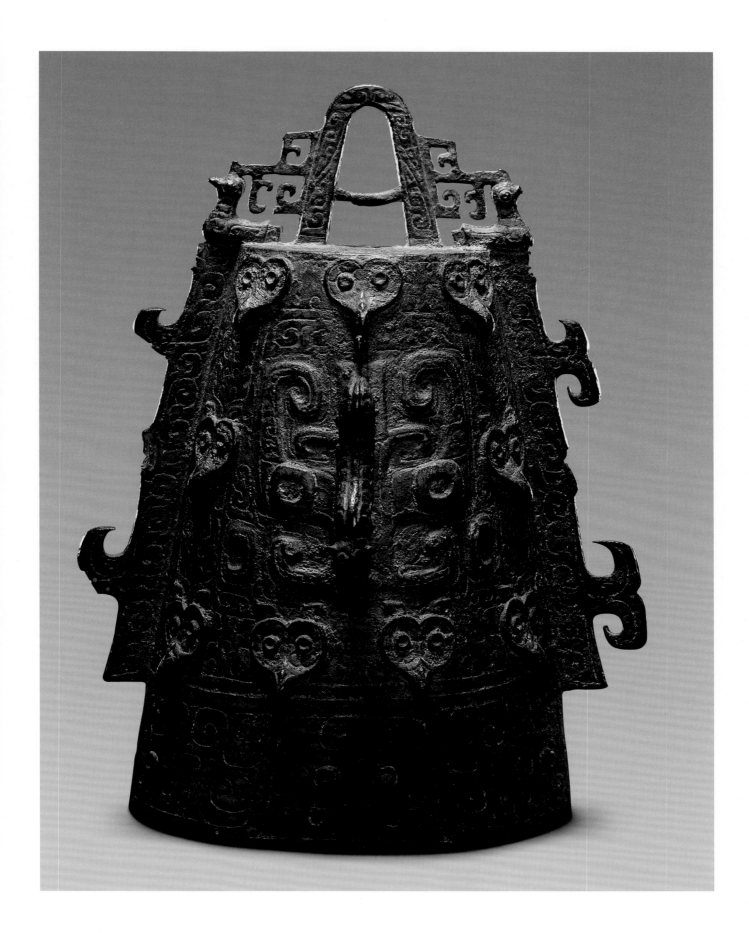

82

Zhe Jian *Zhong*
(Bell, Musical Instrument)
Spring and Autumn Period

Overall height 38.2 cm
Spacing of Xian 20.6 cm

This bell is an ellipsoid and the mouth has a "cutaway" profile. The bell has a wide corpus, a columnar handle, a bell hook *gan*, a suspension part *xuan*, and 36 long studs on the entire instrument. The *gan* is decorated with interlaced hydra designs and the head of a bear. On the upper part of the handle above the *gan* is ornamented with meander patterns and cicada patterns in banana-leaf shape, whereas the lower part has interlaced hydra designs. The *xuan* has thunder patterns, the top and *zhuan* of the bell corpus have geometric patterns, and the *sui* has interlaced hydra designs. On the *zheng* and two drums at the front of the bell is an inscription of 26 characters in four lines.

This *zhong* is a musical instrument of the State of Wu in the Spring and Autumn period. The inscription on the *zhong* is valuable for studying the history of Wu.

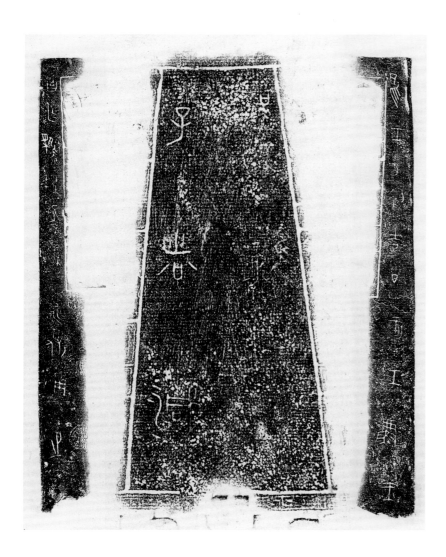

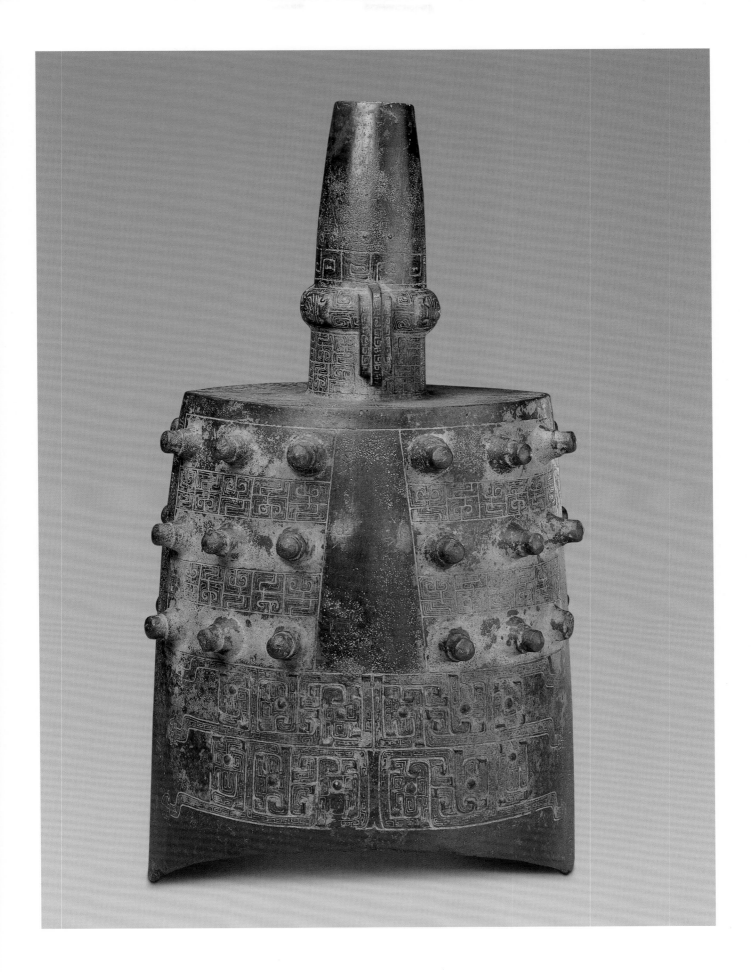

153

83

Zhong (Bell, Musical Instrument)
Made by Ying Ci, Prince of Zheng
Spring and Autumn Period

Overall height 42.5 cm
Spacing of Xian 21.5 cm
Qing court collection

This bell is an ellipsoid and the mouth has a "cutaway" profile. The bell has a straight handle, a suspension part *xuan*, a slightly small corpus, and a total of 36 long studs on both sides of the instrument. The top and *zhuan* have coiling serpent designs, whereas the handle has *kui*-dragons. The *sui* has a variant animal mask composed of coiling serpents. On the *zheng* and left drum is an inscription of 18 characters in four lines.

This *zhong* is an instrument of the State of Zheng in the Spring and Autumn period. Zheng was a feudal state in the latter period of Western Zhou, bearing the family name Ji. The original fief was around the area of present-day Fengxiang County, Shaanxi Province. The State of Zheng was moved to the site of present-day Xinzheng City, Henan Province during the Spring and Autumn period.

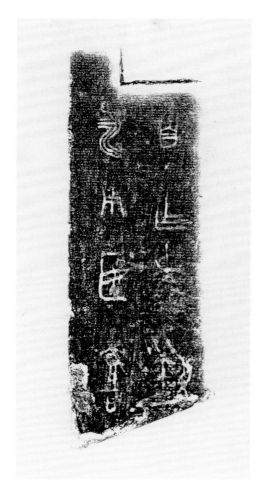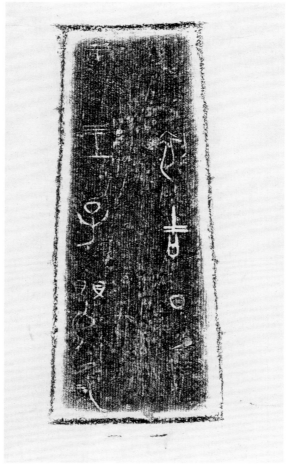

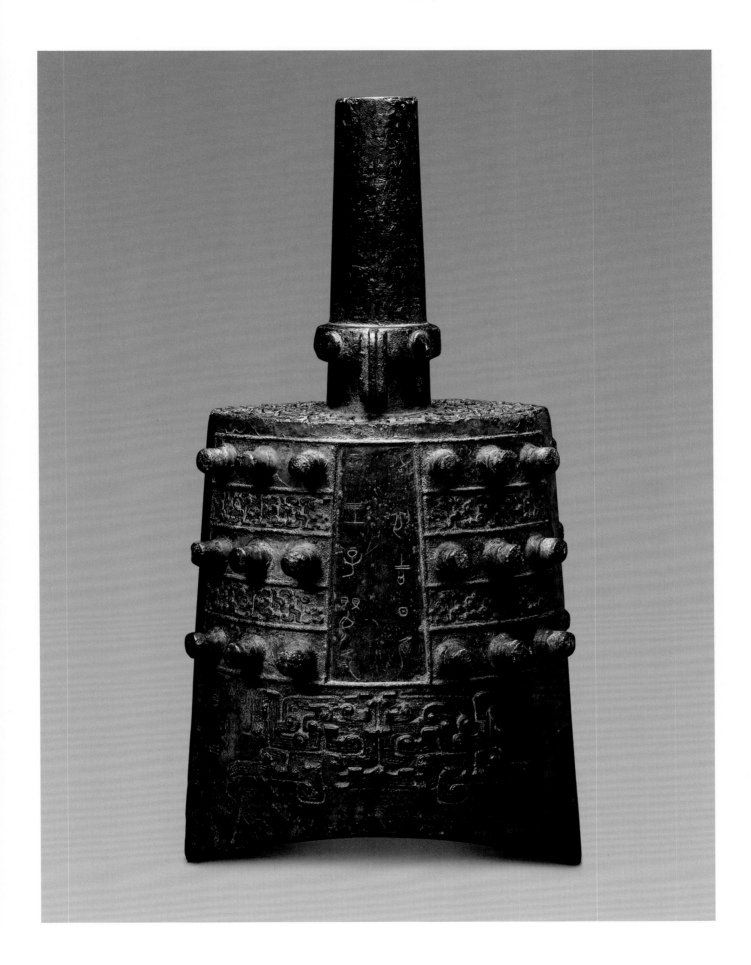

84

Goudiao (Musical Instrument)
Made by Qi Ci
Spring and Autumn Period

Overall height 51.4 cm
Spacing of Xian 19.9 cm

This instrument is an ellipsoid and the mouth has a "cutaway" profile. The corpus is long and the handle is in the shape of a rectangular prism. The base of the handle has decorations of interlaced hydra designs. On the corpus of the instrument, there are meander patterns on the top, designs of banana leaves and coiling serpents on the lower part, and an inscription of 30 characters in two lines is on the two sides.

Goudiao is an ancient musical instrument used in sacrificial ceremonies and banquets. When in performance, the mouth faces up and the instrument is struck with a mallet. *Goudiao* was popular in the States of Wu and Yue during the Spring and Autumn period. This instrument, named "*goudiao*," may be taken as the model instrument for naming this kind of object. It was unearthed at Wukang County, Zhejiang Province in the Daoguang period (1821 – 1851) of the Qing Dynasty.

 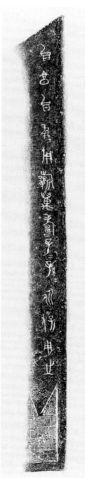 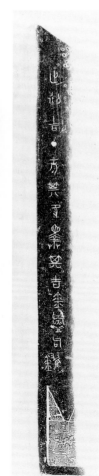

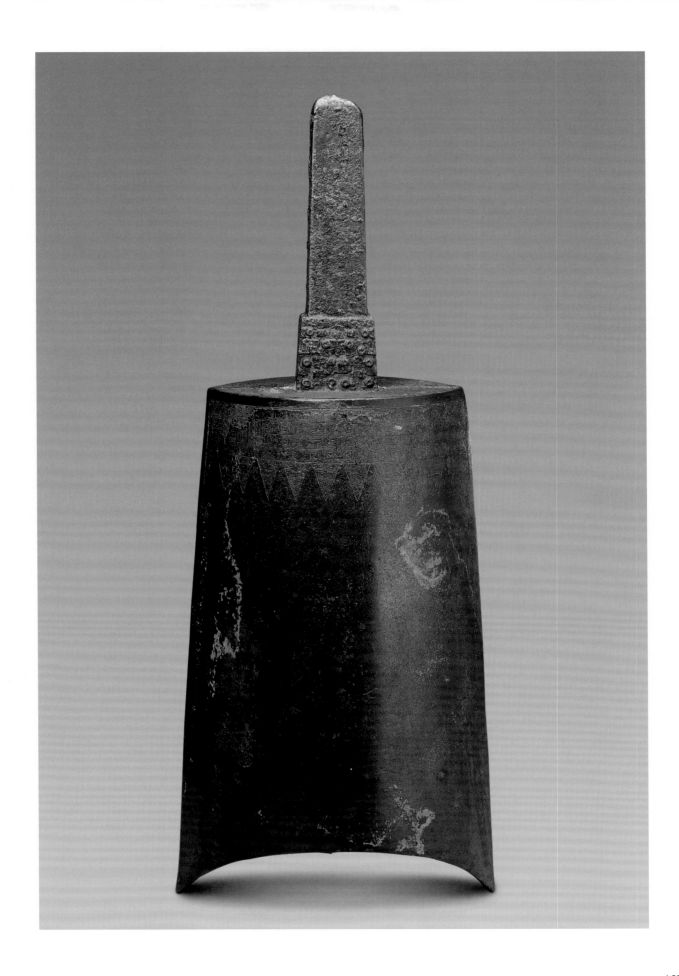

85

Zhe Ci *Zhong*
(Bell, Musical Instrument)
Warring States Period

Overall height 18.3 cm
Spacing of Xian 10.5 cm

This bell is an ellipsoid and the mouth has a "cutaway" profile. The bell has a rectangular and flat lug and 36 studs with whorl patterns at the two sides that look like nipples. The lug, top, and *zhuan* are all decorated with interlaced hydra designs, and the *sui* has a variant animal mask composed of interlaced hydras. On the *zheng* and the left and right drums is an inscription of 24 characters.

It is known from the inscription that this *zhong* is one piece of the Zhe Ci *bian zhong* (chime bells) handed down from ancient times. Zhe Ci, also known as Prince Zhu Jiu, was a son of King Yi of the State of Yue in the Warring States period. He was killed by his fellow countrymen in an internal rebellion in 375 BC. The inscription is valuable for studying the history of Yue.

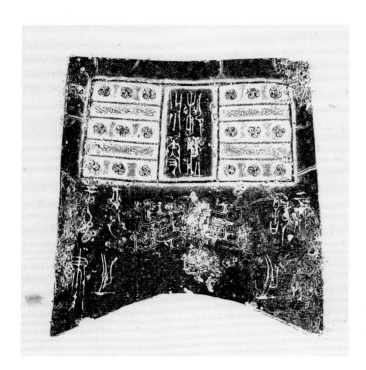 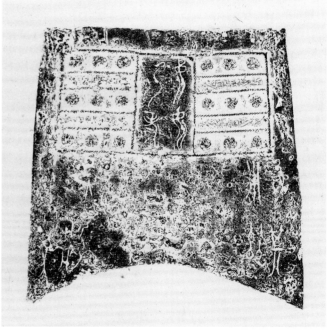

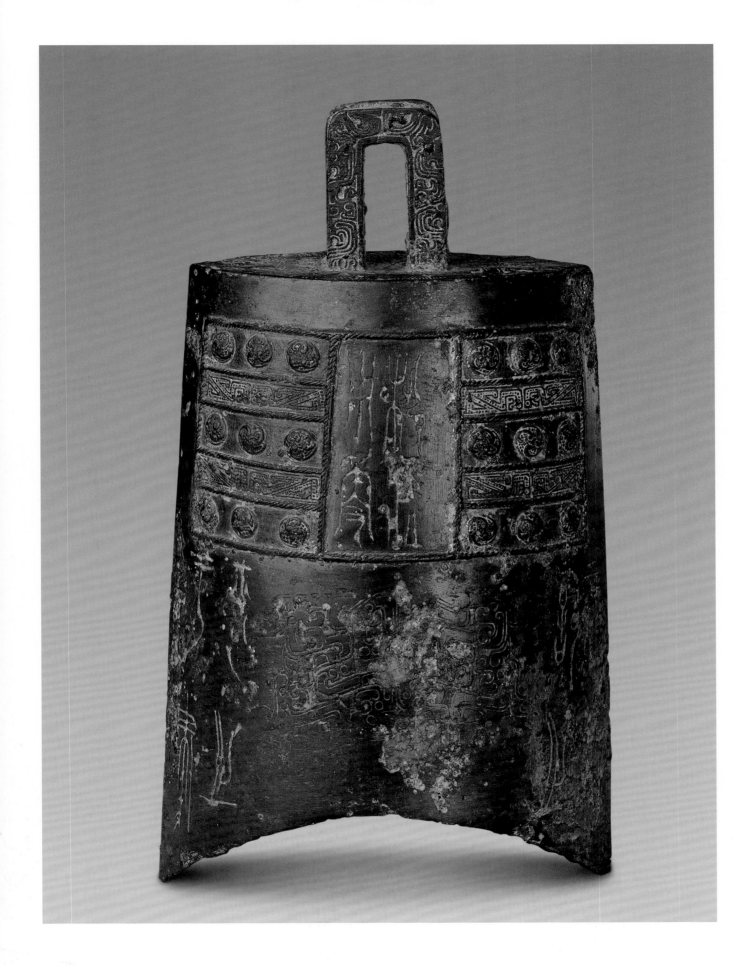

159

86

Bian Zhong (Chime Bells)
with Interlaced Hydra Design
Warring States Period

(1) Overall height 21.1 cm
Spacing of Xian 14.6 cm
(2) Overall height 19.8 cm
Spacing of Xian 13.8 cm
(3) Overall height 18.2 cm
Spacing of Xian 12.7 cm
(4) Overall height 17 cm
Spacing of Xian 11.6 cm
(5) Overall height 15.8 cm
Spacing of Xian 10.9 cm
(6) Overall height 14.3 cm
Spacing of Xian 9.9 cm
(7) Overall height 13.2 cm
Spacing of Xian 8.8 cm
(8) Overall height 11.8 cm
Spacing of Xian 8.2 cm
(9) Overall height 11.5 cm
Spacing of Xian 7.8 cm

All the nine chime bells have the same shape, structure, and design, and are arranged in order of size. They are ellipsoids. The mouth has a "cutaway" profile, and the lug is in a "⌐" shape. Each side of the body has 18 short studs, the border of which has a braid pattern. The top and *zhuan* of the *bian zhong* are decorated with interlaced hydra designs, while *sui* has *kui*-dragon designs.

Bian zhong is a percussion instrument. The bells are hung in groups according to size when in performance and struck with a small mallet. The number of studs varies in different periods.

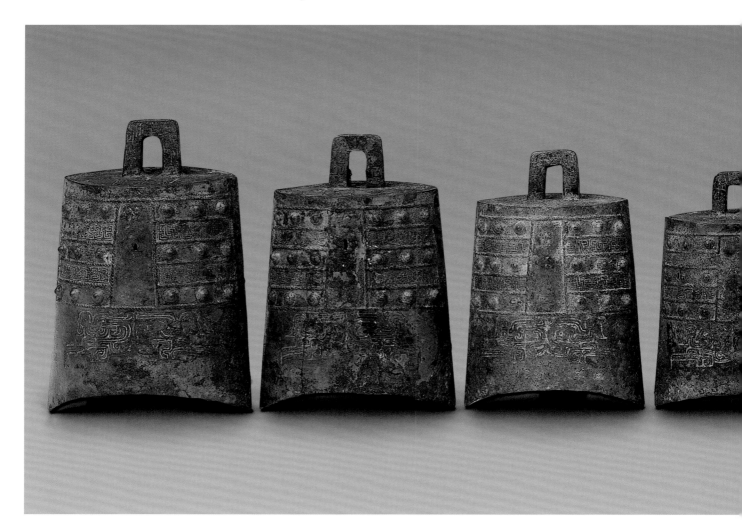

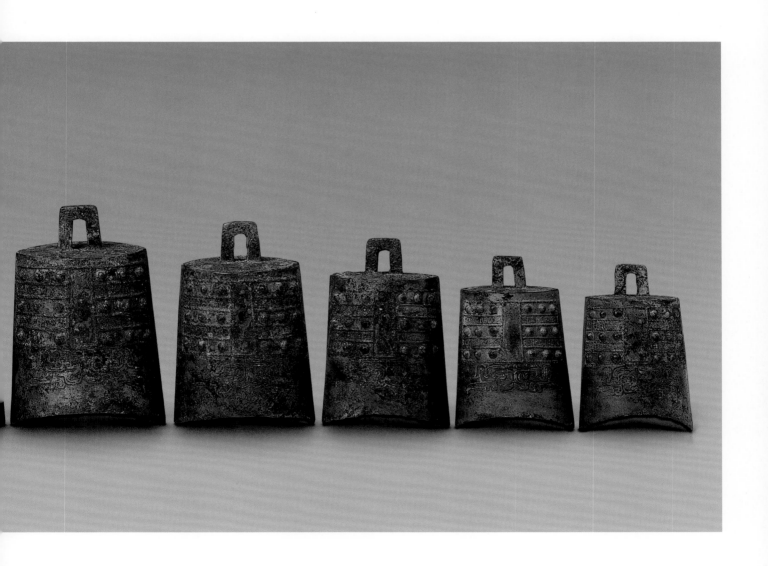

THE RITUAL AND MUSICAL BRONZEWARE

WEAPONS

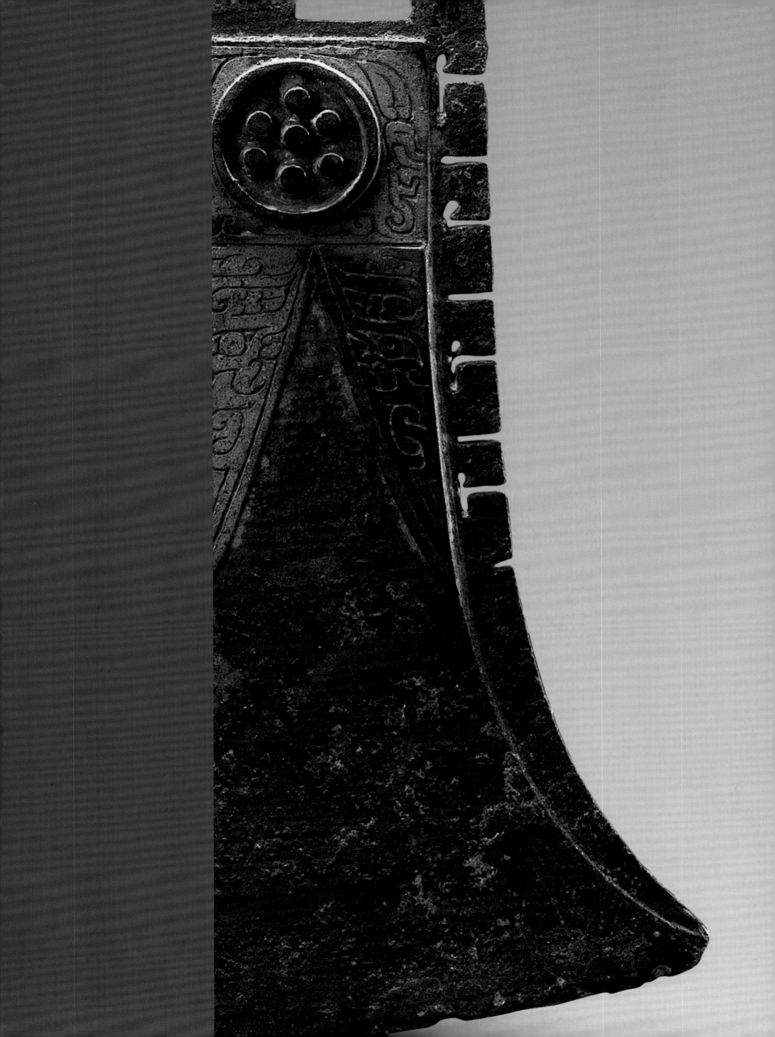

87

Big *Yue* (Axe)
with Animal Mask Design

Shang Dynasty

Height 34.3 cm
Width 36.5 cm
Qing court collection

This *yue* resembles a large axe with an arc-shaped edge. The two sides of its upper part are decorated with a band of T-shaped openwork patterns. The body has animal masks, separated by protruding spirals. The lower part has banana leaves with *kui*-dragons facing each other. There is a rectangular hole on the top of both sides for the insertion of a long handle.

Yue was an ancient weapon and instrument of torture. It was also used by guard of honour in ceremonies. This *yue*, rather large and beautifully decorated, would have been a ritual instrument.

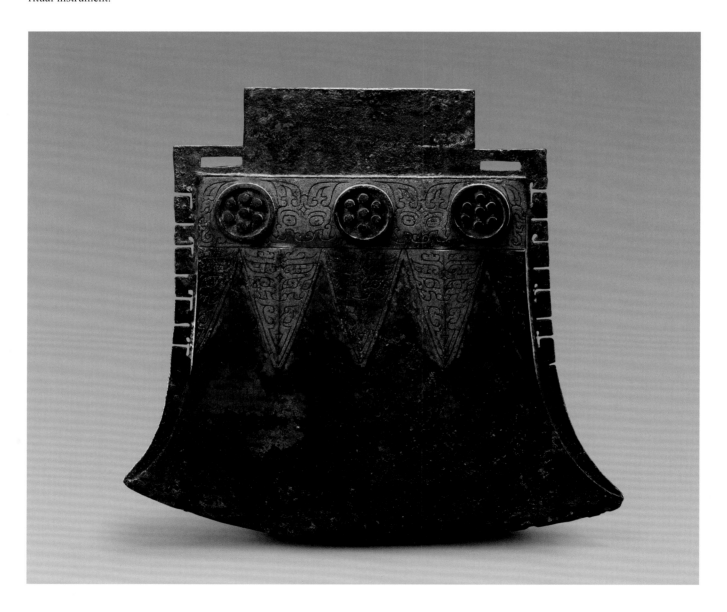

164

88

Ge (Dagger Axe)
with Thread Design Inlaid with Red Copper

Shang Dynasty

Length 21.1 cm
Width 6.9 cm

This dagger axe has a straight tang, a long blade, and a lug. There are tooth-like patterns at both ends of the lug and a round hole in the rectangular tang. The ridge of the dagger axe is inlaid with red copper in a thorn-like pattern. The handle is decorated with lines that look like the character *mu*.

Ge is a crooked weapon used for hooking and killing. Bronzeware inlaid with turquoise was common in the Shang Dynasty, but ones with red copper were rather rare. The latter is very eye-catching and highly decorative. Judging from this *ge*, the craft of inlaying red copper has been quite sophisticated in the Shang Dynasty.

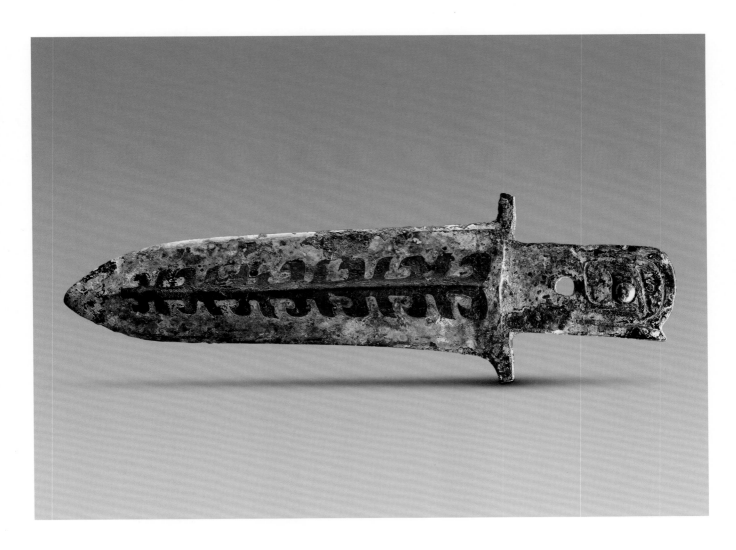

89

Mao (Spear)
with Jade Blade

Shang Dynasty

Length 18.3 cm
Width 4.8 cm
Qing court collection

This spear has a copper shaft and a jade blade. The shape of the jade blade is like a leaf. The part connecting the shaft and the blade is peach-shaped. Below the jade blade is a round tube with a half ring on each of its two sides for hanging tassels. The copper shaft has animal mask patterns.

Mao is basically a stabbing weapon. However, this one has a jade blade, showing that it is not a real weapon for actual battle. Its copper shaft also has beautiful designs of animal masks, and therefore this spear would have been a ritual instrument. Now only two spears with a copper shaft and jade blade exist and remain intact.

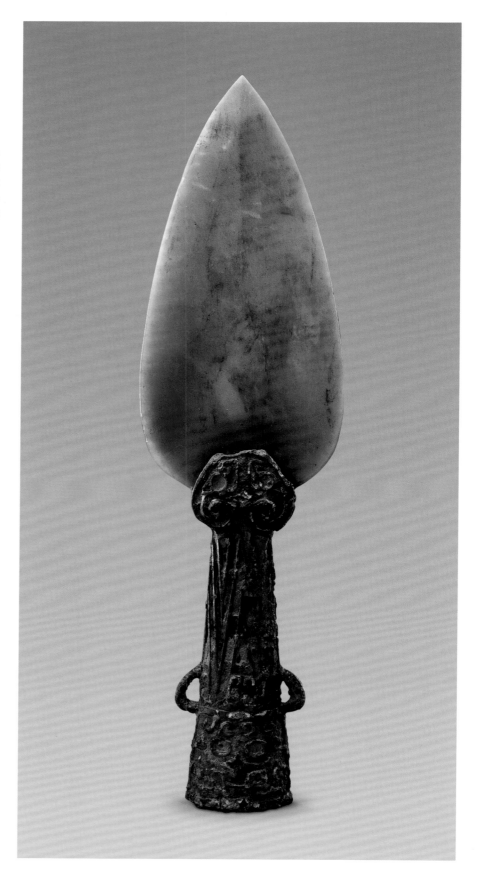

90

Ge (Dagger Axe)
Made for the Use of
Han Wang Shi Ye

Spring and Autumn Period

Length 14.9 cm
Width 6.7 cm
Qing court collection

This dagger axe has a broad blade, a short *hu* (arch), and a tube. Its tang has hollowed-out bird and animal patterns. The blade is concave in the middle and on the ridge of both sides there is an inscription with eight characters recording that this dagger axe was made for the use of Han Wang Shi Ye.

Based on the textual research of Guo Moruo, Han Wang Shi Ye was Shou Meng, the King of Wu, who reigned from 586 BC to 561 BC. This *ge* was beautifully cast; the designs of birds and animals on its tang are unique in style and very vivid.

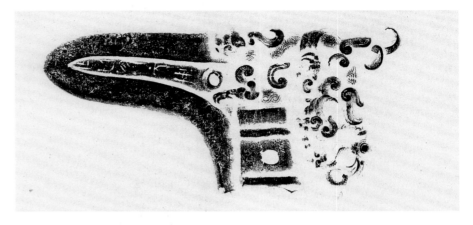

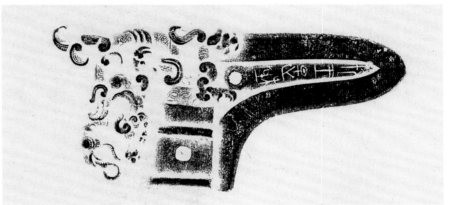

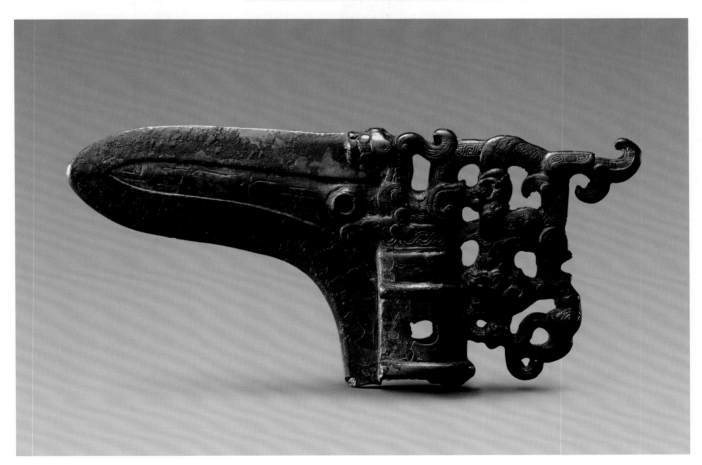

91

Jian (Sword)
with Inscription
"Shao Ju"

Spring and Autumn Period

Length 54 cm
Width 5 cm

The body of the sword protrudes in the middle. There is a hand-guard between the body and handle of the sword. The hand-guard and head of the handle are inlaid with turquoise and gold. On the ridge of the sword is a gold-inlaid inscription of 20 characters in tadpole script, naming the sword "Shao Ju."

This sword was a weapon made in the State of Jin during the Spring and Autumn period. It is meticulously cast with beautiful designs and inscription. Jin was a feudal state with the family name "Ji" in the early Western Zhou Dynasty. It was originally called "Tang," located at the southern part of the present-day Shanxi Province. It was one of the hegemons during the Spring and Autumn period.

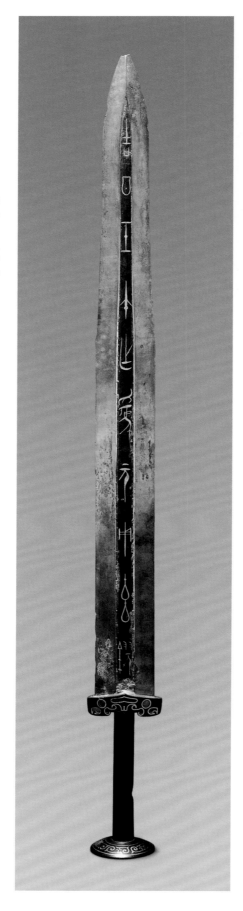
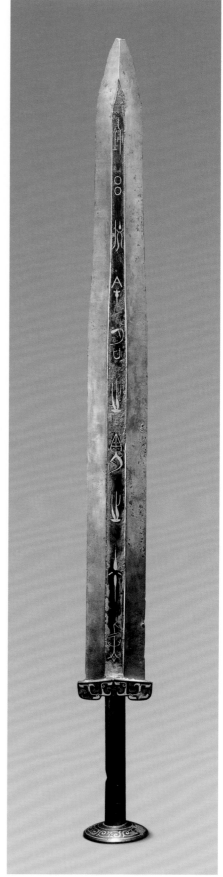

92
Jian (Sword)
of Gou Jian, King of Yue
Spring and Autumn Period

Length 64 cm
Width 4.7 cm
Qing court collection

This sword has a long body, a hand-guard, a handle with a head. The handle has two hoops, the head of the handle is decorated with thunder patterns, and the hoops are inlaid with turquoise. Inscribed on the two sides of the hand-guard are a total of eight characters in bird script, recording the owner of this sword. On one side, two characters *yue wang* were inscribed at both ends; whereas on the other side, four characters were *zhe zhi yu yang* inscribed.

"Yue wang" means the King of Yue. *Zhe zhi yu yang* means Shi Yue who was the son of Gou Jian, King of Yue. Shi Yu reigned from 464 BC to 459 BC. The sword's inscription in bird script is exquisite and its designs are also very beautiful.

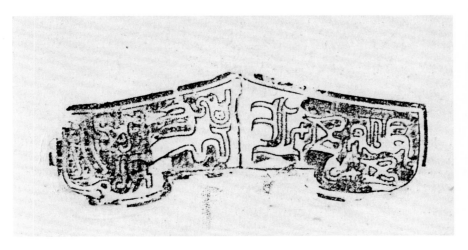

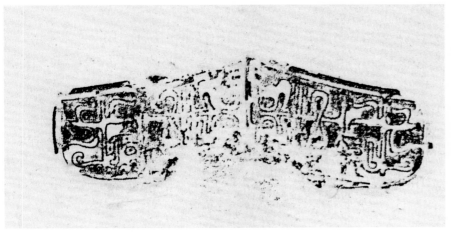

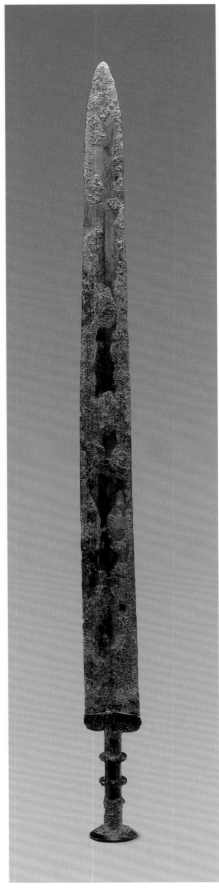

93

Ge (Dagger Axe) of Yin Zhang, King of Chu

Warring States Period

Length 22.3 cm
Width 7.2 cm

This dagger axe has a long blade with a protruding ridge, and a rectangular tang, inside which is a long hole. Its *hu* is damaged and has a hole. Inscribed on the blade and the damaged *hu* are 18 characters in gold-inlaid bird script, recording that this dagger axe was an instrument of Yin Zhang, King of Chu.

Yin Zhang was Xiong Zhang, King Hui of Chu, reigned from 488 BC to 432 BC. Its perfect craftsmanship and well-written inscription are rarely seen on such a weapon, and has high historical and artistic value. In addition to this dagger axe, a sword and a bell of Yin Zhang, King of Chu, are also handed down from that period.

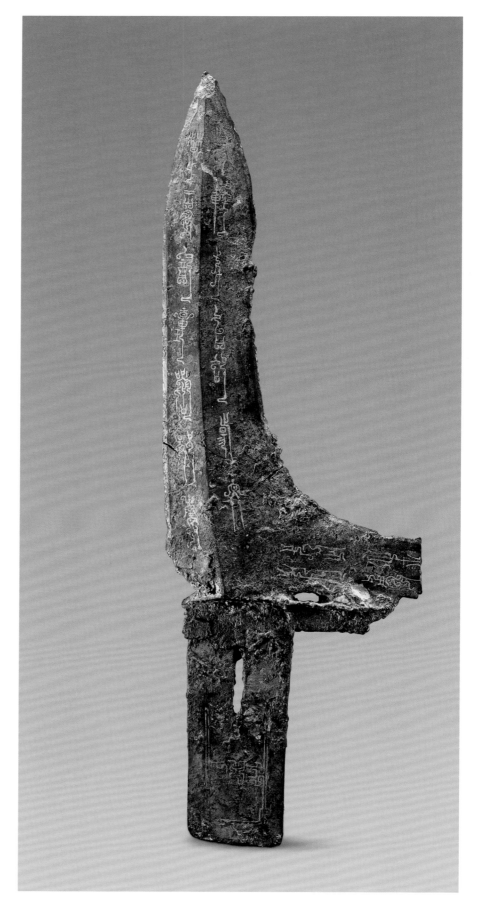

170

94

Ji (Halberd)
with a Wheel

Warring States Period

Length 37 cm
Width 12.2 cm

This halberd has a curved blade, which droops on the front part. It has a *hu*, behind which is a round tube. Behind the tube is a tang in battle-axe shape, which has a round hole. Behind the tang is a wheel, which has eight spokes in it. Both sides of the tang are decorated with designs. On the one side, there is a snake on both upper and lower parts of the tang and a tortoise near the wheel. On the other side, there is one dragon and one tiger.

This *ji* has an extremely unusual shape and structure, being the only one of its type that exists in the world.

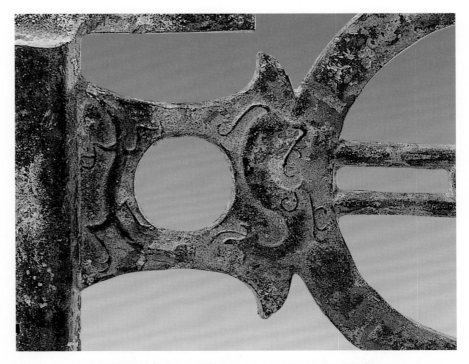

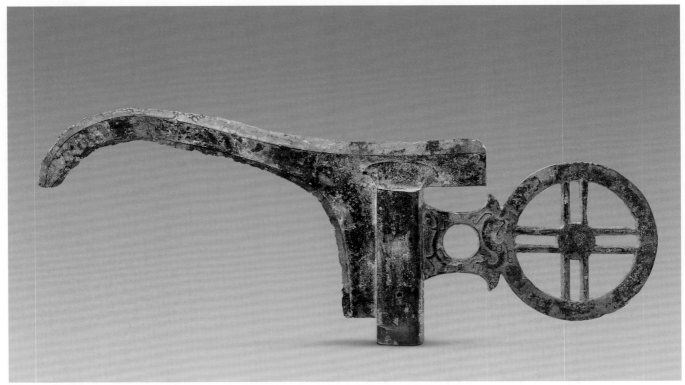

95

Dui (Spear Ornament)
Made by Da Liang Zao for Shang Yang's Use
Warring States Period

Length 5.7 cm
Width 2.4 cm

This *dui* is cylinder-shaped, with a flat base, and a protruding hoop near the mouth. On the body is an inscription of 13 characters in four lines, recording that a spear was made by Da Liang Zao for Shang Yang in 346 BC.

Dui is an ornament at the lower end of the handle of a spear. Shang Yang, born in the State of Wei in the Warring States period, assisted the State of Qin to carry out reforms that strengthened Qin. Da Liang Zao is a Qin title of nobility, and Shang Yang was awarded this title in 352 BC. This *dui* has high historical value as it records the exact time of its casting and use by Shang Yang.

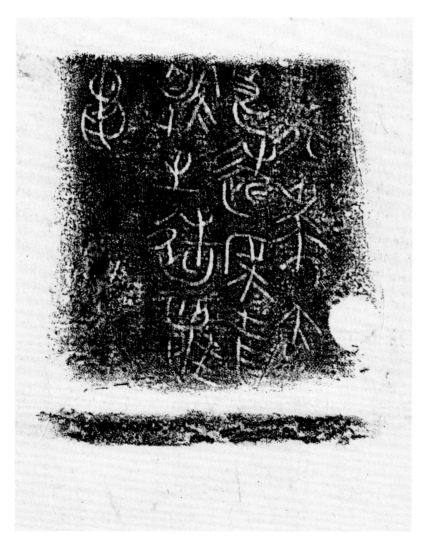
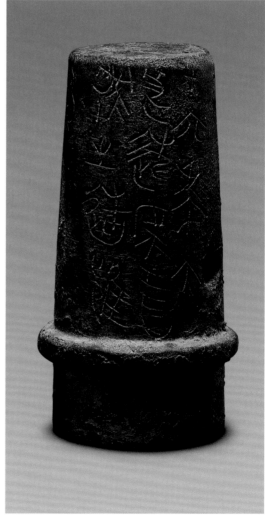

96

Yue (Finial of Dagger Axe) Inlaid with Gold and Silver

Warring States Period

Length 17.1 cm
Width 6.7 cm

This *yue* has a circular tube, on which sits an eagle sculpture. The bird is turning around to tidy up its feathers. The whole instrument is inlaid with gold and silver, and the tube has designs of clouded dragons, tigers, deer, phoenixes, and people. The feathers of the bird sitting on the tube are inlaid with gold and silver threads.

The *yue* has an ornament on the upper end of the handle. This instrument is of exquisite workmanship and vivid design. The bird's image is particularly vivid and lively, showing the development level of bronze craftsmanship at that time.

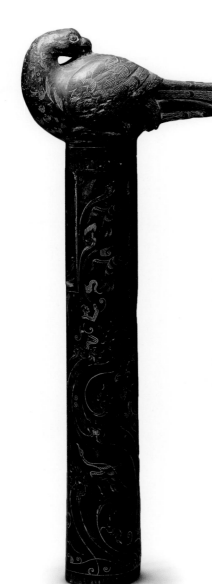

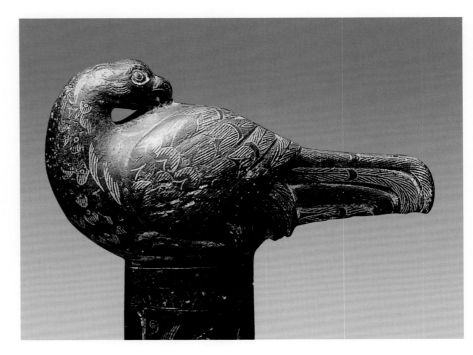

173

97

Hawk Tally

Warring States Period

Length 4.7 cm
Width 3.6 cm

This tally appears like an eagle sculpture and has a round hole respectively on the upper and lower parts. On the eagle's body are patterns of scale-shaped feathers. There is an inscription on the two wings of the eagle.

A tally is a warrant for transmitting orders and deploying forces. A tally has writing on it and is cut into two parts, one of which is to be kept by each of the two parties. When in use, these two parts should match each other as confirmation. Tallies were often in the shape of tigers during the Warring States period, and rarely in the shape of eagles.

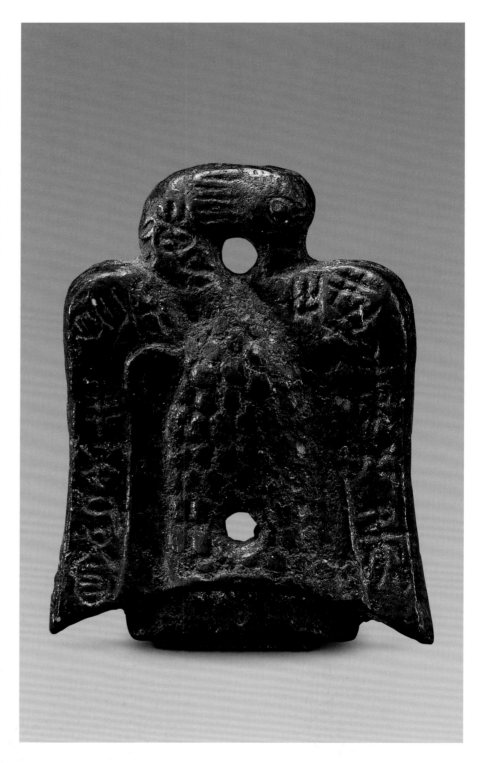

98
Tiger-shaped *Jie*
(Warrant, Serving as a Pass)
Warring States Period

Length 10.7 cm
Width 15.9 cm

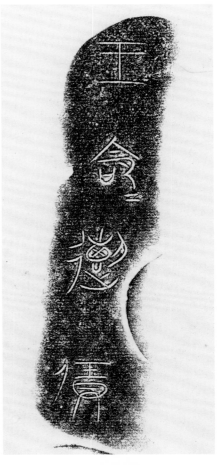

This warrant is in the shape of a crouching tiger, with its mouth open, its head raised, its body bent, and its tail curled up in the posture of leaping, the image of which is extremely vivid. Five characters are inscribed horizontally across its body.

Jie served as a pass in ancient times, and was usually held by an envoy going abroad on a diplomatic mission.

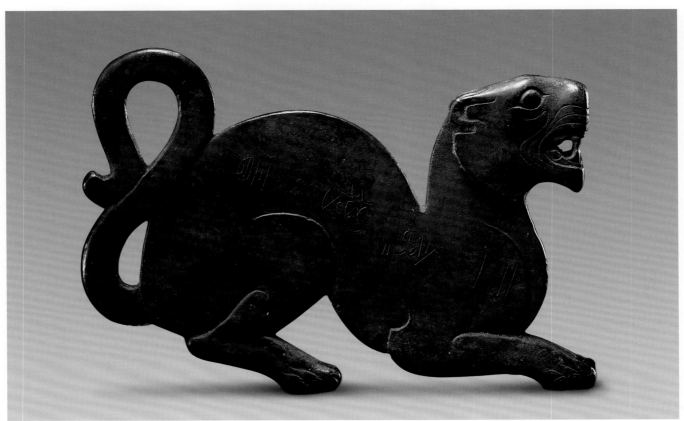

BRONZEWARE FOR DAILY USE

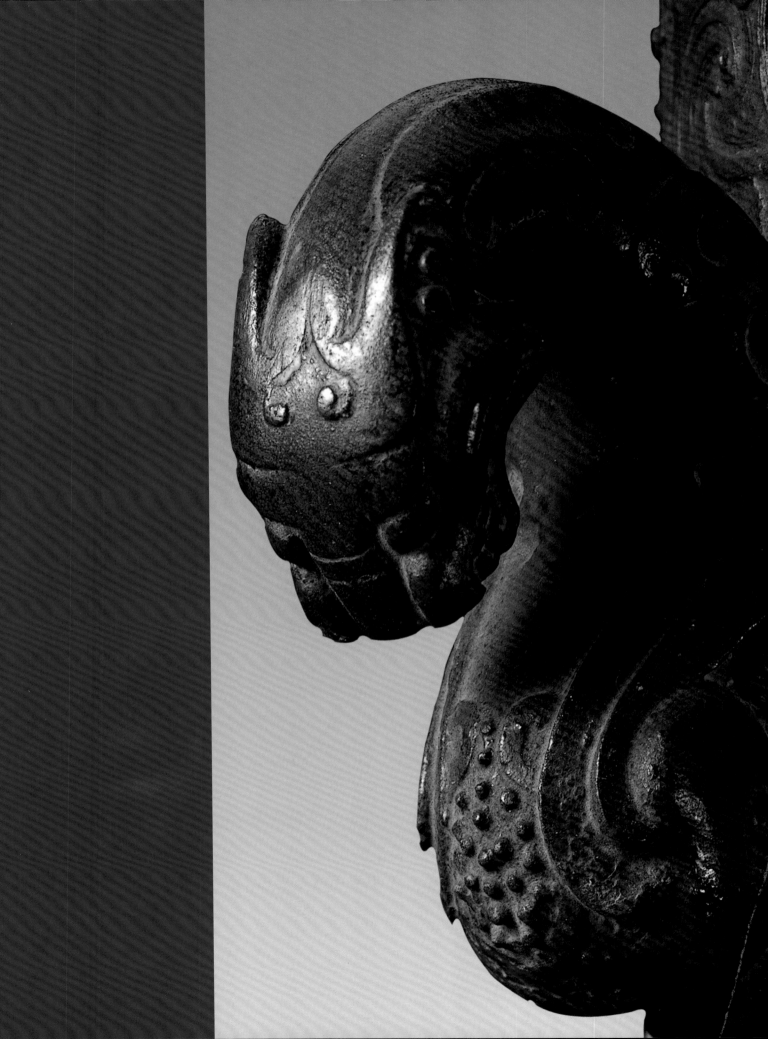

99

Bronze Chariot Ornament
with Double-rabbit Design

Shang Dynasty

Height 8.8 cm
Width 15.6 cm

The body of this instrument is cylindrical with the openings at each end being different in size and thickness. On top of the tube are sculptured two rabbits with long ears, round eyes, and cloud designs all over their bodies. The rabbits have their tails joined and are standing back to back.

This chariot ornament is cast meticulously and is vivid and lively. Its rabbits appear real. This is rare in chariot ornaments of the Shang Dynasty.

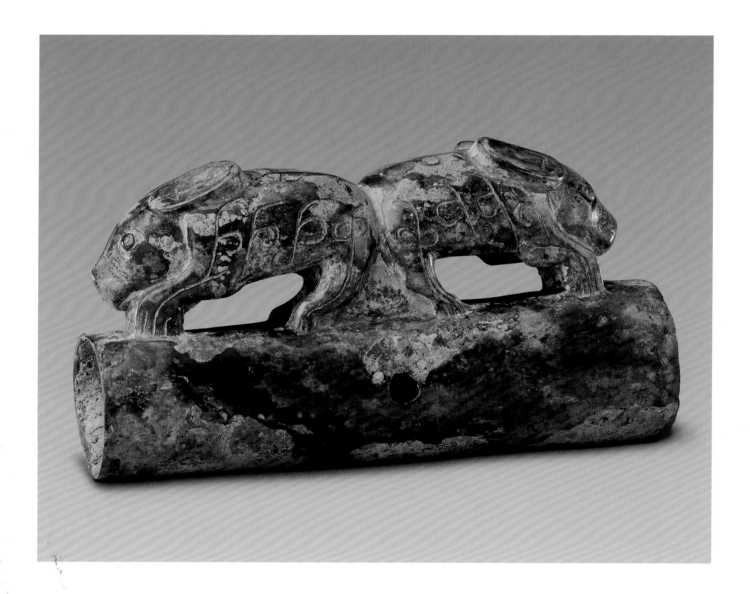

100

Bronze Horse Mask
with Animal-mask Design

Western Zhou Dynasty

Height 17.8 cm
Width 34.5 cm
Qing court collection

This instrument is in the shape of an animal face with thick eyebrows, round eyes, and a large nose. There are holes on the edge of the mask for fastening leather strings.

A horse mask was an ornament to be worn on a horse's forehead. Archaeological findings show that this kind of object was mostly used during the Western Zhou Dynasty. It was previously mistaken as a tool for driving out epidemics and evil spirits. However, recent discoveries of three similar articles with animal-mask designs which were worn on horses' heads in the Western Zhou No. 2 Chariot and Horse Pit in Zhangjiapo, Xi'an, Shaanxi Province, and the excavation of these ornamental articles together with round bits of bridles in Xin Village, Jun County, Henan Province, proved that this object was a horse mask.

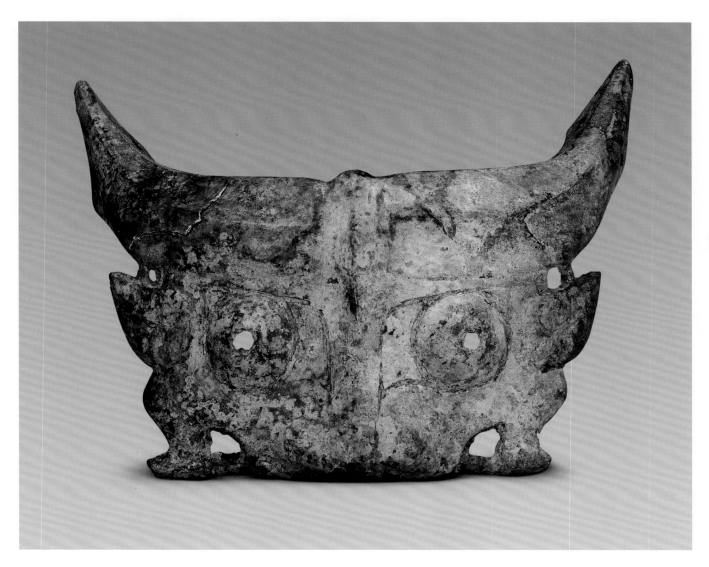

101

Bronze Chengzhou Bell
Western Zhou Dynasty

Height 8.5 cm
Spacing of Xian 6.5 cm

This instrument is an ellipsoid with a semicircular lug. There is a lug in the instrument to which a loop is fastened. Below *wu* (the top), there is a hole on each of the front and back sides of the instrument. On the front side is an embossed inscription in two lines of four characters.

A bell is a musical instrument as well as an ornament of a chariot, flag, and horse. The first two characters of the inscription refer to Chengzhou, the eastern capital of the Western Zhou Dynasty, present-day Luoyang, Henan Province. During the period of Western Zhou, bronze bells rarely had inscriptions. This instrument has considerable value in the study of the system of using bells and other social customs of the Western Zhou Dynasty.

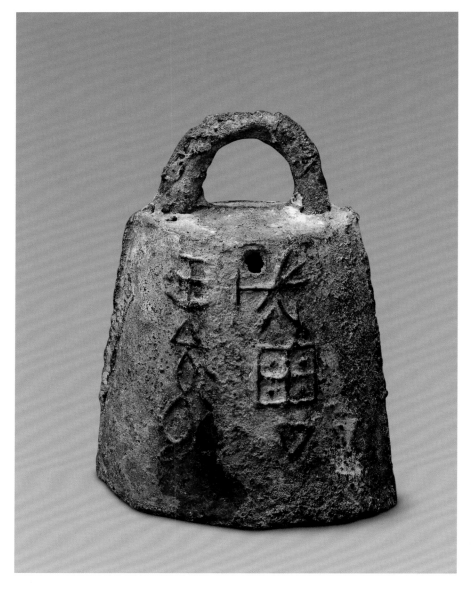

102

Bronze Chariot Linchpin in the Shape of a Human Head

Western Zhou Dynasty

Height 12 cm
Width 5.6 cm

This instrument has a prolate body, having a rectangular tube on one end, and a three-dimensional figure of a human head. The facial features are finely arranged. The eyebrows, nose, mouth, and ears are in convex profile, the eyelid edges are clear, and the eyeballs are slightly protruding, making the face extremely life-like.

A linchpin was a part of an axle in carts of ancient times, used together with another necessary part called *wei*. It was used to pin the axle and *wei* together to avoid the *wei* from falling off.

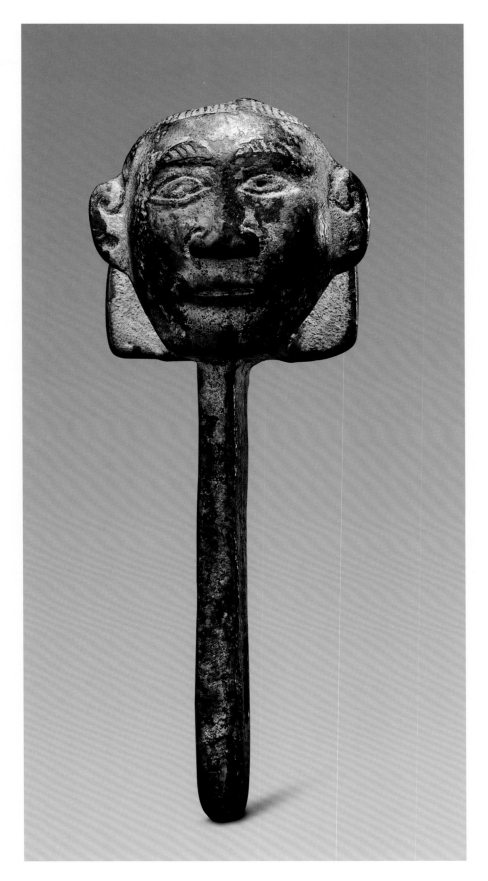

103

Bronze Chariot Bell
with Inscription
"Ze Bao"
Western Zhou Dynasty

Height 17 cm
Width 9 cm

The upper part of this instrument is round in shape, with a spherical bell in the middle. The bell has a round hole at the centre, encircled by eight teeth-like openings, and has a stone pellet inside it. The outer edge of the bell has a band of openwork ring rim. The lower part of the instrument is a ladder-shaped hollow base. Each of the four walls of the base has a vertical straight line in the middle, and four spikes. Each of the two side-walls has a round hole near the bottom. One of the side-walls has an inscription in two lines with four characters, recording that the chariot bell was an instrument of the State of Ze.

This bell would have been used for a chariot, and fastened on the upper part of the crossbar. The State of Ze was a feudal state granted by the Western Zhou Dynasty, having a family name "Jiang." It is presently located at Qian He river valley, Baoji City, Shaanxi Province.

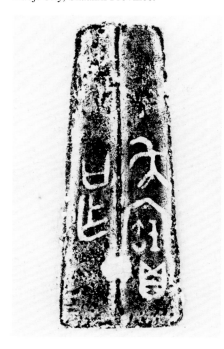

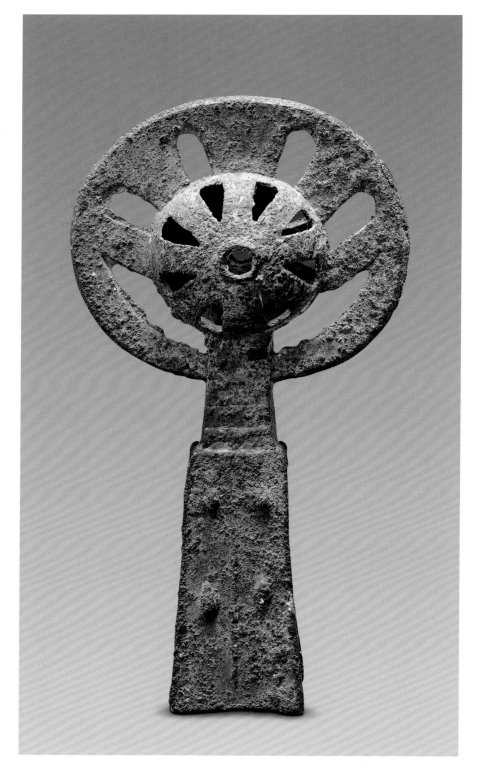

182

104

Bronze Stove
with Coiling Serpent Design
Spring and Autumn Period

Overall height 34.5 cm
Diameter 50.5 cm

This instrument is in the shape of a round plate, with its rim folded outwards. It has a shallow belly, a flat base, under which are three short legs. On each of the two sides below the rim is a chain, which has a rectangular buckle on one end, and is connected to the round lug of the stove on the other end. The outer side of the stove has a coiling serpent design.

This is a charcoal stove called *xuan* in ancient China. A charcoal dustpan was still attached to it when it was unearthed in 1923 in Xinzheng City, Henan Province. Charcoal was burned in it for keeping warm.

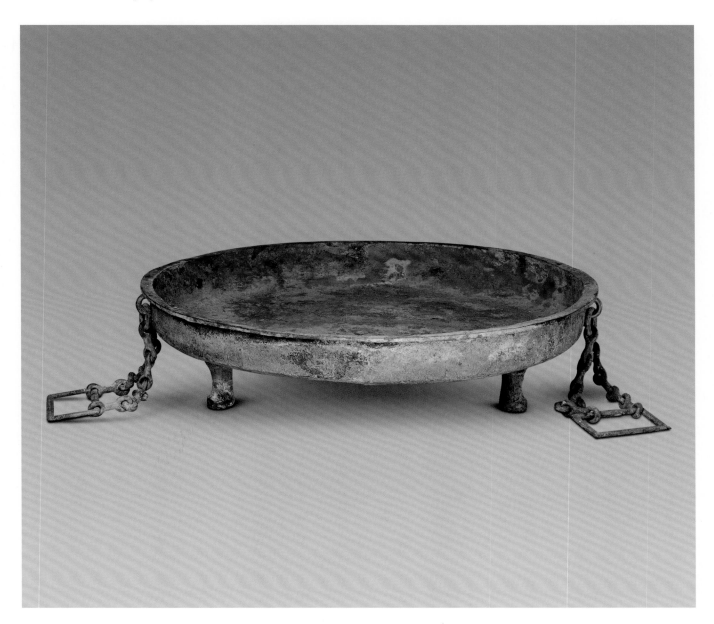

105

Bronze Shovel
with Small Openings
Spring and Autumn Period

Height 9.5 cm
Width 33.5 cm

This instrument is in the shape of a dustpan, broad at the front and narrow at the back. There are rectangular and rhomboid openings at the bottom and on the three sides of the shovel so that ashes could escape. At the back is a hollow round-tube-shape handle.

A shovel is also known as a charcoal dustpan. It was a tool for lifting and moving charcoal, accessorised with a stove for keeping warm. It was unearthed in 1923 in Xinzheng City, Henan Province.

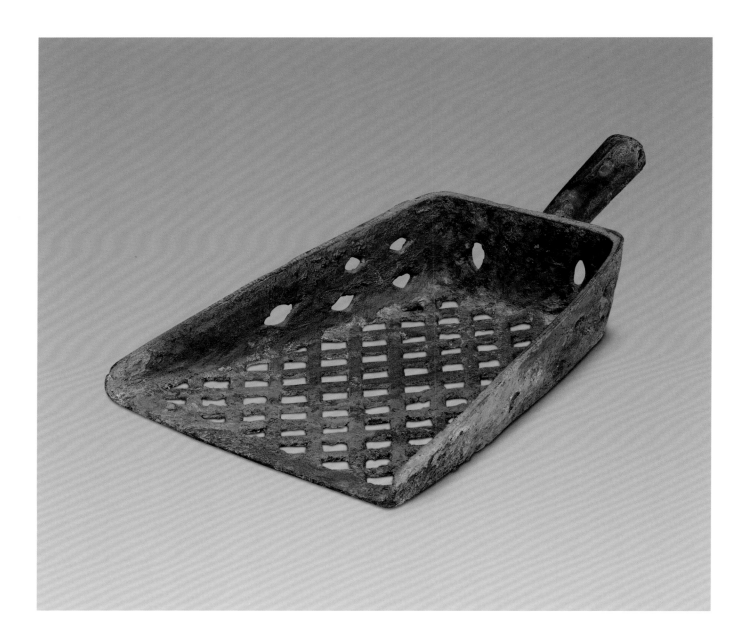

106

Bronze Chariot *Wei* (Axle Endpiece)
with Interlaced Hydra Design

Warring States Period

Height 9.3 cm Width 9.2 cm

This axle end-piece is in the shape of a tube, closed on one end and with a round opening on the other end. The opening has a broad flat border. On each of the two sides near the opening is a rectangular hole, through which a linchpin is pegged. There is a hole on each of the two ends of the linchpin. On the outer wall, there is a ridge around the tube at the point about one third from the opening, and there are designs of interlaced hydras in the area between the ridge and the opening. One end of the linchpin is also decorated with interlaced hydra designs.

Wei was an important component of chariots in ancient times. It was placed on the outer side of a wheel at the very end of the axle. It was used as a set with the linchpin to prevent the wheel from falling off. If the linchpin fell off, the *wei* would fall off; if the *wei* fell off, the axle would also fall off.

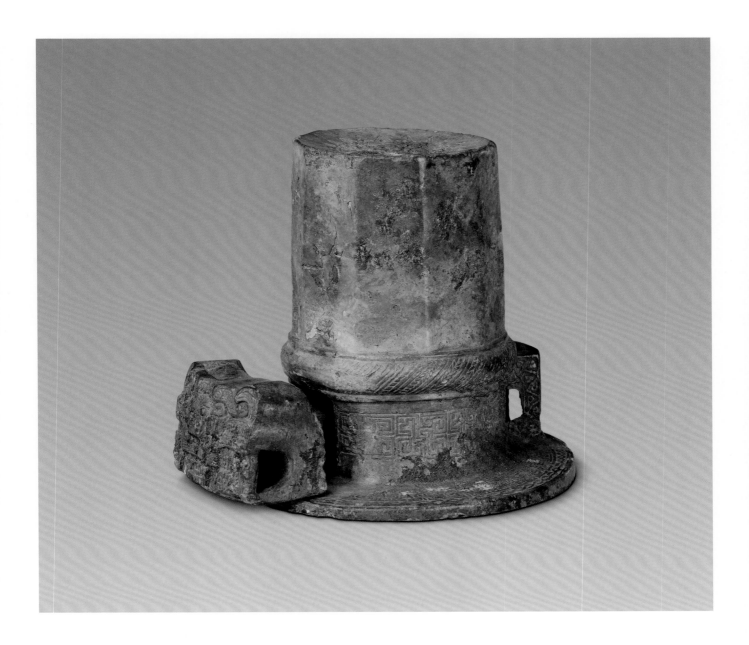

107

Bronze Candleholder with Silver-inlaid Lozenge Design

Warring States Period

Height 32.1 cm
Width 21.9 cm

This candleholder has a shallow round plate, and a long thin handle that stretches down to a base that looks like a concave cone. At the centre of the plate is a pointed rod for holding a candle. The whole instrument is decorated with silver-inlaid designs of geometric figures such as lozenges.

A candleholder, also known as *ding*, was a lighting appliance used in ancient times. Bronze candleholders were mainly popular during the Warring States period, and the Eastern and Western Han Dynasties. It has a great variety of styles and shapes, such as stemmed bowls, animals, trees, and human figures. A candleholder of this shape and structure is also called a stemmed-bowl candleholder as it looks like a *dou* (stemmed bowl) which was a food container. This candleholder is an outstanding work of its type.

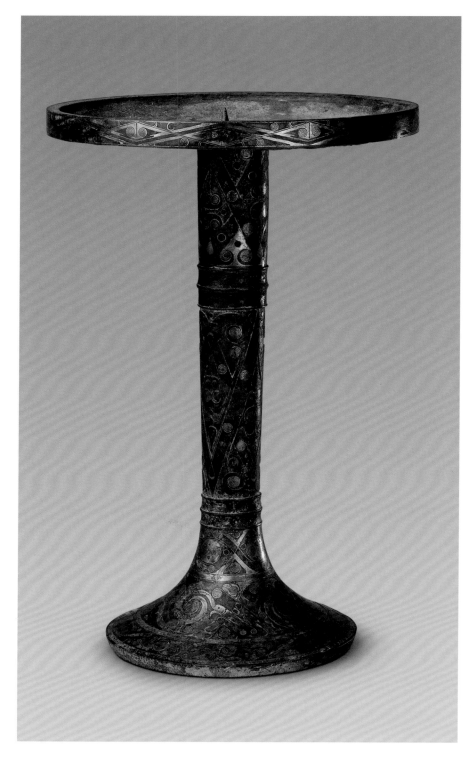

108

Bronze Mirror
with Four Patterns in the Shape of the Chinese
Character "山" (Mountain)

Warring States Period

Diameter 11.4 cm

This mirror is round in shape. It has a small button with a bowstring design and a folded edge. The four sides of its square-shaped button base have out-stretching leaves patterns. It has four patterns in the shape of the Chinese character *shan* 山 (mountain) arranged in an anti-clockwise direction. It has feathers as its background.

The front of this bronze mirror is for looking at one's face. Its back side is decorated with patterns. Mirrors with the patterns of the Chinese character *shan* 山 (mountain) were a fashionable design during the Warring States period. Four mountain patterns were the most popular.

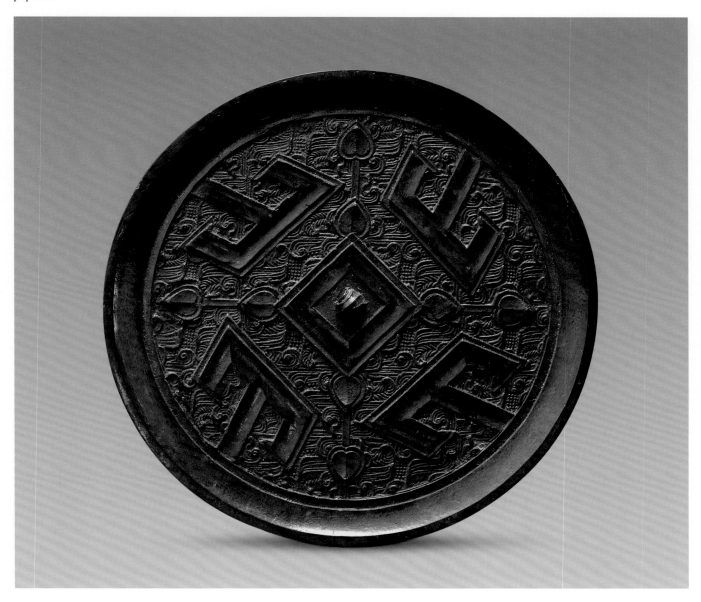

109

Bronze Mirror
with Five Patterns in the Shape of the Chinese
Character "山" (Mountain)

Warring States Period

Diameter 11.4 cm

This mirror is round in shape. It has three bowstring buttons and an upturned edge. The outside of its round base is surrounded by five petals. Its main motif is five patterns of the Chinese character *shan* 山 (mountain), and it has small feather-like patterns as its background.

This mirror was skilfully cast with beautiful patterns as decorations.

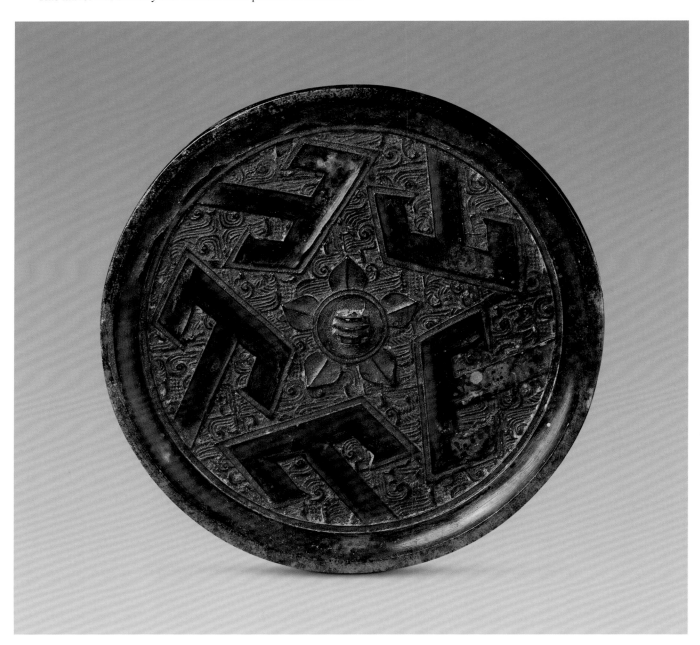

110

Bronze Mirror
with *Kui*-dragon Design
Warring States Period

Diameter 19.3 cm

The mirror is round in shape. It has three small bowstring buttons, a round button base, and a plain and upturned edge. The exterior side of the button base is decorated with a band of cords. The main motif is the three groups of *kui*-dragons that surround the body of the mirror. It has the cloud and thunder patterns as its background.

The patterns of this mirror are refined, smooth, and skilfully structured and particularly outstanding in their details, reflecting the maturity of the casting industry at that time.

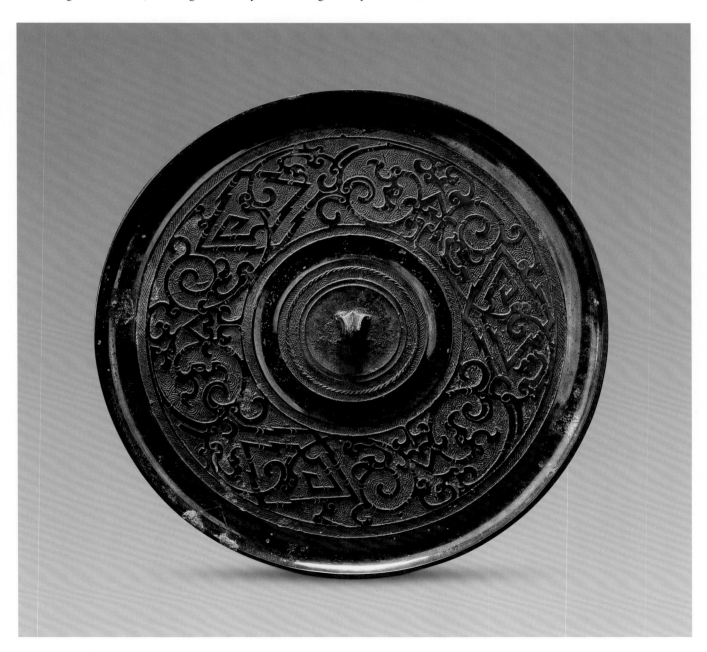

111

Bronze Mirror
with Feather Design

Warring States Period

Diameter 7.7 cm

This mirror is round in shape. It has a small bowstring button, a square button base, and a plain, broad, and upturned edge. Its main motif is a feather-shaped design, like fluttering waves, and there are small clouds and thunder patterns as its background.

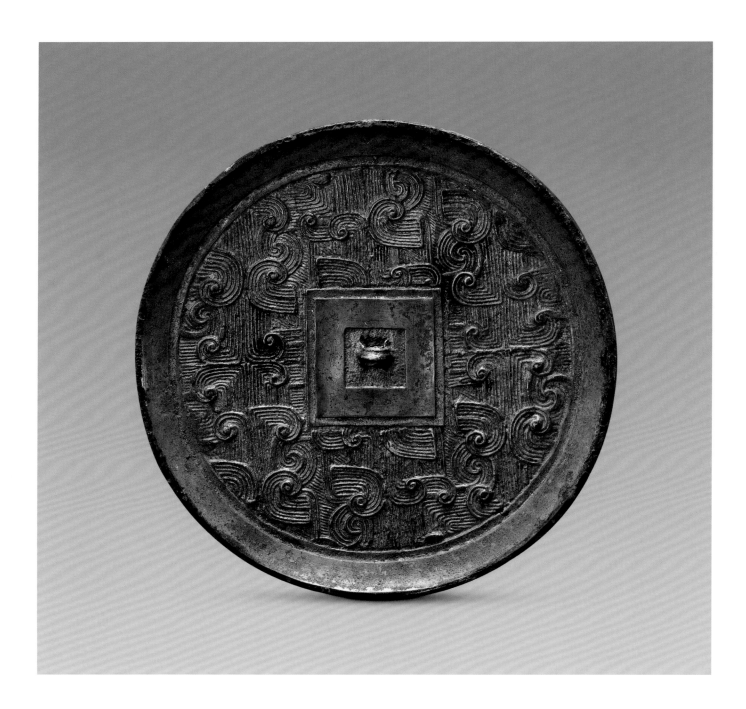

112

Bronze Mirror
with Lozenge Design

Warring States Period

Diameter 13 cm

This mirror is round in shape. It has three small bowstring buttons, a square button base, and an upturned edge. The concaved water chestnut design is the main motif, with feather-like patterns as background.

This mirror uses geometric patterns to form its design, which is highly decorative in nature.

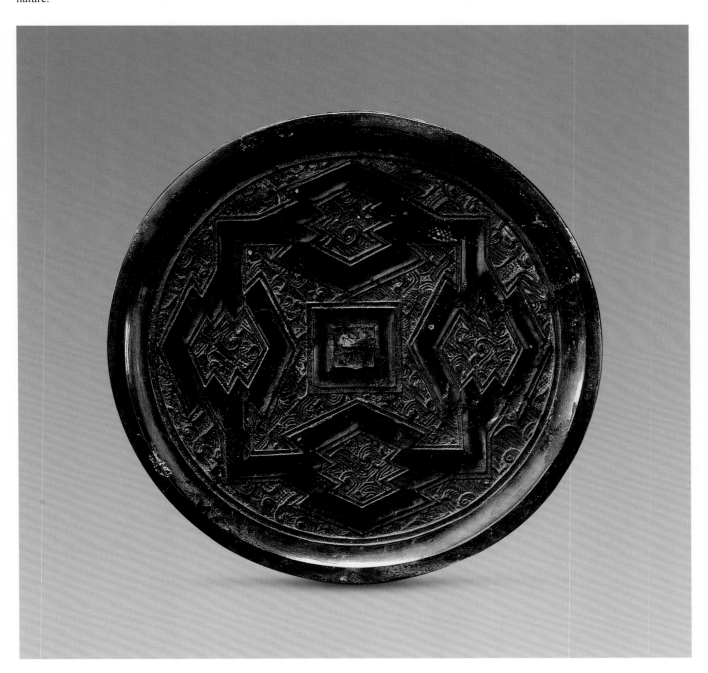

113

Bronze Mirror
with Petal Design

Warring States Period

Diameter 9.2 cm

This mirror is round in shape. It has a square button base, three bowstring buttons, and a plain upturned edge. The main motif is a neatly arranged 12-leaf pattern, and the spaces between leaves are linked by a protruding bowstring pattern, while cloud and dot patterns serve as background.

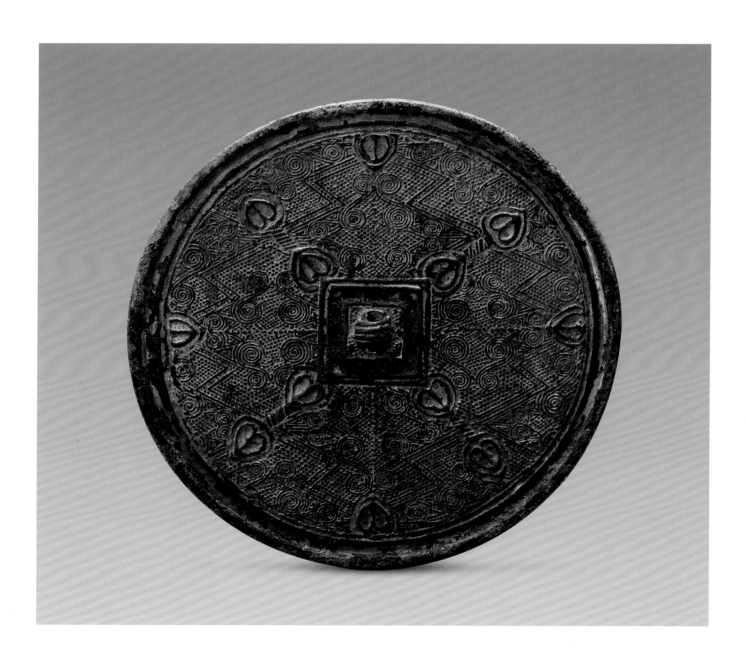

114

Bronze Belt Hook Inlaid with Gold and Turquoise

Warring States Period

Length 14 cm Width 1.4 cm

This belt hook is in the shape of a willow tree leaf, with a leaf's natural curvature. It is flat on one side and spherical on the other. On one end of this hook is a small animal head, with a round button on its flat surface. The surface is inlaid with gold, decorated with clouds and thunder patterns separated by inlaid turquoise.

Belt hooks, also called *shibi*, were hooks worn at the waist by the nobility, intellectuals, and warriors in ancient times, and are made of various materials, such as bronze and jade. This belt hook, inlaid with gold is elegantly crafted, and its sheen manifests its elegance and beauty.

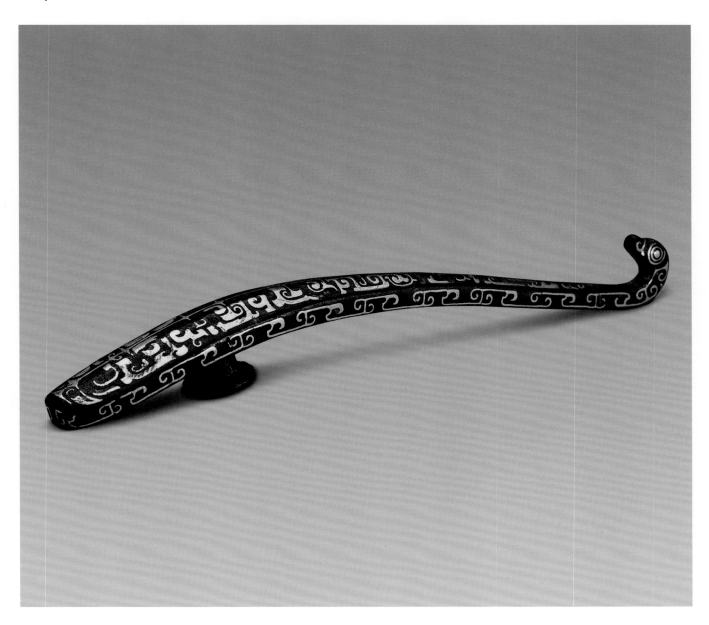

115

Bronze *Huzi* (Urinal) with Dragon-and-Phoenix Design in Gold and Silver Inlay

Warring States Period

Height 13.6 cm Width 22.6 cm

This urinal is an ellipsoid. It has a bulging belly and a flat base. On the back is a bow-shaped handle and in front of the belly is a tube-shaped spout. The entire body is decorated with patterns of beautifully inlaid gold and silver. The belly and back are inlaid with gold and silver, and dragons and phoenixes. The end of the handle has inlaid gold and silver cloud patterns, and the mouth and lower part of the belly are decorated with saw teeth patterns.

Huzi is a urinal, but some say that it is a water container. Most urinals after the Han Dynasty are ceramic and in the shape of an animal. This urinal is exquisitely made with beautiful decorations, allowing us a glimpse of the life of the nobility in ancient times.

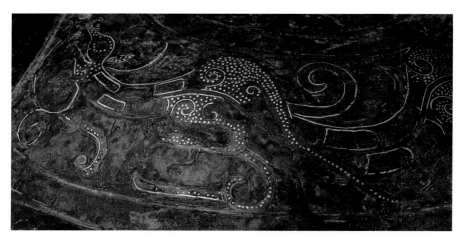

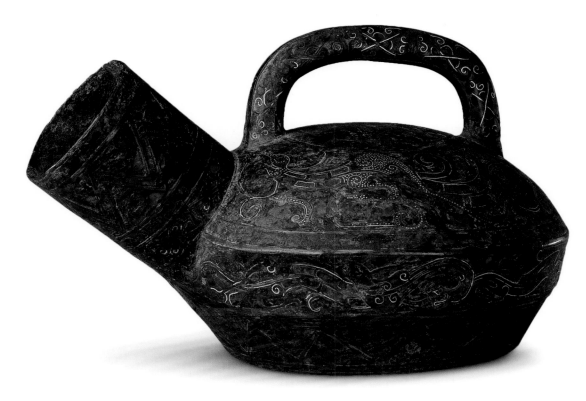

116
Turtledove-shaped Bronze
Head of Walking Stick Inlaid with Silver
Warring States Period
Height 7.7 cm Width 13.4 cm

This walking stick head is in the shape of a pigeon, with its head raised. It has a long neck and tail, and under its belly there is a tube-shaped hole on the axe for installing the handle. The entire body of this stick head is patterned with inlaid silver. The back of this stick head is decorated with feathers and clouds, and the hole, with saw teeth. Under the bird's tail is an inscription.

According to legend, *jiu* (turtledove), also called *banjiu*, is a bird that would not choke on their food. In ancient times, pigeons were engraved on the head of a stick to be given to an elderly person over 70 years of age, hoping that this person would not choke when eating food, meaning that the giver wishes the elderly person longevity. This stick head is made with great craftsmanship, illustrating a high level of artistic attainment, and it also confirms the contemporary social practice of showing respect to elderly people.

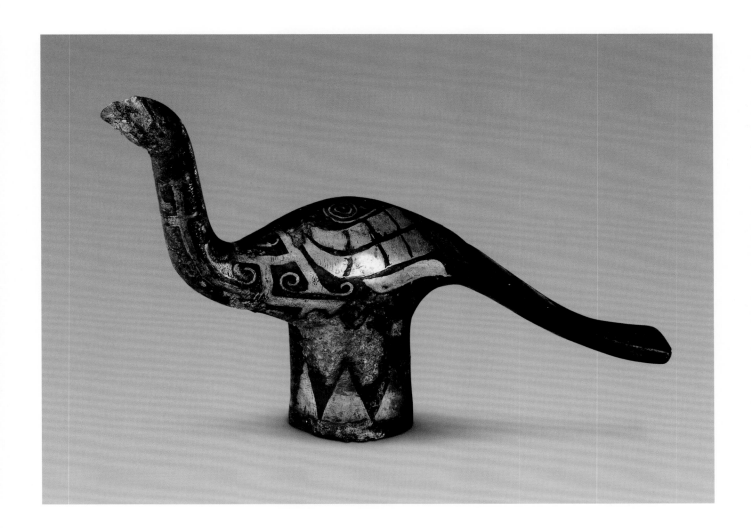

117

Bronze *Dui* (Food Container) with the Character "Gui"

Qin Dynasty

Height 18.8 cm
Width 23.4 cm

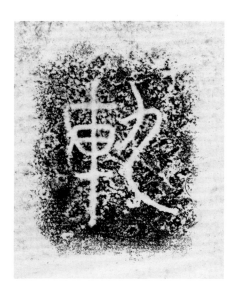

The body of this container is round. It has a deep belly, and on the two sides of its belly are symmetrical door knockers with ring handles. It has a round lid, on top of which has a button with three sacrificial animals. The base has three short legs. On the upper part of the belly is a band of protruding bowstrings, and on the lid top are three bands of distorted interlaced hydras that resemble trees and branches. The vessel and lid are both inscribed with the character *gui*.

The inscription on this container is written in an elegant style, with all the charm of the lesser seal script. *Gui* 軌, homonymous to *gui* 簋 in classical Chinese, should be the original name of food containers. In the Qin Dynasty, food containers in the shape of *dui* were called *gui*. This provides important information for the study of the naming system for bronzeware. This food container was unearthed from the Qin graves of the Western Palace in Luoyang, Henan Province.

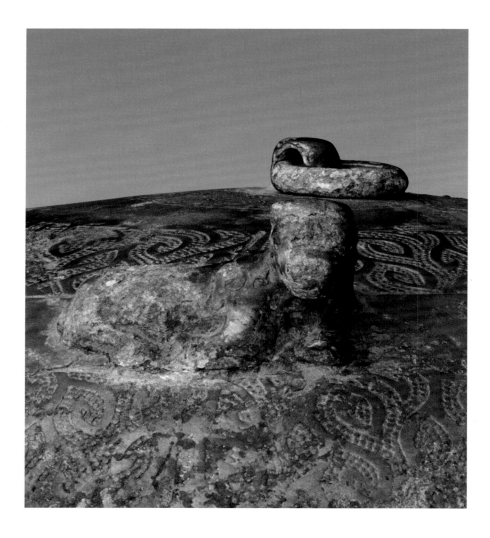

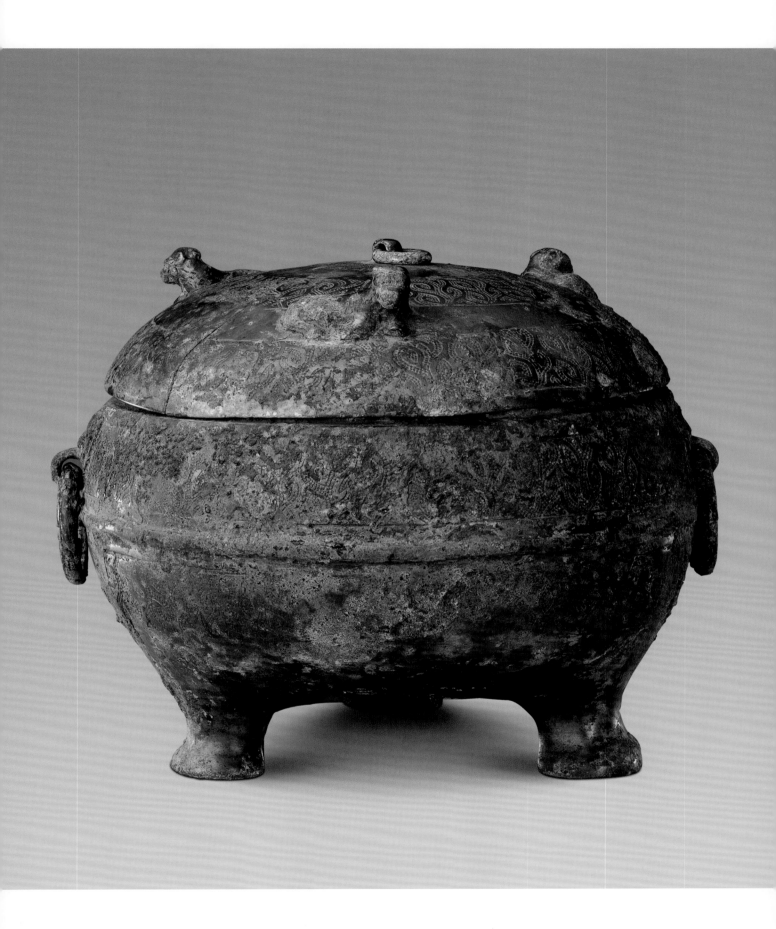

118

Bronze Weighing Apparatus
Qin Dynasty

Height 3.5 cm
Width 4.7 cm

The body of this apparatus is in the shape of a circular cone. It has a flat base, and its top has a flat button in the shape of a bridge. Inscribed on its two sides are 40 characters in 14 lines written in seal script, recording the proclamation of the First Emperor of the Qin Dynasty on the unification of weights and measures in the 26th year of his reign (221 BC).

This is an instrument for weighing objects. In 221 BC when the State of Qin annihilated the Six States, it unified the weights and measures of the entire country, and this proclamation was inscribed on weighing apparatuses. This apparatus is tangible proof of this historical fact.

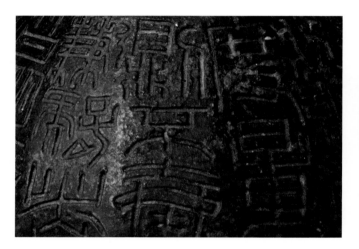
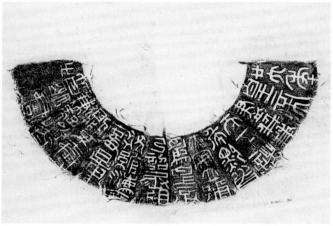

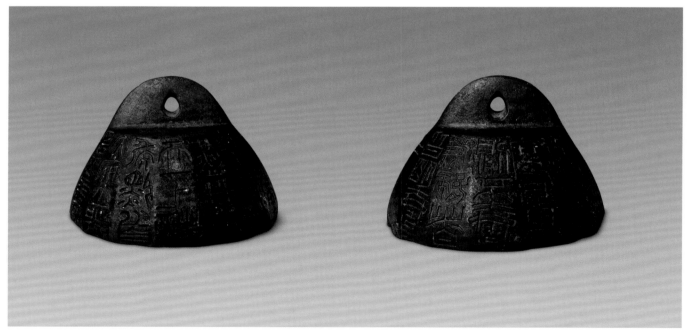

119

Yang Chu *Ding* (Cooking Vessel)

Han Dynasty

Height 19.4 cm
Width 14.7 cm

This vessel is round in shape. It has a deep belly, an inward mouth, two side ears, and a lid on which are three ring buttons. The middle part of the belly has a band of flat and protruded edge, and the lower part has three hoof-shaped legs. The entire body is plain and undecorated. Under the mouth rim is an inscription of 19 characters, recording the places where this vessel was used, its weight, and the time the vessel was cast. Dijie is the title of a period in the reign of Emperor Xuandi of the Han Dynasty. The third year corresponds to 67 BC.

This vessel is simple and neat. Its inscription shows very clearly that this is a kitchen utensil, and its capacity and weight have great value for the study of the system of weights and measures in the Han Dynasty.

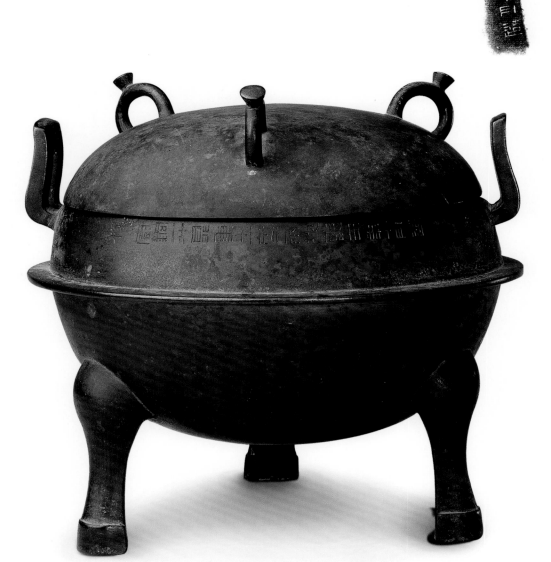

120

Chang Yang Gong *Ding*
(Cooking Vessel)
for Sacrificial Use

Han Dynasty

Height 29.3 cm
Width 19 cm

The body of this cooking vessel is flat and round. It has an inward mouth, a bulging belly, two belly ears, and three short hoofed-shaped legs. It has a round lid and three ring-shaped buttons. The lid top and under the mouth rim have an inscription in seal script, recording the places where this vessel was used and its capacity.

This vessel was a utensil used at the Chang Yang Palace. This palace was an old palace in the Qin Dynasty, and was located 30 Chinese miles to the east of present-day Zhouzhi County in Shaanxi Province. The palace was renovated during the Han Dynasty to serve as a temporary imperial abode.

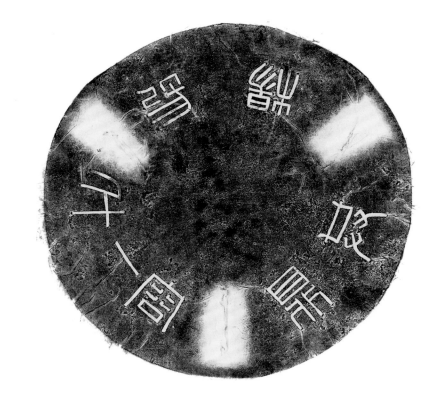

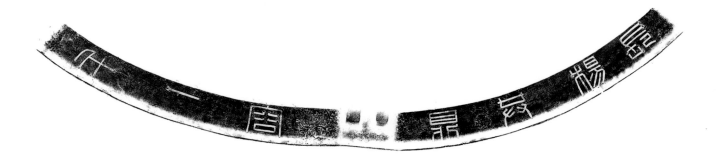

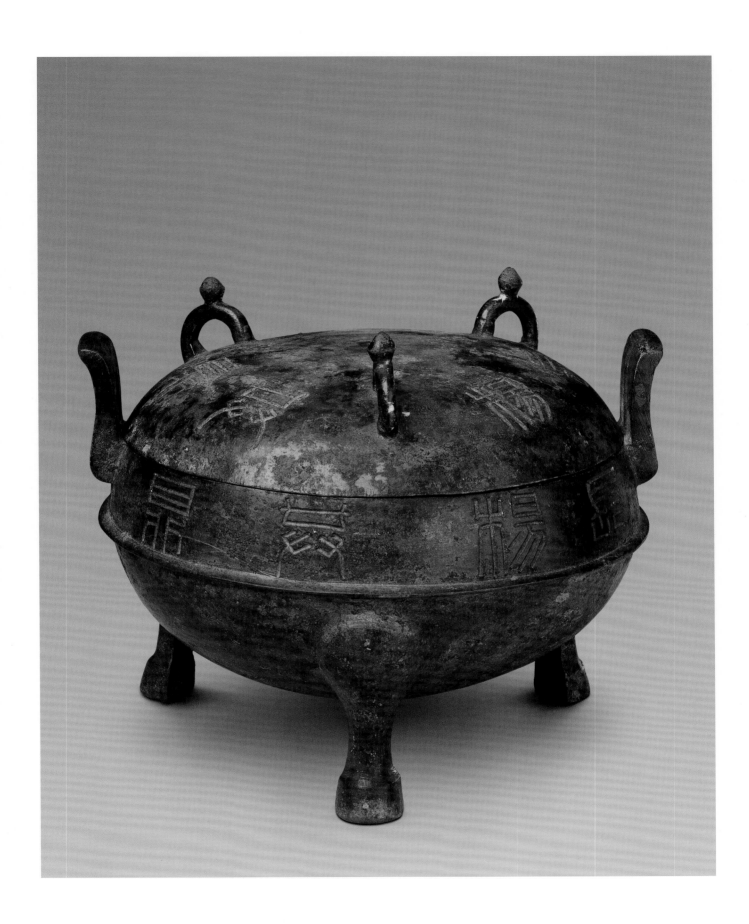

121

Gilded Bronze *Ding* (Cooking Vessel)
Made in the Fourth Year
of Yuanshi Period

Han Dynasty

Height 17.2 cm
Width 20.6 cm

This vessel has a round body, a deep belly, a round base, and three hoof-shaped legs. It has two ring-shaped side ears. The entire body of the vessel is gilded, and on its belly has a band of protruding flanges. Below its mouth rim is an inscription of 25 characters in one line, with some characters damaged. This inscription records that this vessel was made in the fourth year of the Yuanshi period (AD 4) in the reign of Emperor Pingdi of the Han Dynasty.

This vessel contains its exact year of casting and is fully gilded, which is extremely rare.

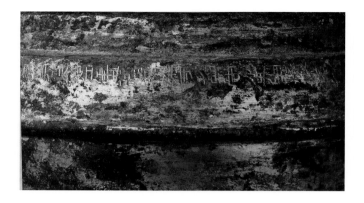

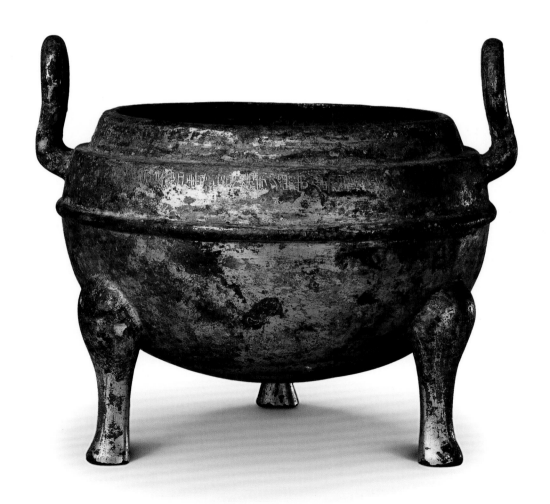

122

Animal-shaped Bronze Cooking Stove

Han Dynasty

Height 10.9 cm
Width 21.9 cm

This cooking stove is in the shape of an animal. The middle part is hollow. It has a flat base and four flat legs. On the top of the stove range are three mouths: one is large and the other two small, arranged in the shape of a triangle. Three frying pans, one large and the other two small, are placed respectively on the mouths. At a corner of the cooking stove there is a small raised tube, on which is placed a smoke pipe. One end of the smoke pipe is in the shape of an animal head with a wide-opened mouth to facilitate smoke emission. The back of the stove has a rectangular opening, which allows the taking and placing of charcoal.

This stove is a burial object and is entombed with the deceased. Its shape is simple and its design, exquisite.

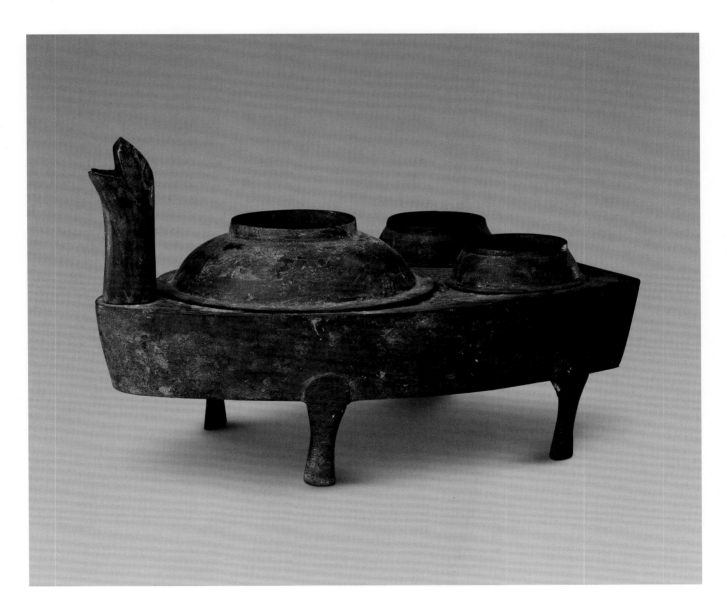

123

Bronze Flat Flask with Two Ears Decorated with Deer Design

Han Dynasty

Height 10.5 cm
Width 9.6 cm

This flask has a vertical mouth and a flat belly, with its two sides in the shape of an arc. The left and right sides of its shoulder have each a ring ear and it has a rectangular foot. The belly has leaves, with its upper part is decorated with waves and a running deer above the water, and its lower part, with diamond-shaped nets. The mouth rim and the foot are decorated with saw teeth and bowstrings.

Bronze flat flasks, also called *jia* or *tong pi*, are mostly wine containers. This piece is small in size and delicate in its modelling. Its craftsmanship is skilful and its decorations are beautiful and lively. This is fairly rare in bronze flasks of the Han Dynasty.

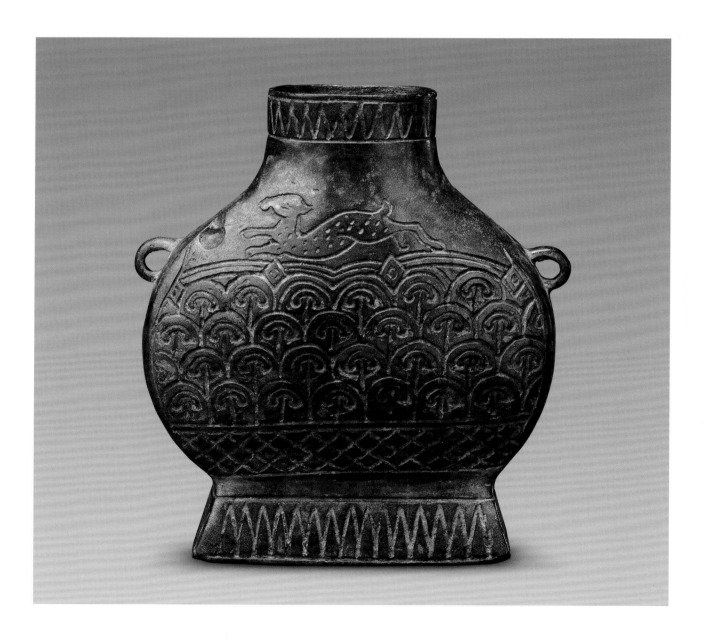

124

Long-necked Bronze Vase with Cloud Design in Silver Inlay

Han Dynasty

Height 29.3 cm
Width 19 cm

This vase has a vertical mouth, a long neck, a flat round belly, and a ring foot. The body of this vase is fully decorated with inlaid silver clouds. The mouth rim and the middle part of its belly are decorated with broad bands, and the place where the neck is connected to the belly is decorated with bowstrings.

Long-neck bronze vases were rarely seen in the Han Dynasty. Most of them have been unearthed in the southwestern region, such as Guangxi and Yunnan provinces. This vase was probably unearthed in this region in some years ago.

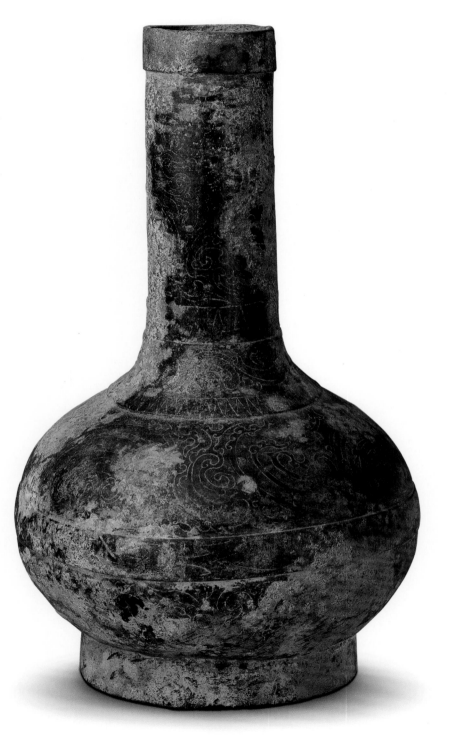

125

Bronze Flat Flask
in the Shape of a Garlic Bulb

Han Dynasty

Height 30.7 cm Width 32.2 cm
Qing court collection

The mouth of this flash is in the shape of a garlic bulb. It has a small neck and a flat belly in an ellipsoid shape. The two sides of its shoulder have each an animal head holding a ring. It has a rectangular ring foot with a flat ring button in its interior. The entire body is plain and undecorated.

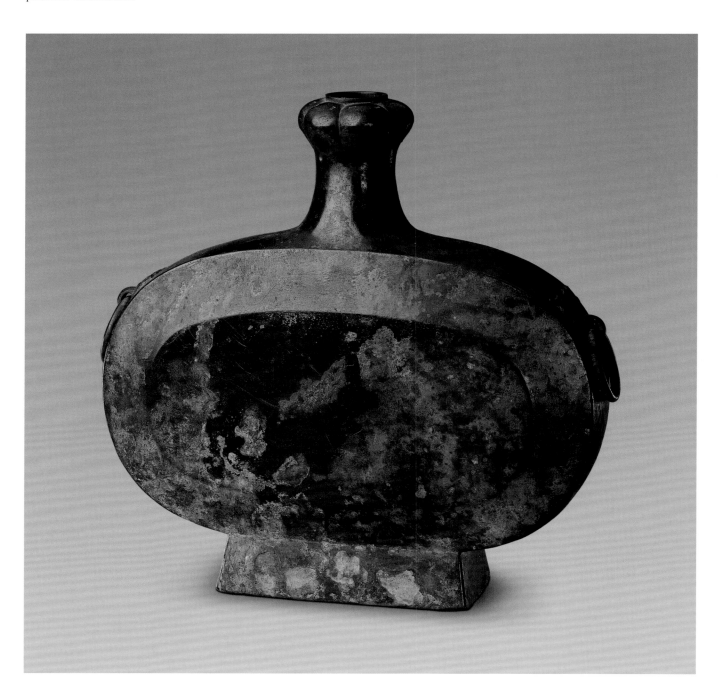

126

Bronze Jar
with Inscription
"Wan Jin"

Han Dynasty

Height 37.5 cm
Diameter of belly 22.8 cm

The mouth of this jar is in the shape of a garlic bulb. The small neck is relatively long and the large belly is in a drooping shape. It has a splay ring foot. The base has an embossed inscription of the characters *wan jin* in seal script.

The body of this jar is slim and long, with an exaggerated posture. The way the character *wan* is written in the inscription is also unique.

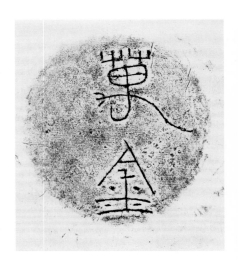

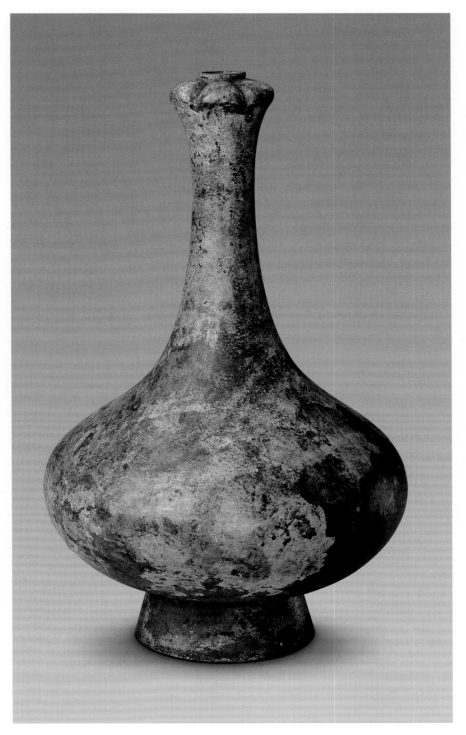

127

Loop-handled Bronze Jar with a Bird-shaped Cover

Han Dynasty

Height 34.4 cm
Diameter of belly 26.3 cm

The mouth of this jar has a spout, above which is a lid in the shape of a bird's head. The mouth of the spout and the bird's beak have lids, which can be opened or closed. The lid top is decorated with two rings, which links the two cross beams and the body of the jar to form a loop handle. The belly is round and bulging, and decorated with a band of broad bands. It has a ring foot.

The shape of this jar is unique, and is rarely seen in bronze jars of the Han Dynasty.

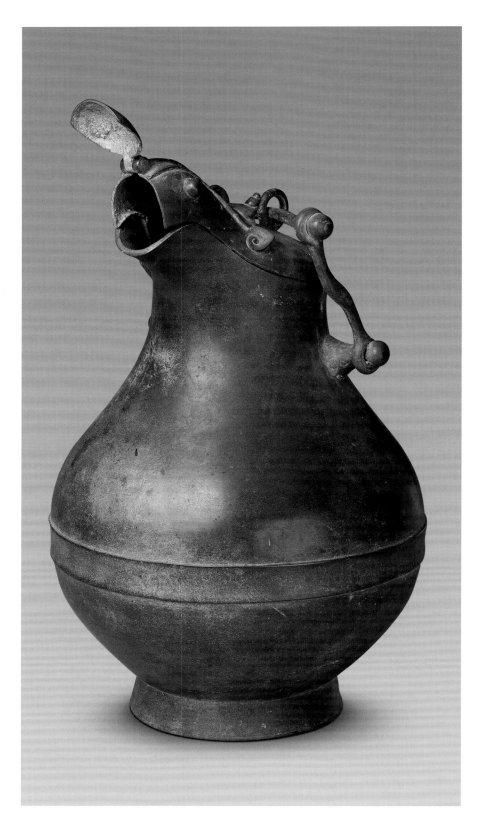

128

Bronze Jar with Inscription "Le Wei Yang"

Han Dynasty

Height 34.9 cm
Diameter of belly 30 cm

This jar has a wide, flared mouth, a contracted neck, a bulging belly, and a ring foot. On the sides of its shoulder are ears each with an animal mask holding a ring. The mouth has broad band pattern around its rim, and the shoulders, belly, and the lower part of the belly are each encircled with three bands of protruding bowstrings. Cast on the base is an embossed inscription nine characters in three lines in seal script, relating to longevity and wealth.

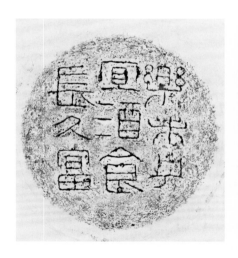

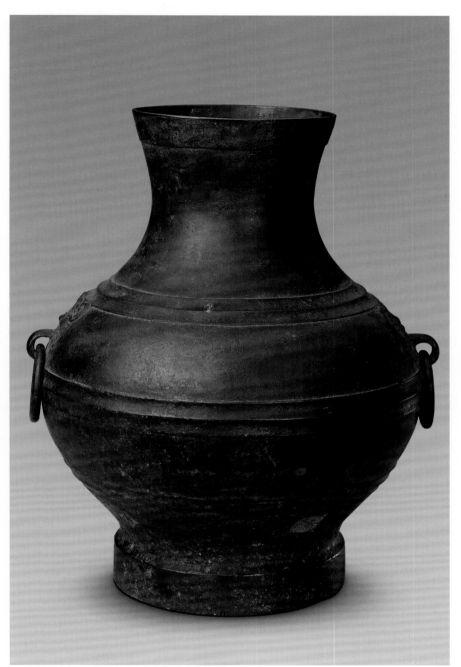

129

Bronze Jar in the Shape
of a Waist Drum

Han Dynasty

Height 19.4 cm
Width 30.3 cm
Qing court collection

This jar has a vertical mouth, a thickened mouth rim, and a short and contracted neck. The shoulder has two ears, each with a round ring. The belly is in the shape of a waist drum, under which there are two rectangular feet. It has a lid which has holes in the form of five-petal plum flowers. The four sides of the lid are surrounded by patterns of five plum flowers. It has a ring-shaped button.

The jar is uniquely made. This shows that jars in the Han Dynasty were plentiful and varied.

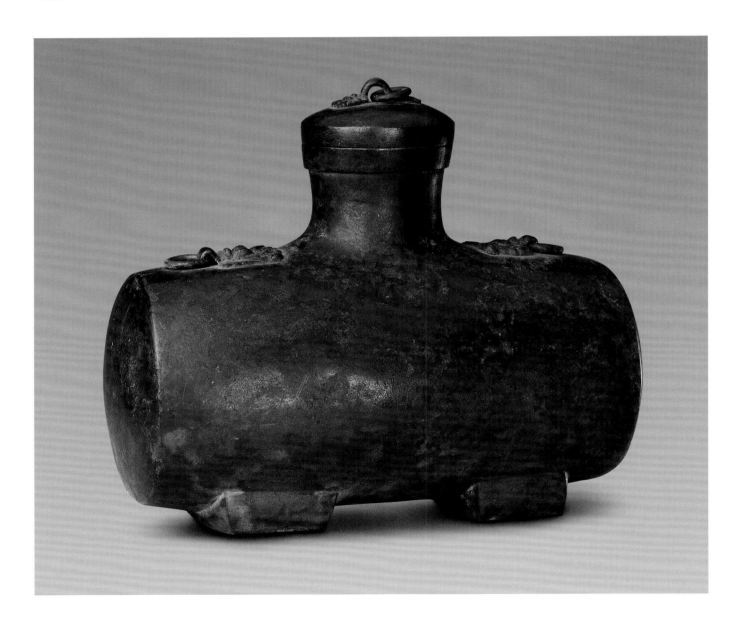

130
Gilded Bronze Jar
Han Dynasty

Height 44.9 cm
Width 37.2 cm
Qing court collection

This jar has a large, everted mouth, a short, contracted neck, a bulging belly, and a high ring foot. The shoulder has a pair of ears each with an animal mask holding a ring. The entire body is gilded. The mouth rim and the upper, middle, and lower parts of the belly are each decorated with a broad band.

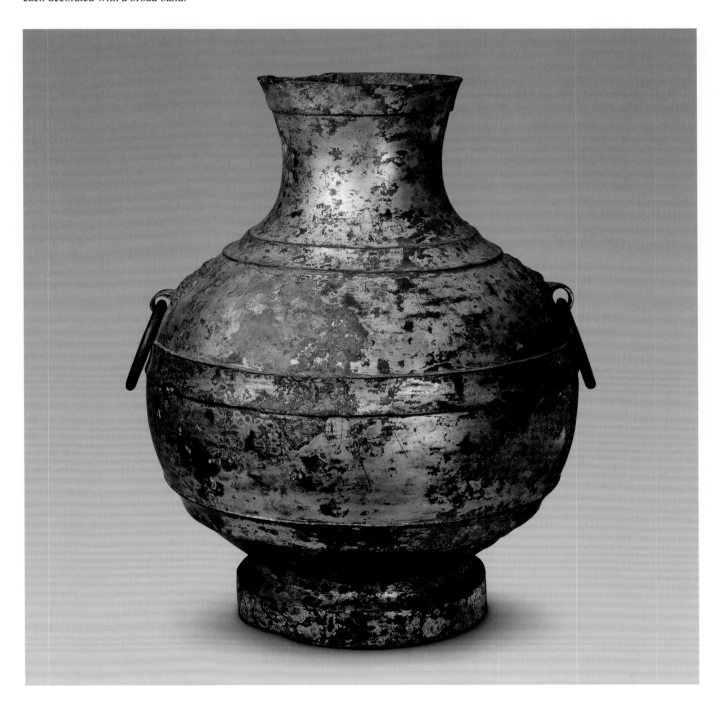

131

Bronze *Fang* (Rectangular Jar) with Inscription "Zhong Shi Si Jin"

Han Dynasty

Height 35.9 cm
Width 24.7 cm

This jar is rectangular in shape. It has a wide flared mouth with a thickened rim, a short, contracted neck, a bulging belly, a relatively high ring foot. The left and right sides of the belly have each an animal mask holding a ring. The side of the foot has an inscription of five characters in two lines, recording the weight of this jar (weighing 14 catties).

Fang is a square-shaped vessel. In the Han Dynasty, square vessels were named *fang*.

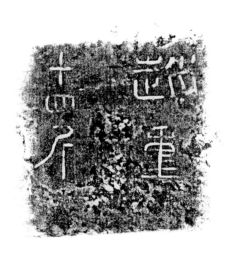

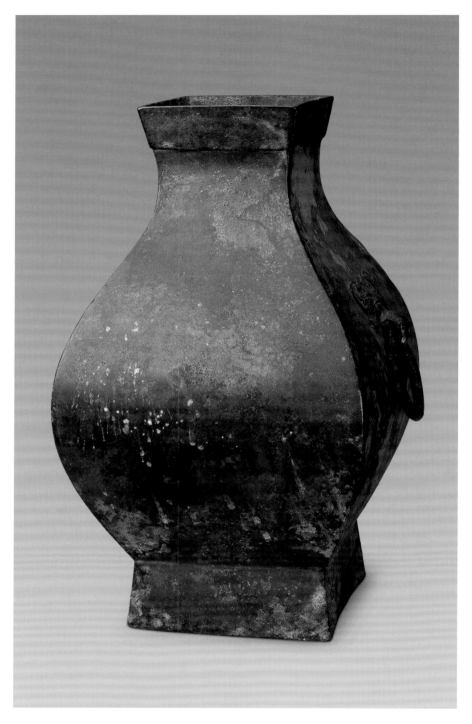

132

Bronze Ladle with Inscription "Ban Sheng"

Han Dynasty

Length 15 cm
Diameter of ladle 11.5 cm

The ladle is semicircular in shape, with a tube-shaped and hollowed handle on one end. The interior base is cast with the characters *ban sheng* (half litre) to mark its capacity. It has value for studying the weights and measures of the Han Dynasty.

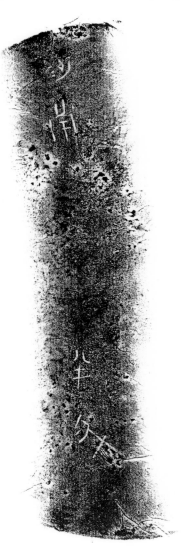

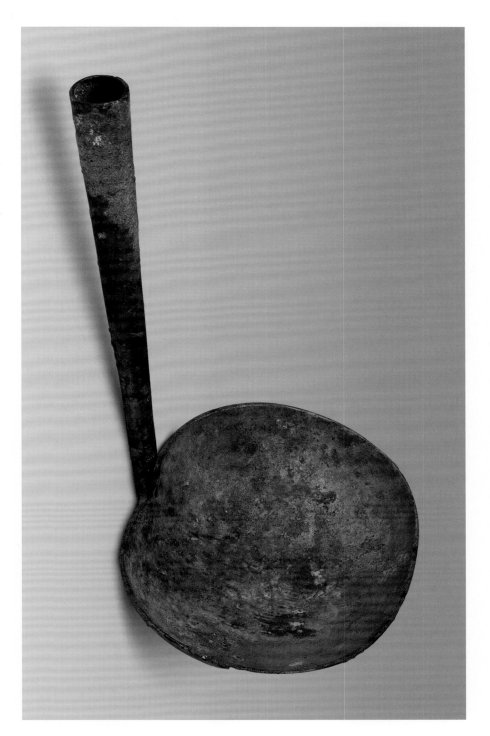

133

Bronze *Zun* (Wine Vessel) Inlaid with Gold and Silver

Han Dynasty

Height 9.5 cm Diameter 12.4 cm
Qing court collection

This vessel is cylindrical in shape. It has a vertical wall, a flat base, under which are three supporting short hoof-shaped legs. The body has three bands of protruding hoops. It is inlaid with gold and silver and decorated with floating clouds and geometric patterns.

Zun, a wine-warming utensil, was popular in the Han Dynasty. As a result of the development of crafts such as ceramics and lacquerware, the production of bronzeware in the Han Dynasty declined, and the types, decorations and inscriptions of bronzes became simpler. Due to the wide application of the techniques of gilding and gold and silver inlaying, the patterns of bronzeware became more elaborate and their colours, more varied. This vessel is a rare piece.

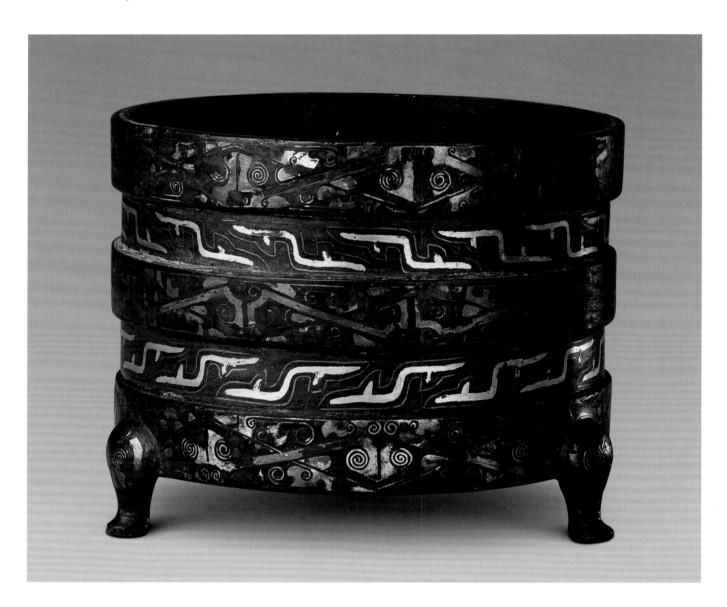

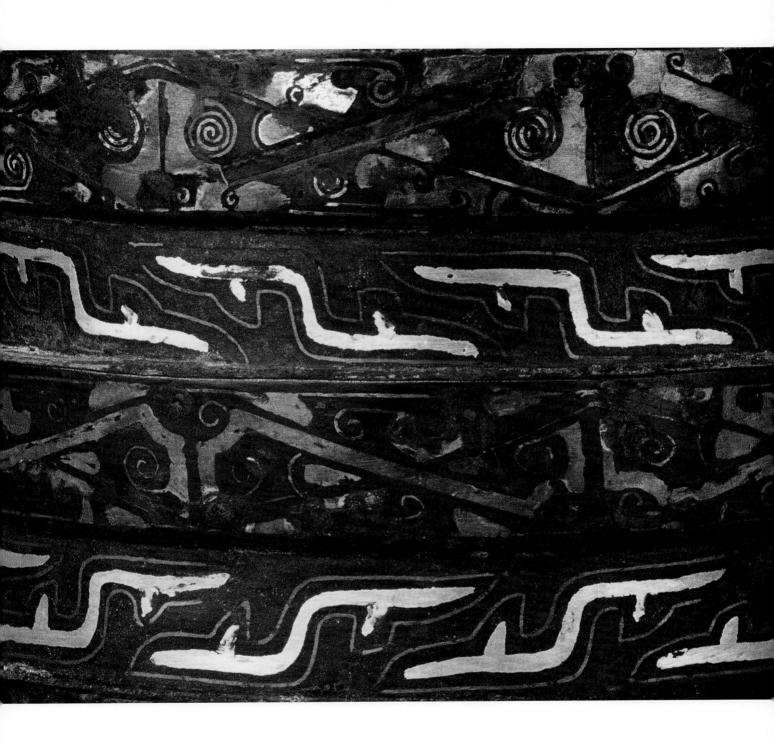

134

Gilded Bronze *Zun* (Wine Vessel)
with a Handle

Han Dynasty

Height 8.7 cm
Width 11.8 cm

This vessel is cylindrical in shape. It has a vertical wall and a flat base, under which are three supporting legs in the shape of a bear. On one side is a flat ring-shaped handle. The entire body is gilded. The body is decorated with two bands of protruding bowstrings.

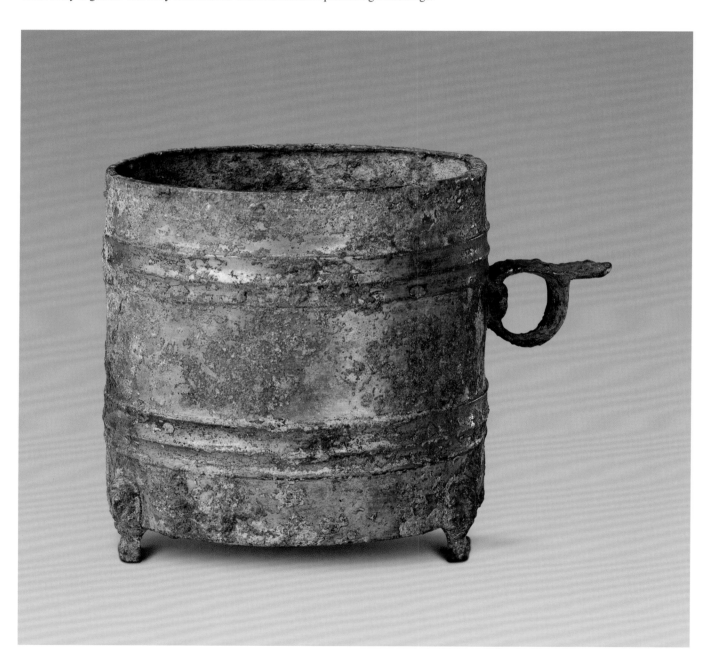

135

Bronze *Zun* (Wine Vessel)
with Inscription "Guang Wu"

Han Dynasty

Height 16.2 cm
Diameter 25 cm

This vessel is in the shape of cylindrical tube. It has a vertical wall under which are three supporting hoof-shaped legs. The exterior wall is decorated with three bands of bowstrings and has three equidistant protruding animal masks in the middle. The interior base is cast with two fish, and the space between them has an inscription of 17 characters in clerical script, stating clearly that this piece is a wine vessel.

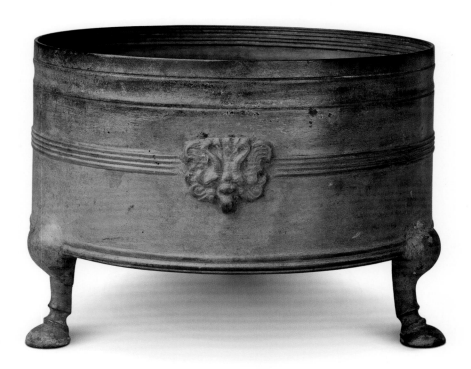

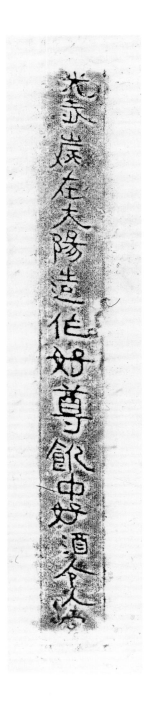

136

Bronze Chengyu *Hu* (Dry Measure)
Made in the 21ˢᵗ Year of Jianwu Period

Han Dynasty

Overall height 41 cm
Dry measure 35.3 cm
Diameter of plate 57.5 cm

This measure is divided into the two parts of a dry measure (*hu*) and a tray (*pan*). The entire body is gilded. The measure is in the shape of a cylindrical tube, with its wall slightly turning inward. The belly has three ears each with an animal head holding a ring, under the belly are three supporting legs in the shape of a bear whose body has inlaid turquoise, whose head is raised, and whose mouth is open, in the shape of supporting the measure. The edge of the plate is inscribed with 62 characters, recording that this measure was made in the 21ˢᵗ year of the Jianwu period (AD 45) in the reign of Emperor Guangwu in the Han Dynasty, and it also records its name, its size, the caster, and supervisor of this measure.

Hu is a measure. Though it is named *hu*, it is used as a wine bottle, not as a measure. This measure is cast skilfully with beautiful decorations. Its inscription is of importance for the study of the establishment and system of the official bronze casting industry and the appellation of casters in the Han Dynasty.

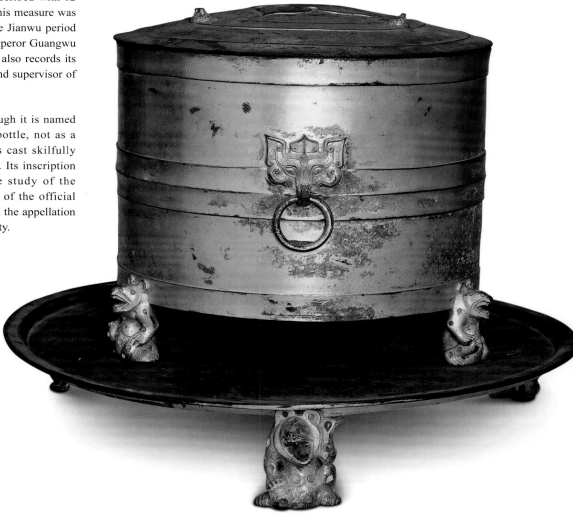

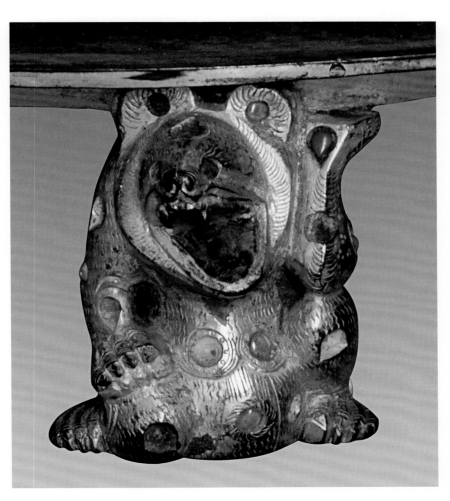

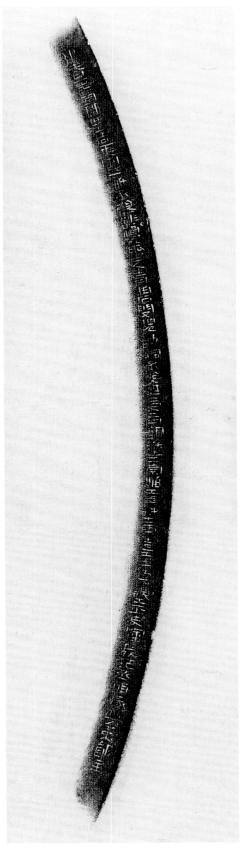

137

Bronze Washer
Made in the Fourth Year
of Yuanhe Period

Han Dynasty

Height 21.5 cm
Diameter 45.5 cm
Qing court collection

This washer has a tray-shaped mouth, a round and bulging body which narrows downward, and a flat base. The belly has a broad band pattern, and its left and right sides have symmetrical ring noses with animal masks. The interior base has an embossed inscription, recording the year and place of that this washer was made.

Xi is a utensil for washing. Yuanhe is the title of Emperor Zhangdi of the Han Dynasty. The "fourth year" is AD 87, and Tanglang is the name of an ancient town located in present-day Qiaojia County in Yunnan Province.

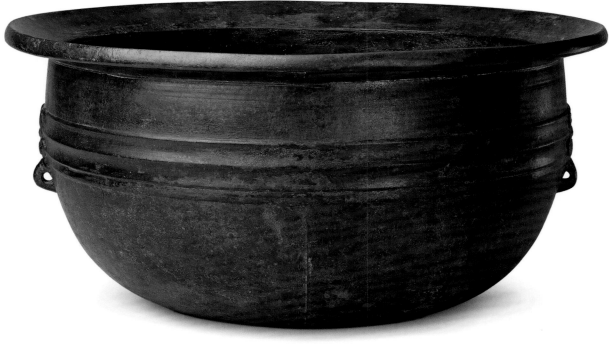

138

Bronze Washer with Inscription "Fu Gui Chang, Yi Hou Wang"

Han Dynasty

Height 7.2 cm
Diameter 37.9 cm

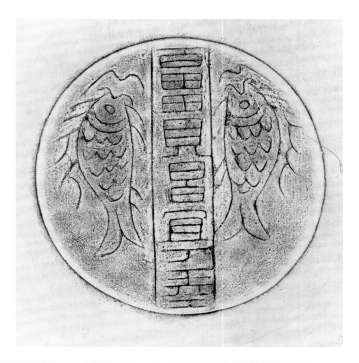

This washer has a tray-shaped mouth, a shallow belly, and a flat base. The left and right sides of the belly have each a symmetrical and inverted animal mask with a ring in its nose. The interior base is cast with two embossed fish and there is an inscription between them. It includes the good wish for fortune, wealth, and longevity.

The shape of this washer is simple and unadorned and the inscription and decorations are exquisite. The inverted animal masks on the belly are in particular rare.

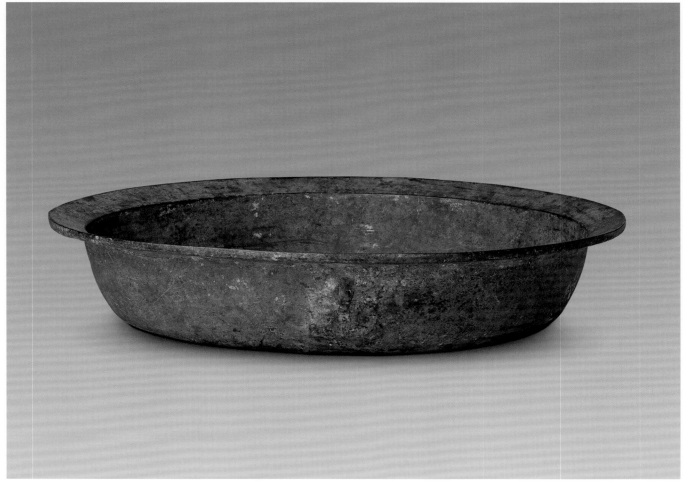

139

Bronze Washer
with Inscription "Shu Jun"

Han Dynasty

Height 8.5 cm
Width 32.4 cm

This washer has a wide-flared mouth, a contracted neck, a shallow bulging belly, and a flat base. The left and right sides of the belly have each a symmetrical animal mask with a ring in its nose. The interior base is cast with a three-legged tripod with its upper side inscribed with the characters *Shu Jun*, indicating that this washer was made in Shu (in present-day Sichuan Province).

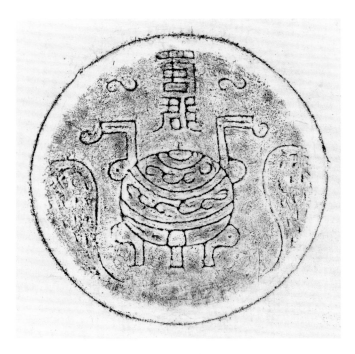

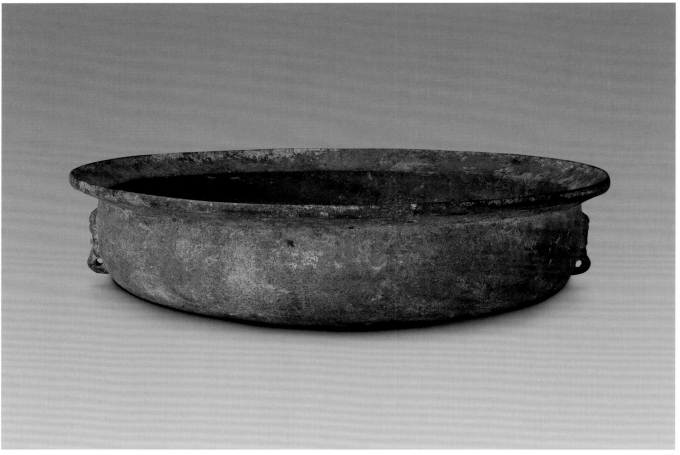

140

A Bronze Chime Bell with Cloud Design

Han Dynasty

Overall height 49.8 cm
Spacing of Xian 25.6 cm
Qing court collection

This bell has a high handle and reinforced with a dragon-shaped hook. The corpus is wide and short with 36 studs. It has an arch-shaped mouth. The handle, head of the corpus, upper part of the corpus, and decoration of the corpus have floating clouds. The part below the drum has animal masks.

In the Han Dynasty, bells were not a major type of bronzeware and their position was not as important as they used to be. The decoration and casting of this bell is exquisite, which reflects the level of bronze craftsmanship in the Han Dynasty.

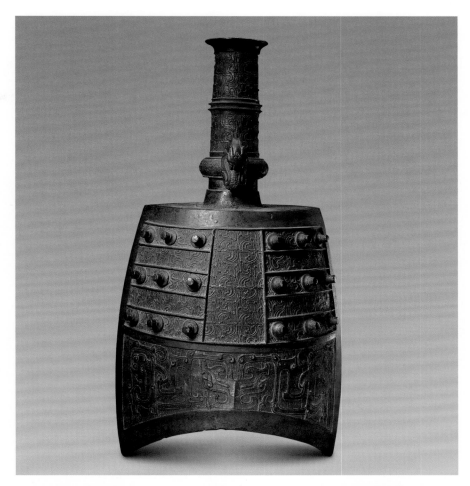

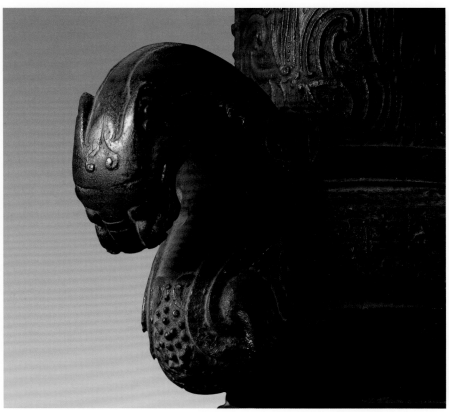

141

Bronze Drum with Design of Human Figures, Birds, and Animals

Han Dynasty

Height 19.1 cm
Diameter of face 32.4 cm

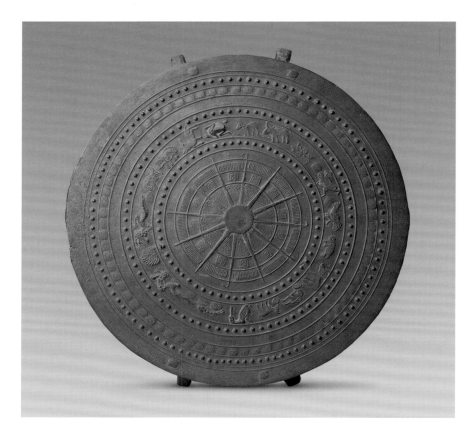

This drum has a round shape and a contracted waist with four-ring ears. In the middle of its surface is a sun emitting light. The exterior edge has three bands of round dots, separated by human figures, birds and beasts, and flowers and grass. The body is decorated with round dots, clouds, leaves, and geometric patterns.

Bronze drums are musical instruments used in war, dancing, and feasting. They also symbolise power and wealth. Drums were mostly produced in the southwestern areas inhabited by minority nationalities such as Guangxi Province. The casting of this bronze drum is exquisite and its decorations are rich and distinctive. This drum has unique local characteristics.

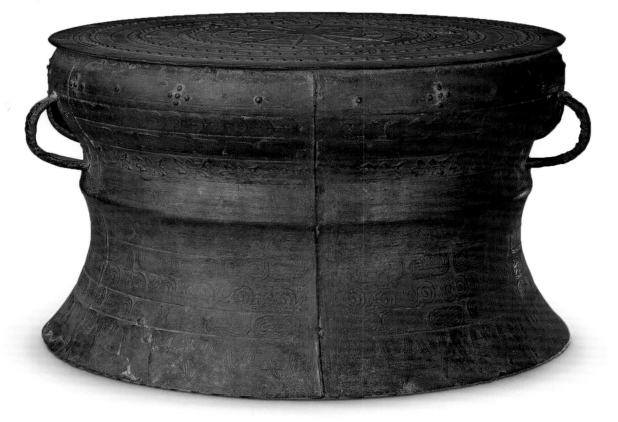

142

Bronze Candleholder with Inscription "Guan"

Han Dynasty

Height 30.1 cm
Width 21.6 cm

This candleholder has nine panels cast on a round pedestal. Cast at the rear part of each panel is a flame. At the centre is an upright copper column with branches supporting a candle panel on its top, and the top of this panel has a short column supporting another candle panel with its sides cast with three flames. It is inscribed with the character *guan*.

The shape of this candleholder is novel, and it goes well with the flame design when an actual flame is burning. The *guan* character inscribed on the candleholder may indicate that this it was owned by the government, or it could be the name of the owner.

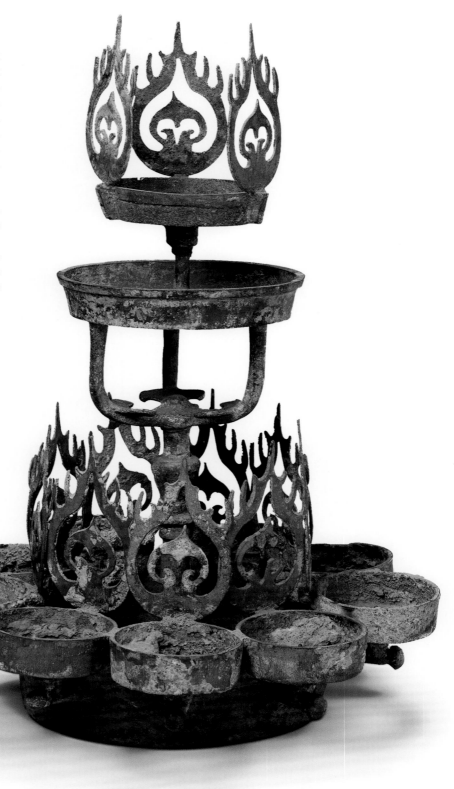

143

Bronze Candleholder in the Shape of an Ox

Han Dynasty

Height 9.5 cm
Length 19.5 cm
Qing court collection

This candleholder is in the shape of a crouching ox with short and incurved horns. The belly is hollow. It has a lid on its back, with a protruded part as the candle panel.

The shape of this candleholder is a combination of realism and exaggeration. Its image is basically realistic, while the patterns on the face and body are exaggerated, especially those patterns on the face, which have traces of animal mask patterns of the earlier periods.

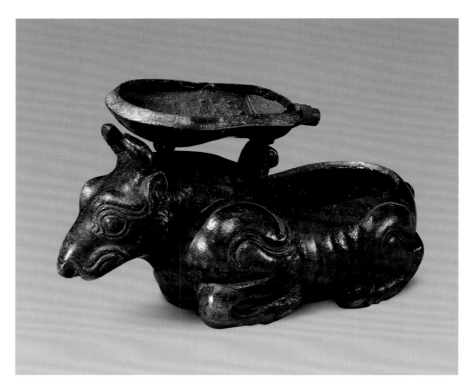

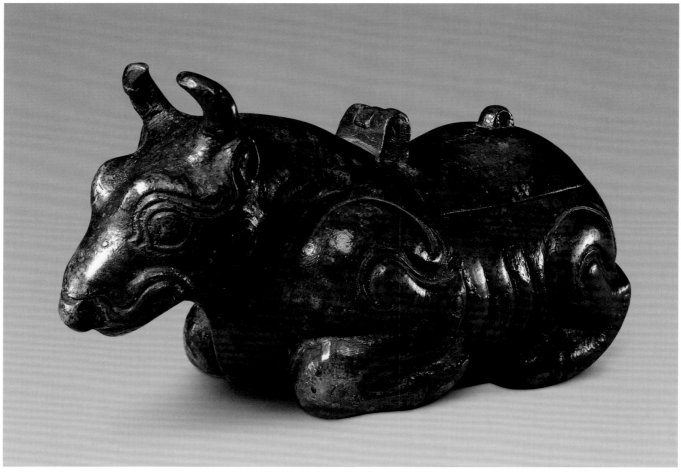

144

Bronze Candleholder
in the Shape of a Ram

Han Dynasty

Height 10.4 cm
Length 15.6 cm

This candleholder is in the shape of a crouching ram with its head raised and two curved horns. The interior of the belly is hollow for storing oil. The back has a lid, which becomes a panel when opened. The interior of the panel has a drill.

The making of this candleholder is exquisite and its image is lively. It is both a practical item and a beautiful work of art.

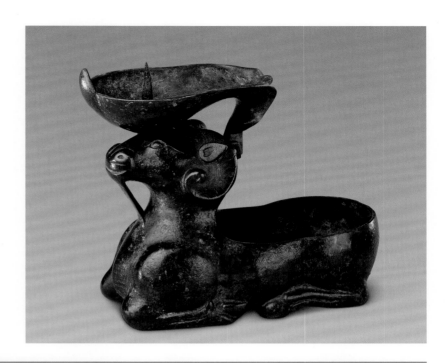

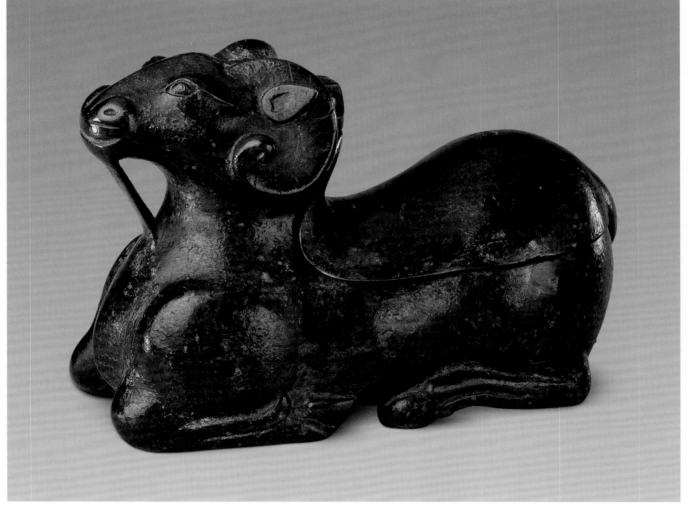

145

Bronze Candleholder Made in the Third Year of Jianzhao Period

Han Dynasty

Height 6 cm
Width 25.5 cm

The tray of this candleholder is shallow. It has a vertical wall under which are three hoof-shaped legs. The back of the cup has a long handle which is plain and undecorated. The lower part of the handle has an inscription of 46 characters in three lines, recording that this candleholder was made in the third year of the Jianzhao period (36 BC), and it also shows weight and the names of the supervising official and the maker.

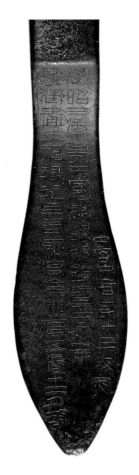
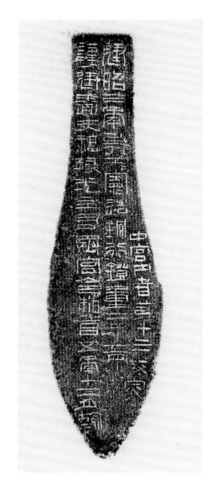

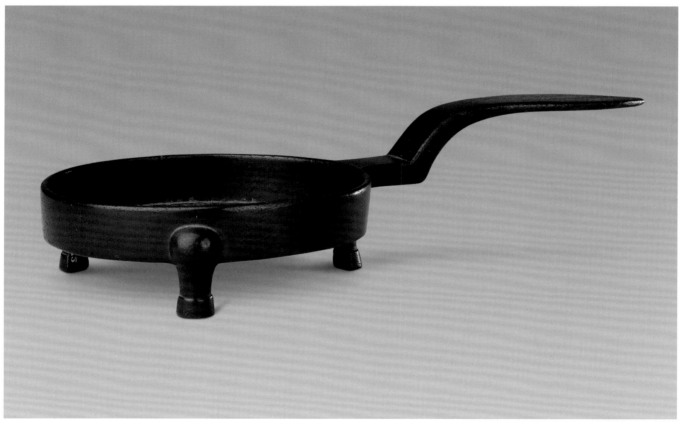

146

Bronze Candleholder with a Base in the Shape of a Wild Goose's Leg, Made in the First Year of Suihe Period

Han Dynasty

Height 16.1 cm
Width 12.7 cm

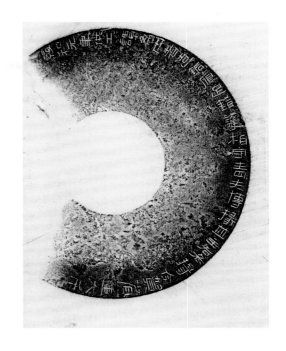

This candleholder has a round-shaped tray with a ring in it. The column and base are in the shape of a wild goose's leg, under which there is a base with a hollow interior. The lower part of the tray has a band of concaved inscriptions, recording that this holder was made in the first year of the Suihe period and it also shows its weight and the names of the supervising official and the makers.

Suihe is the reign title of Emperor Chengdi of the Han Dynasty who began his reign in 8 BC. This candleholder has the exact date of its making and also the names of the maker and official, which has historical value. It is exquisite in appearance, skilfully designed, and also a work of art.

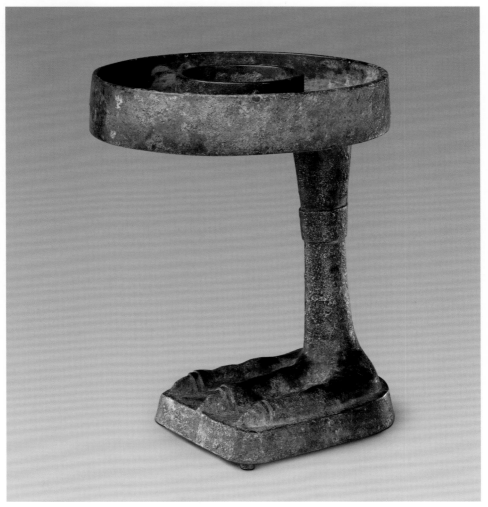

147

Bronze Candleholder with Inscription "Shao Fu"

Han Dynasty

Height 7.3 cm
Width 20.5 cm

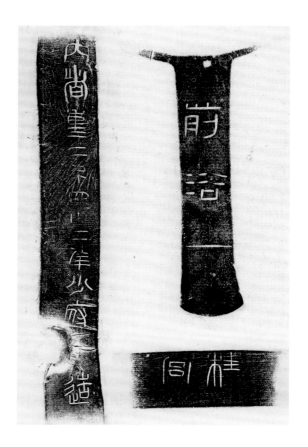

This candleholder has a shallow tray, a wall that turns inward, and three hoof-shaped legs under the tray. The back of the tray has a handle that curves upward. On one side of the exterior wall has an inscription of 12 characters, recording that this holder was made by *Shaofu*. The other side is inscribed with the characters *gui gong*. The surface of the handle is inscribed with the characters *qian yu*.

This holder is compact and orderly in appearance and neatly made, representing the level of the development of the handicraft industry at that time. *Shaofu* was an official title that came to be used from the time of the Warring States period, and was also used in the Qin and Han Dynasties as one of the Nine Chamberlains. This official was charged with the responsibility of managing the revenues generated from all over the country and the making of handicrafts for the royal house; the official also served as the personal secretary of the emperor.

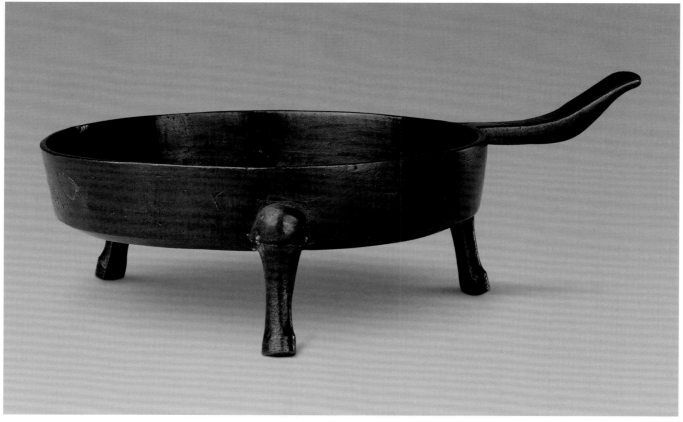

148

A Combined Set
of Three Bronze Candleholders

Han Dynasty

Height 12.4 cm
Width 17 cm

This candleholder is in the shape of a round tube, consisting of three parts. The lid can be opened, and it can be taken away as a separate holder with a removable handle. The interior candle pedestal linked with the base through a hidden column actually forms one unit, and it can be taken out to become a separate candleholder. When the interior lid is open, it forms another candleholder with the body of the vessel. The entire body is undecorated.

The appearance of the whole candleholder is simple, while it actually contains three holders inside. The design of this bronze candleholder is ingenious.

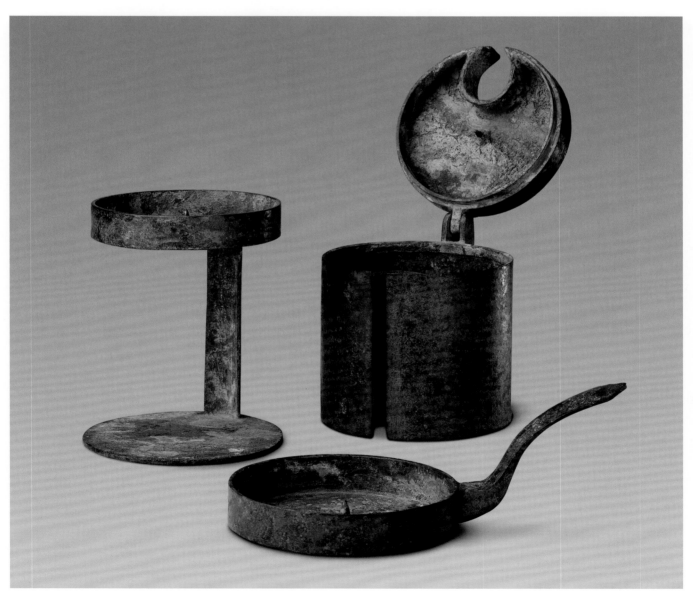

149

Bronze Candleholder
with Inscription "Yi Zi Sun"

Han Dynasty

Height 6.2 cm
Width 9.8 cm

The shape of this candleholder is elliptical. It has two flat ears on its left and right sides and a short ring foot. Half of the upper lid can be turned up to become a candle pedestal. The lid and the ears are decorated with dragons and tigers. In the middle of the lid is a six-character inscription.

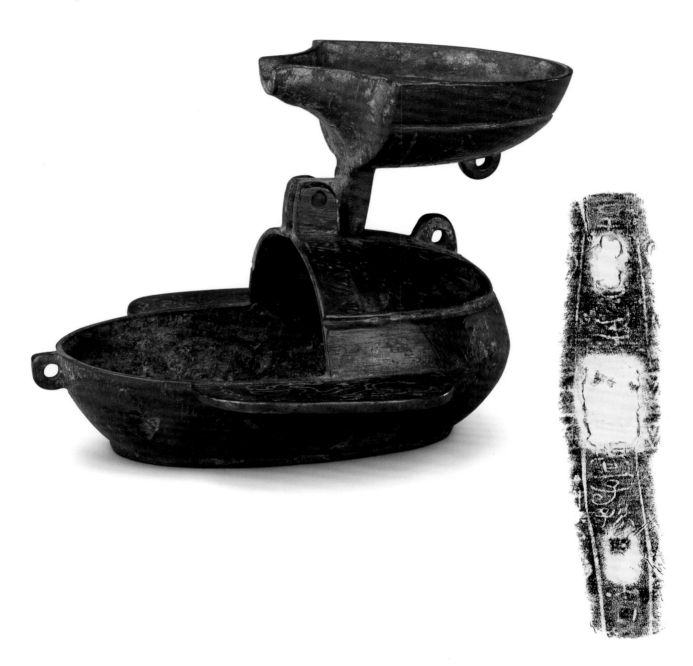

150

Bronze Boshan Censer Supported by a Strong Man on the Back of a Dragon

Han Dynasty

Height 23.9 cm
Width 10.1 cm

The base of this censer is a strong man riding on the back of a dragon. This half-naked strong man presses against the neck of the dragon with his left hand, with his right hand supporting the body of the censer. The body is in the shape of the Boshan Mountains with undulating hills. There are carved holes at the centre of the body with a bird standing on the lid top.

The Boshan censer is used for burning incense. The incense is lighted and burned in the censer, and the smoke comes out from the small hole in the lid. It is named the Boshan censer because the lid top is carved in the shape of undulating mountains, which symbolizes Boshan, a fairy mountain chain in the ocean.

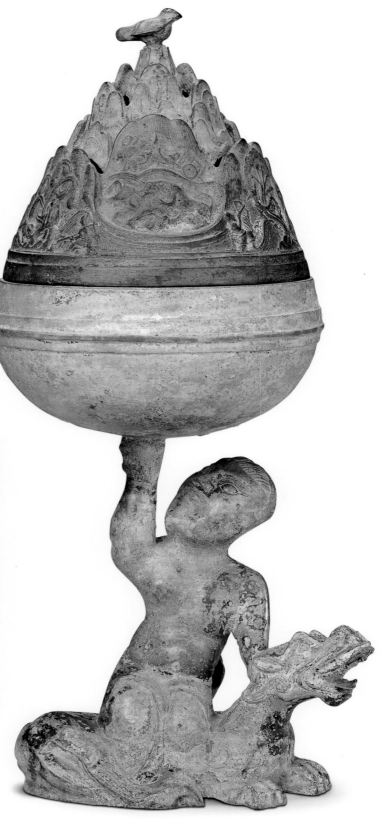

151

Gilded Bronze Boshan Censer

Han Dynasty

Overall height (with cover) 18.6 cm
Diameter of plate 18.7 cm
Mouth diameter of cover 14 cm

This censer is made of the body, lid, and tray. The body has patterns of mountains in relief. The lid is in the shape of Boshan, which has carved holes according to its terrain. The tray has a shallow belly with an outward-turned rim.

This censer is skilfully made and the entire body is gilded, which makes it even more magnificent. This piece is a treasure of the Western Han Dynasty.

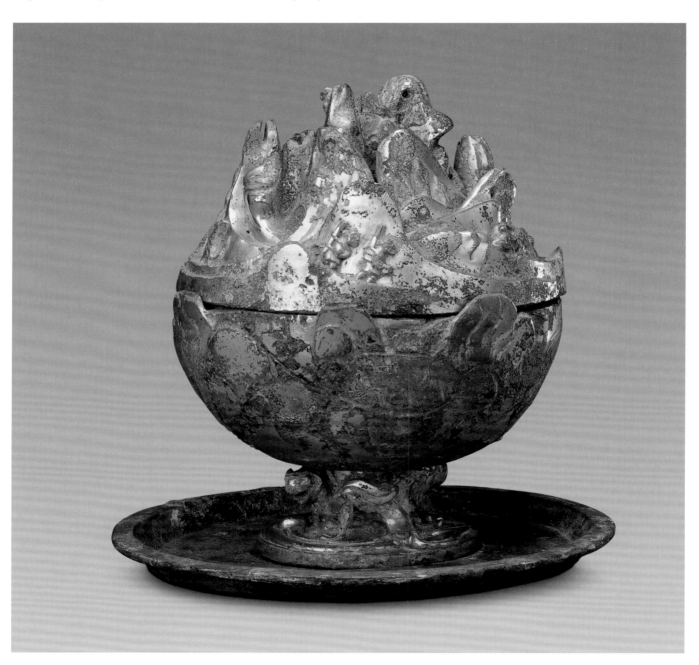

152

Duck-shaped Bronze Incense Burner

Han Dynasty

Height 14.6 cm
Width 16.9 cm
Qing court collection

This shape of the burner is like a standing duck with a raised head. The back of the duck is the lid carved with hollowed holes.

Most of the burners in the Han Dynasty are of the Boshan style, only a few having a tripod or spoon shape, let alone being shaped as an animal. The image of this censer is realistic and lively. It is a treasure among Han Dynasty incense burners.

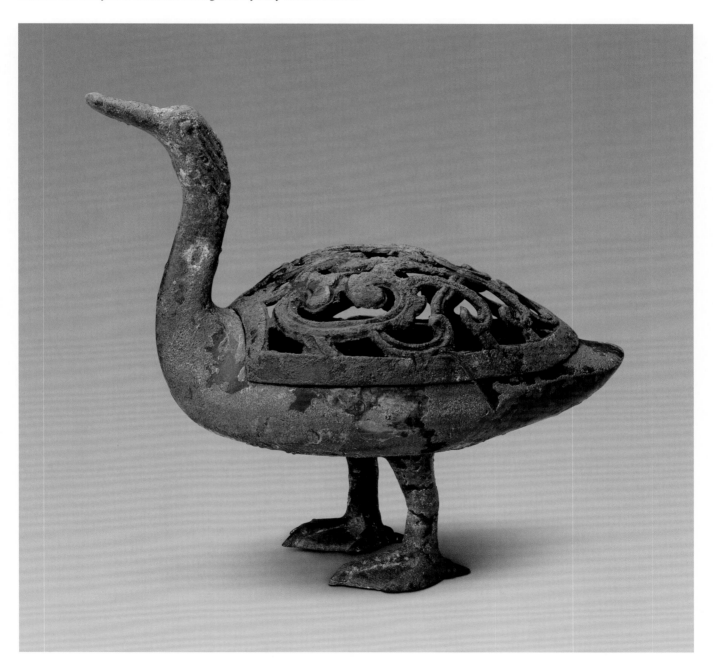

153

Bronze Incense Burner
with Inscription "Yang Quan"

Han Dynasty

Height 13 cm
Width 12.8 cm

This vessel has a contracted mouth to suit the lid. It originally had a lid and a plate tray, but they are now lost. The round belly narrows down and it has a ring foot. The lower part of the belly has leaves and the ring foot has patterns of birds, animals, mountains, and rivers. The exterior wall of the belly has an inscription of 47 characters, recording the places where this burner was used, its weight, its maker, and its supervisor.

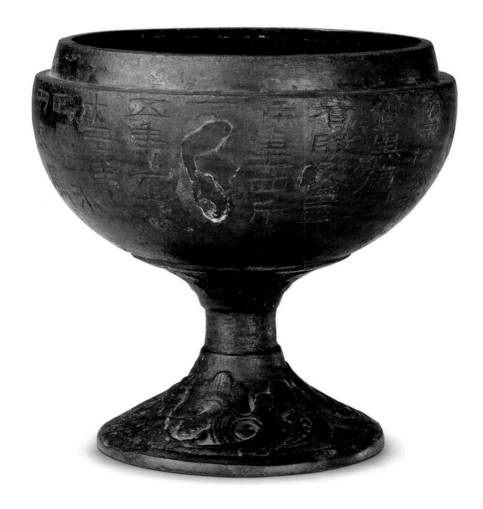

154

Bronze Mirror
with Linked Curve Design

Han Dynasty

Diameter 17.1 cm

This mirror is round in shape. It has a semicircular button and an undecorated, broad, and high rim. The inner section has a band of small circles and eight linked curves surrounding the button, the outer section has two bands of saw teeth with a band of inscription in the middle. This inscription, read on clockwise, has 28 characters.

Inscriptions on bronze mirrors in the early Western Zhou period were frequently merged into the patterns. Their style is elegant, and they are mostly about lovesickness and prayers for wealth.

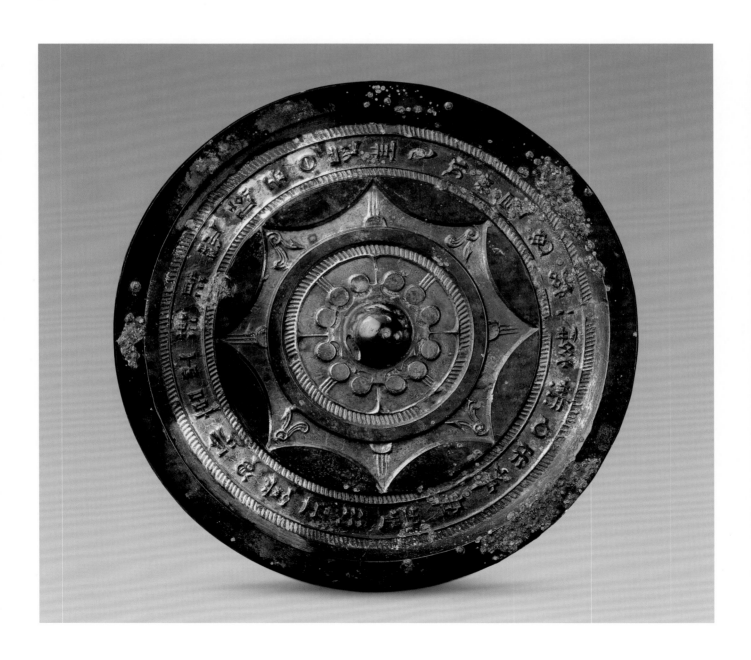

155

Bronze Mirror
with 12 Seal Characters for 12 Earthly Branches and
Design of Four Supernatural Animals Symbolizing
the Four Quarters

Han Dynasty

Diameter 18.7 cm

This mirror is round in shape. It has a semicircular button. On its square-shaped button stand are the 12 Earthly Branches written in seal-character calligraphy, with each branch being separated by small nipples. Outside the button stand are eight nipples and the four supernatural animals: Green Dragon, White Tiger, Red Sparrow, and *Xuanwu* in pairs of two. The exterior edge has a band of saw teeth and a band of double hooks.

The 12 Earthy Branches are: *zi, chou, yin, mao, chen, si, wu, wei, shen, you, xu*, and *hai*, representing the 12 periods of a day. The four gods are the auspicious animals popular in the Han Dynasty who ruled over the four directions of east, west, south, and north, and they were frequently used in decorations.

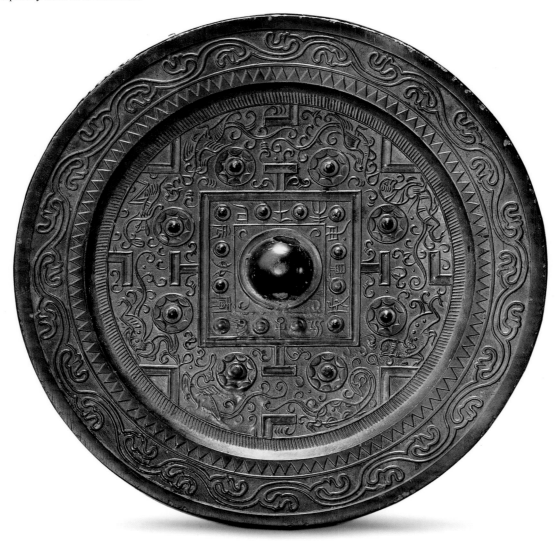

156
Lü's Bronze Mirror
Han Dynasty

Diameter 23 cm

This mirror is round in shape. It has a relatively large semicircular button. Its motif patterns are separated into four groups by nipples. The White Tiger turning its head and brandishing its claws is diametrically facing the Green Dragon that has stretched its neck in order to roar. Another matching pair is Dong Wang Gong and Xi Wangmu in the company of their dancers, musicians, and attendants. Outside the motif patterns is a band of inscription and a ring of vertical lines. The handwriting of the inscription is casual, and some of the characters are damaged. It has a broad rim, with birds and animals as the background.

It can be seen from the inscription that this mirror was made by Lü, and the relief decorations create a strong three-dimensional impression. Dong Wang Gong and Xi Wangmu are legendary figures in ancient mythology, and their images are often seen in the stone portrait drawings of the Han Dynasty. They later evolved into Daoist immortals, and Xi Wangmu is also an icon of longevity.

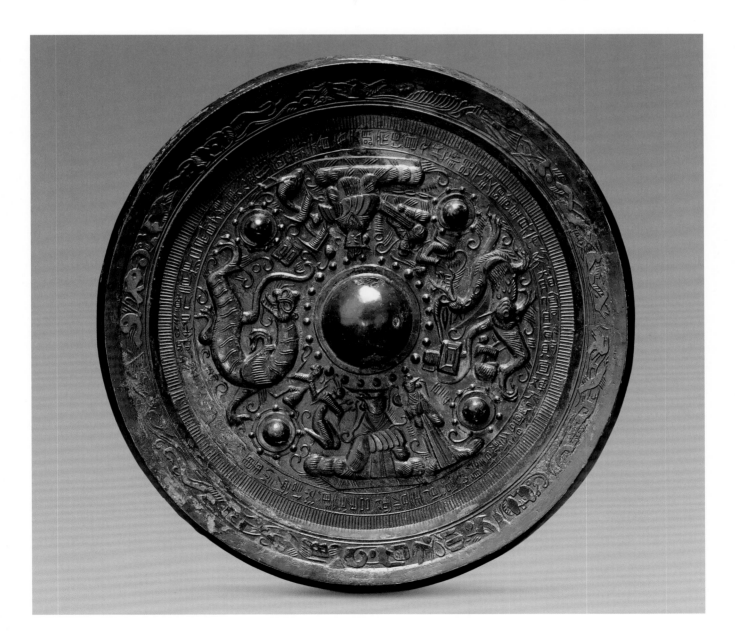

157

Bronze Mirror
with Inscription in Bird-and-Insect Script

Han Dynasty

Diameter 13.8 cm

This mirror is round in shape. It has an arched animal-shaped button with a square button stand. The square frame has a bird-and-insect inscription. The exterior of the square frame has leaves, and its outer rim has 16 linked curves.

The patterns and contents of this mirror are unique. The inscription is about lovesickness and praying for health and happiness. The bird-and-insect script, also known as the "insect script" or "bird-and-insect seal script," is a special type of artistic handwriting. The bird script, also known as bird and seal script, writes the strokes in the form of a bird, which is to merge characters with the shape of a bird into one form. The strokes of the insect script are in a meandering form, just like insects bending their bodies, which is how this script got its name.

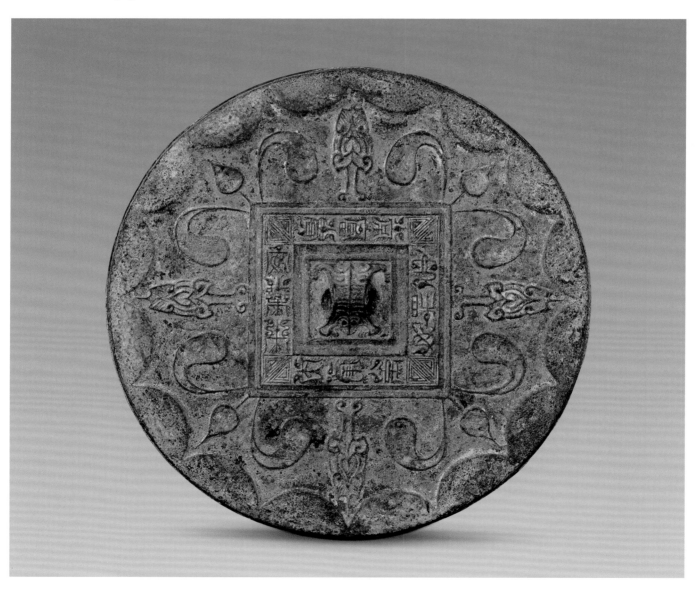

158

Gilded Bronze Mirror
with Geometric Pattern

Han Dynasty

Diameter 11.3 cm

This mirror is round in shape. It has a semicircular button, a round button stand, with an exterior square frame. It is gilded and the exterior of the frame has geometric patterns, interlaced with birds and animals. It has a broad exterior rim decorated with cirrus clouds.

Geometric patterns are similar to the structure of the *liubo* chessboard in ancient times, which is why it is also called the "*bo*-chess pattern." This mirror is skilfully crafted with exquisite decorations. Its gilded geometric patterns are rarely seen.

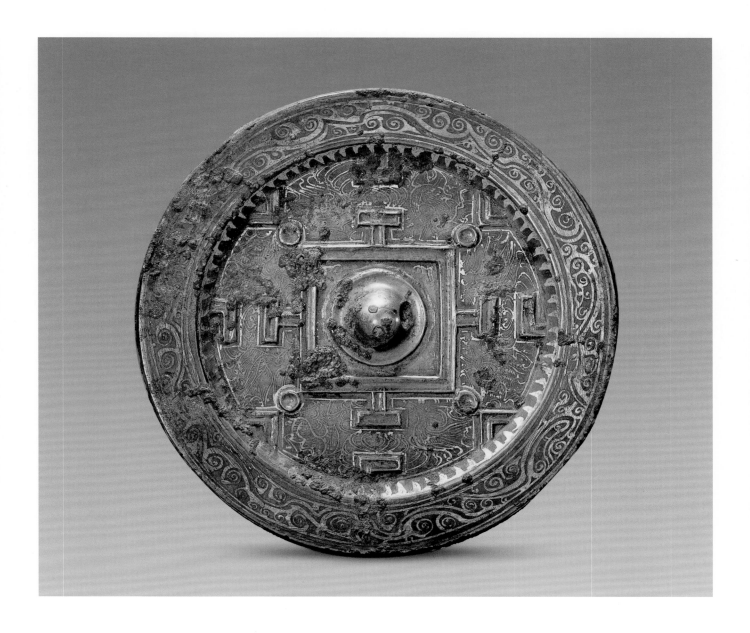

159

Bronze Mirror
with Design of Human Figures, Birds, and Animals

Han Dynasty

Diameter 14.3 cm

This mirror is round in shape. It has a semicircular button, a concave back and a convex front. The four nails outside the button divide the mirror into four sections showing playing music, talking, fighting, and dancing. The broad and flat rim has human figures, birds, and animals. The inner circle has saw teeth.

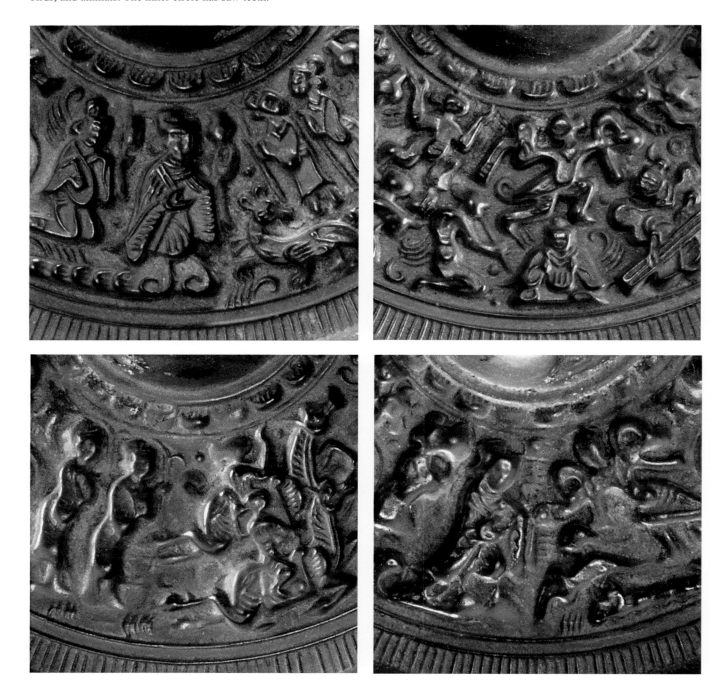

The contents of this mirror are varied, especially on the scenes of people's activities, which give a glimpse of people's life in the Han Dynasty. This mirror has considerable value in studying the clothing, music, and dances of that time. The shape of this article is unique, and the lines on various parts are neat and smooth.

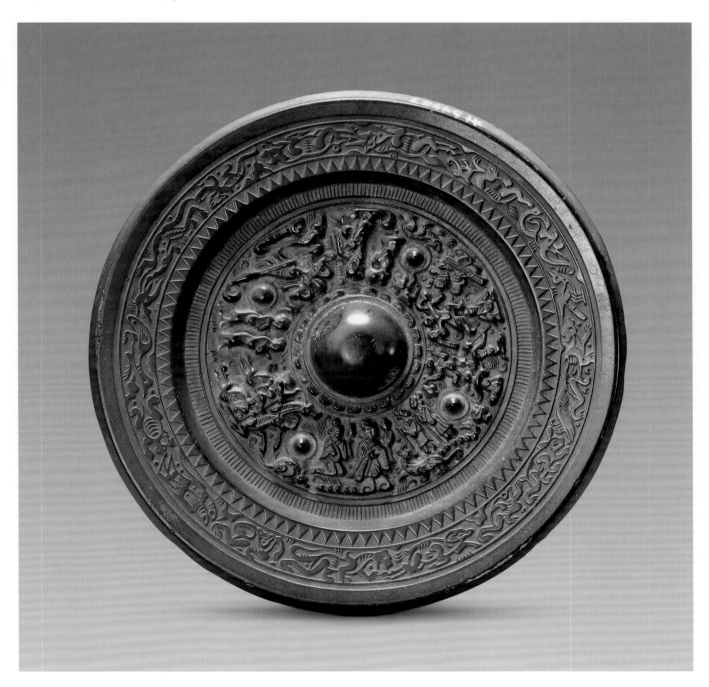

160

Bronze Belt Hook with Inscription "Bing Wu"

Han Dynasty

Length 15.7 cm
Width 3 cm

This hook is in the shape of an animal head. It has a round button. The body of the hook is in the shape of a monster embracing a fish. The entire body is plated with gold and silver and inlaid with turquoise. It has an inscription at its back which tells of a successful official career.

The shape of this hook is rather unique. The image of the animal is grotesque and its decorations are beautiful.

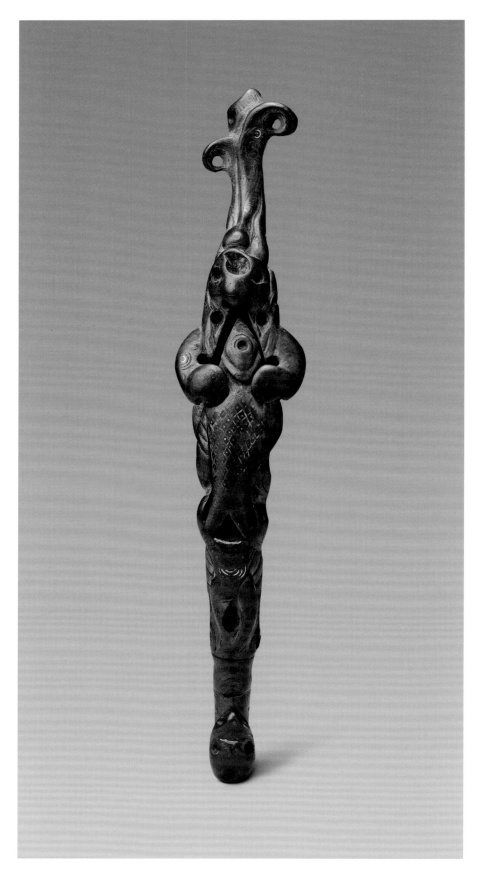

161

Gilded Bronze Belt Hook Inlaid with Turquoise

Han Dynasty

Length 17 cm

This hook is in the shape of an animal head. The head is narrow and the body is broad. It has a round button. The entire body is plated with gold and inlaid with turquoise. The decorations of this hook are in high relief.

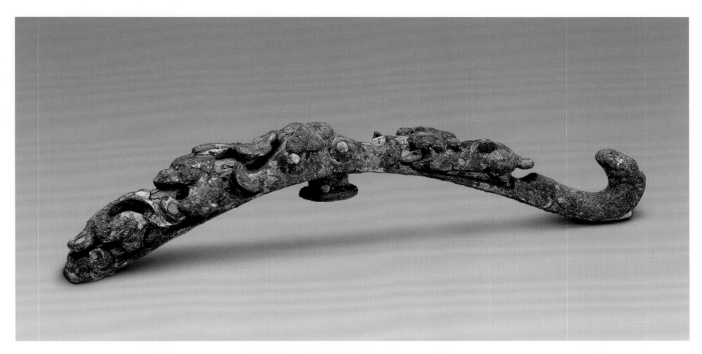

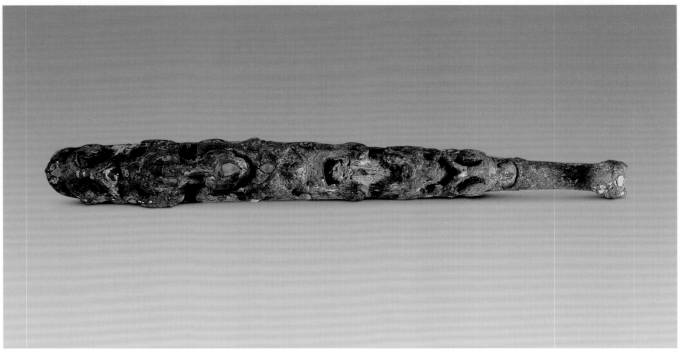

162

Bronze Belt Hook Inlaid with Crystal

Han Dynasty

Length 18.2 cm

This hook is in the shape of an animal head. It has a round button. The body is broad and large, with its front side inlaid with three pieces of crystal.

Belt hooks of the Han Dynasty are frequently decorated with inlays, including gold, silver, and turquoise. But crystal inlays are extremely rare. This hook reflects the level of inlaid craftsmanship attained at that time.

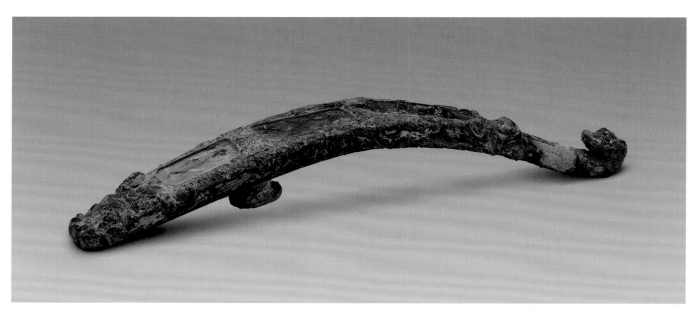

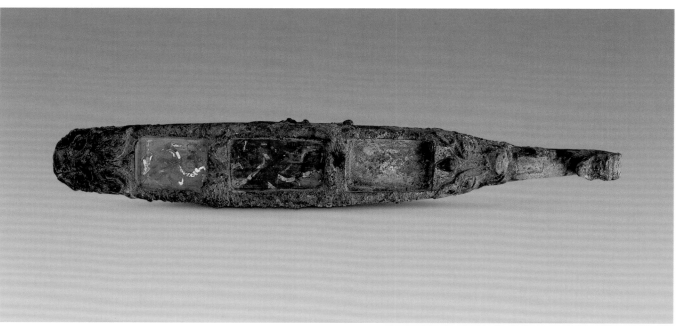

163
Bronze Belt Hook
Made in the Second Year of Zhanghe Period
Han Dynasty
Length 18 cm

This hook is in the shape of an animal head. It has a round button. The body has gilded gold and cloud patterns. The back has an gilded inscription which records that the belt hook was made on the fifteenth day of the fifth month in the second year of the Zhanghe period. Zhanghe is the reign title of Emperor Zhangdi of the Han Dynasty, and the second year is AD 88.

This belt hook has beautiful decorations and an accurate date, so it can be taken as a standard utensil for periodization.

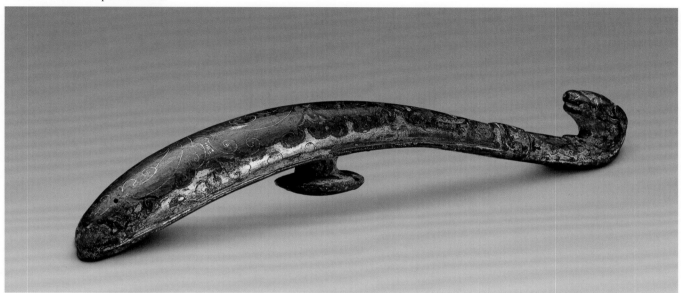

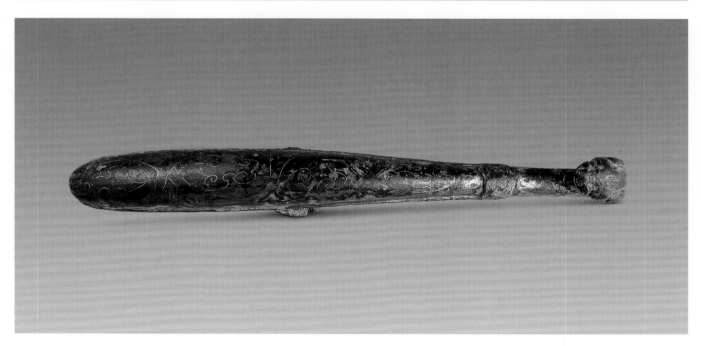

164

Bronze Panel
with Design of a Tiger Biting a Horse in Openwork
Han Dynasty

Length 13.4 cm
Width 8.3 cm

The entire body of this panel is carved openwork. It depicts a ferocious tiger biting the neck of a horse. The body of the tiger is decorated with curved lines that resemble a real tiger's skin.

A panel was a waist belt decoration of nomadic tribes in the north. The image of the animal in this panel is vivid, showing a high level of skill reflecting the degree of production, life, and craftsmanship of the northern tribes in the Han Dynasty.

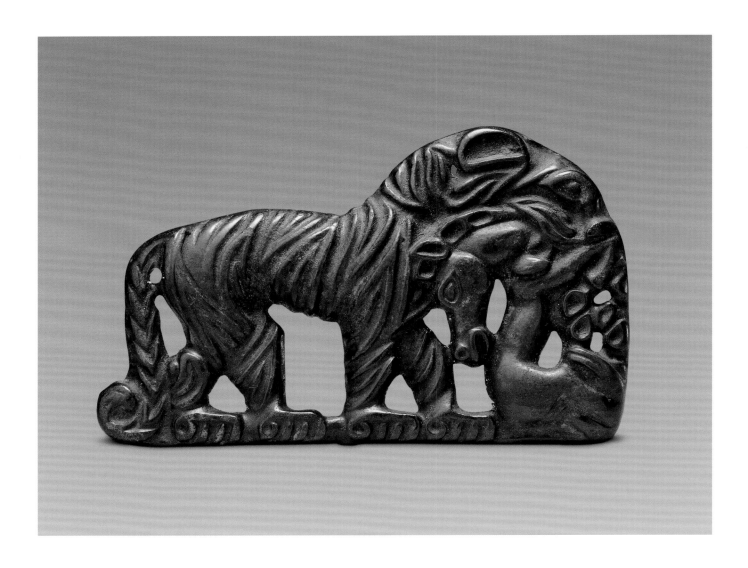

165

Bronze Panel
with Design of Deer Pulling Cart in Openwork

Han Dynasty

Length 11.5 cm
Width 7.5 cm

The entire body of this panel is carved openwork. It shows a scene of hunting, with the hunter on horseback pulling his bow to hunt, and in the front is a cart pulled by a deer, with a hunting dog on it. The picture is a lively reflection of the life of a nomadic people.

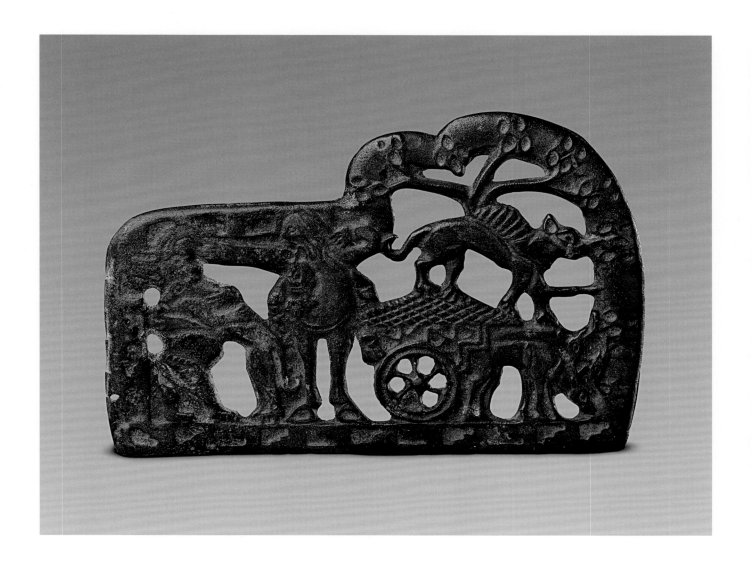

166

Bronze Ornament
in the Shape of a Celestial Horse

Han Dynasty

Length 7.6 cm
Width 6.2 cm

This panel is in the shape of a celestial horse. The horse raises its head, neighs, kicks out its hoofs, sticks up its tail; it also has wings on its two sides.

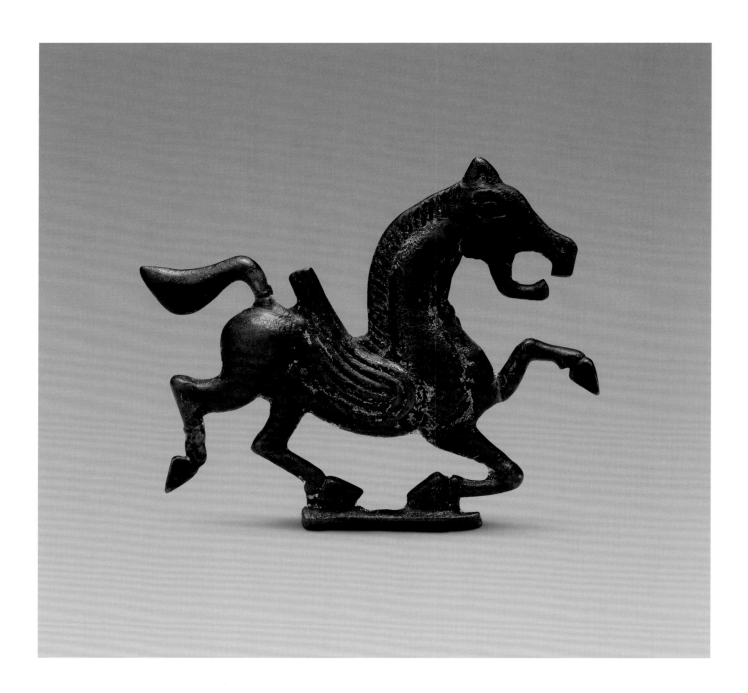

167

Bronze Ornament
in the Shape of Two Snakes Biting a Frog
Han Dynasty

Length 19.4 cm
Width 5 cm

The main body of this panel has two intertwining snakes biting respectively the rear left and right feet of a frog and they are about to swallow it. The frog has a fat body, with eyes opened wide. Decorated on the bodies of the snakes are water chestnut patterns.

The shape of this panel is vivid, and it is made more so for the green patina that has formed on images of the frog and snakes over time. This panel is an important resource for the study of the bronze culture of the northern tribes in the Han Dynasty.

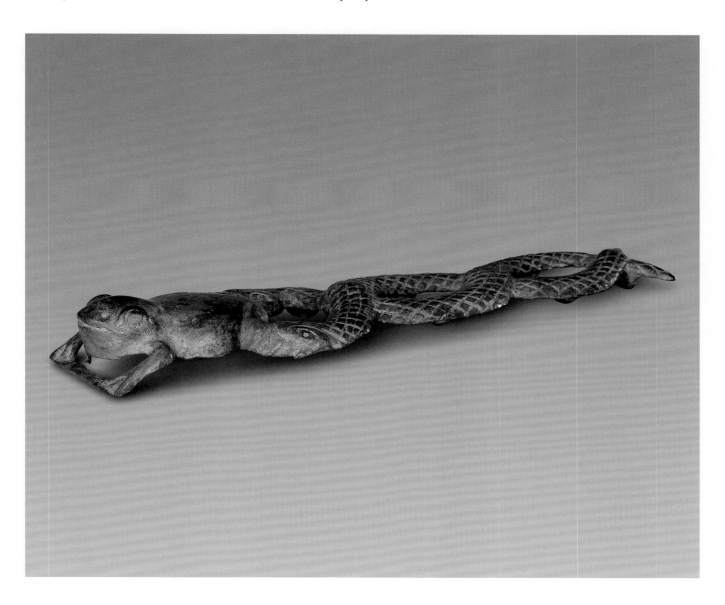

168

Bronze Measure
with Inscription "Chang Le Wan Hu"

Han Dynasty

Height 10.2 cm
Diameter 26.5 cm
Qing court collection

This measure is round in shape. It has a ring handle and a flat base. The exterior wall is cast with bowstrings. The base has an embossed four-character inscription.

This measure was a utensil to determine volume in ancient times.

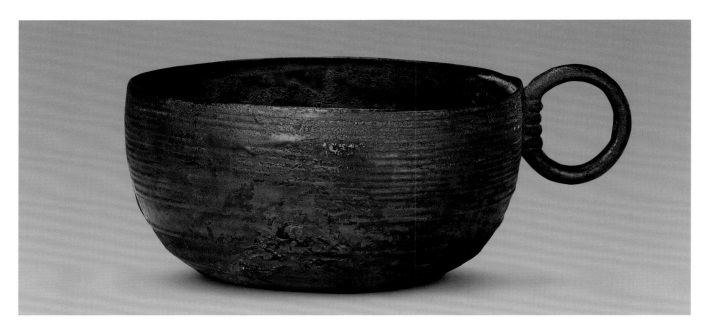

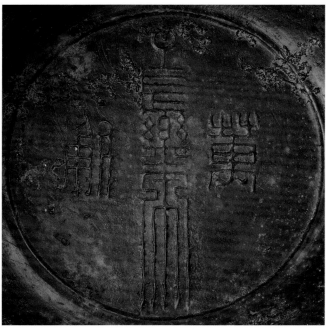

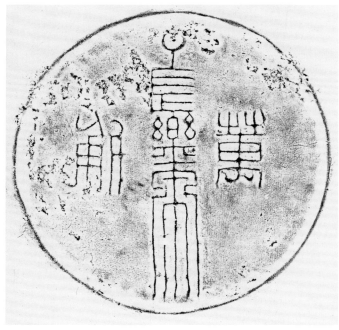

169

Bronze Flat Iron
Made in the Sixth Year
of Yongyuan Period

Han Dynasty

Height 5.1 cm
Width 31.5 cm

This is an iron in the shape of a round basin. It has a folded rim, a round base, and a long hollow handle. The surface of the handle is inscribed with 30 characters, recording that this iron was made in the sixth year of the Yongyuan period (AD 94) in the reign of Emperor Hedi of the Han Dynasty; the inscription also lists the weight and value of this iron.

Irons made of bronze were used to iron clothes in ancient times.

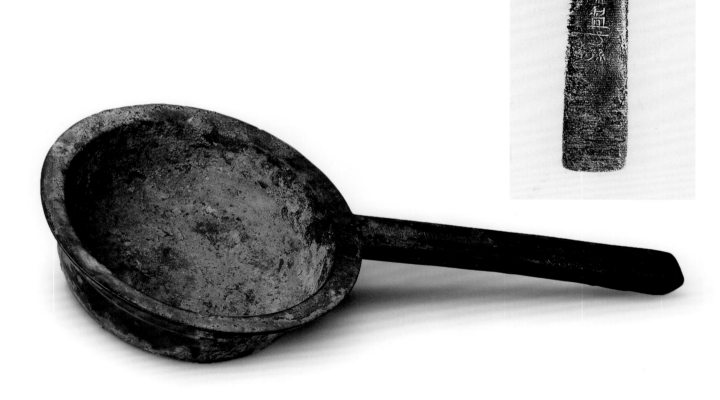

170

Bronze Weight
in the Shape of a Crouching Tiger Inlaid
with Gold and Silver

Han Dynasty

Height 7.6 cm
Width 9.2 cm
Qing court collection

The entire body of this weight is in the shape of a round sculptured tiger, with its head raised, its mouth wide open, in a crouching position. It has a flat base. The body is inlaid with gold and silver.

This paperweight is skilfully crafted and is extremely beautiful with inlaid gold and silver. Weights were a means to flatten a mat in ancient times. They first appeared in the Warring States period and were most popular in the Han Dynasty. Before the Song Dynasty, most people squatted and slept on the ground, so they needed weights to weigh down the four corners of the mat. Advances in furniture and the changes in people's way of sitting and sleeping saw weights gradually becoming one of the stationery accessories.

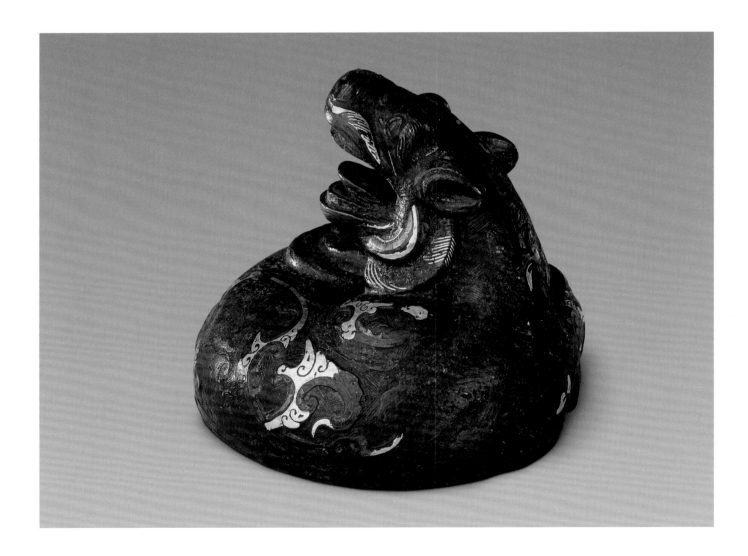

171

Bronze *Fu* (Cooking Vessel) Made in the Third Year of Taikang Period

Jin Dynasty

Height 12.8 cm
Width 22.3 cm

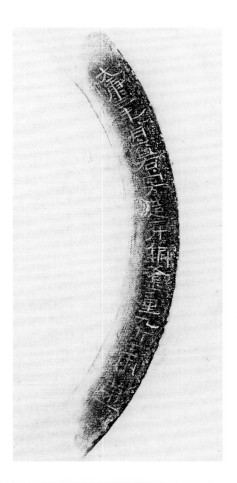

This vessel is round in shape. It has a vertical mouth, a bulging belly, and a semicircular shoulder. The middle part of its belly has a broad and flat edge for easy carriage. It has a flat base. Under the mouth rim is an inscription of 23 characters, recording that this vessel was made in the third year of the Taikang period (AD 282) in the reign of Emperor Wudi of the Western Jin Dynasty by the Right Directorate for Imperial Manufactories (*You Shangfang*) responsible for the food and drink vessels of the imperial family.

Fu is an item of kitchenware. It is placed on the mouth of a stove to cook food on top of which a steamer is placed. This vessel was popular in the Han Dynasty. *Shangfang* was a directorate responsible for the acquisition and management of kitchenware in the palaces under the administration of the Chamberlain for the Palace Revenues. This unit was set up in the Qin Dynasty. During the Han Dynasty, it was divided into three units prefixed Central, Left, and Right, and these divisions continued down to the Wei and Jin periods. The date of this vessel is clearly marked, and as such, it is of considerable value in the study of the official positions and institutions of the Western Jin period.

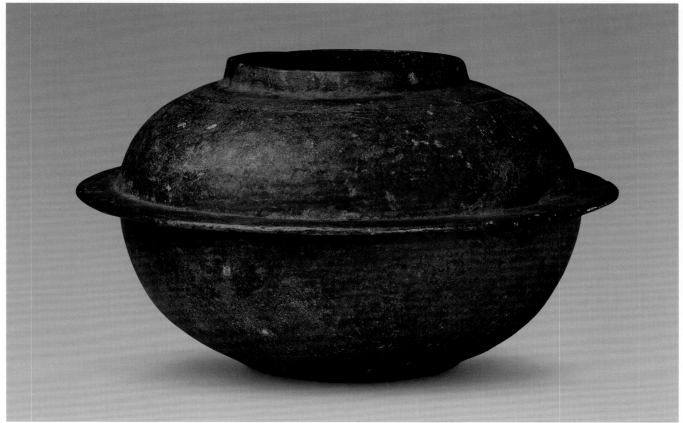

172

Bronze *Zun* (Wine Container) Made in the Tenth Year of Taikang Period

Jin Dynasty

Height 19.3 cm
Width 16.5 cm
Qing court collection

This container is in the shape of a round tube. It has a vertical wall and a deep belly. Under the mouth is a pair of ears each with an animal head holding a ring. The flat base has three animal-shaped feet under it. The exterior wall has three rounds of protruding broad bands. The exterior base has an inscription in clerical script recording the time and place of casting this container. It was made in the tenth year of the Taikang period (AD 289).

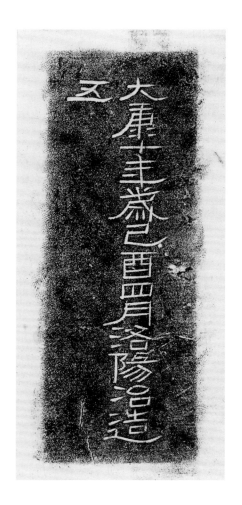

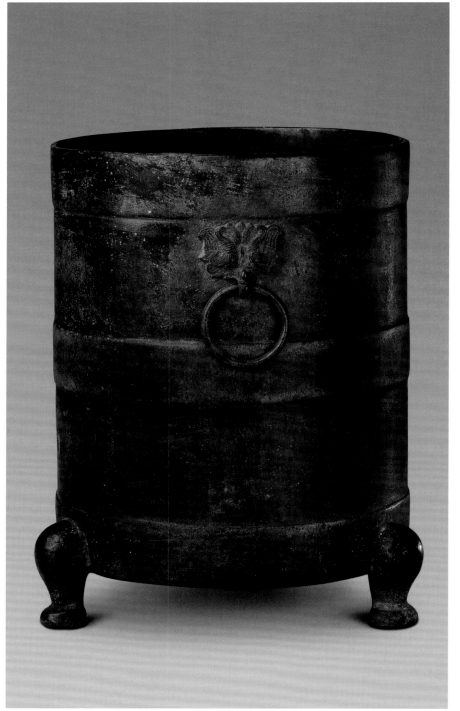

173

Bronze Mirror
Made in the Fourth Year of Tianji Period
Three Kingdoms

Diameter 11.6 cm

This mirror is round in shape. It has a semicircular button. The main motifs are mythical animals which are protruded like relief. The periphery has semicircular and square bands, and vertical lines. It has a broad edge on which is an inscription with damaged characters. Its rim is broad, on which there is an inscription with corrupted characters.

Tianji in the inscription is the reign-title of Sun Hao, the last ruler of the State of Wu in the Three Kingdoms period. The fourth year of the Tianji period is AD 280. It was in the third month of that year that the State of Wu was conquered by the Jin Dynasty.

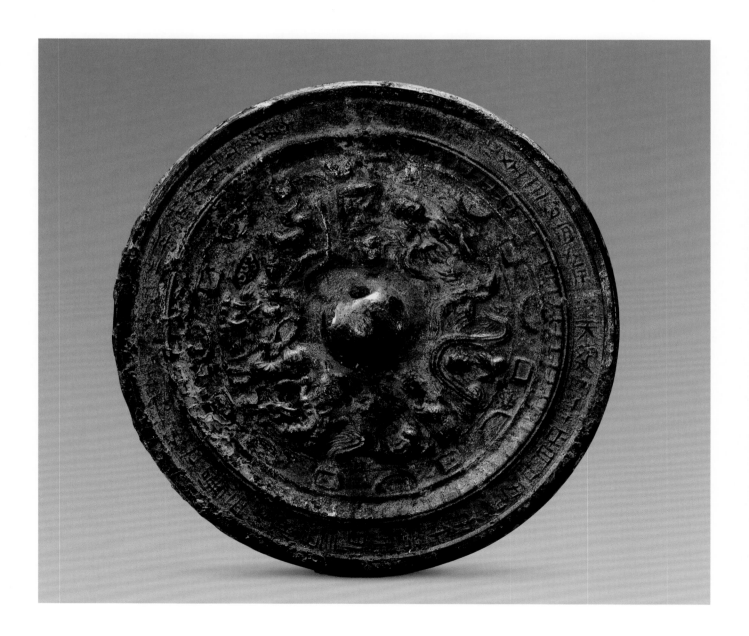

174

Bronze *Jiaodou* (Soup-warming Vessel) with a Dragon-head Handle

Six Dynasties

Height 15.4 cm
Width 19.5 cm

This vessel is round in shape. It has a wide mouth. On one side of the mouth rim is a spout. It has a flat bottom under which there are three hoof-shaped legs. It has a curved handle with the head of a dragon.

Jiaodou was for warming soup or soup-like food.

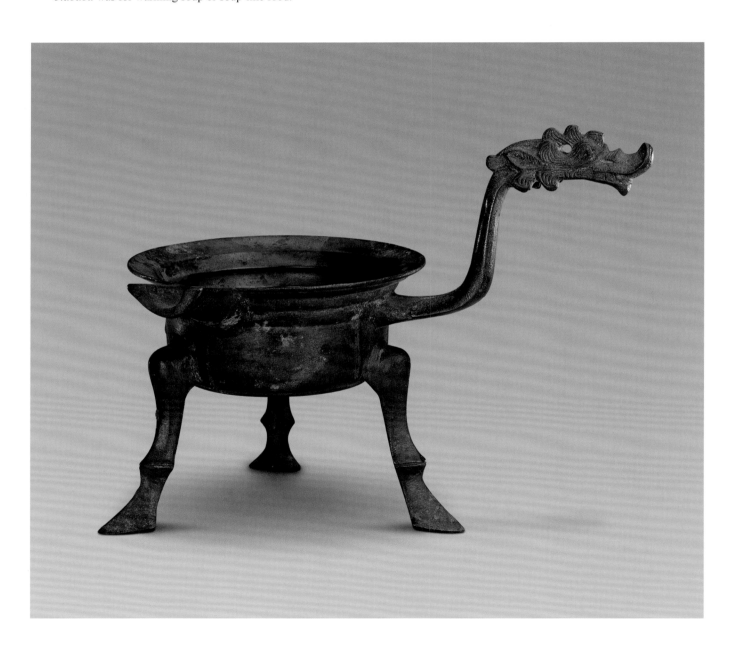

175

Animal-shaped Bronze *Yandi* (Water Dropper)

Six Dynasties

Height 7.1 cm
Width 15.6 cm
Qing court collection

This dropper is in the shape of the mythical beast *bixie* in carved openwork. It is in a crouching position, holding the ear cup in its mouth. The back has a pipette. The body of the dropper is hollow and its interior can therefore contain water.

Yandi is a utensil to pour water into an inkslab. Also called a water-pourer or water-container, it is a stationery accesory. In the early days, it was made of copper. Later, most droppers were made of ceramic. Most water-droppers were made in the shapes of animals, such as mythical creatures, toads, and tortoises.

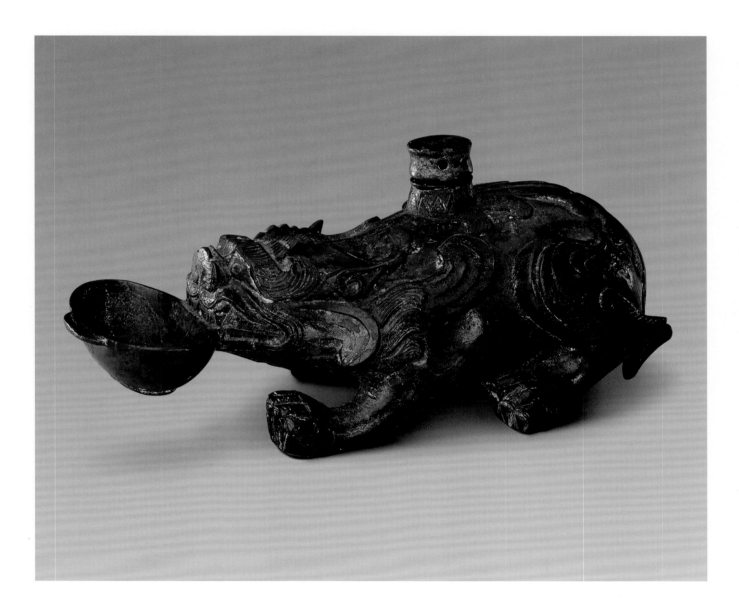

176

Bronze Writing-brush Stand
in the Shape of Two Hornless Dragons

Six Dynasties

Height 4.9 cm
Width 18.1 cm

This writing-brush stand is in the shape of two hornless dragons biting each other, with the natural rise and fall of the last part of their body forming the place for resting the writing brush.

A writing-brush stand, also called a writing-brush holder, was an accessory for holding a writing-brush. The shape of this writing-brush stand is vivid with smooth and flowing lines, which makes it highly ornamental.

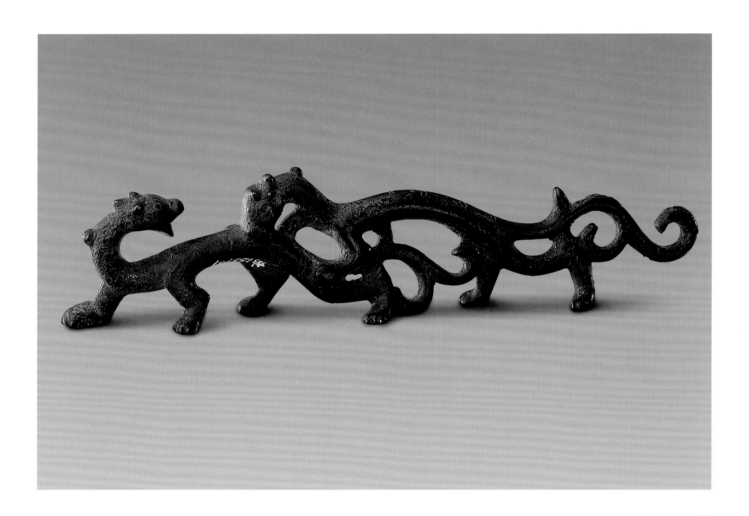

177

Bronze Paperweight
in the Shape of a Coiling Dragon Inlaid with Gold

Six Dynasties

Height 11.4 cm
Width 11.4 cm
Qing court collection

This paperweight is in the shape of a coiling dragon with its body curved, its head raised, and its entire body decorated with gilded clouds and round circles.

The design of this paperweight is exquisite, its shape modern, and its craftsmanship superb. This paperweight is a superior example of its type.

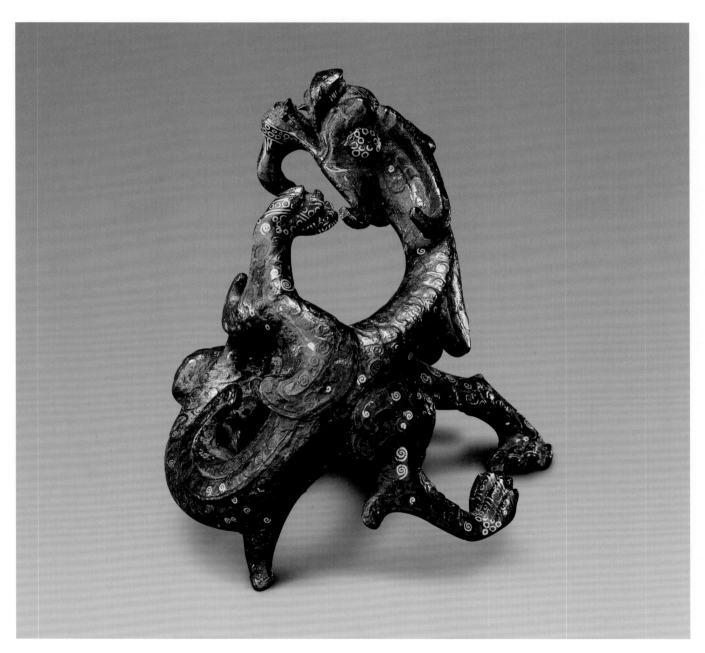

178

Bronze Mirror
with Design of 12 Symbolic Animals
Representing a Person's Birth Year
Sui Dynasty

Diameter 13.1 cm

This mirror is round in shape. It has a semicircular button, a button stand with linked-pearl design, and a plain and narrow frame. The interior section has honeysuckles with intertwining branches. The exterior section has 12 lively symbolic animals.

In traditional Chinese culture, it was around the time of the Han Dynasty that a correspondence between the 12 symbolic animals and the 12 Earthly Branches was established. These were: *zi* and Mouse, *chou* and Ox, *yin* and Tiger, *mao* and Rabbit, *chen* and Dragon, *si* and Snake, *wu* and Horse, *wei* and Ram, *shen* and Monkey, *you* and Rooster, *xu* and Dog, and *hai* and Pig. They are for marking years and time.

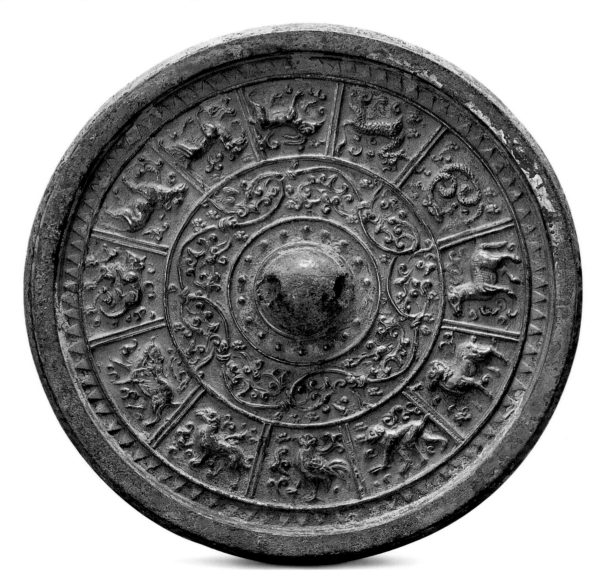

179

Bronze Mirror
with Inscription "Zhao Ri Ling Hua"

Sui Dynasty

Diameter 14 cm

This mirror is round in shape. It has a semicircular button. The inner section has four mythical animals, separated by floating clouds and flowers. Its outer section has two bands of teeth. The high edge has an inscription of a poem with five characters to each line in regular script.

The craftsmanship of this mirror is exquisite, its decorative patterns are refined and smooth, and the mirror is a fine example from the Sui Dynasty.

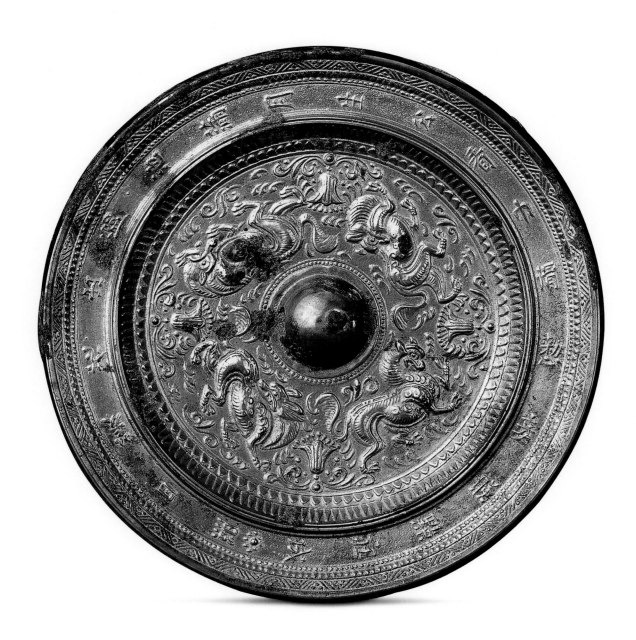

180
Bronze Mirror
with Inscription "Yu Xia Pan Kan"
Sui Dynasty

Diameter 16.2 cm

 This mirror is round in shape. It has a semicircular button, a square button stand decorated with petals. The motif of the inner section is the four mythical animals arranged in four directions, separated by floating clouds. The outer section has two bands of teeth. It has a high edge inlaid with an inscription of a poem with five characters to each line in regular script.

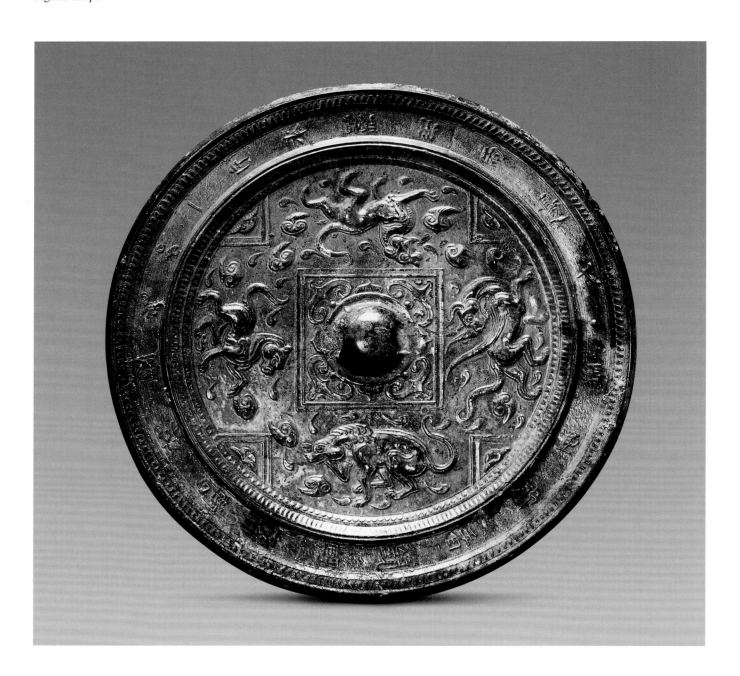

181

Bronze Bowl
with Bowstring Design and a Cover

Tang Dynasty

Overall height 14.1 cm
Diameter of mouth 20.8 cm

This bowl is round in shape. It has a tray-shaped mouth, a belly with bowstrings, and a
ring foot. The lid is round in shape to fit the rim. It has a round-shaped tray, a shallow belly,
and a ring foot. This kind of bronze bowl is rarely seen.

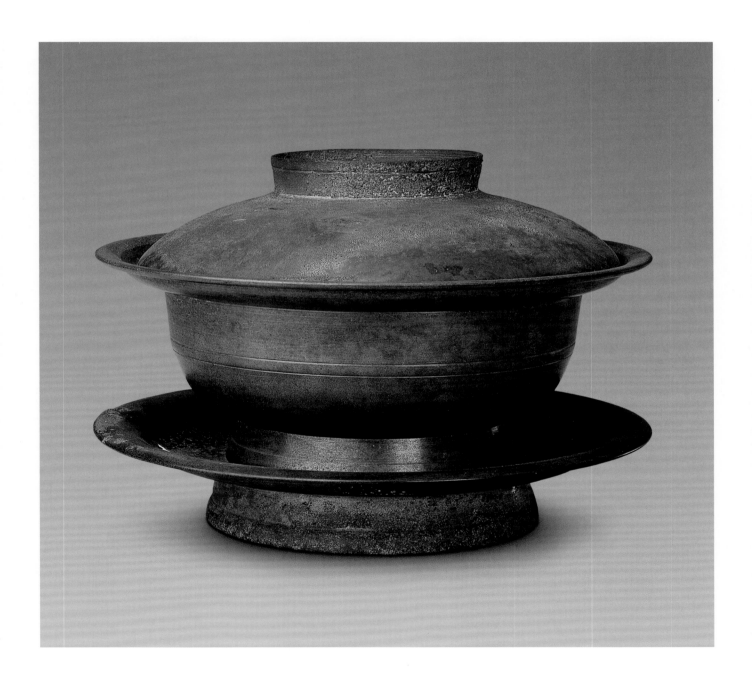

182

Bronze Plate
with Bowstring Design and a Long Stem
Tang Dynasty

Height 7.9 cm
Diameter 14.7 cm

This is a round plate. It has a shallow belly, a long stem, a tray-shaped mouth, and its foot is decorated with bowstrings.

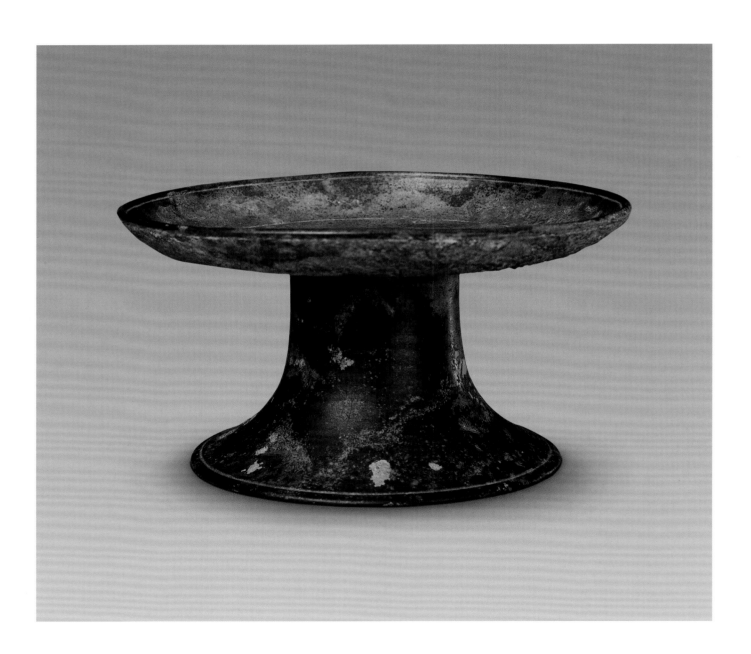

183

Long-necked Bronze Pot

Tang Dynasty

Height 32.3 cm
Diameter of belly 14.5 cm

This pot has a long narrow neck, a vertical mouth, and a long handle with a cap-shaped lid. The belly is round and bulging. The shoulder has a water inlet.

The shape of this pot is exquisite, and the lines on different parts are neat and smooth.

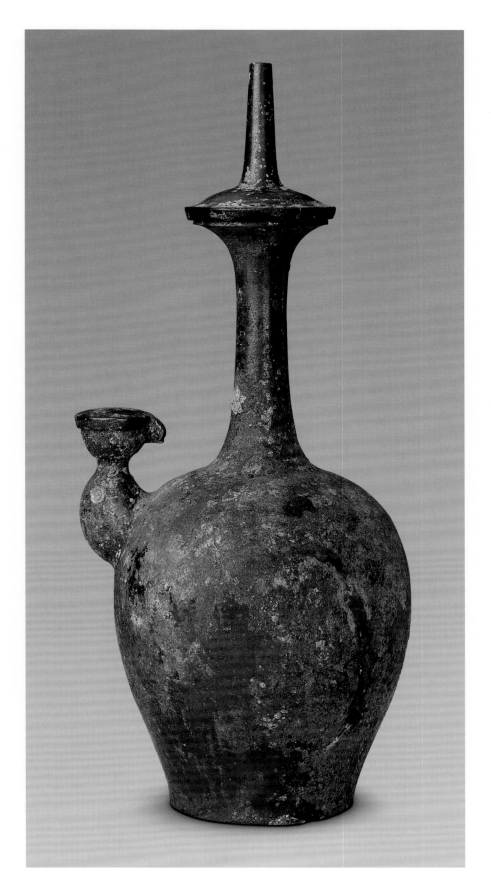

184

Gilded Bronze Cup with Design of Horsemanship and Archery

Tang Dynasty

Height 7.4 cm
Diameter of mouth 5.9 cm

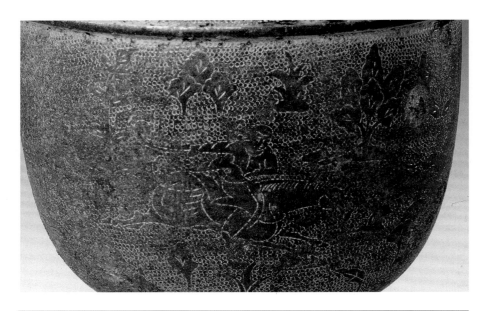

This cup has a vertical mouth, a round lip, and a vertical wall. The belly narrows downward. It has a long stem. The entire body is gilded. Below the mouth rim of the exterior wall is a band of bowstrings. Patterns on the cup are divided into two parts. The upper part has flowers and grass. The lower part has people on horse archery, separated by flowers, grass, and trees. The foot has lotus petals.

Bronze cups were rare in the Tang Dynasty. This cup is made with the highest level of craftsmanship and has beautiful decorations. It is a treasure among Tang Dynasty bronzeware.

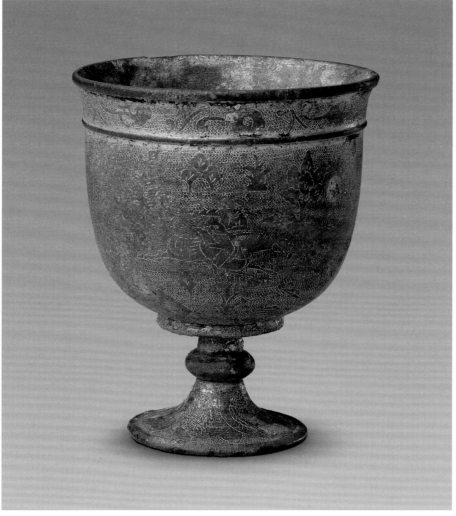

185

Gilded Bronze Brush Washer

Tang Dynasty

Height 6.5 cm
Diameter of mouth 22 cm

This brush washer has a round and vertical mouth with an everted rim. Below the mouth rim is a band of bowstrings. The shallow belly narrows down slightly. It has a flat base. The entire body is gilded.

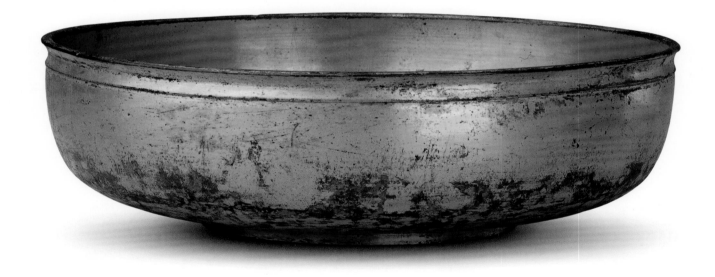

186

Small Bronze Bell with Inscriptions "Tian Bao" and "Ren Ma"

Tang Dynasty

Height 7 cm
Spacing of Xian 7.2 cm

This bell is round in shape. It has a flat mouth and an arched ring nose. One side of the exterior wall has a round-shaped frame in which is inscribed with two characters in which is inscribed with two characters "Ren Ma" in regular script showing the casting was made in "the twelfth month of the tenth year of the Tianbao period." Tianbao was the reign title of Li Longji, Emperor Xuanzong of the Tang Dynasty, and "the tenth year" is AD 751.

This bell was an item for a horse's harness. It has an exact year of casting and is therefore of high research value.

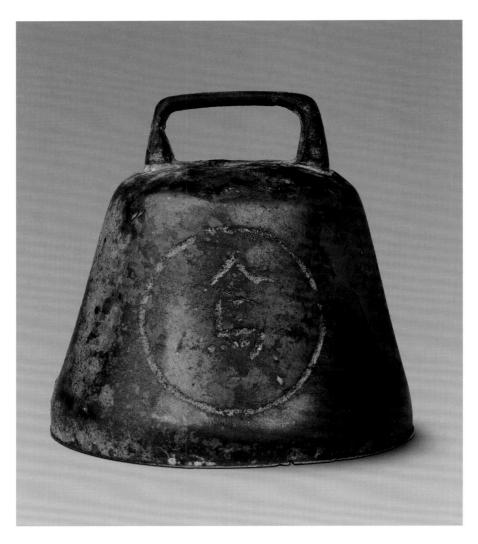

187

Small Bronze Bell
with Inscription
"Si Ji Ping An"

Tang Dynasty

Height 8 cm
Spacing of Xian 7.6 cm

This bell is round in shape. It has a flat base, and an arched button. The exterior wall has two layers of decorations: the upper layer is two groups of animal masks, separated by an inscription *si ji ping an* (Safe and Sound All Year Round), carrying an auspicious meaning. The lower layer has curled leaves and flowers, separated by an inscription stating the bell's maker: "Made by Cao."

The casting of this bell is skilled and the patterns are elaborate.

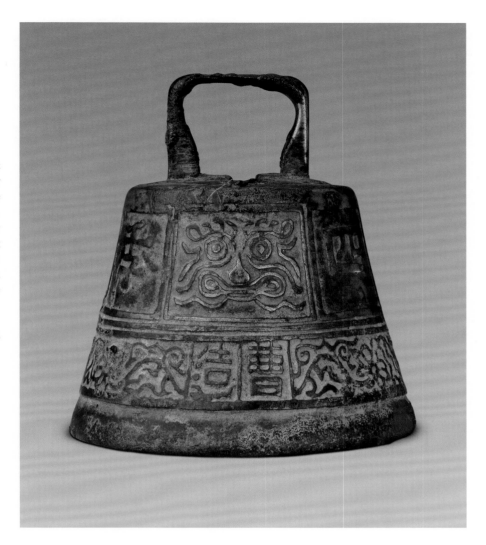

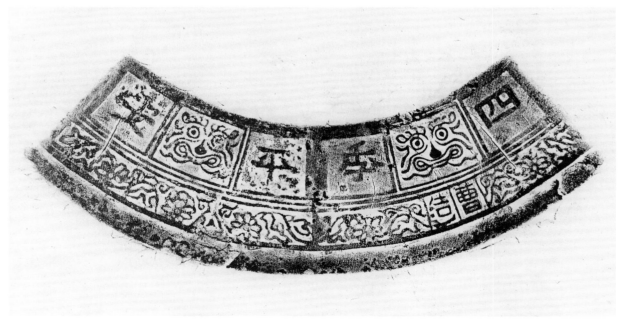

188

Bronze Mirror
in the Shape of a Water Chestnut Flower
with Design of the Moon Palace
Tang Dynasty

Diameter 14.5 cm

This mirror is in the shape of a water chestnut with eight petals. The inner section is concaved, with a carved scene of the Moon Palace in relief. The middle has a cassia tree with luxuriant foliage, and the raised part in the middle of the trunk is hollowed out to form the button of the mirror. On one side of the mirror is Chang E dancing with flown sleeves, and on the other, the Jade Rabbits grinding herbal medicine, with the lower part having a toad which is about to leap. There are clouds at the edge of the mirror.

Most of the bronze mirrors before the Tang Dynasty were either round or square in shape. From the Tang Dynasty onwards, mirrors with flowers came into vogue, with the water chestnut flower design being the most characteristic.

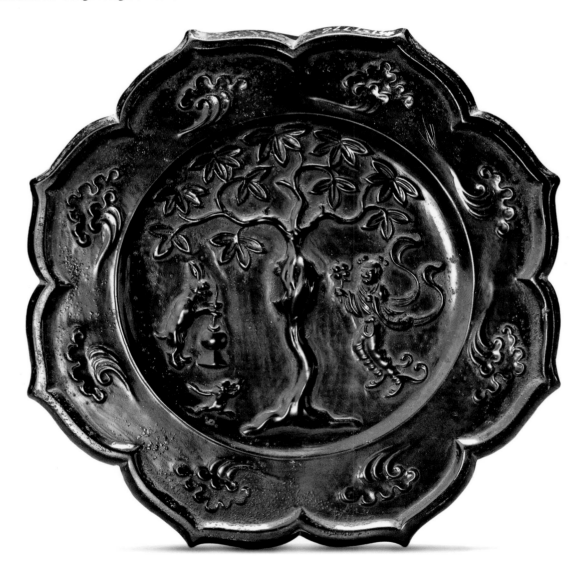

189

Bronze Mirror
with a Scene of Polo Contest

Tang Dynasty

Diameter 19.3 cm

This mirror is in the shape of a water chestnut with eight petals. It has a ball-shaped button. The motif of the inner section is polo contest, showing four people, two in a group, playing polo on horseback. Each player has a mallet in their hand while galloping their horses. Some are in a posture of striking the ball, some are scrambling for the ball, and some are preparing for the attack. Their postures are lively, with the small ball flying in the air. This scene is interspersed with patterns of flowers and grass.

Polo was a popular sport in the Tang Dynasty. The design of this mirror vividly shows the energetic nature of polo. This mirror is an exquisite example of Tang Dynasty bronze mirrors.

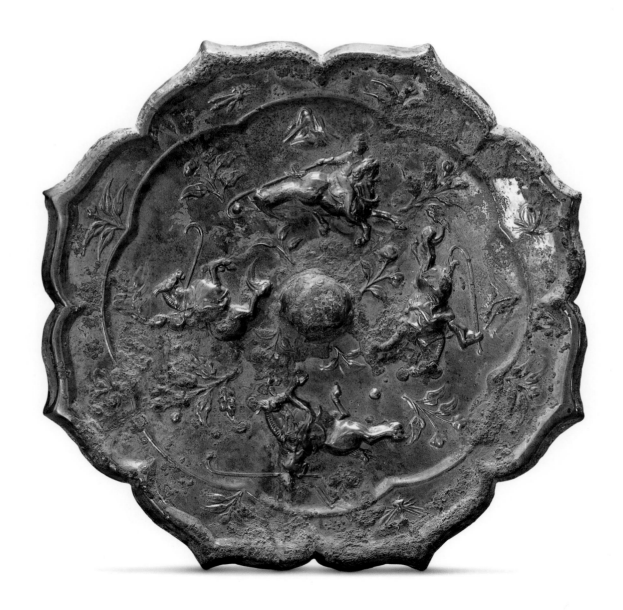

190
Bronze Mirror
in the Shape of a Water Chestnut Flower
with Bird Design
Tang Dynasty

Diameter 17.7 cm

This mirror is in the shape of a water chestnut flower with eight petals. It has a round button. The motif of the inner section is a design of four birds standing on the flowers, some of which stretch their necks and stand upright or flap their wings intending to fly. The outer section has flowers, bees, and butterflies.

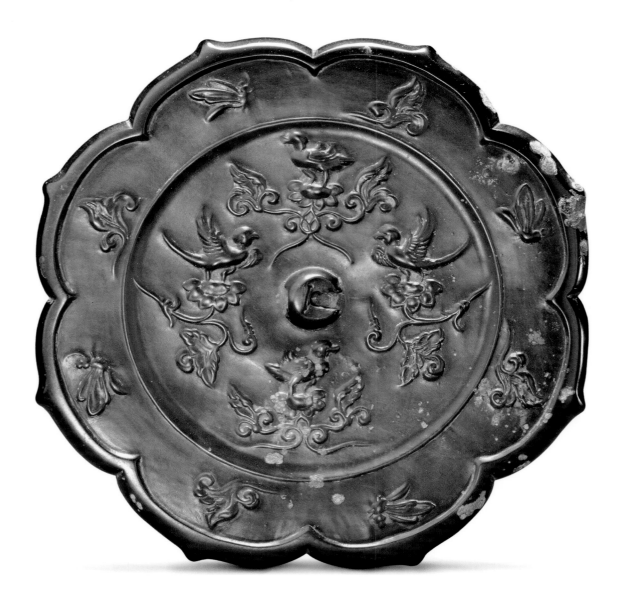

191

Square Bronze Mirror
with Design of Sea Beasts and Grapes

Tang Dynasty

Length of sides 11.5 cm
Qing court collection

This mirror is square in shape. It has a button in the shape of a beast. It is thick, heavy, and white. A protruding frame divides the patterns on the back of the mirror into the inner and outer sections. The inner section has four sea beasts, with grapes in the background. The outer section has birds resting on the luxuriant branches and leaves of the grape trees.

Most of the bronze mirrors of the Tang Dynasty have design of sea beasts and grapes and are in a round shape. Square mirrors are quite rare.

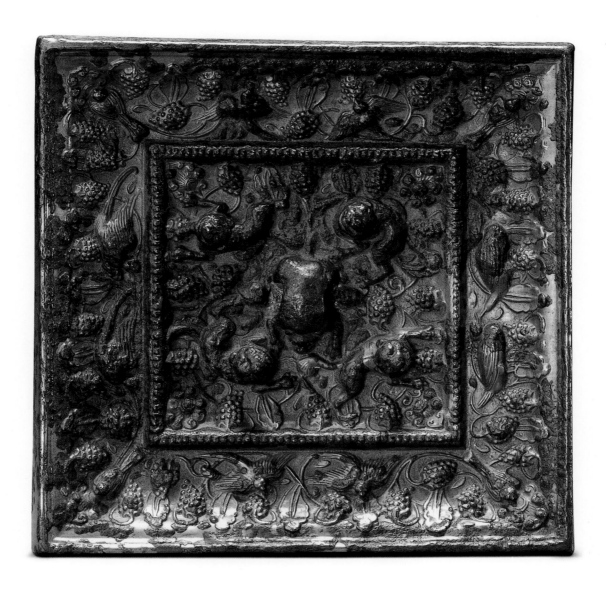

192

Gilded Bronze Stirrups

Tang Dynasty

Height 4.7 cm
Width 3.3 cm

This pair of bronze stirrups is in the shape of a round ring. The upper part has a round button ring for hanging up the stirrup and the lower broad base is the pedal. The entire body is gilded.

The stirrup is a pedal used for horse-riding. The bodies for the stirrups are relatively small and they therefore are not articles for actual use. They are likely to be burial objects and used in sacrifices. The gilded body shows that the status of the deceased would have been rather high.

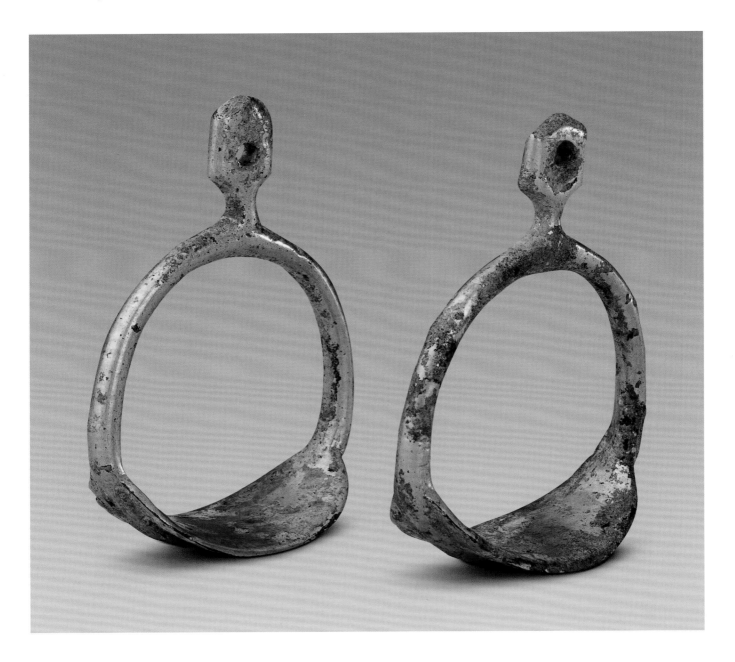

193

Camel-shaped *Yandi* (Water Dropper) Made in the First Year of Zhenguan Period

Tang Dynasty

Height 6.8 cm
Width 11.2 cm

This water dropper is in the shape of a crouching camel with a raised head and an opened mouth as if it is about to grunt. There is a hole inside its mouth. It has two humps. The lower part of the rear hump has a hole for pouring in water. A natural trough is formed between the two humps and the head and neck, which can also serve as a writing brush holder. The base is inscribed with the words "The first year of the Zhenguan period of the Tang Dynasty." Zhenguan is the reign title of Li Shimin, the First Emperor of the Tang Dynasty. The "first year" is AD 627.

A water dropper, also known as a water dripper or a studio dropper, is for storing water for grinding the inkslab. The shape of this water dropper is vivid, and it is a creative design in that it can be used both as a writing brush holder or a water dropper.

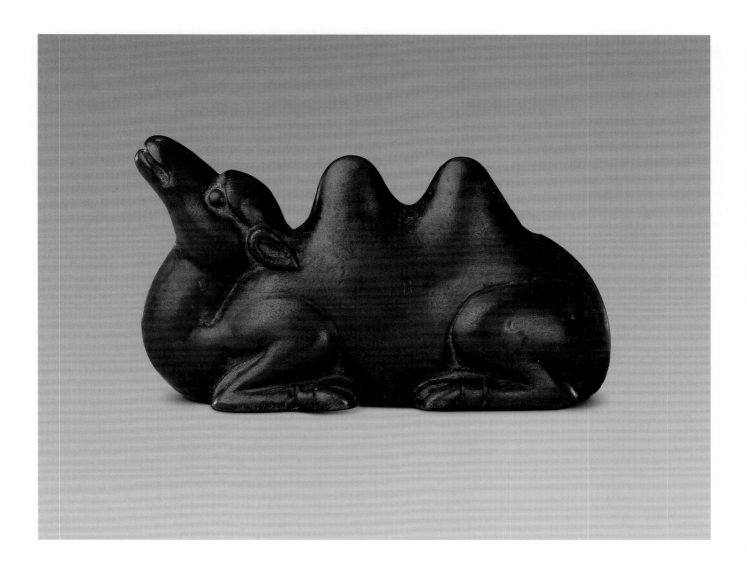

194

Gilded Bronze Pagoda Made by the King of Wuyue Kingdom

Five Dynasties

Height 22.4 cm
Width 7.9 cm

The body of this pagoda is rectangular. It has a Sumeru pedestal. The contracted waist is cast with imagesof the Buddha. The four sides of the body have round-shaped caves with images of the Buddha or Buddhist stories in them. The four corners of the top of the pagoda have horns with their exteriors decorated with guardian warriors, and their interiors, images of the Buddha. In the middle of the top of the pagoda is a gilded seven-storey stupa with a spire. The inside of the base has an inscription recording that "Qian Hongchu, the King of Wuyue, made this eighty-four thousand precious pagoda in the year of yimao."

Qian Hongchu, also known as Qian Chu, was the King of Wuyue during the period of the Five Dynasties and Ten Kingdoms, who ascended to the throne in AD 948 – 978. Yimao is AD 955. From this inscription we know that many pagodas were made at that time, but they are rarely seen today.

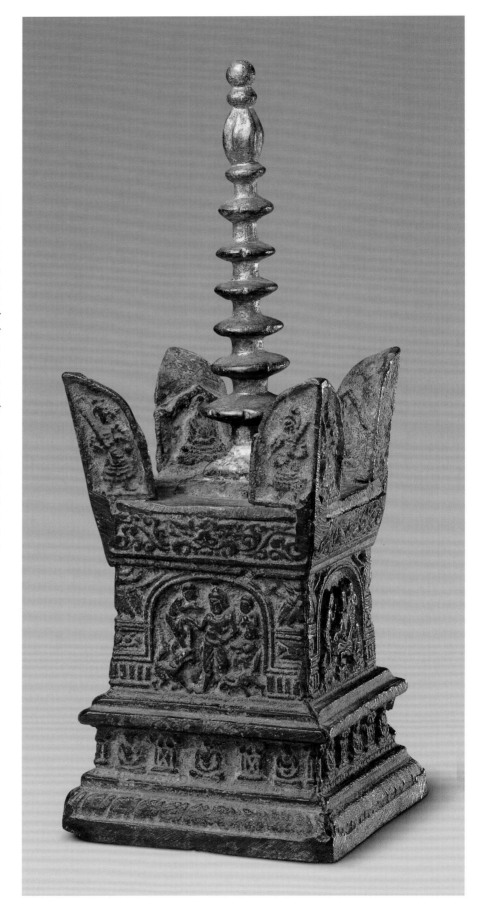

195

Bronze *Zun* (Wine Vessel)
Made in the Third Year of Xuanhe Period

Song Dynasty

Height 27.7 cm
Diameter of mouth 20 cm
Qing court collection

This wine vessel is round in shape. It has a wide flared mouth. The body is divided into sections and has ridges evenly distributed on it. The belly and foot have animal masks and the neck has banana leaves and silkworms. Cast on the interior base is an inscription of 26 characters written in big seal script, recording that this vessel, based on the original one, was made in the third year of the Xuanhe period (AD 1121), and was placed at the Fangze Altar for use in sacrifices.

It was very popular to model an item after an original antique during the reign period of Emperor Huizong in the Northern Song Dynasty, and this wine vessel is a typical example. This vessel provides an important material concerning the bronze casting industry in the Song Dynasty, and as a typical piece of that period.

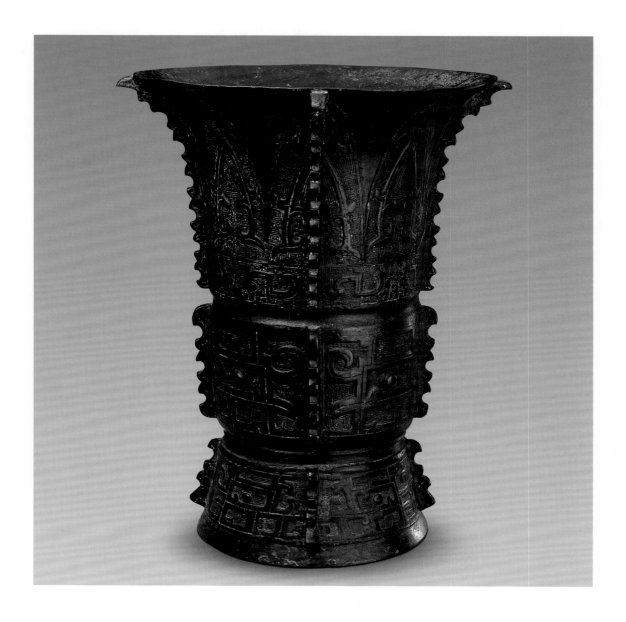

196

A Set of Six Bronze Bells with Inscription "Da Sheng"

Song Dynasty

(1) Height 28 cm
Spacing of Xian 18.4 cm
(2) Height 27 cm
Spacing of Xian 18 cm
(3) Height 27.7 cm
Spacing of Xian 18 cm
(4) Height 27.5 cm
Spacing of Xian 18.1 cm
(5) Height 27.4 cm
Spacing of Xian 18.2 cm
(6) Height 27.5 cm
Spacing of Xian 18.2 cm

These bells are ellipsoid in shape. They have flat mouths and buttons with two coiled-bodied dragons facing each other. The heads of the dragons are linked to form a crossbeam. Between the two dragons is a button in the shape of a rectangle. Each side has 18 spiral studs. The areas between and below the studs are decorated with coiling serpents. The middle part of the bell corpus has an inscription in seal script, with the title of a musical piece on one side and the title of a stanza on the other. One of the bells is *jiazhongqing* with the title of *dahe*, which was originally named *dasheng* but was changed to *dahe* to avoid clashing with the name of Wanyan Sheng, the First Emperor of the Jin Dynasty (Jurchen) when the court had the bell.

In the third year of the Chongning period in the reign of Emperor Huizong of the Song Dynasty (AD 1104), six Song Gongcheng bells were unearthed in Shangqiu, Henan Province. Shangqiu was the former domain of the State of Song, the place where the First Emperor of Song rose in prominence, and one of the alternative capitals of the Northern Song Dynasty. Emperor Huizong saw this as an anauspicious sign. He therefore established an administrative unit there, known as "Dashengfu," and ordered this unit to compose music and create a special casting unit known as "Zhuxiewu" to copy the Song Gongcheng bell by making a number of Dasheng bells, some of which are presented here.

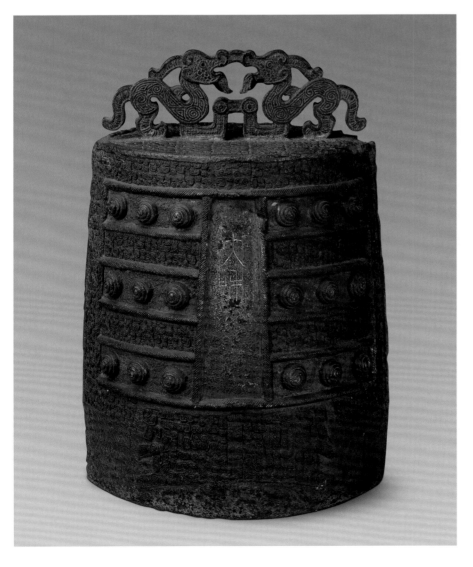

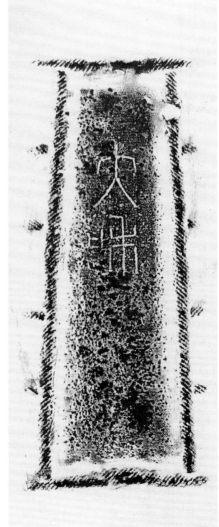

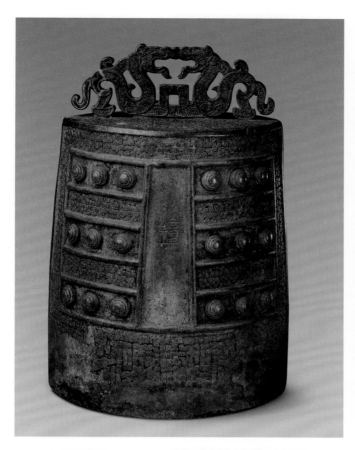

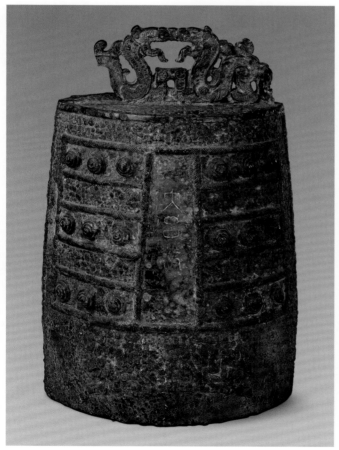

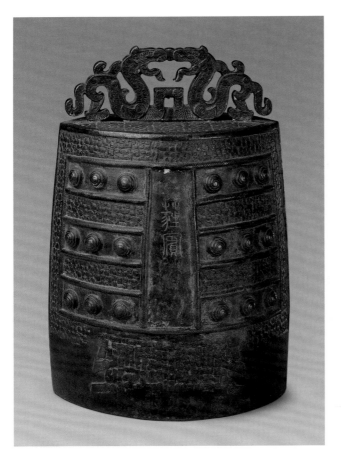

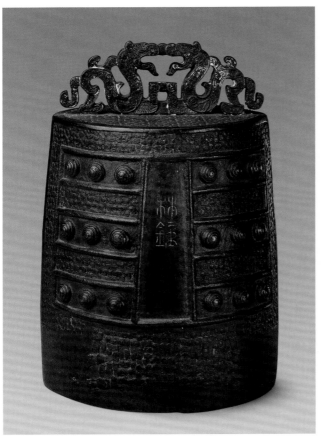

282

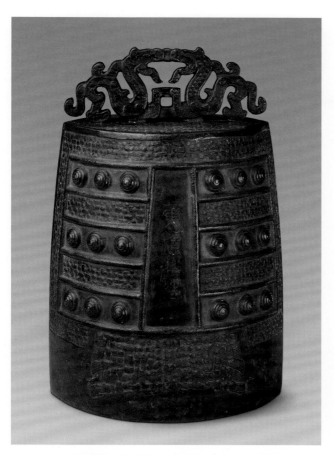

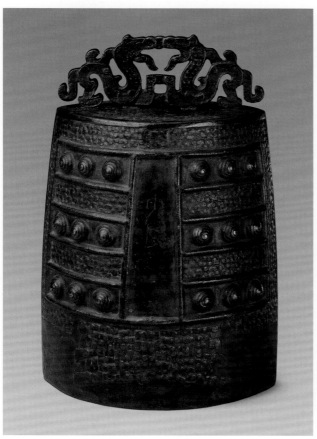

197

Bronze Mirror
Made in the Third Year of Chongning Period
Song Dynasty

Length of sides 13.4 cm

This mirror is in the shape of the character *ya* 亞. It has a round button. The inner section has petals and linked-pearl ring bands. The outer section is decorated with lotus with interlocking branches and linked-pearl belt patterns in the shape of the character *ya* 亞. This mirror has a broad edge and an inscription engraved on one side. It records that this vessel was made in the third year of the Chongning period (AD1104) in the reign of Emperor Huizong of the Song Dynasty.

Mirrors in the shape of the character *ya* 亞 were popular mainly in the northern areas, and a considerable number of these mirrors were unearthed from the graves of the Song period in Henan Province. The mirror is regular in shape and its patterns are fine and beautiful. This mirror is a fine exemplar of the Song period.

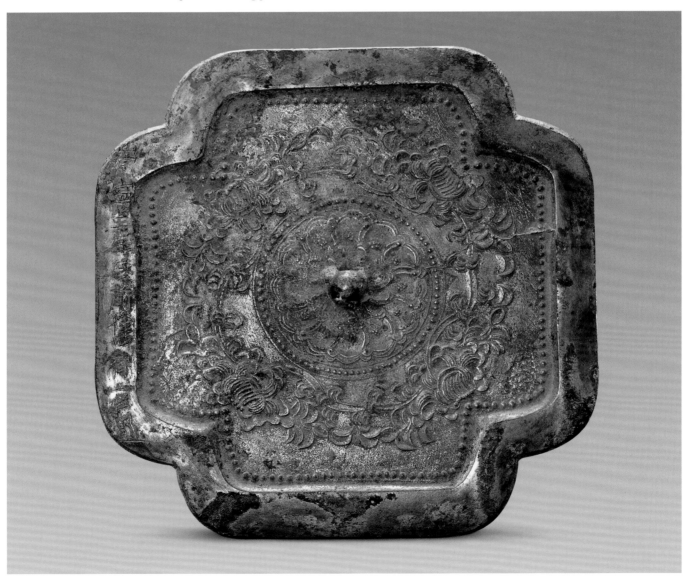

198

Bronze Mirror
with Human Figures and Pavilion Design

Song Dynasty

Diameter 21.3 cm

This mirror is round in shape. It has a round button. On the back of the mirror is a full picture of Buildings and Pavilions on the Fairy Mountain. It has a building floating in the misty air with three immortals standing on the end of the cloud. Under the building are a bridge and flowing water, with two immortal strolling on the bridge and a flood dragon jumping over the water. A sky-touching pine tree with abundant branches and leaves take up a large part of the sky.

The decorative patterns of this mirror are very painterly and the mountains, rivers, buildings and pavilions, and human figures in this mirror are depicted in a brilliant manner. Attention has been paid to the composition, showing the development of Song Dynasty painting.

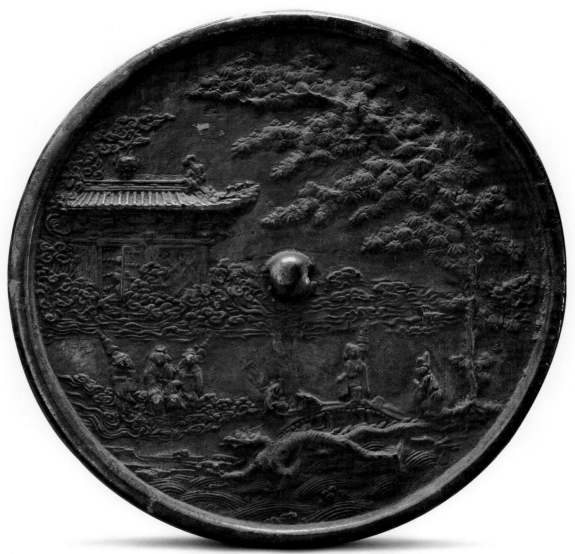

199

Bronze Mirror
Made by the Liu Family in Chengdu
Song Dynasty

Diameter 13.3 cm

This mirror is in the shape of a sunflower with six petals. It has a round buttons and a plain surface. On the right side of the button is a long rectangular box with two lines of inscription in regular script, and the two lines are separated by a single line.

From the time of the Han Dynasty onwards, Chengdu in Sichuan had been an important place for casting bronze mirrors. Many bronze mirrors are inscribed with company names, such as "the Liu Family of Chengdu," "the Liu Clan of Chengdu," and "the Gong Family of Chengdu," which reflects the flourishing of the bronze mirror casting industry in Chengdu.

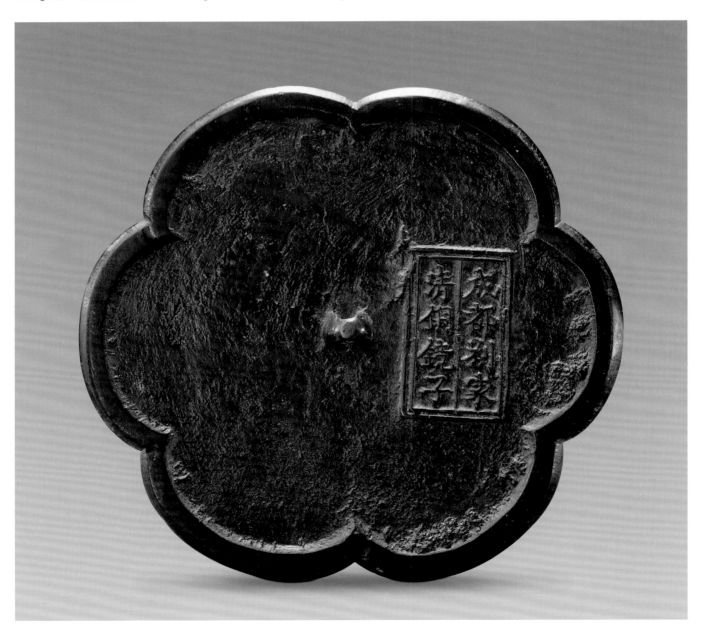

200

Gilded Bronze Pagoda

Song Dynasty

Height 32.9 cm
Width 12.6 cm

The base of this pagoda is a Sumeru pedestal in the shape of a contracted waist octagon and is decorated with lotus petals and flowers. The eight sides of the base have vertical columns, and the spaces between the columns have railings. The body of the pagoda has five stories. The first storey has a frontal open-mouth shrine, and on the two sides of its door are two guardian warriors. From the second storey to the fifth storey, each side is decorated with a shrine door, and each storey has a protruding eave decorated with round tiles. The pagoda has a round top. The entire body of the pagoda is gilded.

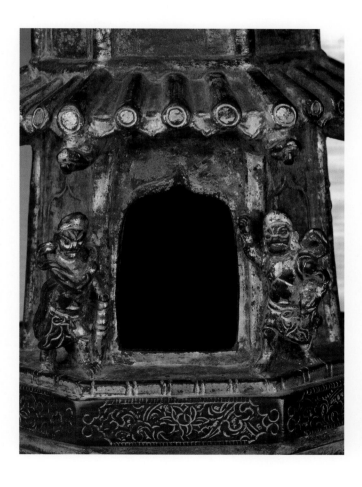

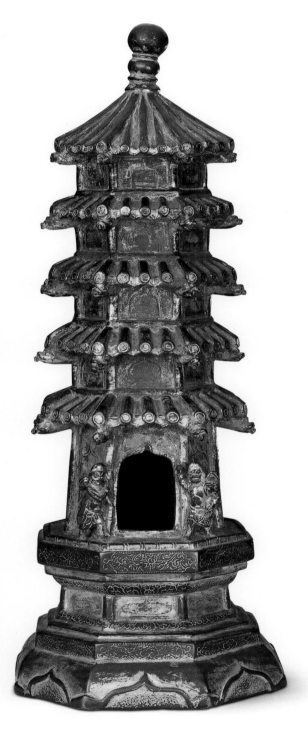

201

Bronze Mirror
Made in the Third Year of Tianqing Period

Liao Dynasty

Diameter 12.6 cm

This mirror is round in shape. It has a semicircular button, and a round button base. The inner section of this mirror has an inscription written in large, embossed characters in standard script: "Made in the twelfth month of the third year of the Tianqing period."

Tianqing is the title of the period in the reign of Yelü Yanxi, Emperor Tianzuodi of the Liao Dynasty. The third year of this reign is AD 1113 (the 12th month of the lunar year might be in the year of AD 1114). This mirror has the exact year of its making, and it can be regarded as a typical bronze mirror of the Liao Dynasty.

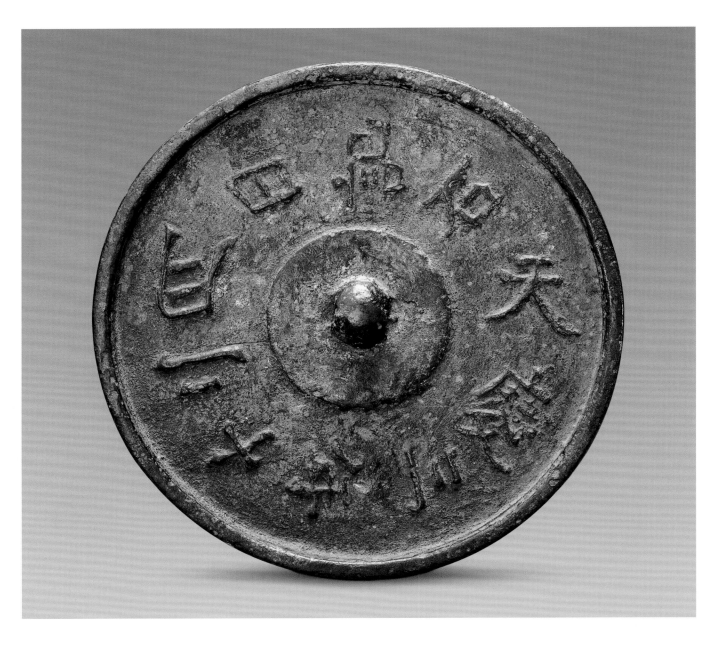

202

Bronze Mirror
Made in the Third Year of Cheng'an Period

Jin Dynasty (Jurchen)

Diameter 12.1 cm

This mirror is round in shape. It has a round button. Patterns at the back of this mirror can be divided into two sections. The inner section has patterns such as animals, water, and rolling clouds. The outer section has a band of inscription with a signature sign, recording that this mirror was made by an official unit in the third year of the Cheng'an period (AD 1198), on the 15th day of the first month. "Shaanxi Commissioner of Eastern Transport" in the inscription would be an abbreviation of "Shaanxi Commissioner of Transit Transportation for the Eastern Route."

This mirror has an exact date, and can be regarded as a typical bronze mirror of that period. The inscription shows the stringent national regulations of the bronze casting industry in the Jin Dynasty.

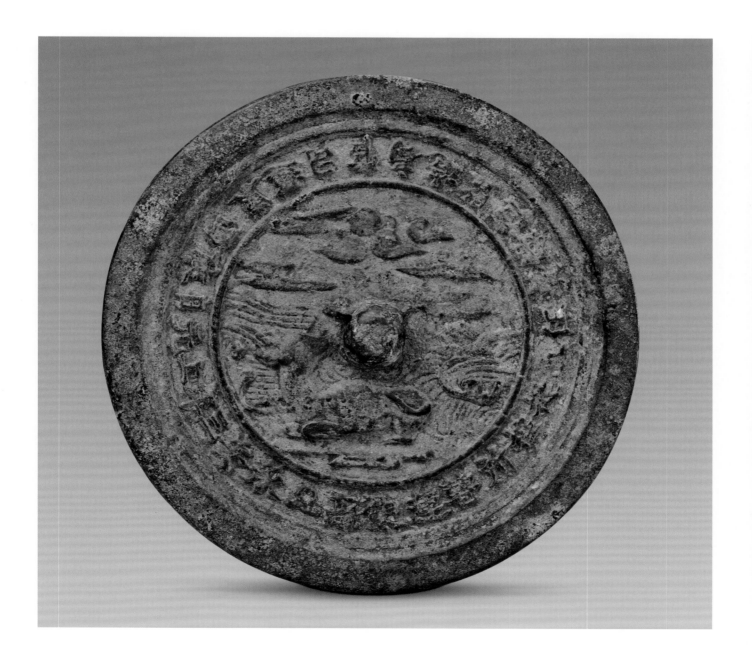

203

Bronze Mirror
with Inscription "Changping County"

Jin Dynasty (Jurchen)

Diameter 17.1 cm

This mirror is in the shape of a water chestnut with eight petals. It has a round button. The scene is an old tree reaching into the sky, and there are fairy mountains, buildings, and pavilions, under which are a small bridge and flowing water, with people crossing the river on the bridge. Inscribed next to the trunk is an inscription.

Changping County in the Jin Dynasty was under the administration of the Daxing Command, which is the present-day southeastern part of Changping County in Beijing. People were forbidden to cast bronze mirrors at this time. The inscription on the mirror has a mark showing official certification.

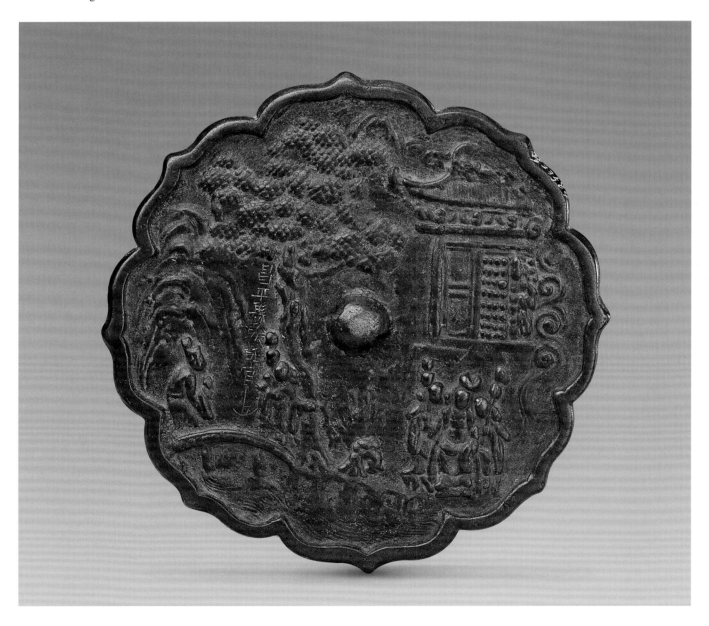

Inscriptions on Bronzeware

Arranged in the order of the picture numbers, the following are the Chinese characters inscribed on the bronzeware pieces.

2. Rectangular *Ding* (Cooking Vessel) Made by an Official Fou as a Sacrificial Utensil　小臣缶方鼎

王易（錫）小臣缶渪
賓（積）五年，缶用
作享大（太）子乙家
祀尊。舉父乙。

3. Rectangular *Ding* (Cooking Vessel) Made by Tian Gao for Mother Xin　田告母辛方鼎

田告作
母辛尊。

5. *Gui* (Food Container) with Inscription "Er"　耴簋

辛巳，王畲多亞，
耴享京麗，
易（錫）貝二朋，用作大（太）子丁𣪕。

10. Shi Lü *Ding* (Cooking Vessel)　師旅鼎

唯三月丁卯，師旅眾仆不
從王征于方，雷更（使）𤖅友弘
以告于白懋父，在荸，白懋
父廼（乃）罰得𢾜古三百孚，今弗
克𤖅罰，懋父令（命）曰：義（宜）播
𢿢（諸）𤖅不從𤖅右征，今毋播
斯又（有）內於師旅。弘以告中
吏（使）書。旅對𤖅質於尊彝。

11. Song *Ding* (Cooking Vessel)　頌鼎

唯三年五月既死霸甲戌，
王在周康邵宮。旦，王各（格）大（太）
室，即立（位）。宰弘右頌入門立
中廷。尹氏受王令（命）書。王乎（呼）
史虢生冊令（命）頌。王曰：頌，令
女（汝）官司成周，賈廿家。監司
新寤，賈用宮御。易（錫）女（汝）玄衣、
黹屯、赤市（紱）、朱黃（衡）、鑾旂、攸勒
用事。頌拜稽首，受令（命）冊佩
以出，反入堇章。頌敢對揚
天子不（丕）顯魯休，用乍（作）朕皇
考龏叔、皇母龏始（姒）寶尊鼎。
用追孝祈匄康�屯右，通
錄永令。頌其萬年眉壽，
畍（畯）臣天子，霝冬（令終）。子子孫孫寶用。

12. *Ding* (Cooking Vessel) Made by Da　大鼎

唯十又五年三月既霸丁
亥，王在𢧜㚔宮。大以氏（厥）友守。
王卿（饗）醴。王乎（呼）善夫騫召
大以氏（厥）友入攼。王召走馬雁
令取𩢑卅匹易（錫）大。大拜稽
首，對揚天子不（丕）顯休，用乍（作）
朕剌考白（伯）盂鼎。大其
子子孫孫萬年永寶用。

13. *Ding* (Cooking Vessel) Made by Zi Duan, Master Wen of the State of Guo　虢文公子段鼎

虢文公子段
乍（作）叔妃鼎，其
萬年無疆，子
孫孫永寶用享。

14. *Ding* (Cooking Vessel) Made by Ke to Pray for Happiness and Longevity　克鼎

唯王廿又三年九月，王
在宗周，王命善夫克舍
令于成周遹正八師之
年。克乍（作）朕皇且（祖）釐季
寶宗彝。克其日用䵼朕
辟魯休，用匄康勵（樂）屯（純）右（佑）
眉壽，永令（命）霝冬（令終），萬年
無疆。克其子子孫孫永寶用。

15. *Li* (Cooking Vessel) Made by Shi Qin to Worship His Parents　師趛鬲

唯九月初吉庚
寅，師趛乍（作）文考
聖公、文母聖姬
尊鬲，其萬年子
孫永寶用。

18. *Gui* (Food Container) Made by Qin Lin to Worship Father Yi　堇臨簋

堇臨乍（作）父乙
寶尊彝。

19. *Gui* (Food Container) Made by Rong　榮簋

唯正月甲申，榮
各，王休，易（錫）𤖅（厥）臣

父，榮賞王畁
貝百朋，對揚天子
休，用乍（作）寶尊彝。

20.　*Gui* (Food Container) with Inscription "Bo Zuo"　伯作簋
　　伯乍（作）簋

21.　*Gui* (Food Container) Made by Shi You　師酉簋
　　唯王元年正月，王在吳，各（格）
　　吳大（太）廟。公族鴋釐入右
　　師酉，立中廷。王乎（呼）史𩛥
　　冊命師酉：嗣乃且（祖）啻官
　　邑人、虎臣、西門尸（夷）、𡪀尸（夷），
　　秦尸（夷）、京尸（夷）、弄身尸（夷）。新易（錫）女（汝）
　　赤市（韍）、朱黃（衡）、中𪍿、攸勒。敬夙
　　夜勿法（廢）朕令（命）。師酉拜稽
　　首，對揚天子不（丕）顯休令（命），用乍（作）
　　朕文考乙白（伯）宄姬尊彝。酉
　　其萬年子子孫孫永寶用。

22.　*Gui* (Food Container) Made by Zhui　追簋
　　追虔夙夕，卹氒（厥）死事，
　　天子多易（錫）追休，追敢
　　對天子覲揚，用乍（作）朕皇
　　且（祖）考隣簋，用享孝于
　　前文人，用祈匄眉壽
　　永令（命），畯臣天子，霝（令）冬（終），追
　　其萬年子子孫孫永寶用。

23.　*Gui* (Food Container) Made by Ge Bo　格伯簋
　　唯正月初吉癸子（巳），王在成
　　周。格白（伯）叕（付）良馬乘（乘）于倗生，
　　氒貯卅田，劓析。格白邊，殹妊役（及）
　　仡氏從。格白庚（安）役甸。殹
　　氏紉啚谷杜木，遷谷旅桑涉東門。
　　氒書史戩武立。鼏成𡒦。
　　鑄保（寶）簋，用典格白（伯）田。其
　　萬年子子孫孫永寶用。倗。

24.　*Gui* (Food Container) Made by Cui　𣪘簋
　　𣪘乍（作）王母媿
　　氏餗簋。媿氏
　　其眉壽萬年用。

25.　*Gui* (Food Container) Made by Tai Shi Zu　太師盧簋
　　正月既望甲午，王在周師
　　量宮。旦，王各（格）大室，即立（位），王
　　乎（呼）師晨召大（太）師盧入門，立
　　中廷，王乎宰智易（錫）大（太）師盧
　　虎裘，盧拜稽首，敢對揚天
　　子不（丕）顯休。用乍（作）寶簋，盧其
　　萬年永寶用。唯十又二年。

26.　Song *Gui* (Food Container)　頌簋
　　唯三年五月既死霸甲戌，
　　王在周康邵宮。旦，王各（格）大（太）
　　室，即立。宰弘右頌入門立
　　中廷。尹氏受王令書。王乎（呼）
　　史虢生冊令（命）頌。王曰：頌，令
　　女（汝）官司成周，貯。監司新窹
　　貯用宮御。易（錫）女（汝）玄衣、黹屯、

赤市（韍）、朱黃（衡）、鑾旂、攸勒用事。
頌拜稽首，受令（命）冊佩以出，
反入堇章。頌敢對揚天子
不（丕）顯魯休，用乍（作）朕皇考龏
叔，皇母龏始（姒）寶尊簋。用追
孝祈匄康𩱦屯右，通錄永
令。頌其萬年眉壽無疆，畯（畯）
臣天子，霝（令）冬（終）。子孫永寶用。

27.　*Gui* (Food Container) Made by Yang　揚簋
　　唯王九月既生霸庚寅，王
　　在周康宮。旦，各大室即立（位），司
　　徒單白內右揚，王乎內史先
　　冊令（命）揚。王若曰：揚，乍（作）司工，
　　官司量田甸，罖司𡨄，罖司𡨦，罖司工事。易（錫）女（汝）
　　赤㔫市，鑾旂。訊訟取徵五
　　孚。揚拜手稽首，敢對揚天
　　子不（丕）顯休，余用乍（作）朕剌考害白（伯）
　　寶簋，子子孫孫其萬年永寶用。

28.　Dou Bi *Gui* (Food Container)　豆閉簋
　　唯王二月既生霸，辰在戊寅，
　　王各（格）于師戲大室。井（邢）白（伯）入右
　　豆閉，王首（呼）內史冊命豆閉。
　　王曰：閉，易（錫）女（汝）𢧵衣，玄市（韍）、鑾
　　旂，用俤乃且（祖）考事，司𤔲俞（豫）
　　邦君司馬弓矢。閉拜稽首，
　　敢對揚天子不（丕）顯休命，用
　　乍（作）朕文考釐叔寶簋。用易
　　眉壽萬年，永寶用于宗室。

30.　*Xu* (Food Container) Made by Guo Cong　𩰬從盨
　　唯王廿又五年七月既□□□□王在
　　永師田宮，令（命）小臣成友（右）逆杲□
　　內史無蔑大史𧾍曰：章氒（之）𪒠
　　夫𨚓爾比（從）田，其邑𪑅閒𣂤。復
　　友（有）比（從）其（之）田，其邑復訾言二印（邑）。
　　奥𨚓比（從）復𨚓小宮𨚓比（從）田，其
　　邑役罖句商兒罖雔戈。復
　　限餘（賒）𨚓比（從）田，其邑竸槏在
　　三邑，州瀘二邑。凡復友（賄）復友𨚓
　　比（從）田日十有（又）三邑。氒𨚓比（從），善夫克。
　　比（從）乍（作）朕皇且（祖）丁公文考惠公
　　盨，其子子孫孫永寶用。�

31.　*Xu* (Food Container) Made by Du Bo for Offering Sacrifices to His Grandfather, Father, and Close Friends　杜伯盨
　　杜白（伯）乍（作）寶盨，其用
　　享孝于皇申且（祖），考于
　　好朋友，用萊壽匄永
　　令（命）其萬年永寶用。

32.　*Yu* (Food or Water Container) Made by Bo　伯盂
　　白（伯）乍（作）寶尊盂，其萬
　　年孫子子永寶用享。

37.　*Pu* (Food Container) Made by the Grand Minister of Education of the State of Lu　魯大司徒匜
　　魯大司徒厚氏
　　元作膳匜，其眉
　　壽萬年無疆，子子
　　孫孫永寶用之。

39. Qiao *Ding* (Cooking Vessel) Made by Yin Ken, King of Chu　楚王酓肯鐈鼎

□。集腏。

41. *Fu* (Food Container) Made by Yin Ken, King of Chu　楚王酓肯簠

楚王酓肯作鑄金匠以共歲嘗。
戉寅

50. Rectangular *Zun* (Wine Vessel) Made by Xuya Clan to Worship Ancestors　酖亞者姰以

酖亞者姰以
大（太）子尊彝。

53. *Lei* (Wine Vessel) Made by Jue to Worship Zu Jia　乃孫祖甲罍

乃孫厥作祖甲
罍。其□□□弗
□貝其作□。

54. *You* (Wine Vessel) Made by Yu to Worship Zu Ding　毓祖丁卣

辛亥，王在廙，降令（命）
曰：歸福於我多高
岙。易（錫）鬯，用乍（作）
毓（後）且（祖）丁尊。（冊）。

57. *You* (Wine Vessel) Made for Sacrifice by Yi Qi in the Fourth Year of Dixin's Reign　四祀邲其卣

丁巳，王曰：尊
文武帝乙宜，
在畾大廷，遘
乙。翌日，丙午，敢。
丁未，鬺（享）。己酉，王
在杵，邲其易（錫）貝。
在四月，唯
王四祀，翌日。

63. *He* (Wine Vessel) Made by Lai Fu　來父盉

來父作盉，
子子孫孫其永寶。

65. *Fou* (Wine Vessel) Made by Craftsmen　鑄客缶

鑄客為王后六室為之。

71. *Pan* (Water Vessel) Made by Huan　寰盤

唯廿又八年五月既望庚
寅，王在周康穆宮。旦，王各（格）大
室，即立（位）。宰頵右寰入門，立
中廷，北鄉（向）。史□受王令（命）書
王乎（呼）史減冊易（錫）寰玄衣、黹
屯、赤市、朱黃、鑾旂、攸勒，戈
琱戲䀇必（柲）彤沙（緌）。寰拜稽首，
敢對揚天子不（丕）顯叚（嘏）休令（命），
用乍（作）朕皇考奠白（伯）、奠姬寶般（盤）。
寰其萬年子子孫孫永寶用。

72. *Ling* (Water or Wine Container) Made by Zheng Yibo　鄭義伯罍

奠（鄭）義白作季姜霝（罍），余曰（以）行曰（以）征，盛即沽
我，用曰（以）匋烝，征
弋曰（以）蕾，猷用賜眉壽，孫子為永寶。

73. *Pan* (Water Vessel) Made by Qi Yingji's Nephew　齊縈姬盤

齊縈姬之媵
作寶盤，其眉
壽萬年無疆，
子子孫孫永寶用享。

75. *Yi* (Water Vessel) made by Cai Zi　蔡子匜

蔡子佗自
作會□。

78. *Zhong* (Bell, Musical Instrument) Made by Zu　敌鐘

鉦部
唯正月初吉丁亥，
敌乍（作）寶鐘，用追

鼓部
孝于己
白（伯），用享
大宗，用
濼（樂）好宗。
敌眔（及）蔡
姬永寶，用
邵大宗。

79. *Zhong* (Bell, Musical Instrument) Made by Shu Lü of the State of Guo　虢叔旅鐘

虢叔旅曰：不（丕）顯皇考惠叔，
穆穆秉元明德，御於乒辟，夐（渾）
屯之敋（懿）。旅敢曁帥井（型）皇考
威義（儀），□御于天子。廼天子
多易（錫）旅休。旅對天
子魯休揚，用乍（作）朕皇
考惠叔大䓊龢鐘。
皇考嚴在上，異（翼）在下，
數數爰爰，降旅多福，旅其
萬年子子孫孫永寶用享。

80. Ke *Zhong* (Bell, Musical Instrument)　克鐘

佳（唯）十又六年九月初吉
庚寅，王才（在）周康剌（厲）宮，王
乎（呼）士䚅召克，王親令克，
遹涇東至于京
師，易（錫）克甸車、馬。

82. Zhe Jian *Zhong* (Bell, Musical Instrument)　者減鐘

唯正月初吉丁亥，工虞王
皮難之
子者減，
自作□鐘，子孫永保用之。

83. *Zhong* (Bell, Musical Instrument) Made by Ying Ci, Prince of Zheng　王子嬰次鐘

□初吉，日唯
□，王子嬰次
自作□鐘，
永用匽喜。

84. *Goudiao* (Musical Instrument) Made by Qi Ci　其次句鑃

正初吉丁亥，其次擇其吉金鑄句鑃，
以享以孝，用旂萬壽，子子孫孫永保用之。

85. **Zhe Ci *Zhong* (Bell, Musical Instrument)** 者沪鐘

□□兓之，
用爰烈疾，
光之於聿。
汝其用茲，
汝安乃壽，
惠媚（逸）康樂。

90. ***Ge* (Dagger Axe) Made for the Use of Han Wang Shi Ye** 邗王是野戈

邗王是野
作為元用。

91. ***Jian* (Sword) with Inscription "Shao Ju"** 少虡劍

吉日壬午，作為元用，玄鏐
鏄呂，朕余名之，謂之少虡。

92. ***Jian* (Sword) of Gou Jian, King of Yue** 越王劍

戉王，戉王。
者旨于睗。

93. ***Ge* (Dagger Axe) of Yin Zhang, King of Chu** 楚王酓璋戈

楚王酓璋嚴恭寅
乍（作）窹戈，以邵揚文
戈用
武之。

95. ***Dui* (Spear Ornament) Made by Da Liang Zao for Shang Yang's Use** 大良造鞅鐓

十六年大
良造庶長
鞅之造。離。
矛。

98. **Tiger-shaped *Jie* (Warrant, Serving as a Pass)** 虎節

王命：命傳賃。

101. **Bronze Chengzhou Bell** 成周鈴

成周王鈴

103. **Bronze Chariot Bell with Inscription "Ze Bao"** 矢寶車鈴

□作
矢寶

118. **Bronze Weighing Apparatus** 秦權

廿六年
皇帝
盡並兼
天下諸
矦，黔首
大安，立號
為皇帝，
乃詔丞相
狀綰，法
度量
則不壹，
嫌疑者
皆明壹
之。

119. **Yang Chu *Ding* (Cooking Vessel)** 楊廚鼎

楊廚銅一斗鼎，重十一斤二兩，地節三年十月造。

120. **Chang Yang Gong *Ding* (Cooking Vessel) for Sacrificial Use** 長揚共鼎

長揚共鼎，容一斗。

121. **Gilded Bronze *Ding* (Cooking Vessel) Made in the Fourth Year of Yuanshi Period** 元始四年鎏金鼎

銅乘□鼎容一斗，元始四年□□□□守佐□守□□□□□□。

128. **Bronze Jar with Inscription "Le Wei Yang"** 樂未央壺

樂未央，
宜酒食，
長久富。

131. **Bronze *Fang* (Rectangular Jar) with Inscription "Zhong Shi Si Jin"** 重十四斤鈁

趙。重
十四斤。

135. **Bronze *Zun* (Wine Vessel) with Inscription "Guang Wu"** 光武樽

光武歲在大陽造作好尊，飲中好酒令人湍。

136. **Bronze Chengyu *Hu* (Dry Measure) Made in the 21st Year of Jianwu Period** 建武廿一年乘輿斛

建武廿一年，蜀郡西工造乘輿一斛，承旋雕蹲熊足，青碧閔瑰
飾。銅承旋徑二尺二寸。銅塗工崇，雕工業，涷工康，造工業，造
護工卒史惲、長汜、承萌、椽巡，命史郎主。

137. **Bronze Washer Made in the Fourth Year of Yuanhe Period** 元和四年洗

元和四年堂狼造

138. **Bronze Washer with Inscription "Fu Gui Chang, Yi Hou Wang"** 富貴昌宜侯王洗

富貴昌，宜侯王。

145. **Bronze Candleholder Made in the Third Year of Jianzhao Period** 建昭三年燈

中宮內者第十三，故家。
建昭三年，考工工憲造銅行鐙重二斤一兩。
護建、嗇夫福、椽光、主左丞宮、令相省，五年十二月輸。

146. **Bronze Candleholder with a Base in the Shape of a Wild Goose's Leg, Made in the First Year of Suihe Period** 綏和元年雁足燈

綏和元年，供工工譚為內者造銅雁足鐙。護相守、嗇夫博、椽
並，主右丞揚令賀省，重六斤。

147. **Bronze Candleholder with Inscription "Shao Fu"** 少府燈

內者重二斤四兩，二年少府造。
桂宮
前浴

149. **Bronze Candleholder with Inscription "Yi Zi Sun"** 宜子孫燈

□□宜子孫吉

153. Bronze Incense Burner with Inscription "Yang Quan" 陽泉熏爐

陽泉使者
舍熏盧一，
有般及蓋，
並重四斤
一□□□
五年六安
十三年
正月乙未
內史屬
賢造，雒
陽付守長
則丞善，
掾勝，傳
舍，嗇夫兌。

154. Bronze Mirror with Linked Curve Design 連弧紋鏡

絜清白而事君志行之弅明□玄之流澤恐□而日忘美人□□思毋絕

157. Bronze Mirror with Inscription in Bird-and-Insect Script 鳥書銘鏡

常毋相忘，常富貴，安樂未央。羊

160. Bronze Belt Hook with Inscription "Bing Wu" 丙午帶鉤

丙午鉤，手抱白魚中宮珠，位至公侯。

163. Bronze Belt Hook Made in the Second Year of Zhanghe Period 章和二年帶鉤

章和二年五月十五日丙午造保身鉤

168. Bronze Measure with Inscription "Chang Le Wan Hu" 長樂萬斛量

長樂萬斛

169. Bronze Flat Iron Made in the Sixth Year of Yongyuan Period 永元六年熨斗

永元六年閏月一日，十湅（煉）牟尉（熨）斗，宜衣，重三斤，直（值）四百，保二親，大富利，宜子孫。

171. Bronze *Fu* (Cooking Vessel) Made in the Third Year of Taikang Period 太康三年釜

太康三年八月六日右尚方造一斗銅釜，重九斤七兩。第一。

172. Bronze *Zun* (Wine Container) Made in the Tenth Year of Taikang Period 太康十年樽

太康十年歲己酉四月洛陽冶造。五。

179. Bronze Mirror with Inscription "Zhao Ri Ling Hua" 照日菱花鏡

照日菱花出，臨池滿月生，公看巾帽整，妾映點妝成。

180. Bronze Mirror with Inscription "Yu Xia Pan Kan" 玉匣盼看鏡

玉匣盼看鏡，輕灰暫拭塵，光如一片水，影照兩邊人。

186. Small Bronze Bell with Inscriptions "Tian Bao" and "Ren Ma" 天寶人馬鈴

人馬
天寶十年正月

187. Small Bronze Bell with Inscription "Si Ji Ping An" 四季平安鈴

四季平安
曹造

193. Camel-shaped *Yandi* (Water Dropper) Made in the First Year of Zhenguan Period 貞觀元年駱駝硯滴

大唐時貞觀元年

194. Gilded Bronze Pagoda Made by the King of Wuyue Kingdom 吳越國王鎏金塔

吳越國王錢弘俶敬造八萬四千寶塔，乙卯歲記。

197. Bronze Mirror Made in the Third Year of Chongning Period 崇寧三年銘鏡

崇寧三年已前舊有官（押）

199. Bronze Mirror Made by the Liu Family in Chengdu 成都劉家鏡

成都劉家清銅鏡子

201. Bronze Mirror Made in the Third Year of Tianqing Period 天慶三年鏡

天慶三年十二月日記石

202. Bronze Mirror Made in the Third Year of Cheng'an Period 承安三年銘鏡

承安三年上元日，陝西東運司官局造。監造承事任（花押），提控運使高（花押）。

203. Bronze Mirror with Inscription "Changping County" 昌平縣銘鏡

昌平縣驗訖官（押）

Dynastic Chronology of Chinese History

Xia Dynasty	Around 2070 B.C.—1600 B.C.
Shang Dynasty	1600 B.C.—1046 B.C.
Zhou Dynasty	
Western Zhou Dynasty	1046 B.C.—771 B.C.
Eastern Zhou Dynasty	770 B.C.—256 B.C.
Spring and Autumn Period	770 B.C.—476 B.C.
Warring States Period	475 B.C.—221 B.C.
Qin Dynasty	221 B.C.—206 B.C.
Han Dynasty	
Western Han Dynasty	206 B.C.—23A.D.
Eastern Han Dynasty	25—220
Three Kingdoms	
Kingdom of Wei	220—265
Kingdom of Shu	221—263
Kingdom of Wu	222—280
Western Jin Dynasty	265—316
Eastern Jin Dynasty Sixteen States	
Eastern Jin Dynasty	317—420
Sixteen States Periods	304—439
Southern and Northern Dynasties	
Southern Dynasties	
Song Dynasty	420—479
Qi Dynasty	479—502
Liang Dynasty	502—557
Chen Dynasty	557—589
Northern Dynasties	
Northern Wei Dynasty	386—534
Eastern Wei Dynasty	534—550
Northern Qi Dynasty	550—577
Western Wei Dynasty	535—556
Northern Zhou Dynasty	557—581
Sui Dynasty	581—618
Tang Dynasty	618—907
Five Dynasties Ten States Periods	
Later Liang Dynasty	907—923
Later Tang Dynasty	923—936
Later Jin Dynasty	936—947
Later Han Dynasty	947—950
Later Zhou Dynasty	951—960
Ten States Periods	902—979
Song Dynasty	
Northern Song Dynasty	960—1127
Southern Song Dynasty	1127—1279
Liao Dynasty	907—1125
Western Xia Dynasty	1038—1227
Jin Dynasty	1115—1234
Yuan Dynasty	1206—1368
Ming Dynasty	1368—1644
Qing Dynasty	1616—1911
Republic of China	1912—1949
Founding of the People's Republic of China on October 1, 1949	